the JOY of Digital PHOTOGRAPHY

Jeff Wignall

Book Design: Sandy Knight
Front Cover Design: Thom Gaines
Back Cover Design: Sandy Knight
Assistant Editor: Haley Pritchard
Associate Art Director: Shannon Yokeley
Editorial Assistance: Delores Gosnell and Dawn Dillingham

The Library of Congress has cataloged the hardcover edition as follows:
Wignall, Jeff.
 The joy of digital photography / Jeff Wignall.
 p. cm.
 Includes index.
 ISBN 1-57990-578-1
 1. Photography--Digital techniques. I. Title.
TR267.W54 2004
775--dc22
 2004001116

10 9 8 7 6 5 4 3 2 1

Published by Lark Books, A Division of
Sterling Publishing Co., Inc.
387 Park Avenue South, New York, N.Y. 10016

First Paperback Edition 2006
© 2006, Jeff Wignall
Photography © 2006, Jeff Wignall unless otherwise specified

Cover Photos:
© Thom Gaines: Boy on front cover.
© Jeff Wignall: All other photos and picture elements except product shots.

Product names are trademarks of their respective manufacturers.

Digital Technology Timeline, pages 58-63, © 2006 Lark Books
Photos for the Digital Technology Timeline courtesy of:
Apple Computer, Canon USA, Inc., Dycam Inc., Eastman Kodak Company, Epson
America, Fuji Photo Film, Inc., Kurzweil Technologies, Inc., Lucent Technologies
Inc./Bell Labs, Nikon Inc., Sigma Corp., and Sony Corp.

Useful Photographic Websites, pages 296-297, © 2006 Lark Books

Distributed in Canada by Sterling Publishing, c/o Canadian Manda Group,
165 Dufferin Street, Toronto, Ontario, Canada M6K 3H6

Distributed in the United Kingdom by GMC Distribution Services,
Castle Place, 166 High Street, Lewes, East Sussex, England BN7 1XU

Distributed in Australia by Capricorn Link (Australia) Pty Ltd.,
P.O. Box 704, Windsor, NSW 2756 Australia

If you have questions or comments about this book, please contact:
Lark Books, 67 Broadway, Asheville, NC 28801
(828) 253-0467

Manufactured in China

ISBN 13: 978-1-57990-578-1 (hardcover) 978-1-57990-947-5 (paperback)
ISBN 10: 1-57990- 578-1 (hardcover) 1-57990-947-7 (paperback)

For information about custom editions, special sales, premium and corporate
purchases, please contact Sterling Special Sales Department at 800-805-5489
or specialsales@sterlingpub.com.

"Joy
in looking
and
comprehending
is nature's
most
beautiful
gift."

—ALBERT EINSTEIN

the JOY of Digital PHOTOGRAPHY

Jeff Wignall

LARK BOOKS

A Division of Sterling Publishing Co., Inc.
New York

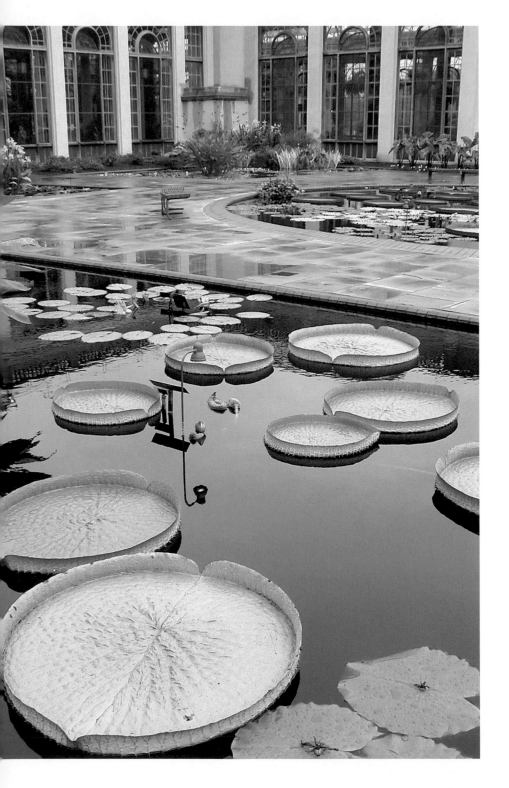

Dedication

for Lynne

*and for my brother David
who gave me the gift of
the West—until we meet again.*

Contents

1

Taking Great Digital Pictures 64

Design 98

Contents

4

Light 130

5

People 152

6

Nature 178

7

The Image Enhanced 226

Contents

8

Improvising on an Idea　256

9

The Digital Darkroom　276

Many people gave freely of their time, talent and energy to make this book happen and I would like to thank them:

First and foremost, I would like to thank my friend and editor Derek Doeffinger, with whom I've had the great pleasure of working on various projects for more than twenty years. Without his help this book would be twice as long but not half as good. Thanks Derek.

My deep appreciation also to Sandy Knight of Hoopskirt Studio who gave up many months of little things like sleep, days off and walking the dog to design this book. Her supreme talent is evident on every page.

Thanks to Kevin Kopp at Lark Books and to my friend Jerry O'Neill for their fine work researching and writing portions of the Digital Technology Time Line—it's an amazing addition to the book. And to Peter K. Burian for creating such a thorough web resource. Thanks also to Haley Pritchard at Lark Books for tireless editorial assistance.

I am grateful to the many gifted photographers who contributed so much to the look of the book: Nancy Brown, Peter K. Burian, Derek Doeffinger, Bill Durrence, Franklin Square Photographers, Robert Ganz, Dan Heller, Doug Jensen, James A. Langone, Boyd Norton, Brian Oglesbee, Moose Peterson, Jan Press Photomedia, Jack Reznicki, Ray Sarapillo, Rob Sheppard, Steve Sint, and Vera Sytch.

Thank you to my friend and lawyer Alan Neigher for all of his hard work on this book project. Thanks also to Jon Van Gorder for his Photoshop expertise and for responding to my many late-night emails; to Andrew J. Hathaway for inspiring me to learn Photoshop way back when; to Michael Guncheon for technical review; and to everyone at Milford Photo, of Milford, Connecticut.

I'm especially grateful to the following software and camera equipment manufacturers for responding cheerfully to my requests for information, product photos and equipment loans: Apple Computer, Auto FX Software, Bogen Imaging, Canon U.S.A., Inc., ColorVision, Inc., Ben Willmore and Regina Cleveland at Digital Mastery, Dycam Inc., Pam Barnett and Dan (Dano) Steinhardt at Epson America Inc., Eastman Kodak Company, Fuji Photo Film, U.S.A., Inc. H&M Systems Software, Kurzweil Technologies, Inc., Lexar Media Inc., Lowepro, Lucent Technologies Inc./Bell Labs, Heidi and Quest at LumiQuest, Henry Froehlich and Jan Lederman at MAC Group, NIK Multimedia Inc., Nikon Inc., Olympus America, Inc., Ott-Lite (Environmental Lighting Concepts, Inc.), Ulead Systems, Inc., Liz Tjostolvsen and everyone at Realviz S.A., Michael Hess at RoadWired, Roxio, Inc., Sigma Corporation, SmartDisk Corporation, Sony Corporation, Len Rue Jr. of Leonard Rue Enterprises, Inc., Unisys Corporation, Virtual Training Company, Inc. and Wacom Technology Company.

Many thanks also to my radio partner Ken Brown and all of my friends at WPKN (www.wpkn.org), the greatest FM station on earth, for giving me time away from my radio show to work on the book.

And my gratitude to the kind people of the Navajo Nation for generously keeping Monument Valley and other Navajo Nation Parks open to the public. For more information visit: www.navajonationparks.org.

Finally, thanks to Lynne for providing more support and encouragement than any one person is entitled to—and for understanding the concept of being "all in" on this enormous adventure.

—J.W.

Introduction

In 1979 my mother gave me a Christmas present that would change my life: It was a copy of the original book, *The Joy of Photography*. At the time I was working as a newspaper photographer and writing articles for photo magazines. I also had a growing collection of photo books, but there was something different about this particular book.

This was a book about the fun—*the joy*—of taking pictures. Technical things like f/stops and shutter speeds, while well covered, took a backseat to important concepts like exploring lighting, creating moods and mastering design. It was a book as much about discovering the beauty in ordinary subjects—people, nature, close-ups—as it was about cameras and lenses. It changed the way I approached taking pictures.

Little did I know then that a dozen years later, in 1991, Kodak Books would ask me to write *The Joy of Photography, Third Edition*. The first and the second editions had been perennial bestsellers, so being asked to write the third edition was pretty exciting. And, while the first two editions rode the initial wave of popular, affordable SLR cameras, the third edition celebrated the arrival of totally integrated automation: automatic exposure, autofocus and auto TTL flash. At that time digital photography existed only in the mind's eye of a few inspired scientists and engineers in company R&D departments.

What a difference another dozen years has made.

With the possible exception of cell phones, it's hard to think of a technological gadget that has won over as many imaginations—or wallets—as quickly and completely as digital cameras. In fact, it's barely possible to open a newspaper or magazine these days without reading a story about their exploding popularity. Nor can you pick up a Sunday sales circular without being wooed by a gallery of the latest in digital gear.

If you want to see how popular digital cameras have become just go to a local park or popular tourist destination and watch people taking pictures. On a recent Sunday afternoon, in fact, I stood in Rockefeller Center in Manhattan and watched as busload after busload of tourists walked up to the edge of the skating rink, held their cameras a foot from their faces and did the digital squint while composing pictures of smiling companions on their cameras' LCD monitors. No one was using a traditional viewfinder—and no one was loading film.

Annual digital camera sales have now exceeded film camera sales and it's likely market penetration will grow exponentially in coming years. So, what explains this huge and sudden popularity of digital photography? Certainly there are a number of practical reasons for owning a digital camera: no more film to buy, no processing costs, you can see your results instantly (and banish the pictures you don't like into the ether just as quickly). You can edit, alter, enhance and save your images right at your desktop. And just as importantly,

you can send pictures of your daughter's first tooth to friends around the globe in a matter of seconds—and then make an enlargement for your office at the press of a button.

But I think there is more at work here. I believe there is something about the instantaneous nature of digital technology that sets free the creative process. Because the digital photograph remains in your hands from concept to print, there is no emotional gap in the transaction—no third party intercepting or interpreting your ideas. You own the idea from concept to completion.

In the past year I've shot more than 6,000 digital photos—and I've never had so much fun taking pictures! Digital cameras have renewed my energy and my love for photography. That is what I hope this book will help you rediscover: the joy that exists in taking pictures—in making photography a part of your daily life in a way that you could never have imagined just a few years ago.

Like its predecessor, *The Joy of Photography*, this book is rich in technical information. But, more importantly, this book is as much about the emotional content of a photograph as it is about pixel resolution. It is about having a passion for photography as much as it is about cameras and lenses. Most of all, this book is simply about making pictures as a tribute to the joy of living—and recording and sharing pictures in new ways with the people in your life. So, here's to the joy of living, and your newfound joy in digital photography.

—Jeff Wignall
Stratford, Connecticut

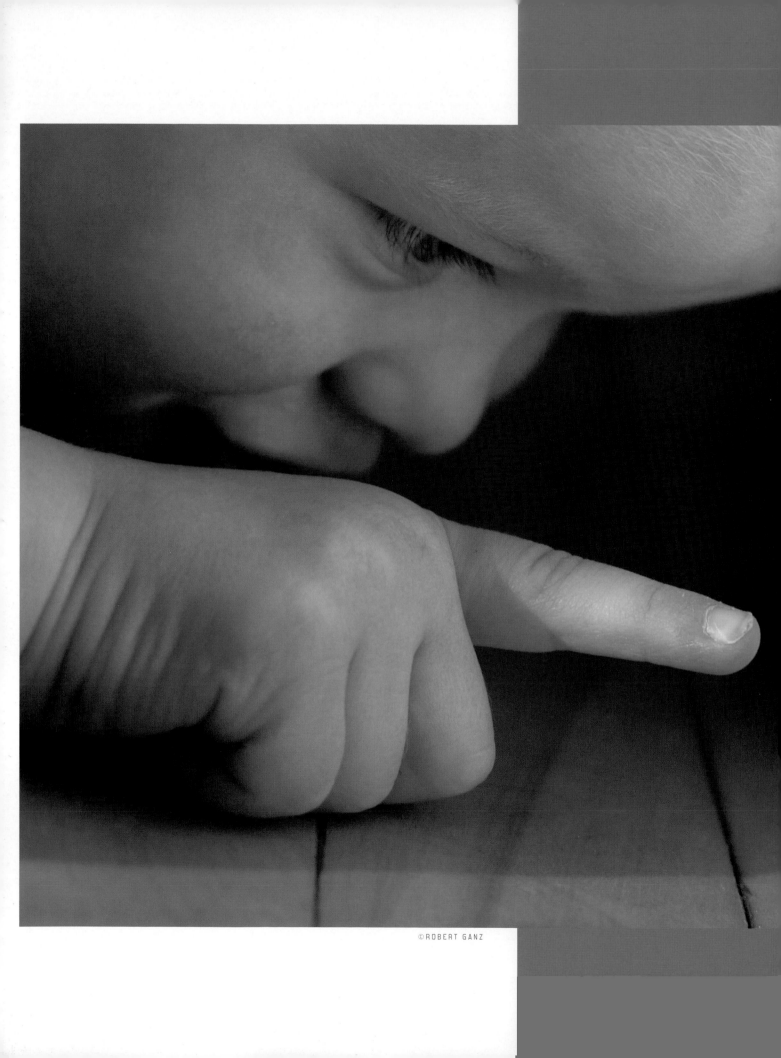

Exploring

the Digital Frontier

In the early 1980s my father, then already retired from a career in photographic research, came home one day with a small black box that had a touch-sensitive keyboard attached to it. It was the first personal computer I'd ever seen (a Sinclair ZX81, for the cyber historians out there) and, even though he had never touched a computer in his life, he was determined to understand, if not how it worked, at least what it could do. It was the first of several computers he would own and, as near as I could tell, his main interest in them remained simply to find out just what—if anything—a computer could add to his life.

For many of us, that curiosity is a large part of our interest in digital photography—to explore a new technology for the pure joy of it and to see what, if anything, it can add to our lives. To delve into digital photography doesn't require the ambition to be a great digital photographer or the desire to become a master at image manipulation, but rather that you live this moment in history a little more fully—to ride the learning curve of the digital world rather than to merely observe it.

You are a pioneer in a virtual Conestoga wagon heading across the digital plain—be brave, be bold, and explore with courage. And know that the images you make will become a part of the illustrated history of a brand new medium. Above all, enjoy.

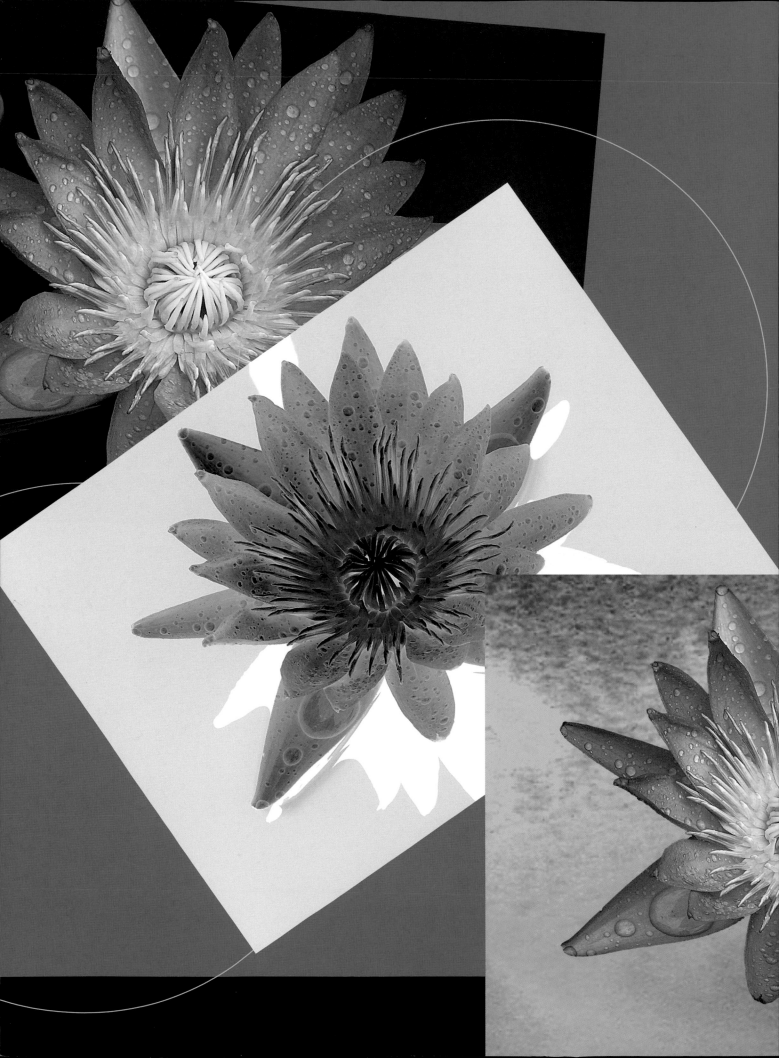

Dancing
with Your
Creative Muse

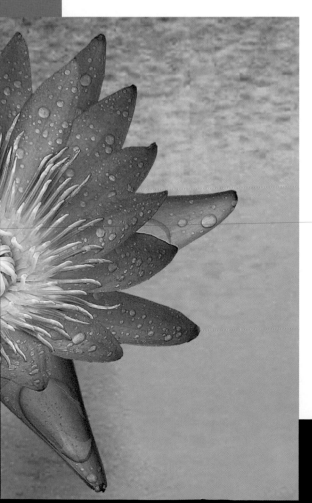

It seems odd that something as deeply rooted in technology as digital photography could birth a visual revolution—yet that is exactly what has happened. Out of the dimness of the research labs has risen a radiant beam of artistic inspiration. From the moment that Adobe's Photoshop image-editing software was introduced in the early 1990s—a decade before the advent of the first mass-market digital SLR cameras—photographers seized its creative potential.

And almost overnight that brilliant light of imagination changed our perceptions of both photography and reality. Schools of neon-colored fish fled their watery confines to soar through the skies, lightning storms were captured in mason jars and visions of angels shimmered in the windows of Spanish mission churches. It was as if the lyrics to the Beatles' *Lucy in the Sky with Diamonds* had suddenly become a photographic anthem—or an instruction manual. And just as these absurd and surreal visions flowed into the mainstream of our visual language, digital cameras and simplified picture-editing software came to the masses. And now you are a part of the digital revolution.

For as long as you are able to manipulate a mouse and read a series of software menus, there is nothing that your mind's eye can conceive that you—with the help of your computer—can't create. Whether you envision a waterfall pouring from a wine glass or your family's history in the New World marching across a virtual collage, you have the tools to realize your visions.

All that you need to thrive here are a fearless imagination, a corruptible sense of reality and a few extra hours in each day to woo your creative muse.

 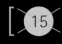

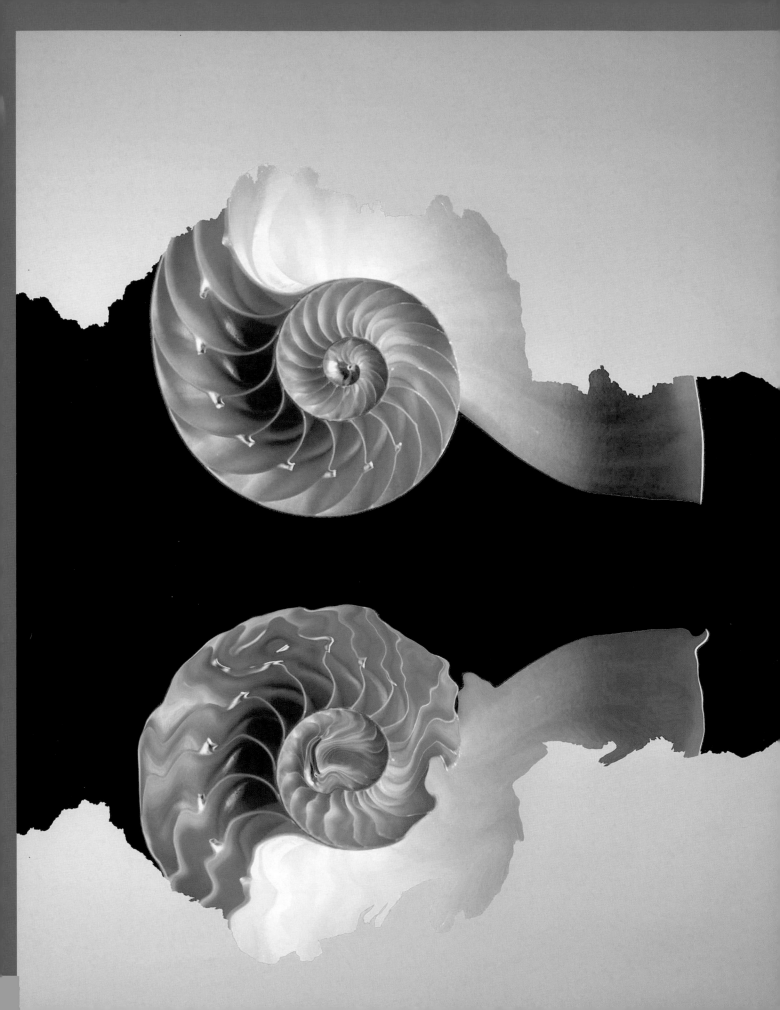

Perfecting

Your Vision

Ahh, perfection—the elusive siren song of every artist who has ever laid brush to canvas or, perhaps, lens to a landscape. It comes, so the saying goes, with practice, but for those of us who have practiced taking pictures much of our lives, perfection appears, at times, not a single millimeter closer.

But in digital photography, perfection seems, if not entirely attainable, at least much nearer at hand. Which is good news for those of us who are tragically afflicted with the compulsion to straighten, crop, organize, sharpen, tweak (and twitch), align, revise, prune (and plant), paint, repaint, add and refine texture—only to begin anew the next day.

From the ability to instantly review (and just as quickly erase and reshoot) your images in-camera to the almost infinite level of enhancement that image-editing software provides, digital photography was created for the compulsive fixer. If perfectionism is in your blood, you have come to the right place.

And perhaps that is the most alluring aspect of digital imaging: the entire process remains in your hands from concept to final product. Here you can literally rearrange molecules (or the digital equivalent—pixels). Here, at long last, you can pluck stray hairs, extract dust specks, turn grins into smiles, digitally botox wrinkles, turn gray skies blue, or perhaps bring out the sun on a cloudy day. Here your pursuit of perfection is acknowledged—and encouraged.

Of course, this passion for the absolute image does not come without a price. There is a little sign on my computer that says, "Welcome to Photoshop, here time has no meaning."

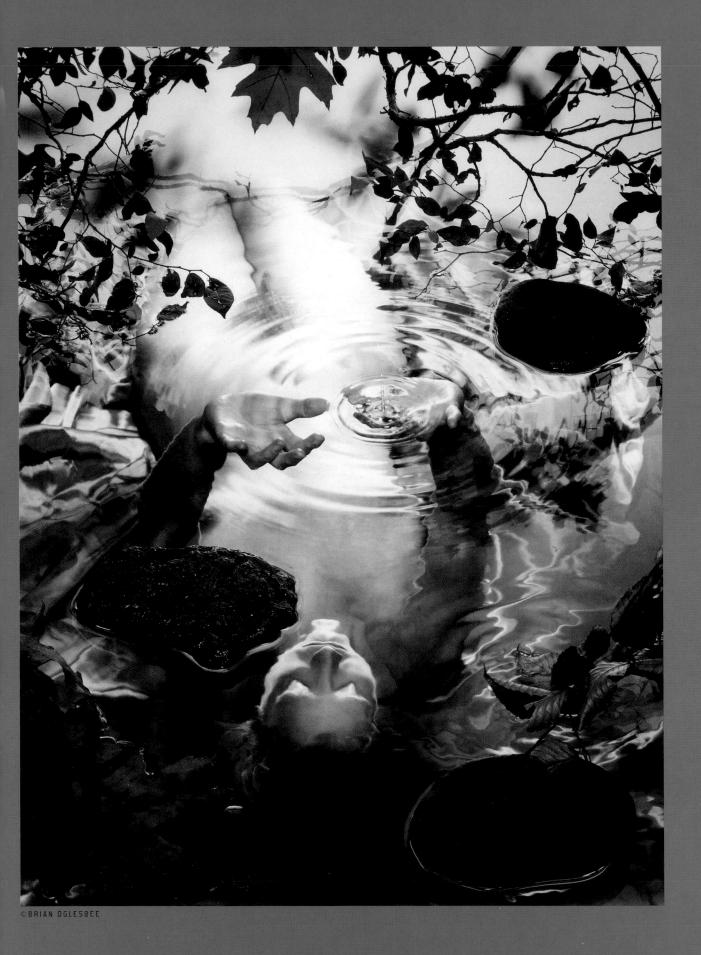

Creating Prints
Fit for a Gallery

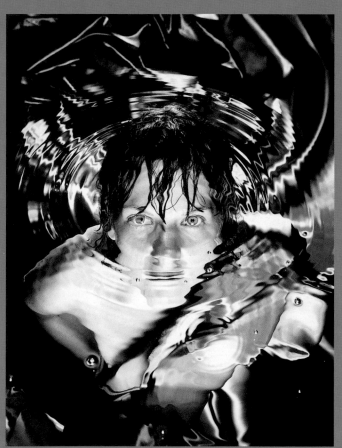

©BRIAN OGLESBEE

Weston, Adams, Avedon—and now just possibly you. And why not? Like digital cameras, digital printers are liberating. Your creative abilities will be unleashed like never before. Your deep well of potential will at last be tapped. Your artistic endeavors will be on display so that the world might bestow upon you the well-deserved recognition earned by a long-suffering (or at least, long-aspiring) artist.

What photographer doesn't envy the well-printed and well-displayed photograph? Whether you're walking into the photographer's tent at the local art festival, pausing at the window of a resort art gallery, or attending the opening night of a master's show at the museum, the finely crafted print catches your eye. It's the ultimate goal: creating and displaying a fine print. And now it's possible for every digital photographer. And for you, it's not only possible but a certainty.

Limits? Place even an inexpensive ink jet printer beside your computer and you, yes you who has never stepped into or out of a darkroom, will have the power of professional printmaking in your hands. We're talking fine-art quality prints. Place a moderately priced ($300-$600) printer such as Epson's eight-color R1800 printer beside your computer and you'll be capable of making prints—in color or black and white—that rival the finest museum prints.

Like many fine art print makers, photographer Brian Oglesbee uses an artful combination of old and new technology to make prints. While they might appear to involve a great deal of digital trickery, his images (including these two images—a part of his extensive "Water Series") are made using old-fashioned technology: film and a view camera. The photos are recorded in his studio with a single exposure and there is absolutely no post production involved. Oglesbee then scans his negatives into a computer and creates black and white inkJet prints. Those prints in turn are used as a guide in making very large-format silver prints (often 24 x 30-inches or larger) in a traditional darkroom, as well as high-end digital prints. Oglesbee's prints are represented in galleries and collections around the world—including that of Sir Elton John.

Melinda and Bob are having a **Spring Fiesta** Party!
may 28th 4pm croquet and cocktails

Back Forward Stop workarea Refresh Home AutoFill Print Mail Google

Favorites History Search Scrapbook Page Holder

jeff Wignall photographs

Travel photography
Utah
Arizona
Nevada
New York
California
Maine
Wyoming
Wisconsin

Image 12/40 Saguaro cactus

Jeff Wignall Photography

Sharing Pictures
to Amuse and Amaze
Your Friends

you are invited to . . .
BROOK'S BIRTHDAY PARTY

If you're older than say, a junior high school student, photography has changed a lot in your life (and if you're younger than that, be patient and read this for an historical perspective). In the pre-digital days, this was the picture-taking routine: You took a few pictures at your friend's winter birthday party, waited a month, shot a few more pictures, finished the roll during summer vacation, came home, dropped off the film at the drugstore, picked up the pictures a few days (or weeks) later, took them home to the birthday boy and wondered why he wasn't excited to see the pictures.

And now that you have a digital camera, as you open the door to pick up the morning paper, you notice your favorite rose is shimmering in the light. You slip outside and shoot several close ups. You drop a slice of bread in the toaster, stroll to the computer, choose your best shot, attach it to an email message and press the Send button just as the toast pops up. And just before you hit the shower, you make an 8 x 10-inch print for the dining room wall.

No, this is definitely not your father's photography.

Celebrating
the Family Album

Just poppin' in to wish you

A MERRY XMAS and a HAPPY NEW YEAR

Doris, Harry and David Wignall

The nuclear family, the extended family, the human family—and now the digital family. How do you define family? Better yet, how do you show family? With digital photography, family pride can swell like never before. And its arms can spread across the world or reach far back into time— perhaps beyond the invention of photography itself.

For family scrapbookers, family historians and proud moms, digital photography offers an ultra-energized dose of inspiration that can turn your sapling photo history efforts into a strong and mighty oak. And it can salvage moments and memories nearly lost to the seasons of time. Even your great-grandparents, who may have been photographed on glass plates before the advent of modern film, can now come to life again in your digital archives.

And what of memories nearly lost? Did freeloading field mice nibble away Lincoln's stovepipe hat and disguise his identify in the picture of your great aunt shaking his hand outside Ford's Theater that fateful eve—forever stealing your family's link to history? Has Mom's wedding photo displayed on the wall of the sunroom faded? Has mildew spoiled the picture of great granddad climbing on the running board of his rumrunner?

Let digital imaging rush to the rescue. Just scan the pictures, restore them with easy picture-editing software, and add them to the family album (or perhaps ship that shot of Lincoln down to the Smithsonian).

Did a recent Internet search on your family name uncover new relatives? Armed with the Internet and family history software, you can turn the family tree into a forest of ancestors and create a visual display of likenesses, connections, and milestone events. From headstones to hometowns, everything about your family's history can be witnessed anew.

My own cousin, in fact, recently traced the Wignall clan to its first known ancestor—Jeffrie Wignall (some coincidence, isn't it?) back in 1696. From the refrigerator door to the unabridged Wignall family history website—digital photography helps put faces on our personal history. Your opportunities to celebrate your own family lineage have expanded exponentially. It's up to you to take advantage of them.

Joining
a Global
Photo Community

©ROBERT GANZ

From Bridgeport to Bejing, people are snapping digital pictures. They're shooting billions and billions (to steal a phrase from Carl Sagan) of digital photos and sharing them in the ether of the global photo community. And you are a part of that community.

From the comfort of your kitchen table you can post a gallery of your close-ups for the world to admire, criticize or perhaps turn into wallpaper for their own computers (go ahead and let them share your images—it's pure flattery).

One way to share the joy is to join an informal photo community—you'll find them at web sites such as www.betterphoto.com or www.photo.net. Here you can read what others are doing digitally, share ideas and ask questions in online forums, and post pictures for discussion. And if you have a competitive side, you can match your skills against other photographers by entering "picture of the day" contests on photo related sites such as www.steves-digicams.com.

And who knows, maybe you'll break into the big time. In fact, the photos on these two pages were shot by Montreal-based photographer Robert Ganz—a serious hobbyist whose photos I discovered and was charmed by while surfing a community site. Since he began posting his images on the web just a few years ago, Ganz' pictures have won contests and been published in books and major photo magazines.

Don't let the light of your monitor be the only place where your inspiration shines—share it with the world. You'll be surprised how it may change your life.

"The camera is an instrument that teaches people how to see without a camera."

—DOROTHEA LANGE

The Camera Revisited

Introduction

Had you been alive back in 1826 and happened to find yourself wandering the French countryside and peering innocently into the windows of farmhouses, you might have spotted an intense looking Frenchman pointing an odd contraption out of his bedroom window at the yard below. About eight hours later (had you sat patiently and watched) you would have seen him retrieve the device with the urgency of a mother cat fetching her wandering kittens. What you would not have seen in the hours that followed was the look of utter astonishment on the man's face as he witnessed the result of his experiment.

That man was Joseph Nicéphore Niépce—a French inventor with a passion for experimenting with light-sensitive emulsions—and what you would have witnessed him doing was recording the very first photograph ever made from nature. Niépce made the picture by coating a polished pewter plate with a mix of bitumen and lavender oil and placing it in a camera obscura, a device invented centuries earlier. He named his process Heliography—or writing with the sun.

Niépce's original photograph (*View from the Window at Le Gras,* c. 1826) still exists today (it's owned by the University of Texas at Austin) and, though the subject's details are not very clear, that eight-hour exposure gave birth to photography. Although cameras have certainly come a long way since then (and exposure times have become noticeably shorter), essentially the device that Niépce used is little different in principle from today's digital cameras. Strip away the electronics, the expensive lens and frilly doodads like the exposure meter, and what you have is what Niépce had: a light-tight chamber, a means for focusing the image, and a light-sensitive receptor for recording the image.

Digital cameras, of course, are a tad more complex and contain a small universe of technological marvels that few of us could have envisioned just a few years ago. But as you read about the various types of digital cameras and their many options and accessories, it helps to keep in mind their origins. The digital camera was born in the bedroom window of a French visionary whose goal was the same as yours: to lock images of light and shadow in a box from which they could not escape, but through which could be witnessed—by all who had the curiosity and imagination to look inside—the story of our existence.

One of the great things about digital photography is that you don't need a clue about how the technology works in order to take great pictures. Even if you never understand one iota of the science behind how a digital camera records an image, no one will ever know and (honestly) it won't change a thing about your pictures. (Of course, knowing how to use a digital camera is an entirely different—and very important—matter.)

Let's review the basic technology. It's actually interesting and besides, you never know when some wise guy will approach you at a party and flaunt his digital knowledge. You can say proudly, "I already knew that." Then you can stun him by revealing your unique theory that proves how the birth of digital imaging sprang from none other than The King, Elvis Presley.

1 Although the practical ability to take pictures without film is only about a decade old, the roots of the technology actually go back to the late 1940's—or specifically to December of 1947. It was then that three scientists—John Bardeen, Walter Brattain and William Shockley—working at Bell Labs in New Jersey, invented the transistor. Without tracing the entire history of that invention, the chief attribute of the transistor was that it replaced vacuum tubes as a means to amplify and modulate electrical current and opened the doors wide for the development of integrated circuits—which paved the way for microprocessors—which are at the very heart of digital imaging technology.

2 The invention of the transistor not only made your digital camera possible, but also your computer, your cell phone, your stereo, your microwave oven and your Xbox—all of which contain countless armies of transistors. The transistor, in fact, is considered by many of the people who think about such things as the greatest invention of all time. As one Internet writer put it (I'm paraphrasing): Your house may contain a few dozen light bulbs, but it has tens of millions of transistors.

How Digital Cameras Take Pictures

(and how getting all shook up over Elvis rocked the camera world)

3 From the moment that Bardeen, Brattain, and Shockley unveiled their 1956-Nobel Prize winning invention to the world, photography was headed for a digital destiny. The challenge to film began long before anyone associated transistors with Kodak moments. And nothing could have popularized the invention of the transistor more than (this is where Elvis comes in) the introduction of the transistor radio in 1954. With everyone under eighteen getting all shook up over that swivel-hipped boy from Tupelo, Mississippi blasting out of a palm-sized transistor radio, it was only a matter of time before transistors invaded cameras with Cyborg-like efficiency.

4 In most respects digital cameras work like film cameras: a lens lets light into the camera and a shutter controls the duration of light. The main difference between film and digital cameras, of course, is how the camera records that image. Film cameras use a piece of silver halide film to capture a latent image that is later processed chemically. Digital cameras, on the other hand, have a silicon computer chip—also called an image sensor—to record the image. The sensor that most cameras use is called a CCD (charge-coupled device) though some cameras use a CMOS (complementary metal oxide semiconductor) sensor.

5 The surface of CCD and CMOS sensors is made up of millions of tiny light-sensitive receptors (known as photosites or pixels) that are arranged in a grid pattern. Each of these microscopic photosites contains a diode that records the intensity of the light striking it and converts the quantity of light to a number. In scientific terms what the CCD is doing is converting photons to electrons, but that's going way too far into high school physics. Incidentally, the light-sensitive sensor itself is actually an analog—not a digital—device. It takes a processing gizmo called an ADC (analog to digital converter) to translate the analog information to the numerical language that your computer can interpret.

6 Because your camera's sensor records *only* light intensity, not color, it is essentially color-blind. To create color images, a precise pattern of color filters are laid over the photosites. The filters (most often arranged in something called a Bayer pattern) represent the three colors of the primary spectrum: red, green, and blue. From these three colors all colors can be created. Light passes through the filters to the photosites. Electronics interpret the intensity of the light that was transmitted to accurately reveal the colors of the original scene. Because any one photosite can record only one color, your camera uses a process called interpolation and combines information from each photosite with information from adjacent photosites to create accurate image colors. (And unless you're a science student, that's as far as you need to go down that road.)

7 When you download your images from your camera's memory card to your computer, your computer is actually reading series of numbers that give it information about color and brightness from which it recreates—with astounding accuracy—the daffodils in your garden or your spouse's smile or whatever you aimed your camera at. In a way a digital photo is like an intensely accurate electronic paint-by-numbers system.

If most of this has left you confused, bleary-eyed, or just plain bored, turn the page and we'll get down to the real fun of digital photography: buying and learning to understand a digital camera. The King would want it that way.

Pixels, Megapixels and Some Old Math

If you were to blow up any digital photograph on your computer screen to its maximum magnification you would see the picture break down into a pattern of identically sized (but different colored) squares **(below)**. Those squares are pixels (short for picture elements) and, though they look very large when they're blown up like that, they are the tiny building blocks of digital images. In fact, they are the smallest element of any digital photograph. As discussed on the previous pages, when exposed in the camera each of these pixels captures information about brightness and color that your computer translates into photographs.

Because pixels on a sensor are so tiny (about 6 microns or 0.000006 meter wide, it takes literally millions of them to create a sharp and detailed image. A million pixels are called a megapixel, and that is the term that is used to describe the resolution of a digital camera. The more megapixels (usually written as MP) a camera has, the more detailed and sharper the image can appear. And as you might have guessed, the more megapixels your camera contains, generally the more expensive the camera.

Only a very few years ago a camera with a resolution of one or two megapixels was considered an astounding technological accomplishment (in 1996-1997 the Nikon/Fujix E2N digital camera featured a whopping 1.3 megapixels and retailed for just under $10,000). Today, of course, even the most basic compact zoom digital cameras typically contain 3 to 5 megapixels and some professional digital SLRs contain in excess of 14 megapixels (some scanning backs for professional studio cameras have a resolution of over 65 megapixels).

Though there really isn't an exact equivalent with film, ISO 100 film is generally considered to have a resolution of approximately 10 megapixels. All things being equal, in a head-to-head competition between an ISO 100 film and any camera below say, 8 megapixels, the film would win at high levels of enlargement.

At more moderate levels of enlargement it would be hard for the average person—or even a very trained eye—to spot the differences between film and a much lower resolution camera. And a 4 x 6-inch print from an ISO 100 film and a 4-megapixel camera are virtually indistinguishable.

As you might surmise, all other things (lens resolution, exposure modes, etc.) being exactly the same, a higher megapixel count will create a better image (see the Pixels and Image Quality section, below). Keep in mind though, I said that everything else was equal: if you put a second rate lens on a higher megapixel camera you won't necessarily get a better image than a camera with a smaller megapixel count. And if you don't hold the camera steady, it won't matter if you're using film or a 30-megapixel camera, you'll get a blurred image.

Like square footage, the total number of a camera's megapixels is determined by multiplying the width of the sensor (or chip) by its length in pixels, of course.

For example:
A 4-megapixel chip might be 2272 pixels wide and 1704 pixels high: 2272 x 1704 = 3,871,488, or approximately 4 megapixels.

You can also describe a camera's resolution by the chip's (or sensor's) pixel dimensions in the preceding example, 2272 x 1704. Although the number of pixels on a sensor chip is fixed, most cameras let you choose a lower resolution setting so that you can store more pictures on a memory card.

When it comes to selling digital cameras, megapixel counts are the simplest way for manufacturers to describe a digital camera's resolution, which is a strong indicator of its image quality. And they use it mercilessly as a selling point.

Incidentally, it's not necessary that you carry any of these numbers around in your head (you might get distracted and trip over a log if you walk through the woods thinking about pixel counts) because you'll find them displayed in your camera's menus.

The Camera Revisited >

Pixels, Megapixels and Some Old Math:
PIXELS AND IMAGE QUALITY

A major factor that determines image quality is the **area resolution,** or the number of megapixels on a camera's sensor. Generally speaking the more megapixels the better, but **not all pixels are created equal.** Of particular importance is sensor size and thus, pixel size. Cameras with larger sensors, such as digital SLRs, generally have larger pixels that produce better images, particularly at low light levels. Smaller pixels are more susceptible to digital noise (random color specks), especially at ISO 400 and higher. Finally, like car engines, DVD players and toasters, not all image sensors are created equal. Some are clearly better than others.

The **in-camera processing** of image files also affects image quality. Unless you use only the RAW file format, your camera's built-in software is manipulating the pictures you take even before you download them. Its JPEG compression might be too severe or poorly implemented, resulting in artifacts. Images might be excessively sharpened or saturated. Or one camera might have built-in software that effectively reduces digital noise and another might not.

The Camera Revisited >
Buying a Digital Camera:

There you are at the threshold of a dream. You've been studying the photo magazines, reading online reviews, talking to your friends at work and you know exactly which camera you're going to buy. But on Saturday morning, just before you leave for the camera shop, the latest photo magazines arrive in the mail. You discover to your dismay that a young techno upstart with hot new features and a sexier zoom has replaced the camera of your affections. And there you go, back to the den to reconsider the purchase—for the hundredth time.

It's easy to understand being hesitant in buying your first digital camera. Not only is the technology new and unfamiliar territory, but it changes so fast you can get whiplash just keeping up with the magazine and television ads. Digital manufacturers replace models—or even entire camera lines—more frequently than most of us replace the roll of paper towels in the kitchen. Trying to buy a new digital camera can be quite a dizzying experience.

The good news is that a good camera is a good camera even when a newer and "better" model appears. If it takes great pictures and fills your needs when you buy it, you can't ask for anything more. The best advice then is to study your own needs carefully and buy the best camera you can afford—and remember, the sooner you buy the camera, the sooner you'll be a participant instead of an spectator.

Modern digital cameras are a bargain. In fact, prices are steadily declining, and camera quality that might have cost thousands—or even tens of thousands—of dollars just a few years ago now costs hundreds of dollars. In the mid 1990s, I borrowed a digital SLR (single lens reflex) from Kodak for testing, and had to insure it for $50,000 (I literally slept with it when I was traveling); today, a camera of far greater sophistication costs under a thousand dollars.

On the following pages we'll look at the different types of digital cameras, their features and useful accessories. We'll also provide some pointers on two of the most important elements in any photo kit: lenses and flash.

basic compact

advanced compact zoom

high resolution zoom

prosumer

interchangeable lens SLR

Types of Digital Cameras

The type of camera you buy and the features you look for should be based on what you expect from the camera and what types of photos you shoot most often—as well, of course, as how much cash you're willing to lay out.

It doesn't make a lot of sense to spend a thousand dollars on a digital SLR if you only email photos to friends and make an occasional enlargement. Similarly, you can't expect to wring poster-sized images from an entry level, basic compact camera—though you certainly can make fine smaller-sized prints. (Enlargement size is mainly—though not absolutely—a matter of resolution, or pixel count, which we'll talk about in the next section.) Digital cameras fall into four groups: compacts, advanced compact zooms, prosumer cameras (sometimes called bridge cameras) and interchangeable lens SLRs. In appearance, most digital cameras resemble their film counterparts.

Your camera's sensor records light intensity, not color. To create color images, a precise pattern of color filters are laid over the photosites. The filters (usually arranged in something called a Bayer pattern, at left) represent the three primary colors of the spectrum. From these three colors all colors can be created. Light passes through the filters to the photosites. Electronics interpret the intensity of this light to accurately reveal the colors of the original scene. Because any one photosite can record only one color, your camera interpolates this information and combines it with information from adjacent photosites to create accurate image colors.

THE EVER EVOLVING DIGITAL CAMERA

The reason that the categories (compacts, advanced compact zooms, prosumer cameras, and interchangeable lens SLRs) can only be loosely defined is that manufacturers are still searching for the ideal combination of features and price, and even camera shape. So features, technological sophistication, and body style are constantly changing. We are in the early stages of digital camera evolution.

Some manufacturers have held fast to the 35mm camera as a model for digital camera design even though there is no film to load and no real reason to cling to that design. Others have begun to explore new shapes and physical designs, hoping to arrive at the most compact, flexible and comfortable package for what is essentially an electronic Cyclops gizmo. A few companies have even experimented with pivoting bodies and odd-shaped models that look more like a video camcorder than a still camera. (And to complicate things further, most digital camcorders also have a still-image mode.)

And, of course, we can't forget the cell phone cameras, PDAs (personal digital assistants), and even wristwatch cameras that seem to pop up on new technology segments on CNN every few weeks. These types of hybrids will only grow in the future for the simple reason that the same type of electronics that receive and transmit digital data in a cell phone is identical to the electronics necessary for capturing and storing images; digital is digital is digital. Just add a lens and an image sensor to almost any electronic device and you have the hottest new camera thingy on the market.

Who knows, maybe next time James Brown struts on stage singing "Poppa's Got a Brand New Bag," he'll be using a wireless microphone camera to take pictures of you taking pictures of him.

BASIC COMPACT CAMERA

This is the entry-level category of digital cameras and is typically a very simple camera with a resolution of 3 to 4 megapixels. These are the point-and-shoot cameras of the digital world. Their emphasis is on ease of use. If you've been using a compact 35mm film camera, the digital version will probably be lighter and smaller. Some compact models feature a fixed-focal length lens, others a moderate-range optical zoom—typically 2x or 3x.

Compact cameras make wonderful travel companions because they are so small. Their exposure and metering options are usually basic, favoring simplicity and automation over complexity and versatility. That doesn't mean their technology is simple. The latest cameras include such features as in-camera red-eye elimination, where a software program built into the camera can identify red-eye in people-pictures and correct it.

A basic camera may offer sophisticated white balance functions (see page 76) so you can take excellent color pictures in a variety of lighting situations. And you can expect ISO ratings (see page 74) up to 400 or even possibly 800, that enable you to shoot easily in dim light without a flash. More advanced cameras, however, will give you even more sophisticated white balance features and higher ISO settings.

Basic Compact Camera

| + Ease of point-and-shoot operation
+ Easily fits in pocket or handbag
+ Affordable but still good quality | − Smaller image sensors mean smaller prints
− No zoom lens or minimal zoom range
− Fewer if any exposure or metering modes
− Built-in flash has short range |

Optical Zoom Versus Digital Zoom

All but the least expensive digital cameras offer an optical zoom lens. And most also have digital zoom. Optical zoom is what you want and, generally, the greater its range the better. Digital zoom is almost worthless. Ignore it when buying a camera, because it is simply an in-camera method of cropping the picture to make it seem like you're magnifying it. In reality you are reducing the quality of the picture, because in cropping you are throwing away pixels that are part of the picture.

However, a good and powerful optical zoom can be an invigorating creative tool. Digital cameras typically have an optical zoom capability somewhere in the range of 2x to 14x (3x and 4x being the most common). What does that mean? It simply expresses the focal length range of the lens. For example, a 35-70mm zoom lens would be 2x. A 35-105mm would be 3x. A 28-280mm would be 10x, and so on. For general photography a 3x, 4x or 5x zoom lens works well. But I like zooms with a range of 8x or more for their great versatility.

As you might expect, this next echelon of digital cameras sports several important added features. Primary among them is a higher megapixel count of 4 to 6 megapixels. The megapixel increase enables you to make high-quality prints up to 16 x 20 inches. The extra megapixels also let you crop pictures more and still make large prints. Cameras in this class also typically feature not only a better quality lens (sometimes glass in place of plastic), but a longer optical zoom range—usually at least 4x, but a few cameras boast 8x or even 14x zooms.

These cameras usually offer enhanced exposure modes, such as Program, Aperture Priority, Shutter Priority and Manual modes. Some feature a variety of special subject modes, including modes for landscapes, portraits, night photography, action/sports, and sometimes specific locales, such as beaches.

The benefit of having more sophisticated exposure modes is that you're able to take full advantage of the various shutter speed and aperture combinations (see the chapter on Taking Great Digital Pictures for more information on exposure and metering modes). Control of the aperture means you can control depth of field (the near to far range that's in sharp focus). Control of the shutter speed means you can decide how motion is captured.

You should also expect to find user-programmable white balance, a variable ISO speed setting, multiple flash modes and a close-up mode in this category.

Advanced Compact Zoom Camera

+ Higher pixel counts
+ More exposure and metering options
+ Choice of special subject modes
+ Programmable white balance
+ Extended zoom range
+ Longer flash range

− More expensive than Basic camera
− Potentially uses more battery power

Advanced compact zooms are, of course, slightly bulkier than basic compacts, but still small enough to carry anywhere, and you'll find that the added zoom range is worth the slight increase in camera size.

Prosumer is a relatively new term to describe cameras with many professional-level features in a consumer camera. Prosumer cameras are an ideal choice for someone who wants a high level of technological sophistication but isn't yet ready for or doesn't want the bother and extra cost of an interchangeable-lens SLR.

Prosumer cameras give you more megapixels, stronger and better optical zoom lenses, and more creative controls. The megapixel count ranges from six to eight—enough to make poster-size prints. They typically offer 8x zoom lenses, using very high quality glass. And almost all add a format unique to this and pro cameras—the RAW file format. The RAW file format enables you to reset many controls after you take the picture. White balance, ISO, and sharpening are just a few areas that you can set anew after taking a picture if you used the RAW file format. It's a boon for both creative and error-prone users.

Metering and exposure modes are generally just as sophisticated in some prosumer cameras as they are in professional digital cameras—including such advanced features as full-manual exposure control, a manual white balance mode and a higher level of exposure compensation. Burst rates (the number of exposures you can fire without waiting for the camera to catch up) are usually much higher in prosumer models, as well. Many prosumer cameras also feature through-the-lens viewing, either with a direct optical finder that shows you what the lens is seeing via a reflex mirror, or with an electronic viewfinder. The latter is like looking into a traditional viewfinder window but seeing an electronic display of what your lens is seeing rather than seeing the subject directly off of the reflex mirror, the way a conventional SLR camera works.

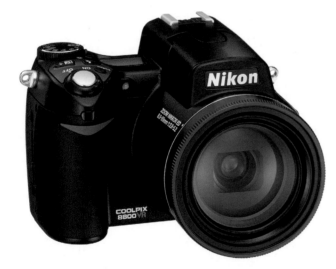

Prosumer Camera

+ Higher zoom ratios and much higher pixel count
+ Sophisticated metering and exposure modes
+ Able to see picture on LCD before it is shot
+ Faster shooting speeds than less expensive cameras, so shutter lag is minimized
+ More file format and image compression options
+ Built-in flash has better range/some take accessory flashes
+ Availability of accessory lenses
+ Wider ISO range
+ More white balance control including manual settings

– Higher price
– Not as compact
– No interchangeable lenses but some take accessory lenses
– Typically use much more battery power
– Few accessory options

Digital SLR

+ Ability to change lenses and add accessory flash units
+ Through the lens viewing and metering
+ Complete range of sophisticated exposure and metering modes
+ Capable of shooting several continuous frames without pausing
+ Minimal or nonexistent shutter lag
+ More white balance controls, including full manual settings
+ Highest ISO range
+ High pixel counts
+ Choice of file formats, usually including TIFF and RAW formats

− Larger and more expensive
− Requires much more battery power
− Image sensors typically need cleaning more often because interchangeable lenses allow dust inside
− You can't see the picture on LCD monitor before it is exposed

The two great advantages of owning a digital SLR are: direct optical through-the-lens viewing and the ability to change lenses. Being able to view your subjects directly through the lens means that you see exactly what the lens sees—even if you're shooting extreme close-ups.

The ability to change lenses is the pinnacle of optical flexibility because it means that, your checkbook allowing, you can buy lenses specific to the subjects you're shooting. If you're a sports shooter, for example, you can buy super long telephotos that will fill your viewfinder with Adam Vinatieri kicking his next Super Bowl-winning field goal from your cozy seat in the stands. Or, if you like shooting extreme close-ups or very wide-angle views of architecture, you can buy lenses designed for those special purposes. Optically, SLRs are the most flexible cameras you can buy.

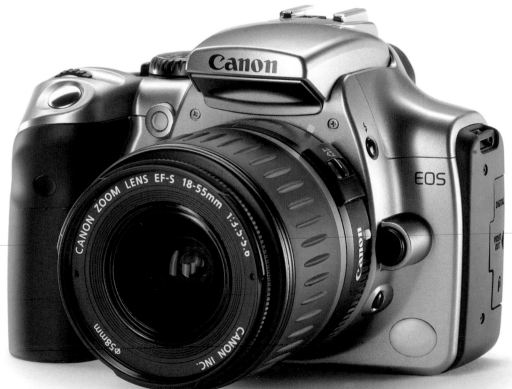

Other advantages of a digital SLR (other than just looking really cool walking around with one) include having overrides for virtually every metering and exposure control. Many SLRs, for instance, have a spot-metering mode that lets you take light readings from very specific and extremely small subject areas. Typically, too, SLRs are very durable and designed to take the abuse that a very active photographer will give them.

Speed of use is also much faster with most digital SLRs. Many of the SLRs have larger and faster memory buffers that enable you to fire off a burst of shots in rapid succession without waiting for the camera to play catch up. (If space aliens suddenly appear in a Des Moines cornfield you want to be able to fire off several frames quickly—those UFOs don't hang around forever.) For sports, news, and wildlife photographers, this is a paramount concern because they can't be waiting for the camera to write the previous frames while the action peaks and disappears.

Megapixel counts continue to escalate in SLR cameras, ranging from 6 to 14 megapixels—and they will probably surpass that range shortly. In order to fund advancements in digital SLRs, manufacturers must get the biggest possible audience, and that means getting consumers hooked once again on the SLR concept. The sensors in SLRs are bigger than those in consumer cameras. Bigger sensors enable bigger pixels, which usually improve the image by lowering digital noise (random colored pixels) at higher ISOs and longer exposures.

One feature of most digital SLRs is that they impose a magnification factor on the lens you are using. The degree of lens magnification depends on the size of the sensor the camera uses. Most SLRs have a magnification factor around 1.5x. For example, if the camera's magnification factor is 1.5x, a 20mm lens acts as a 30mm lens (1.5 x 20 = 30), and a 200mm lens acts as a 300mm lens.

That's because most digital SLR cameras are based on a 35mm SLR film camera chassis. And except for a few high-end (expensive) digital SLRs, the sensor is smaller than a frame of 35mm film. Thus the sensor doesn't capture the entire image being transmitted by the lens. The practical result is that it is difficult to create very wide-angle shots with lenses designed for a 35mm format, but much easier to create telephoto

effects. Why don't manufacturers simply use bigger sensors? Because sensors are fairly hard to make and bigger sensors are very hard to make, which means they're expensive. So to hold camera costs down, a tradeoff is made to use a smaller, less expensive sensor. So if you do a lot of wide-angle photography, look at an SLR camera's specs to determine the magnification factor. But keep in mind that many of these manufacturers are now making extreme wide-angle lenses specifically to address issues raised by the magnification factor.

Digital SLRs also offer the versatile RAW file format and are packaged with special software for handling RAW files. The cameras are often bundled with other manufacturer-specific software to improve handling of files.

© ROB SHEPPARD

HOW MUCH MEMORY DO YOU NEED?

The simple answer to that question is that you need more than you think—or at least, as much as you can reasonably afford. Running out of memory space is exactly the same as running out of film—when you're out, you either stop taking pictures or review the images and delete the less important ones to make room for more pictures. Taking pictures with digital cameras without the fear of wasting expensive film usually causes people to shoot far more pictures than they might anticipate. A few days after buying his first digital camera, a good friend started emailing me pictures of funky neighborhood stores near his office in the Bronx—something he would have never shot if it meant using film. Shooting digital pictures is very addictive.

If you have a laptop computer or a portable storage device on hand, you can download your card and return to shooting but even that much interruption can ruin a day's outing—even a short pause often means missing good picture-taking opportunities. And if you're traveling and don't have a download device, finding memory cards to buy is difficult and they are always more expensive in tourist areas. Shall I tell you my own story of running out of memory cards on a remote island in Maine and having to drive three hours to buy replacements?

Your camera manual likely provides a chart of how many images different size storage cards hold. Or you can estimate the amount of memory you need by the file size of an average picture. I'd suggest using a memory card that holds 100 best quality JPEG pictures. And a spare card that holds 50 pictures. Of course, if you plan to shoot primarily memory-hogging TIFF and RAW files, you might want to invest in a few 1GB or 2GB cards. A TIFF file for a 5-megapixel camera is about 15MB.

To estimate how much memory you'll need, let's use a 5-megapixel camera as an example. Typically, this camera creates a JPEG file size of about 2MB. This means that you could fit about 64 images on a 128MB memory card. If you were shooting in the much more memory-hungry RAW format, the file sizes would probably run about 8MB so that you might only get 16 images on the same card. Having a 64-picture capacity is probably fine for a birthday party or a daytrip, but if you're going on a weeklong vacation to Martha's Vineyard, you're going to need a bigger boat.

Since memory is long lasting, inexpensive and reliable, get about twice as much you think you need. I would suggest starting with at least a 512MG card (and preferably a 1GB card) for your camera and at least a 256MB card for backup. Also, if you're buying a lot of memory (1GB or more), it's best to buy two smaller cards rather than one large one. That way if you lose one card you still have the other.

One of the best things about traveling with a laptop (other than being able to shop on eBay from your hotel room) is that you can download your pictures, back them up on a CD, and even email them to friends at home.

©ROB SHEPPARD

CARING FOR MEMORY CARDS

With the exception of MicroDrive-type cards (which are actually miniature hard drives) memory cards have no moving parts and are rugged and easy to care for. I've shot tens of thousands of digital images and (knock on wood) have never had a card fail. On the other hand, you need to keep these sophisticated electronic devices clean and protected (see tips at right). Interestingly, digital media cards are unaffected by current airport metal detectors, screening devices, and X-ray machines.

- Always store memory cards in their original plastic cases or in a digital film wallet.

- Protect cards from extremes of heat or cold and keep them away from moisture—including wet fingers on a rainy day. Never leave them in a hot car or near a sunny window.

- Keep cards away from strong magnetic fields.

- Let cards adjust to large changes in temperature before shooting with them or downloading them.

Your digital camera won't melt in the rain, but you should protect it. Place it in a zippered plastic bag while you're out exploring—your camera can handle the few raindrops that will hit it when it comes time to shoot. A small umbrella is a wonderful thing for a pleasant companion to hold above you while you shoot. I treat my umbrella holder to dinner on a regular basis. If you don't spring for dinner you may have to make-do shooting from overhangs, shop doors and car windows. Come to think of it, a window seat in a cozy café is an excellent vantage point for photographing the rain.

Transferring Pictures to the Computer

There are a number of simple ways to move your pictures from your digital camera to your computer. One method is to simply connect your camera to your computer. One small but obvious disadvantage of transferring (also called downloading) pictures to your computer this way is that no one else can use the camera (or the computer) while you're downloading the images.

It's simple to hook your camera directly to the computer via a cable that came with your camera. Virtually all cameras are shipped with the necessary cables and acquisition software for downloading pictures and most—like Nikon's Nikon View software—also have some basic editing features, such as red-eye reduction, cropping tools, modest amounts of color and contrast correction and some basic organizational tools.

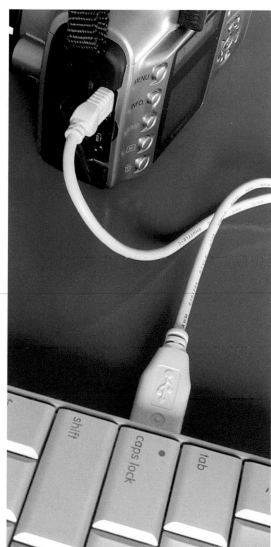

© ROB SHEPPARD

Using a Camera Dock

Kodak's EasyShare system was the first to use a very convenient accessory called a dock that lets you charge your camera's batteries and download your images simultaneously by simply sitting the camera in the dock. You just press a button on the dock and it starts the transfer process. Other manufacturers offer similar docks, but all are compatible only with specific cameras.

Using a Card Reader

A far more convenient method of downloading images is to buy a simple little device called a card reader. A card reader costs about $30, is about the size of a deck of cards, and attaches to your computer with a cable (you can leave it attached).

Some computers have built-in card readers. The advantage of a card reader is that you don't have to tie up your camera while transferring images—just insert another card and keep taking pictures while the full card is being downloaded. To download images you simply pop your memory cards into the reader and then use either the software supplied with the camera, or the software accompanying the computer's operating system (both Windows XP and Apple's iPhoto), or even third-party album-organizing software. Choose a card reader that accepts a variety of multiple media formats, in case you get a second digital camera or have a visitor with a different brand of camera. And naturally, be sure the reader you buy is compatible with the memory cards from your camera. There are also readers that you can hook up to your TV monitor so that you can view images from your media card right on your TV.

Digital Labs

And just in case you like dropping off film on Saturday afternoons, you'll be happy to know that most photolabs can handle virtually all formats of memory cards. The services they offer include burning your images to CD, printing them for you directly, or emailing your images to your computer—or they may post them to a website where you (and your family and friends) can access them from any computer.

Labs can be a blessing when you're traveling and your memory cards fill up—just stop at a nearby lab and have your images burned to CD. You can then erase or reformat the memory cards and reuse them immediately.

Part of the fun of owning a camera is that you get to buy all sorts of neat toys to go with it. And if you choose them carefully, they will make your picture-taking life a lot easier and improve your photos.

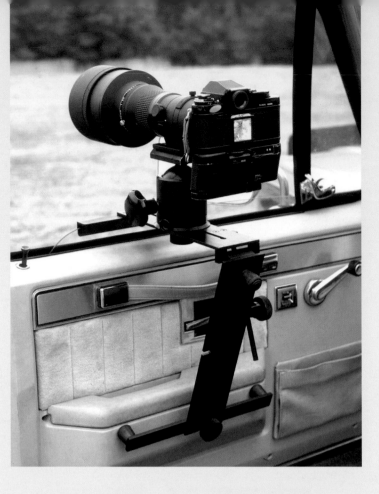

Tripods and Monopods

I think of tripods **(pictured above from Bogen Imaging)** as being indispensable to good photography and regard owning a good one as more of a necessity than an accessory. A good tripod should be light enough so that you'll actually bring it with you but heavy and solid enough so that it can hold your camera and its longest lens. It's also important that a tripod be tall enough to use at eye level without having to extend the center column more than a few inches. The knobs that control the leg length and other functions should be easy to use—even with gloves on.

Metal tripods are far steadier than plastic tripods but weigh more. Carbon-fiber tripods are strong and lightweight, but very expensive.

Monopods—one-legged camera supports—are a good alternative to a tripod when you simply don't have the time or the room to set up a tripod. Monopods are good at providing support when space is limited or when you're in a location (like a botanical garden) where tripods are prohibited.

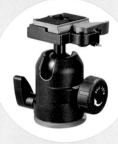

Ball Heads vs. Pan-Tilt Heads

The tripod's head holds the camera. Pan-tilt heads and ball heads are used to mount your camera to either a tripod or a monopod. I strongly prefer ball heads. With a single control, they let you quickly adjust the camera in all directions. The multiple handles of a pan head slow you down because each must be separately loosened and adjusted. Buy the best ball head **(like the Manfrotto pictured above from Bogen Imaging)** you can afford because it will last for many years and make using a tripod a pleasure.

There are camera bags available for all tastes and requirements, including these models from Lowepro (right) and RoadWired (below).

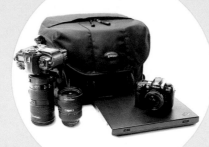

Left
The Groofwin Pod from L.L. Rue is one of the best ways to stabilize a camera when shooting from a car.

Portable Digital Storage Devices

Portable digital storage devices are small hard drives that enable you to download images in the field for safe storage. They are typically small enough to fit in a jacket pocket. Some of the better ones have a small LCD window so that you can review your images after you've downloaded them; a few even have a CD burner attached so that you can burn CDs in your hotel room at night (or sitting on the beach admiring the sunset you just shot, for that matter).

The beauty of these devices is that they let you empty your memory cards in a matter of minutes so that you can reuse the cards and continue shooting. The alternative is to carry a laptop. A laptop adds editing capability but also is more fragile, heavier, and more expensive. It's a good idea to read online reviews or do a test run at the camera shop when you're buying a portable storage device because the menus range from obtuse to superb. The FlashTrax XT from SmartDisk **(above)** is by far the simplest one I've used (its documentation and menus are nothing short of elegant), and it has an oversized LCD screen that makes viewing pictures a pleasure.

Camera Bags

Camera bags come in every size, shape, price and style imaginable. The size and style that you buy will depend largely on the amount of equipment you own. If you have a digital SLR and several lenses, choose a shoulder bag with individual lens compartments; it will protect your investment and put your equipment at your fingertips. Even if all you own is a compact zoom camera, a well-made camera bag is a good investment because it will keep dirt and rain and sticky fingers away from your precious camera. The five most important things to look for in any camera bag are superior protection, exceptional organization (so you can easily access equipment), convenience (zippers and flaps open easily) durability, and light weight so you'll use it.

Electronic Flash Part I

Most of us take for granted the ability to walk into any room, regardless of how dark it is, pop on the electronic flash and take a well-exposed picture. It wasn't always so easy and, in fact, photographic pioneers wrestled with the problem for more than 80 years before a solution was found.

As early as 1850 William Henry Fox Talbot (who invented the basic concept of negative-positive photography on which film photography is based) was experimenting with using electrical charges and crude capacitors to light subjects with a brilliant instantaneous spark of light. What Talbot was trying to find was a source of light that was bright enough to illuminate fast-moving subjects in dim light and that had a short enough duration to stop their movement—and he did have some remarkable successes.

It wasn't until 1931, however, that an MIT faculty member (and former student) named Harold E. Edgerton really solved Talbot's riddle. Edgerton developed the first practical means of creating high-speed portable lighting—the portable electronic flash. He was able to create bursts of light bright enough and fast enough (measured in millionths of a second) to reveal, for the first time, the intricate beauty hidden in moving subjects that were simply too fast for the human eye to discern—drops of water splashing in a pan, hummingbird wings flapping and bullets frozen in midair. If you've never seen any of "Doc" Edgerton's amazing photographs, they're worth investigating.

Today, of course, Edgerton's extraordinary invention is built into virtually every digital camera in the form of a small electronic flash—a miracle of technology and a landmark scientific breakthrough that is available at the push of a button. And though on-camera flash is rarely the most attractive form of photographic lighting, it does provide bright, convenient light. It also provides the extremely short-duration bursts of light (measured in thousandths of a second) that both Edgerton and Talbot were searching for and is often used by professional sports photographers for that very reason—to stop action.

Using flash with compact digital cameras is simple. In fact, by setting your flash to Auto mode, you can even leave the decision entirely up to the camera. The camera will turn the flash on when it thinks the existing light is too low to create a good exposure. The only indication you'll get that you're about to take a flash picture (other than the flash popping up if you have a pop-up style flash) is the small amber flash indicator flickering in the viewfinder.

Because built-in flash provides such a harsh beam of light, however, and because it comes directly from the camera, it tends to produce a flat, featureless light that renders most subjects devoid of the attractive subtleties of texture and form that existing light provides. Still, if you use flash judiciously, study some of the advanced techniques and pay attention to your surroundings, you can get some very pleasing pictures. And besides, if you're at an indoor birthday party and it's too dark to shoot without flash, you really don't have many options.

Tips for getting the most from on-camera flash:

1 Stay within the flash range

You've no doubt seen baseball and football stadiums at night twinkling with the light of a thousand electronic flashes. The effect is pretty to watch on TV and the battery manufacturers must absolutely love it, but not a single one of those thousands of flashes is helping anyone get a better picture of an event happening hundreds of feet away. Typically most built-in flash units have a range of about 4-16 feet; beyond that range (either closer or further away) the flash isn't very helpful.

Because the light from the flash falls off (gets dimmer) the farther it gets from the camera, subjects that are farther from the camera may look darker than those that are closer. If you are shooting a group at a long dinner table, for instance, it might be best to have them all gather on the opposite side of the table from you as if they were in a police lineup (fits my family) so they're all roughly the same distance from the flash.

2 Turn on additional lights

Whenever you're shooting indoors with flash, turn on several room lights, too. Your built-in flash will provide enough illumination for a good exposure of the main subject and the tungsten lights will provide warm pools of attractive background light that lighten shadows to give a more

Left
When using the flash on your compact camera, the subject may appear too dark (underexposed) if you are not close enough. Either move closer or add exposure by using your camera's exposure-compensation feature (set to +1 in the bottom photo).

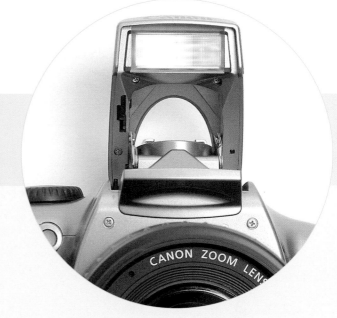

natural-looking atmosphere. During the day, open curtains or doors to let more light inside, but try not to shoot directly into a bright light since this may cause the flash to shut off prematurely. Again, while the flash provides most of the light, the daylight will open shadow areas to prevent very dark backgrounds and will also provide a more balanced exposure.

3 Avoid reflective surfaces

Never aim the flash directly at mirrors or windows or any other highly reflective surface. Light from the flash will bounce off reflective surfaces directly back to the camera. In addition to creating glaring hot spots in your pictures, the reflected light will also cause your automatic exposure system to underexpose the scene by fooling it into thinking there is more ambient light than really exists. Conversely a very dark wall behind your main subject will fool the camera's exposure system into thinking it needs more light and will overexpose your subject.

4 Shoot down at people

If possible, get slightly above your subjects to reduce red-eye and diminish their distracting shadows, which will now fall lower and perhaps fall outside the picture. To further reduce annoying shadows cast by people, keep them a few feet from any wall.

5 Keep batteries charged

Flash drains batteries very quickly so it's important to start with well-charged batteries. As the battery charge dwindles, the recycle times for your flash will increase, and nothing ruins the impromptu mood of a photo like waiting for the flash to recharge. It's a good idea to load a fresh battery just before a long flash photo session; with experience you'll know how many flash shots you can get from fresh batteries.

Electronic Flash Part II—Flash Modes

Many digital cameras offer several modes for flash photography that you can select from the flash menu or by pressing a button on the camera (or both). The mode you're in will normally be displayed in the viewfinder and/or in the camera's LCD control panel. How these modes work vary somewhat from one camera manufacturer to another, and some digital SLRs offer additional modes for accessory flash units. The list that follows is an overview of some of the more common choices for flash photography. Make sure you check your camera's manual to see exactly which modes are available to you and how they work.

Also, it is always best to take some test photos before any big event where the pressure will be on to produce great photos. Take these practice shots a week before the event in similar surroundings, trying out different flash modes and techniques. And remember, you don't have to worry about the cost of test film, plus you can see the results instantly and try another technique if the picture doesn't look as good as it could.

The Basic Flash Modes:

Automatic

In this mode the flash will automatically turn itself on whenever the camera's exposure system determines a scene is too dark. The flash will almost always pop on indoors in this mode, but may also turn itself on when you are working outdoors in deep shade or as the sun begins to wane late in the day. Any time that the flash turns itself on, you have to decide whether you indeed want the flash on or whether it would be best to shut it off.

Flash Off

This mode is essentially an off switch. In this mode the flash will not fire, regardless of the lighting conditions. This is a very useful mode if you're trying to take pictures in a concert or nightclub and don't want to be bounced out by security or glared at by nearby audience members. More importantly, shutting the flash off enables you to take photos by existing-light only indoors or out so that you can photograph a city skyline at twilight, for instance, without flash.

Sometimes the blast of on-camera flash is too harsh. After shooting this "candlescape" with flash (above), I saw how cold it looked on the LCD monitor. So, I turned off the flash and made a handheld exposure (one-half second), resting the camera on the arm of a couch. There's no question about which is the more romantic shot.

Fill Flash

The Fill mode (sometimes just referred to as "always on") lightens distracting shadows when you're photographing people outdoors in sunlight on very bright days, particularly if the light is coming from overhead. In this mode the flash will fire even in bright sunlight. It might seem a bit backwards to use flash in bright sunlight, but when you're photographing people, direct sunlight (again, particularly from overhead) often causes dark shadows in eye sockets and under noses, and using a small amount of flash opens these shadows nicely. Most portrait and wedding photographers who work outdoors a lot use fill-in flash for that very reason. With some more sophisticated accessory flash units, the camera's exposure system balances fill flash with the ambient light. You can also use an exposure compensation feature that lets you create a more natural balance between the existing light and the flash typically providing a flash fill that is about one stop less than the existing light. Read your manual to see if your flash offers a compensation feature or some other method for adjusting flash output.

Fill flash can also be used to fill faces when using strong backlighting from the sun for outdoor group portraits (or even for backlit close-ups of flowers or plants, etc.). By arranging your subjects so that the sun is behind them, you can use the sun's light to create a halo or "rim" light around their head and then using flash to open up their faces. Again, fill-in flash will only work within your flash unit's normal working range, so be sure to check your manual for the useable distances. Finally, remember that for fill flash to work, your shutter speed cannot exceed the camera's flash sync speed.

Red-eye Reduction

Red-eye is that rather demonic looking red glow that occurs in people's eyes when they've been photographed head on by a built-in flash unit. The effect occurs because when you're photographing people in dim settings their pupils open very wide and light from the flash bounces back from the retinal surface (which is filled with tiny blood vessels) at the back of the eye, creating that strange glow. Traditionally red-eye reduction has worked by designing the flash to fire a series of rapid low power pre-flashes that cause the pupil to contract. But now some cameras have built-in software that actually detects and eliminates the red-eye from your pictures before you download them.

Red-eye reduction flash can be a bit annoying because during the time it takes to fire the series of mini-flashes, the spontaneity of the moment is lost. Some cameras are worse than others (and some are a lot worse), and you'll sometimes see people at weddings or parties making their subjects hold a pose while they blister them with a flurry of flashes. Incidentally, as mentioned above, turning on more room lights will also lesson the risk of red-eye because it causes the pupils to contract naturally.

And regardless of how the camera attacks red-eye, you can always remove it after the fact in postproduction. We'll talk about techniques for doing this in The Image Enhanced chapter.

Slow-sync

Normally when you take a flash photograph the shutter opens, the flash fires and then the shutter closes immediately. In the Slow-sync (sometimes called Night Flash) mode, the shutter remains open slightly longer in order to gather more light from the background.

Slow-sync photos have a more natural look because the background receives some ambient exposure. I find this a tremendously creative flash mode and I use it almost constantly when I'm working outdoors at night. If I'm shooting street pictures, for example, the flash will provide enough light to record friends standing on the street corner, and the delayed closing of the shutter records the color glow of neon and traffic streaks in the background. I've also used this mode indoors to create a more natural balance between the flash exposure and the existing room light; you will absolutely notice an improvement with indoors shots if you use this mode over the normal automatic flash mode.

Because the shutter is staying open longer in this mode, however, anything that is moving in the background (people, cars, sparks in a fireplace) will record as motion streaks. If you're concerned about sharpness, you have to hold the camera very steady in the Slow-sync mode (or use a tripod) because any camera movement will also record background lights in a streaky way (see this used for creative effect on page 148).

Strictly speaking, you don't *need* a lens to take a picture. As anyone who has taken a basic photo course and built a pinhole camera knows, a tiny hole poked in a piece of thick aluminum foil will focus an image just fine, a principle that Aristotle wrote about in the 4th Century BC, incidentally—and one that the Chinese were mulling over about 100 years before that. But since your digital camera does use a lens (or lenses) to form its images, understanding something about how camera lenses work and how they differ is useful knowledge to have.

Unlike your eyes that have a set angle of view, camera lenses are made in a wide assortment of viewing angles—from ultra wide-angle lenses that take in the whole horizon in a single glance to telephoto lenses that have a narrow view but magnify the subject. Exploiting these differing angles of view can be a fun and creative exercise and can lead to startling visual discoveries. By expanding or contracting space and distorting apparent perspective, for instance, lenses are able to show us views of the world that we've never actually seen in reality. And the ability of close-up or macro lenses to reveal intimate details of, say, a bug's knees, is like a journey to a hidden world within a world—one that we probably step on more often than we notice.

All lenses are identified by their focal length (stated in millimeters) that describes not only the their angle of view but also their magnification. The shorter the focal length is (the smaller the number), the wider the angle of view; a 28mm lens, for example, provides a wider angle of view than a 100mm lens. Once again, to get a better handle on this, it's helpful to step back into the world of film for a moment (you can look, but don't buy).

In 35mm photography, lenses that have a focal length of roughly 50mm (in practice it's anywhere from about 43 to 60mm) are considered *normal lenses,* because their angle of view and representation of a scene is fairly close to what we see with the naked eye.

Technically a lens is considered "normal" when its focal length is equal to the diagonal measurement of the film or sensor. Since the diagonal of a frame of 35mm film is 43mm, that's the focal length of a normal

lens for that format. Now consider that most digital SLRs have a lens magnification factor and you add a new twist into the concept of a normal lens. If you have a digital SLR, with a magnification factor of 1.5x, then a 28mm or 35mm lens when multiplied by 1.5x would give effective "normal" range focal lengths of 42mm and 52mm, respectively. But the whole concept of normal is only to classify the different types of lenses. So it's nothing to worry about.

Lenses that are shorter than the normal range in focal length are considered wide-angle lenses because they have a wider angle of view than a normal lens. Conversely, lenses with a longer focal length fall into the category of telephoto lenses because they have a narrower angle of view and magnify the size of your subjects. Zoom lenses, of course, include many focal lengths in a single lens.

Lens focal lengths in the digital world

Here's where things take a slight left turn in the digital world (particularly if you're an experienced 35mm photographer). Because most people buying digital cameras have owned a 35mm film camera, they are familiar with the measurements used to describe the lenses for their film cameras. But compact digital camera lenses are smaller and their measurements are different. Rather than force people to become familiar with another system of measurements, most manufacturers express lens focal lengths for digital cameras in measurements that are equivalent to 35mm camera focal lengths.

They tack on the somewhat clunky phrase "35mm equivalent" to virtually all lens descriptions. For example, the zoom range of my Nikon Coolpix 5700 is 8.9mm to 71.2mm (which means absolutely nothing to the 35mm photographer in me) but is described as being "equivalent to 35 to 280mm in 35mm" (numbers that I completely understand).

FOCAL LENGTH CHARACTERISTICS

Normal lenses

Because normal lenses have approximately the same viewing angle as your eyes, pictures taken with a normal lens have a familiar appearance—perspective and spatial relationships are rendered much as we would expect. If you photograph a park scene with a picnic bench in the foreground, a set of swings in the middle ground and some trees in the distance, the scene will look "correct" in your photographs.

Of course, merely looking correct is no ringing creative endorsement, but a normal perspective is useful when you're photographing groups of friends (sitting at the picnic table in the park, for example) or simple landscape scenes. And the very familiarity of the view can lead to a heightened intimacy between viewer and subject. The great photographer Ernst Haas, one of the true pioneers of 35mm color photography, had a particular fondness for working in the "normal" focal length range because it reflected his personal vision and not some optical exaggeration. Haas had a wonderful way of accepting the world at face value and the normal lens helped him present that vision faithfully. You can see some of his wonderful pictures and learn more about him at www.ernst-haas.com.

Wide-angle lenses

Like arms flung wide to embrace the world, wide-angle lenses are able to record views well beyond even our widest peripheral vision and are often used by landscape photographers for that very reason. Another reason that wide-angle lenses are so useful in landscape work is that they expand the spaces between nearby and more distant subjects, making the scene seem deeper and wider. When you combine this spatial exaggeration with the intrinsic close-focusing ability (often as close as a few inches) and their inherently rich deep depth of field, you can create some very interesting compositions. Using the equivalent of a 28mm lens and getting down low on the ground, for instance, I was able to make the grape hyacinths tower over their surroundings (see the advanced tip in the Nature chapter on page 215).

This comparison, with both pictures taken from the same location, clearly shows the extreme focal-length range of an 8x zoom lens.

The very properties that make wide angles useful (spatial distortion, lots of depth of field) can also be used creatively to distort other familiar subjects—shooting straight up at a skyscraper, for instance, might transform an already tall building into a towering rocket ship. And you've probably seen wildly distorted portraits taken with a wide-angle lens only a foot or so away from the face—a creative (let's hope the subject sees it that way) technique that creates a carnival-mirror. Wide-angle lenses (particularly in the range of 20-24mm in 35mm equivalents) also come in very handy indoors and are essential for shooting architectural interiors, for instance, or when you are in a tight spot and simply can't physically back away from a subject. Unfortunately most digital zoom cameras don't feature the kind of ultra wide-angle lenses available for digital SLRs, but, with some cameras, you can buy accessory wide-angle lenses.

It's amazing how different the same subject can look when photographed using different focal lengths. Train tracks appear to stretch into infinity when photographed with a moderate wide-angle lens (top), and become compressed with a moderate telephoto lens (bottom). The ability to manipulate perspective is a primary reason for selecting different zoom settings.

Telephoto lenses

Unlike wide-angles that exalt space, telephoto lenses (also called "long" lenses) compress it, while making far-off subjects seem closer and larger. In fact, the longer the focal length of a lens, the narrower its angle of view, and the more compressed space appears, and the greater the magnification of a subject. Get that? Here's a real life example: With your zoom lens set to 100mm and pointed at a deer standing in a meadow, for instance, the deer will appear twice as large in your viewfinder as it would when seen through a 50mm lens setting. With a 300mm lens it would appear to be six times larger.

Wildlife and sports photographers are particularly fond of long lenses because without them they couldn't take pictures of their favorite subjects. In fact, their love is often directly proportional to a lens' degree of magnification. Telephoto lenses range from (and once again, we're talking 35mm numbers here) 85 to 600mm and longer, and are often categorized in two groups: medium telephotos in the 85 to 300mm range and super telephotos in the 300mm and longer range.

All but the most expensive compact zooms have a fairly limited maximum telephoto capability—usually in the 135mm range, though a few have zooms as large as 380mm. Fortunately, for general subjects, the most useful focal lengths are in the 85 to 135mm range. These are typically referred to as portrait lenses because they provide an attractive perspective and a comfortable working distance for head-and-should type portraits. Also, the inherent shallow depth of field of longer lenses helps to toss backgrounds out of focus and concentrate attention on your subject.

Super telephoto lenses are available only for digital SLRs with interchangeable lens capability, such as the Canon EOS Digital Rebel. And while they're wonderful for shooting skittish animals or not getting clobbered by linebackers, lenses in this range have three things in common: they're big, heavy and expensive (and we're talking dipping-into-the-kids-college-fund expensive for some of the best lenses). Also, as you might have guessed, telephoto lenses have an inherently shallow depth of field and, in the case of the super teles, have almost no depth of field.

Finally, even in the moderate telephoto range, longer lenses magnify and exaggerate camera shake and subject motion and really require use of a tripod.

Zoom lenses

Most compact digital cameras, of course, have a zoom lens that contains a range of different focal lengths, usually a 3x to 10x range. A 3x zoom covers from moderate wide-angle to a moderate telephoto. A 10x zoom ranges from moderate wide-angle to long telephoto—typically over 300mm. The broader the range of focal lengths, of course, the greater your photographic versatility—and the more you'll pay for the camera.

In most instances the wide-angle focal lengths of most zooms are fairly similar, it's the telephoto range that gets more powerful with wider-range zooms. If most of your photography consists of taking snapshots around the house or informal people pictures, a 3x to 4x zoom range will probably be adequate. If you travel a lot and want a lot of versatility or if you frequently shoot high school sports or any type of distant subjects, you'll appreciate the magnifying ability of a more powerful zoom.

I find that an 8x zoom is the perfect travel companion because it enables me to get the same wide shots as a milder zoom, yet lets me isolate more distant subjects such as people or architectural details. On the other hand I often carry a camera with a 3x zoom that takes terrific landscape pictures and is excellent for group portraits—and it's a much more compact camera.

Of course, all of these observations about the advantages and disadvantages of various focal lengths are based on how lenses are traditionally used. There's nothing in the instructions for using wide-angle lenses that says they are only useful in landscape photography or that telephoto lenses are only meant for far-off subjects. Your vision may be entirely different—think of how many great artists have defied convention and shown us new ways to see. Did Seurat discover Pointillism or Picasso unearth Cubism in a textbook on how to paint well? Personal vision comes from experimenting—

so take everything you read about what you're supposed to do with certain lenses with a grain of salt.

Digital photography did not materialize out of thin air. Like all technology it has a history, and like all histories, it is rife with splendid and unexpected victories. Each of the milestones described below was an incremental hop that, taken as a whole, led to our current wealth of superb digital cameras, image-editing software and computers. Take this stroll through digital technology's memory lane and you'll see just how inspired the journey has been.

1951

UNIVAC I, the world's first commercial computer, is put into service by the U.S Census Bureau. Remington Rand built less than fifty units of this computer, the size of a small garage.

No film! **The Video Tape Recorder (VTR)** is developed at Bing Crosby Laboratories. It uses electrical impulses to record images on magnetic tape.

1947

The **transistor** is developed by John Bardeen, Walter Brattain, and William Shockley at Bell Laboratories. The discovery leads to a Nobel Prize for the three men and initiates a revolution in the electronics industry, replacing large vacuum tubes and mechanical relays with the small amplifying device.

A picture of the infant son of Russell A. Kirsch at the National Bureau of Standards is recorded as the **first photo to be scanned,** using an early mechanical drum scanner.

Shockley Semiconductor Laboratories (a division of Beckman Instruments in Palo Alto, California) experiment with the creation of **silicon crystals,** giving rise to a nascent industry as well as the term, "Silicon Valley."

1956

1957

1963

David Paul Gregg invents a **Videodisk Camera.** Although the camera could store only several minutes' worth of images at one time, the technology is recognized as a precursor to digital photography.

1964

Video cameras on board the Mariner spacecraft **transmit electronic images of Mars** back to NASA's Jet Propulsion Laboratory in Pasadena, California.

1959

The computer revolution gains momentum with the invention of the **integrated circuit** by Fairchild Semiconductor manager Bob Noyce, who would later co-found Intel Corporation.

1969

While working at **Bell Laboratories** in October 1969, Willard Boyle and George Smith design the Charge-Coupled Device (CCD), now used to sense and process light and record images in digital cameras, among other media.

The Advanced Research Projects Agency (ARPA), a branch of the U.S. Military developed **ARPAnet, the grandfather of the Internet.** The first computers to exchange data over the net belong to UCLA and Stanford University.

Digital Technology Timeline

1947-1980

1975

Using new integrated circuit (IC) technology, the **first CCD Flatbed Scanner** is incorporated into the Kurzweil Reading Machine by Kurzweil Computer Products, Inc. Kurzweil's pioneering work in Optical Character Recognition (OCR) technology is undertaken to serve the needs of the blind.

1977

The Apple I, Apple Computer, Inc.'s first home computer, is introduced. Customers built their own cases to enclose the circuitry.

1980

1971

Ray Tomlinson, a computer engineer, sent the **first email message.** Tomlinson also adopted the keyboard's @ symbol to represent "at" in email addresses.

Eastman Kodak Company produces one of the first operational **electronic CCD still-image cameras.** The camera uses a Fairchild B&W CCD that contains 10 kilopixels (not megapixels) and records an image onto cassette videotape.

1979

1972

The first patent is filed for a **filmless electronic camera** by Texas Instruments.

A scientific team from The University of Calgary, in conjunction with Fairchild Semiconductor, helps develop the **Fairchild All-Sky Camera, perhaps the earliest digital camera** actually used in the field. It is used to photograph auroras.

Sony Corporation is the first to commercially market **color video cameras with a solid-state image sensor, the CCD.**

1981

In what is considered a true milestone in the development of digital photographic technology, **Sony Corporation announces the Mavica (Magnetic Video Camera) Electronic Camera.** Not truly a "digital camera," the Mavica is actually an SLR, interchangeable-lens TV camera that can record still photos in analog video format onto magnetic disks.

Though a number of companies have marketed small computers for individual users, the "PC Age" is truly launched with the introduction of the **IBM 5150.**

Apple Computer, Inc. runs their famous "1984" ad during January's Super Bowl, introducing the Macintosh. This personal computer features a speedy and friendly interface using a mouse and emphasizes the use of graphics.

1984

Canon Inc. uses their newly minted RC-701 still video camera to test the **analog transmission of digital images via phone lines** from the Los Angeles Olympics to Japan. The resulting pictures are received in only 30 minutes and printed in a Japanese newspaper, giving Canon the technical confirmation needed to begin full-scale development of their Still Video System products.

1985

This year marks the introduction of the breakthrough **Commodore Amiga A1000.** This sophisticated PC offers superior capabilities for graphics and sound. Users can multi-task in an environment that includes Graphical User Interface and a 4096-color palette.

1987

Letraset launches the **grayscale image-editing program ImageStudio,** developed by Fractal Technology for Macintosh computers. This software later inspires the development of Adobe Photoshop.

1988

Joint Photographic Experts Group develops and implements standards for an image compression format (JPEG) that will enable digital cameras to efficiently utilize available memory.

The DS-1P from Fuji Photo Film Co., Ltd. is the **first electronic still camera to record digital images on memory cards.** The camera uses an internal 16MB card developed by Toshiba, but it is not marketed or sold in America.

Hewlett Packard introduces the first mass-market inkjet printer, the **HP DeskJet.** It uses plain paper.

Digital Technology Timeline
1981-1991

1990

Using a Sony Mavica still-video recording system to capture images in conjunction with Sony's DIH 2000 (digital image handler) to transmit them, CNN circumvents Chinese news censors to deliver current images of the famous Chinese student political uprising at Tiananmen Square. Though the movement is violently suppressed by authorities, the images inform and stun the world.

The Personal Computer Memory Card International Association (PCMCIA) is an international organization established to develop and sponsor standards for Integrated Circuit memory cards and to promote interchangeability among personal computers.

1989

This is it! The **first entirely digital camera** for consumers: Dycam Model 1 (Logitech FotoMan). Recording in black and white, the Dycam's photo resolution is 90,000 pixels (or less than one-tenth megapixel).

The Eastman Kodak Company releases a prototype electronic camera back intended to suit the needs of photojournalists.

PhotoShop 1.0 is released by Adobe Systems Incorporated for use with Macintosh computers, quickly followed by version 2.0.

The Eastman Kodak Company presents its **Photo CD system** to show images on TV screens, converting negatives or slides to CD. The system offers an international standard for color definition in the digital environment.

The Hubble Space Telescope captures images from far in space using four high-tech Charge-Coupled Devices (CCDs), each containing 640,000 pixels. (Do the math; the Hubble possesses a 2.5-megapixel camera).

Launching what is often considered the first genuine useful digital camera for general sale, Kodak presents its **DCS (Digital Camera System) 100.** It uses a modified Nikon F-3 body with a 1.3-megapixel sensor. The cost is approximately $20,000.

Electronic imaging techniques are widely used by Gulf War photojournalists to transmit pictures of their onsite coverage.

1991

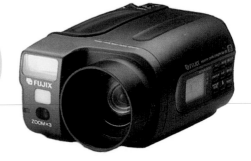

The Fujix DS-100 is an early true digital camera that uses a removable memory card for image storage.

1992

Mosaic is released by The National Center for Supercomputing Applications (NCSA). This early browser is the first to allow users to see photographs over the Internet.

The first widely accepted third-party plug-ins for Adobe Photoshop, **Kai's Power Tools** developed by Kai Krause, are introduced by Harvard Systems Corporation (soon to become HSC Software).

Kodak integrates the disparate components of its DCS line to offer the **Kodak Professional DCS 200 digital SLR,** the first pro digital camera combining hard drive unit and camera "all in one."

HSC Software introduces their **LivePicture** image manipulation software.

Adobe Photoshop becomes available for MS-DOS/Windows computer platforms.

1993

1994

The **CompactFlash (CF) memory card** is introduced by SanDisk Corporation.

The Apple QuickTake 100, at a price tag of less than $1,000 and resolution of 640 x 480 pixels, is reputed to be the first consumer-oriented color digital camera.

1995

Casio Computer Co., Ltd. markets the **first digital camera furnished with an LCD monitor,** the QV-10.

Seiko Epson Corporation introduces the Epson Stylus Color, an ink jet printer with a printing resolution of 720 dpi. It is one of the first home printers to produce true photo-quality prints.

The *Vancouver Sun* and the *British Columbia Province* become the first major newspapers in North America to convert from film to all digital photo capture, adopting Nikon N90-based 1.3 megapixel NC2000 camera, which was developed jointly by the Associated Press and the Eastman Kodak Company.

1997

Intel Corporation announces that, in order to achieve mass-market penetration, the industry needs a good digital camera at a price point of less than $200. Intel's "good quality" guidelines call for a resolution value of 640x480 pixels (0.3 megapixel).

Nikon Corporation produces the D1, a professional model that is the first digital SLR to be designed and manufactured by a single camera company, not as a joint venture. It lowers the cost floor for this type of equipment, and features a sensor of 2.7 megapixels, allowing for larger prints and higher quality output than previously available.

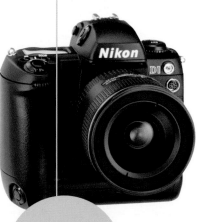

1996

1999

The first digital camera to utilize **removable CompactFlash cards** is Kodak's DC-25.

1992-2005

The Eastman Kodak Company breaks the 10-megapixel barrier with the DCS Pro 14n digital SLR with a CMOS sensor that is the same size as a 35mm film frame (full-frame). The 14-megapixel full-frame sensor eliminates the focal-length magnification effect caused by smaller sensors. Photographers using 35mm SLR lenses can now get true wide-angle coverage.

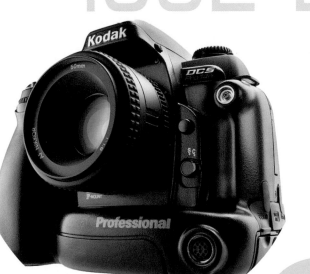

The quantity of digital cameras purchased this year exceeds for the first time the number of conventional cameras purchased.

Canon Inc.'s 6.3 megapixel EOS Digital Rebel, which can be purchased for less than $1,000, is the first digital SLR to make a major impact on the consumer market. It uses the same interchangeable lenses as Canon's 35mm SLRs

2002

2003

The 3.4-megapixel Sigma SD9 digital SLR is the first generally available digital camera equipped with the Fovean X3 CMOS imaging chip, in which every pixel "sees" all the colors without needing a color filter array over the pixels.

The Epson Stylus Photo 2200 desktop printer is considered a break-through because of its use of pigment inks to extend longevity of prints to approximately 100 years.

2004

Several major camera manufacturers produce **8-megapixel** "prosumer" digital cameras, all-in-one models with long-range, built-in, zoom lenses.

2005

In response to the ever-increasing demand for digital cameras and the shrinking conventional market, Nikon announces it will phase out its film camera production and focus on digital cameras going forward.

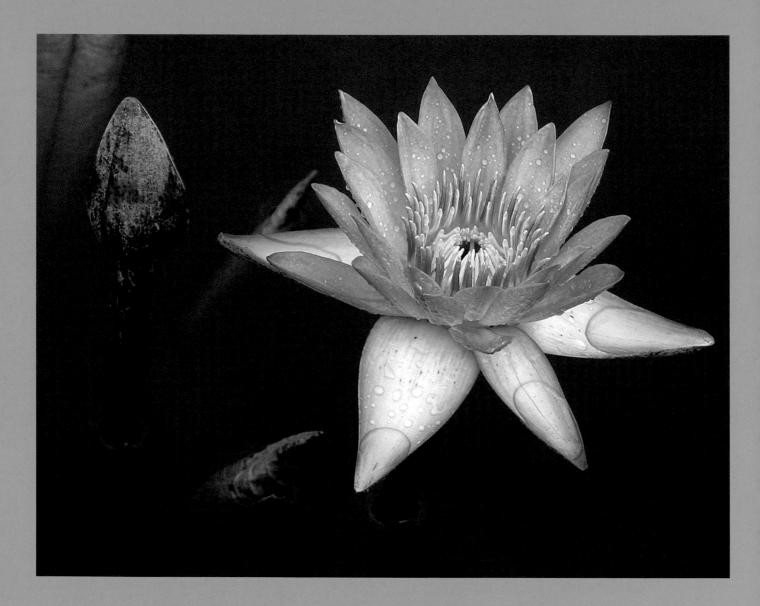

"As a matter of fact nearly all the greatest work is being, and has always been done, by those who are following photography for the love of it, . . ."

—ALFRED STIEGLITZ, IN 1899

Taking Great Digital Pictures

Introduction

Presumably as you're reading this it's dark outside, the winds are howling, there's a black driving rain, and the local news anchor has reported there is officially nothing outside (or inside) worth photographing. Ah, but tomorrow the sun will rise, your kids will be playing in the yard, rainbows will arch behind every cloud—and photo opportunities will blossom everywhere. Now is the time to get to know your camera, think about what you might be photographing and create a game plan for your adventures into digital photography.

When all the hype and ballyhoo of being a part of the digital revolution subsides, the real excitement of owning a digital camera begins: taking great pictures. And digital cameras make that easier than ever before—provided you take the time to get familiar with your new camera and the digital shooting process.

While the technology and some of the camera features used for recording digital images are entirely new, many of the camera controls and techniques for getting sharp, well-exposed images are similar—or even identical—to film cameras. The controls and technologies for light metering, flash illumination, auto focusing and exposure are virtually identical for film and digital cameras.

In fact, with the exception of loading your camera with a memory card instead of film and using an LCD monitor instead of (or in addition to) an optical viewfinder, a digital camera will feel very familiar in your hands. Of course you'll be dealing with some totally new concepts that are going to seem absolutely alien the first time you encounter them. They include navigating menus, choosing image resolution and image quality settings, and selecting a white balance setting.

On the following pages we'll take a closer look at how some of the features of your new camera work—and how to use them to get good quality pictures. We'll also talk about building good shooting habits. You might want to have your camera and manual handy. The specifics of every camera will be different—and who knows, you might just get inspired to put the book down, turn on the camera and shoot a picture of your dog napping by the fire.

And won't he (not to mention the rest of your family) be impressed in the morning when there's a brand new picture of him hanging on the refrigerator door.

Getting to Know Your Camera

Although manufacturers have made much progress in making digital cameras simple to use—even for the absolute novice—there is little that is intuitive about some camera controls. You aren't any more likely to guess your way through digital menus, for instance, than you would be to wing your way through programming a VCR's timer controls (try as we might). As impatient a person as I am when it comes to playing with a new toy, I always take time to study camera controls before shooting any pictures. I also read every piece of paper that comes in the box. I even read the dumb questionnaire that wants to know how much education I have (why don't they ask that *before* you buy the camera).

> Before you start taking pictures get to know your camera so you can get a good picture the first time you press its shutter button.

Here are some tips on getting to know your camera

Read your manual

Granted, reading some digital camera manuals is like deciphering instructions written in a long-dead language on knitting a sweater for an octopus, but muddle through it the best you can. And always keep your camera handy while you're reading so that you can identify camera parts and try different things. Some manuals are surprisingly lucid, and good manuals are a treasure trove of useful information. I think there should be an annual award for the folks who write the good ones.

Never force any type of control on your camera, but never be afraid to try any feature. If you fear the camera, you won't use it and you're unlikely to break anything by touching it gently (but you wouldn't touch the surface of the lens, right?). After you've read the manual a few times even the obtuse language of camera designers will become clear and a hint of logic will begin to emerge. Become familiar with the names of various camera features and understand the icons on the displays.

A lot of manufacturers sell cameras with an abbreviated print manual and include a more complete manual on CD ROM. Unless you carry a laptop computer everywhere you go, the CD ROM manual will do you absolutely no good. In fact, you should always ask to see a camera's manual before you buy any camera; at least that way you know what you're getting into.

Read more online

You can find a lot of excellent model-specific information for free by doing a simple search on the Internet (try www.google.com) using the camera's brand and model name as keywords. Many manufacturers' websites, such as Nikon, Canon, Epson and Kodak, provide extensive educational material. There are also several fine review sites where you'll find in-depth information on camera controls and techniques (www.steves-digicams.com and www.dcviews.com are excellent starting places).

You'll also find many user reviews and list serves devoted to particular brands and models of cameras that address specific user issues. Joining a "user group" for your camera is an excellent idea. Check web sources like www.yahoo.com for listserves that might apply to your camera. There are also publishers (among the best are Magic Lantern Guides) who publish much more detailed and model-specific instruction manuals.

Take a course

Camera shops and community education organizations offer basic courses in digital photography. If photography or internet communications are a part of your company's work, they may be willing to pay to train you in basic digital photography, so it's worth inquiring at work, too. The classes are usually informal, basic and inexpensive.

If you take a class before you own a digital camera, you'll get to hear a lot of other folks' thoughts on their cameras that may help you in choosing your own camera. And if you take it after you've bought a camera you'll have a captive instructor to answer your camera-specific questions.

Take small bites

Trying to learn to use every feature of a digital camera all at once can feel overwhelming, so try to digest information in small pieces. Once you've got the basic features down and can get an acceptable picture in the programmed mode, try experimenting with one new control each time you use the camera. You're far more likely to master things like macro modes, different flash modes and special effects modes if you delve into them one at a time. The same goes for accessories like tele-extenders or accessory flash units add one new tool to your repertoire each time you go shooting.

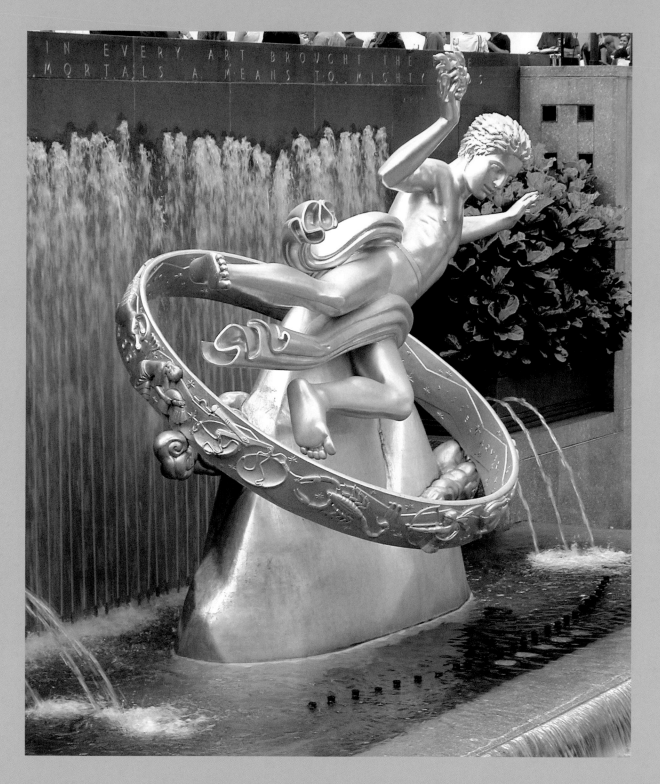

Choosing a File Format

One of the first things you have to do before you can take any photos with a digital camera is to tell the camera in which *file format* you want to record the images. A file format is basically a language used by digital devices (including cameras, computers and scanners) to read, write and transmit image data. Without some standardization in formats, every device would be speaking its own unique language and none of them would understand any of the others—kind of like the United Nations having a heated debate in many different languages without the benefit of translators (they *do* have translators, don't they?).

Some basic cameras offer only one type of file format, but most offer several. The format you choose impacts not only the quality of your images, but also how many images you can fit onto your memory cards, and also how fast your camera can process images.

There are actually dozens of different file formats in existence, but fortunately for those of us who would rather take pictures than make format choices, camera manufacturers have settled on just a few.

One of the main differences in types of image formats is that some use a technique called compression to shrink images when they save them and others do not. Most of the time you will be using a format with compression. The ability to compress images is important because, as you might guess, photographs create relatively huge digital files. Compression works kind of like a garbage compactor (not that your photos are garbage, of course) and squeezes the files down to a smaller size. It provides a number of important benefits, not the least of which is speed: smaller files are faster for your camera to process and much faster to move from your camera to your computer (and also, of course, from computer to computer via email or the Internet). An equally significant advantage is storage: by making the files smaller you can fit more of them onto your memory cards and also onto your computer's hard drive.

When it comes to choosing file formats and compression, ask yourself this simple question: What is the ultimate use of this photo? If you're using your pictures exclusively for email or posting on the web, you can use much smaller files and fit more images on your memory card.

But, if you're planning to make prints the size of the shot at left (approximately 6 x 9-inches), you'll need to record substantially larger files.

Far and away the most widely used file format is called **JPEG** (pronounced "jay peg"), and it was, as every computer book on the planet will tell you, named after the Joint Photographic Experts Group that developed it. JPEG can greatly shrink the size of digital files (up to 90%) but in doing so it reduces image quality because it throws away image data. Thus it is known as a lossy format. How much data (and image quality) is lost depends on how much you compress the files. At the highest quality setting, loss of data won't noticeably affect image quality, even though the file is compressed 3X or 4X. At your camera's lowest quality JPEG setting (greatest compression), loss of data is great, and loss of image quality is noticeable.

To shrink file size, the JPEG compression algorithm discards redundant color and brightness information from the image data. Most cameras offer a choice of JPEG quality levels, typically referred to as *high, medium and low,* or sometimes by proprietary designations such as Olympus' SHQ (super high quality), HQ (high quality) or SQ (standard quality). However they refer to them, what they are really referring to is: good, better, best. The key thing to remember in selecting a quality level is that image quality goes down as compression level goes up. Generally you would use the low quality setting (the highest compression) for images intended for web use or email, and the medium

and high quality settings for making prints. The "better" selection is fine for general-purpose photography and will yield excellent snapshots and good enlargements. But unless you're desperate for picture space on your memory card, make it a practice to use the best setting as often as possible.

Finally, while some manufacturers marry image quality and pixel resolution, many cameras offer a choice of JPEG quality settings within a particular pixel resolution setting—which can get terribly confusing when you first begin using a digital camera. So at each pixel resolution, you can still choose a JPEG quality of good, better or best. Ultimately both decisions rest with what you want to do with your images. I would suggest you choose the highest pixel resolution and the highest quality JPEG setting for most of your shooting, but especially for enlargements, and using lesser settings when you only need to email pictures or make snapshot-sized prints.

Below
If you open a JPEG file on the computer and work on it, you should save it as a TIFF file or in the application's native format. That's because each time you open and resave a JPEG file in the JPEG format you throw out more data, further reducing the image quality (below, right). Do this three or four times and your picture will indeed look poor. However, if you simply open the file and do not work on it, you can close the file without saving any changes. This effectively leaves it in its original state as it came from the camera and maintains its small file size and the quality set during capture.

Original JPEG image.

The same image, opened and resaved as a JPEG multiple times.

TIFF AND RAW

Capacity for CompactFlash cards has grown tremendously in recent months and cards of 1 gigabyte and larger are common. This 8 gigabyte card from Lexar Media (which has a speed rating of 80X) can hold literally thousands of high resolution photographs—you could probably shoot an entire vacation trip on a single card.

There are two other file formats you should know about: **TIFF and RAW.** TIFF (Tagged Image File Format) provides extremely high image quality because it does not use compression. It also provides extremely large files (roughly 15 megabytes vs. about 2 megabytes for a high quality JPEG from the same 5-megapixel camera). TIFF images gobble up a memory card very quickly—a 256-megabyte CompactFlash card, for example, will record only about seventeen 15-megabyte images. Because of their big size, TIFF images are also painfully slow for your camera to record—taking several seconds for the camera to process a single image; during that time you won't be able to take pictures. Maybe some people like watching the little red light flicker on the back of their camera as it processes images, but it makes me nuts.

TIFF File Format

Why would anyone use TIFF as a camera file format? Quality. TIFF is called a lossless format, because, unlike JPEG, no data is lost. So if you're out driving someday and a brilliant double-rainbow happens to appear in the sky and you're thinking this would make a great poster-sized enlargement for your den—shoot TIFF if your camera offers it. But for everyday picture taking, save yourself time, money and memory space by using the high-quality JPEG setting—and your rainbow shot will still look awesome.

RAW: the Superman of File Formats

But wait just one moment. You may own one of the cameras that offer the most powerful of all file formats: the RAW file format. It is the Superman of file formats. And for that once-in-a-lifetime rainbow, the RAW file format would be even better than the TIFF. In virtually all other file formats, including TIFF, your camera does some degree of image processing (adjusting color and contrast, for example). Not with the RAW format. The RAW format records images exactly as they were seen by the camera and makes no adjustments. The RAW format is often called a "digital negative" because it is the pure digital image to which little camera processing

has been applied. Practically, this means that the camera has not applied sharpening, color or exposure correction, or white balance. You get to do all that when you open up the RAW file on your computer. If you shoot an image in the RAW format and decide later that you had the wrong ISO set on your camera, you can actually go back into the image and reset the ISO speed. It's almost like traveling back in time to undo your mistakes—if only there was a RAW format for my stock transactions.

About 1/3 the size of a TIFF file from the same camera, a RAW file is still quite large—about 6 MB for a 6-megapixel camera. Because no standards exist for the RAW format, you must open images taken in that format with an image-editor capable of translating that type of RAW file (such as Adobe Photoshop with a manufacturer's RAW plug-in) or with the camera maker's own software.

So which format should you use on a regular basis? For most purposes, the highest quality JPEG setting on your camera will provide exceptional quality images, let you shoot quickly, and enable you to store dozens of pictures on your memory card. If you were to make a side-by-side comparison of 11 x 14 prints made from highest quality JPEG and RAW pictures files (throw in a TIFF file if you want), you couldn't tell the difference. However, if you come across a once-in-a lifetime scene, are faced with a difficult exposure, or are simply a perfectionist (or mistake prone), then the use the RAW format. But stock up on lots of memory cards so you can store its large files.

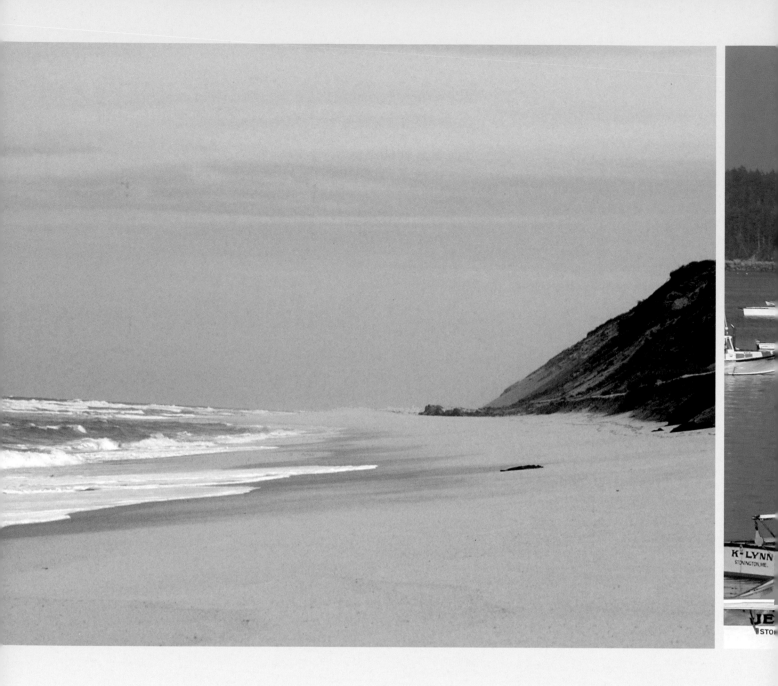

Once you've got the basic features down, try experimenting with one new control each time you use the camera.

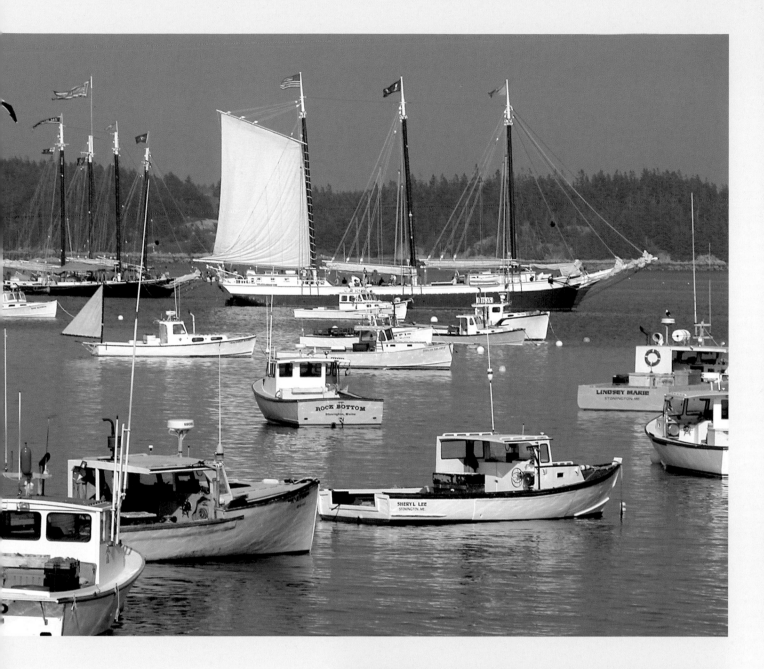

Tip

The self-timer is useful with both macro (close-up) lenses and long telephotos where getting blurred pictures from camera vibration is a danger.

One of the great luxuries of owning a digital camera is that you no longer have to grapple with the insidious issue of choosing a film speed—well, not entirely anyway. No longer do you have to stand flat-footed at the film counter pondering the eternal question: "What speed film should I buy?" You do, however, still have to consider the issue of light sensitivity and ISO speeds as they apply to your digital camera's light sensor. To understand these numbers, we have to jaunt back into the film world.

All photographic films are given a rating known as an ISO number (ISO stands for the International Standards Organization) that reflects their relative sensitivity to light—the higher the number the more sensitive the film is to light. Films that are more sensitive to light (and have a higher ISO number and) are referred to as faster. Films less sensitive to light have a lower ISO number and are referred to as slower. A film with a rating of ISO 200, for example, is faster (twice as fast, in fact) than a film rated at ISO 100. The advantage of having a variety of film speeds is that you can match your film to the amount of available light. The brighter the light is, the slower the ISO you can work with and, conversely, when the light gets dimmer, you can switch to a faster speed (higher ISO) film. Typically films with a lower ISO produce better quality images (they have less film grain) than those with a faster ISO.

Now back to digital. Virtually all digital cameras have a variable sensitivity ISO setting that can increase or decrease the sensor's response to light. And in an effort to bridge the technological leap from film to

Many cameras have a self-adjusting ISO setting that increases in dim lighting. The splendid interior of the San Xavier del Bac mission south of Tucson, Arizona was so full of beautiful detail, however, that I set the ISO at 100 for maximum image quality and use a very long two-second exposure. The camera was on a monopod and held tightly against a pew for steadiness— sometimes you just have to improvise.

digital, digital camera manufacturers have kept the exact same sensitivity and numbering system as used for film cameras. When your digital camera is set to ISO 100, therefore, your camera responds to light as an ISO 100 film would respond.

Most cameras have a default setting of ISO 100. From the moment you first take the camera out of the box, that setting is already programmed into the camera. Many digital cameras also have a self-adjusting ISO setting, and the light sensitivity setting changes automatically as the camera detects changing light levels.

With cameras that don't have this feature, unless you intentionally alter the ISO setting (using your camera's menu system), you'll be shooting at the default setting. Quality-wise, leaving your camera set at ISO 100 will provide the best picture quality. A few cameras also have ISO settings lower than ISO 100, but the quality difference of shooting below ISO 100 is probably negligible to the average photographer.

There will be times, though, when daylight is too dim, or when you decide to take pictures indoors without flash, and you'll want to increase your sensor's ISO setting. Unlike films, however, many digital cameras have a much more limited range of available ISO settings—typically ranging from ISO 100 to ISO 800 (though some SLRs and professional models have even higher settings). As with films, though, using higher ISO settings begins to degrade the image quality by adding a somewhat grainy pattern called digital noise to your images. Noise is similar in appearance to the grain patterns that you get from using faster films, and while it's usually not a devastating defect, it is detectable.

Unless you're really desperate for a faster ISO setting (if you're shooting indoors by available light, for instance), you're better off sticking with the camera's ISO 100 setting—particularly if you plan to

Often when you're shooting indoors by available light, as in this shot of the late blues harmonica great Junior Wells, you'll find yourself desperate for a higher ISO setting. Otherwise you're better off sticking with your camera's ISO 100 setting for maximum image quality.

make substantial enlargements from your files. When the light gets dim, however, if your subject isn't moving, you can use a tripod and make longer exposures; or, if you happen to own a digital SLR, you can switch to a faster aperture lens. If your only opportunity to get a picture is by switching to a faster ISO, give it a chance—after all, you're not wasting any film. Better yet, test different ISO settings before you get into a crucial shooting situation and you'll know what to expect.

Finally, if you're only posting pictures on the web the noise produced by faster ISO speeds really isn't that much of an issue—but you will still see some quality difference as you go higher in speed.

As magical as taking pictures with a digital camera seems at times, you're still working with a camera and you still have to pay attention to some basic camera-handling techniques. If you've ever watched professional photographers work, you've no doubt seen how methodically and carefully they approach each picture—and how natural the camera seems in their hands. They've developed a system of good work habits that ensures that every picture will have the same high quality. You should develop the same good habits.

HOLD THE CAMERA STEADY

Finding a comfortable and steady stance is important for getting sharp pictures—there's no sense paying for a camera capable of great resolution and then shaking the sharpness out. If your pictures continually seem to have a bad case of the jitters or just lack the crisp focus you expect from a good camera, it's probably because *you* are giving your camera the shakes.

Holding a camera sometimes feels like holding a baby for the first time—it's small and delicate, and there aren't many good handholds. A camera, though, is a lot more rugged (and a lot less wiggly) than a baby, so don't be afraid to hang on tightly—being sure to keep your fingers clear of the lens, the flash and the metering window.

One interesting thing that has happened since the introduction of the digital camera is that an entirely new picture-taking stance has evolved—I call it the digital gaze. In the pre-digital days holding a camera meant pressing the camera to your forehead and squinting into a tiny viewfinder window—a posture that actually provided some stability to the camera. Today framing a picture often means holding the camera a foot or more from your face and using an intent stare (the gaze) to compose the image on the camera's LCD screen. And it seems to work for a lot of people. Still, by planting your left elbow against your body and spreading your feet a bit you'll keep the camera much more steady. You might also find it helpful to lean your body against a tree or to rest your elbows on a nearby fence rail or car hood.

You should be able to safely handhold a camera at shutter speeds of 1/125 second or faster but anything slower is getting onto shaky ground—particularly with telephoto or close-up subjects. And that brings up the subject of tripods…

USE A TRIPOD

If I were asked what one thing you could do to improve all of your photographs, my answer would be simple: use a tripod. Most digital cameras—both compact and SLR models—are capable of shooting at shutter speeds slower than should be handheld. By using a tripod you extend the range of useable slow shutter speeds into full seconds or even minutes and hours (for nighttime skyline shots, for example). The introduction of vibration-reducing lenses from both Canon and Nikon have raised (or I should say lowered) the bar for the minimum shutter speed at which you can get a sharp picture—but a tripod makes all shutter speeds available to you with equally sharp results.

Besides providing a steady platform, a tripod allows you to be more precise when it comes to composition; you're much less likely to get tilted horizons and errant foreground objects if you take the few minutes needed to use a tripod. Tripods also give you more latitude with exposure combinations—enabling you to use a small aperture and a long shutter speed to enhance depth of field, for instance—and to use longer shutter speeds to creatively blur motion.

Most importantly, tripods force you to slow down and consider your decisions; after all, you've spent all day looking for a good picture, why rush the shooting to save five minutes?

A monopod is a one-legged support that can save the day when the light starts to fail and you're in situation when a tripod would be inappropriate. A lot of public gardens and zoos, for instance, won't allow a tripod but will let you shoot with a monopod. It's not as steady as a tripod, but it enables you to safely shoot at shutter speeds far lower than you could handhold.

FOCUS CAREFULLY

Most compact digital cameras focus so quickly and accurately we barely notice it happening. It's important though to pay attention to *what* your camera is focusing on—or you may end up getting a sharp picture of a tree in the background and turning your kids posing in the foreground into an unsightly blob.

Your camera will focus on whatever is behind the focus indicators in the viewfinder or LCD panel. The focus indicators are usually small brackets in the center of the viewfinder. If your main subject (a person, for instance) is off to one side of the frame, the camera will focus past your subject and lock in on whatever is in the background—or in the foreground if there is a nearby object in the center of the frame. Some manufacturers use a series of focus indicators in the viewfinder and the camera automatically detects what it *thinks* is the main subject and shifts focus to that area. Both my Nikon Coolpix 5700 and my Canon EOS Digital Rebel have a variation of this feature, and I find it flawless a very high percentage of the time.

But regardless of whether your camera has one or several focus indicators, most digital cameras have a focus lock feature (which may or may not be married to the camera's metering system) that also enables you to focus on an off-center subject. Once you've focused, you press the lock and reframe the scene; the focus will remained locked until you press the shutter or release the lock. Focus lock can be particularly good with close-ups where you want to focus on a particular subject plane and prevent the autofocus from wandering.

Focus lock is more than a fail-safe system for getting sharp focus, though—it can be used as a creative tool to prevent you from nailing all of your subjects to an imaginary target in the center of your viewfinder. The freedom to move your main subject off-center means that you can place emphasis on a particular area of your scene by selecting it to get the sharpest focus. If you combine careful focusing with selective focus, you can lead viewers right to the important part of the frame.

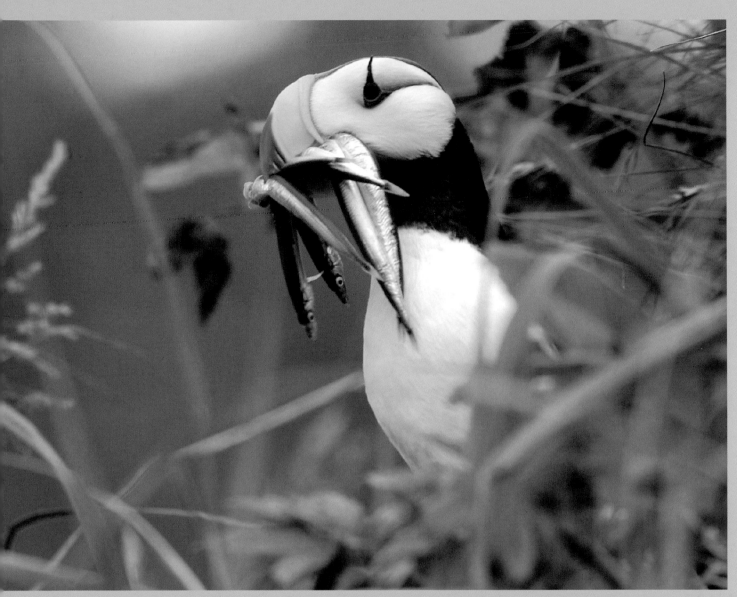

If you combine careful focusing
with selective focus, you can lead
viewers right to the important part
of the frame.

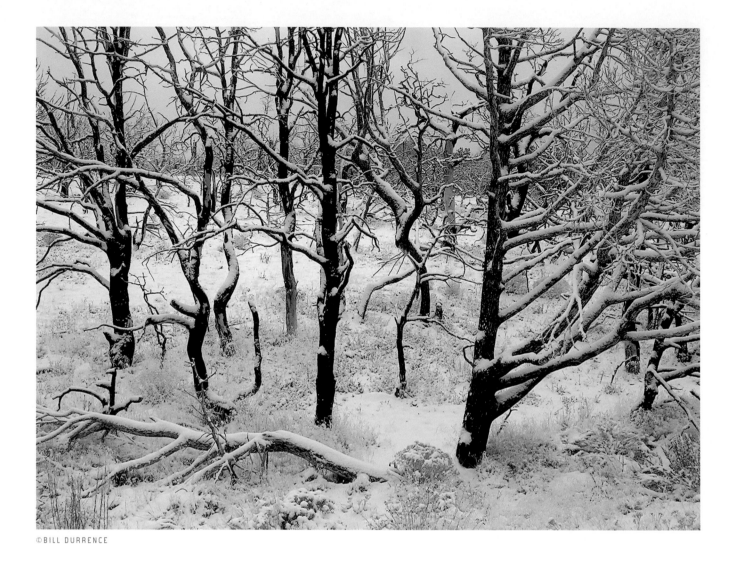

©BILL DURRENCE

If you're shooting in cold weather, keep your main and backup batteries in an interior pocket (under a parka) and load up only when you're about to shoot.

BATTERY MANAGEMENT

Gone are the days when you could put a battery in your camera and forget about it for a year or more—or until the bottom of your camera started to corrode and you found a puddle of battery acid on your closet floor. Digital cameras drink up battery power like a thirsty sailor and when they run out, all you have is an expensive reminder that you should have bought more batteries. Even a brand new battery will run down in a few hours in a digital camera and, unless you commit to using rechargeable batteries, single-use (throw-away) batteries will become an expensive vice—and fast.

Most digital cameras come with a battery charger and one rechargeable battery to get you started, but the per-charge life of a rechargeable battery may be only a few hours, so having a few on hand is a good idea. How long the charge will last depends on several factors, including how good your camera is at managing power, how many camera features you're using and the ambient temperature. If you zoom around a lot looking at potential subjects and like to use the LCD more than an optical finder, your battery power will go much faster.

Most cameras do operate with standard disposable batteries, of course, but they're very expensive to be tossing away. Unless you own stock in a battery company and are trying to see profits grow, it's a good idea to be conservative with battery usage.

TIPS FOR GETTING THE MOST FROM YOUR BATTERIES

1 > Use the right battery. Your manual will tell you what batteries are safe to use; you risk damaging your camera if you use the wrong type.

2 > Keep batteries freshly charged. If it's been a few weeks since you've shot any pictures, test the battery the night before you plan to use it and recharge if necessary. If your batteries can safely be charged in a trickle charger you might want to keep a spare battery constantly charging (just don't forget to pack it in your bag when you go out to shoot pictures).

3 > Beware of memory build up. This is mostly a problem with NiCd type batteries and not the NiMH batteries that many digital cameras use. NiCd batteries will retain a "memory" and if not allowed to go completely dead or completely discharged prior to charging they won't be able to recharge fully. Read the information that came with your battery to see if discharging is required (or safe).

4 > Use your LCD sparingly. LCD panels gobble up a lot of battery power If your camera provides both an optical and an LCD viewfinder, try to use the optical finder as much as possible. Some cameras, of course, only have an LCD, so it's a moot point.

5 > Review pictures sparingly. Even though one of the main draws of digital cameras is the ability to instantly review and/or delete pictures, using the LCD to constantly review pictures drains batteries quickly.

6 > Don't play between shots. It's tempting when you're walking around with a camera to point it at everything that looks interesting and zoom in and out to test compositions, but such behavior will drain the batteries. As much as possible try to shut the camera down between shots and, Wayne's World" aside, avoid unnecessary zooms.

7 > Protect batteries from the cold. Extremely cold temperatures drain batteries quickly and can sap all battery power. If you're shooting in cold weather, keep your main and backup batteries in an interior pocket (under a parka) and load up only when you're about to shoot.

8 > Store fully charged batteries in the freezer. Cold is only bad for batteries when they're actually being used because it interferes with the internal chemical reaction that creates power. Charged batteries that aren't being used will hold their charge longer if frozen but you must give them time to warm up before using them.

9 > Keep spares handy. Even if you have to spring for a single-use battery as a backup, stashing an extra battery in your camera bag could save the day. Lithium batteries, in particular, have a long shelf life and provide a tremendous amount of power. Of course, it kills me to toss $15 in the garbage when they're used up but it's better than not getting the picture.

Pity the poor photographers (myself included) who started taking pictures back when a light meter was something you strung around your neck on a strap and you practically had to press it into the face of your subject to get a good light reading. Today light meters are built into all cameras and metering happens the instant you tap the shutter release button. It happens so effortlessly, in fact, that sometimes we forget it's still an important part of the picture-taking process.

What a light meter does, of course, is measure the amount of light reflecting from a particular scene. It doesn't care what color the light is, what its source is or how provocative it makes your subject look—it simply wants to know one thing: How much light is there? That information is fed into the exposure system and your camera sets (or suggests) a good exposure. And most of the time the exposure is darn accurate, even in complex situations.

Good as it is, though, your camera's light meter is most reliable when you're photographing subjects of average reflectance in an average amount of light coming mainly front the front of the subject. In other words, you won't have any trouble getting a good exposure for kids playing on the backyard swings on a sunny afternoon. But once you dip your toes into the waters beyond the realm of average subjects or lighting, your camera's meter can get all wet in a hurry. So knowing how a meter works can come in handy.

Multi-Segment Metering

Virtually all digital cameras use matrix or evaluative metering as the default means of measuring light. Using algorithms that would make a high school algebra student's eyes spin, matrix meters measure and compare the light from a set pattern of segments of a scene. The camera compares the brightness of each segment to thousands of exposure examples stored in its memory. Some sophisticated SLR cameras even use subject distance and size information supplied by the autofocus system to help the metering system determine a good exposure.

When a matrix meter sees an area of brightness toward the top of the frame, for instance, it makes an educated guess that you're outdoors and that the bright area is the sky. A good guess, usually. It assumes that the foreground is the more important subject matter and it gives preference to setting exposure for that area. The system works breathtakingly well—most of the time.

But what happens when the important part of your scene occupies only a tiny part of your composition? Let's assume you've gotten very creative and you're shooting a portrait of a fair-skinned, platinum-haired person in front of a moderately dark background (the side of a deep red barn, for instance); the meter may do a fine job of exposing the background but your subject might be considerably overexposed.

Center-Weighted Meters

Once again, technology comes to the rescue. To help you cope with small but important subject areas, many cameras offer alternative light-metering modes. Center-weighted meters, for instance, measure only the light from a small area in the center of the viewfinder, typically an area that represents about 25% (depending on the focal length of the lens you're using) of the entire scene. Switching to this mode is useful when the center part of your scene is important—for instance, a lone sunlit sunflower standing in front of a deeply shaded background.

The concept of center-weighted metering, of course, assumes that you want your main subject in the center of the frame—which is rarely the most interesting place to put a subject.

To get both the exposure and composition you want, use the camera's exposure-lock feature to set and hold the meter reading, and then recompose the scene.

Spot Meters

Spot meters are a refined version of center-weighted meters; they measure an even smaller area of the viewfinder—often a tiny circle as small as 3% of the viewfinder. Spot metering is a very accurate method of measuring light because it enables you to read from an extremely precise area—or to read small areas from great distances. Using a spot meter takes patience and experience. You have to determine the correct target to measure and then you have to "hit" that target when you take a meter reading. Choosing the wrong target or missing it can create a poor exposure.

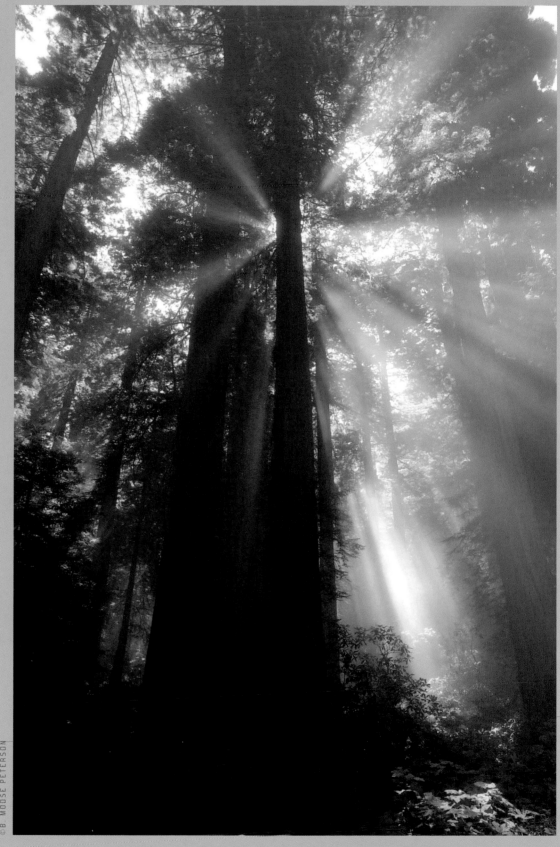

Shutter speed affects the degree to which subjects will appear frozen or blurred. Aperture size affects depth of field: the front-to-back sharpness in a picture.

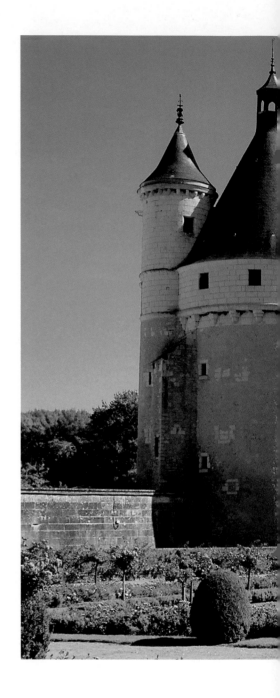

Taking Great Digital Pictures >
Exposure and Exposure Modes:

Human vision has an amazing ability to make all scenes seem like they have just the right amount of brightness. Even though we may perceive some scenes as dim (the gloomy innards of a trendy restaurant) or exceedingly bright (high noon in the mall parking lot), our brain ratchets the light levels up or down so that we can see details and colors in both shadows and highlights. It's a great system and one that keeps us from tripping over waiters in the restaurant and playing bumper cars in the parking lot.

Digital cameras, on the other hand, rely on a sophisticated battery of electronic gizmos to capture acceptable exposures and for the most part they do an exceptional job. Even in relatively tricky situations, such as backlighting or dim light, they are able to record detail in both highlight and shadow regions with a fair amount of accuracy. When you combine this with the ability of image-editing programs to fine-tune exposure, technology has largely chased away the bugaboo of bad exposure that haunted so many of us with film photography.

The two controls that determine exposure are shutter speed and aperture. The shutter speed (measured in fractions of a second for normal exposures) determines how long the camera's sensor will be exposed to light. The aperture (the opening in the lens that lets light into the camera) determines how intense the light will be. When your camera sets exposure automatically, it selects a combination of these two

controls. For any particular exposure, however, there are a number of combinations of shutter speed and aperture that will provide the exact same exposure. But while each of these exposures may be correct, the specific camera settings chosen will have a visible effect on certain aspects of your images.

BASIC EXPOSURE MODES

To give you control over exposure settings, many digital cameras offer a choice of several basic exposure modes, including:

Program Mode (P)
camera chooses both aperture and shutter speed

In this mode (sometimes referred to as Programmed AE or Programmed Autoexposure) the camera chooses both aperture and shutter speed. The exposure is not biased for either shutter speed or aperture, but the camera will typically select a shutter speed that is safe for handholding (provided there's enough ambient light) and a corresponding aperture. Program mode is fine for shooting ordinary subjects in bright light (your dog napping on the front lawn) where an extreme shutter speed or aperture is not required.

A souped-up version of the Program mode is the **Program Shift mode.** With this mode, you can quickly shift through the series of reciprocal exposures to adapt quickly to a fast-breaking special situation. Imagine you're leisurely focusing on your benchwarmer offspring, when suddenly she leaps from the bench and dashes pell-mell down the field. You have an instant need for a fast shutter speed. Enter the Program Shift mode (let's say it's a sunny day), and you can instantly choose a fast shutter speed from these reciprocal exposure combinations (1/4000 second at f/2.8, 1/2000 second at f/4, 1/1000 second at f/5.6, 1/500 second at f/8) to freeze her action as she heads the ball.

Aperture-Priority Mode (Av or A)
you set the aperture / camera selects the shutter speed

In this mode, you select the aperture and the camera chooses a corresponding shutter speed. The advantage of selecting your own aperture is that you control depth of field. By selecting a larger aperture (f/4, for example) you can focus sharply on the main subject (a person, for instance) but toss the background totally out of focus. If you're shooting a landscape where you want as much as possible in sharp focus, you can select a very small aperture (f/22, for instance).

Many pros use aperture priority as their default mode, except when controlling motion is important. The reason is that unless your subject is moving, depth of field is usually the overriding creative concern. By leaving the camera in Aperture-Priority mode, you can manipulate depth of field and let the camera handle shutter speed.

Shutter-Priority Mode (Tv or S)
you set the shutter speed / camera selects the aperture

In this mode you select shutter speed and the camera selects the aperture. Use this mode any time that motion is an inherent part of your subject. If you're trying to blur the water of a rushing river, for instance, you can select a relatively long shutter speed of 1/2 second or more and the camera will choose a corresponding aperture. If your subject is moving—a high jumper at a track and field meet or a three-year-old on the backyard swing—you can choose a fast shutter speed (perhaps 1/500 second) to freeze the motion.

Manual Exposure Mode (M)
you select both the shutter speed and the aperture

In the Manual mode you set both aperture and shutter speed using the camera's exposure meter (or a separate handheld meter) as a guide. The benefit of manual exposure is that you can override the camera's settings when you believe it's being misled by the subject (a very dark or very bright subject, for example) or when you want to depart radically from the recommended exposure for creative effect.

Exposure Tips

I often switch to Manual mode when photographing stage events indoors because the contrast between the brightly lit performers and the black background often fools even the best meters. By switching to Manual and then using the camera's spot-metering mode, I set exposure from a reading taken from an important subject area such as a performer's face or costume.

RECIPROCAL EXPOSURE SETTINGS

Your camera produces the exact same exposure for any number of aperture and shutter speed settings because these two controls enjoy a reciprocal relationship. You can alter either the shutter speed or the aperture in either direction and, as long as you make an equivalent change in the other setting, the exposure will remain the same. It may sound complicated at first, but it's really a very logical and simple system—it's a concept Mr. Spock (or any other Vulcan) would just love.

One important thing to remember about exposure settings is that each time you alter either the aperture or the shutter speed by one stop, you either halve or double the light reaching your sensor. If you open the aperture from f/16 to f/11 (a one-stop increase in aperture size), for instance, you double the light. Conversely, if you change it from f/16 to f/22 (a one-stop smaller aperture opening), you halve the light hitting the digital sensor.

The exact same relationship exists with shutter speeds. Each time you slow the shutter by one stop (from 1/125 to 1/60 second, for instance) you double the light hitting the sensor. If you speed up the shutter speed by one stop, you halve the light.

Let's assume, for instance, that your camera's meter selects an exposure of 1/125 at f/11—a nice middle-of-the-road exposure setting. But let's say that your subject is a fast moving ice skater gliding down the ice and you know that you're going to need a shutter speed of 1/500 second to stop the action and get a sharp picture. If you increase the shutter speed by two stops (to 1/500 second) you'll be able to stop the action—but your image will be two-stops underexposed. If you now open the lens by two stops (from f/11 to f/5.6), however, your exposure (the amount of light the camera allows to reach the sensor) will remain exactly the same, except that you'll now have a sharper picture of your skater.

Remember, though, because you opened the lens two stops, you've lost considerable depth of field. In this example, however, the sacrifice would be worth it since throwing the background out of focus would emphasize the skater even more.

EXPOSING DIFFICULT SUBJECTS

One of the inherent problems you'll face in dealing with a light meter is interpreting tonalities—particularly extreme tones such as blacks and whites. Our eyes are constantly adjusting and modifying their interpretation of tonalities so that we see a more or less accurate rendition of subject tones—white sheep are white, black sheep are black and gray sheep are gray.

Meters on the other hand are calibrated to presume that the entire world is one lackluster shade of middle gray—about the color of a deeply overcast sky.

Since most scenes contain a generous mix of different tonalities, the metering system can provide accurate exposure information. Difficulties begin when your subject's brightness departs radically from the average tones that your meter is biased to record. In an effort to see all things equally, it will give the same exposure to a white swan as it will to a black cat—turning them both a medium shade of gray in your final image. You and your camera may bounce merrily along through a winter landscape anticipating getting a wonderful white snowfall for your holiday cards only to discover the snow has turned gray.

One solution is to use your exposure compensation feature to add or subtract light from the recommended exposure setting.

Above
In the case of a bright white swan, for example, you should add light using the "+ exposure" setting (typically about 1 stop) to the recommended exposure so the swan appears white and not gray.

Conversely, if you're photographing a close-up of your black lab's soulful face, you should subtract light (again, you might try with one stop at first) to give the fur its rich black tones and not washed out gray ones.

Determining the actual amount of compensation is a matter of experimentation and experience because meters and subjects are all different. Of course, a lot of exposure compensation can be performed using your image-editing software and the levels or brightness controls, but it sure is nice to open an image right out of the camera and have it be exposed perfectly.

Left
The delicate white petals of this cereus plant (which always remind me of swan feathers) presented a particularly difficult exposure challenge: Not only is the entire blossom white, but it is a night-flowering plant. The plant only blooms for one night a year and the blossoms (which are the size of dinner plates) fade by dawn.

I initially tried using the camera's built-in flash to illuminate the flowers, and a −2 stop exposure compensation to keep the highlights from blowing out. But, the direct flash was kind of boring so I supplemented it with light from a pair of ordinary flashlights— one placed behind the blossom for backlighting and one placed to the side to create random highlights.

Right
Dappled sunlight can be a tricky exposure subject because you have a pattern of competing highlights and shadows. If you expose to get good detail in the shadows, the highlights blow out; if you expose for the highlights the shadows fade to black.

The solution? In this instance I took a center-weighted meter reading from the green leaves—a good average subject—and used the camera's exposure lock feature to hold that exposure while I recomposed the scene. Even so, I used the Levels tool in Photoshop Elements to bring down the highlights a touch while keeping the shadows open.

Although you seldom notice it, your eyes continually adjust focus to make everything—whether near or far—appear to be fairly sharp. A camera lens, however, can focus on only one thing at a time. If you focus your camera lens on a bottle of milk sitting on the kitchen counter, for example, it can focus sharply only on that bottle. There is, however, an area in front of and behind the bottle that is *acceptably sharp* and that zone is called the depth of field.

The depth of field in any given photograph can range from just a few millimeters in a close-up photograph of a flower, for instance, to great distances—even miles—in a landscape shot. Depth of field is not like the edge of the earth; foreground and background details gradually soften as they get farther from the point of sharp focus. Remember, we are talking about acceptable sharpness.

By manipulating depth of field and, therefore, sharpness, you can emphasize and subordinate subjects in a scene. It is a primary creative control. By focusing carefully on the eyes in a head-and-shoulders portrait and intentionally keeping the depth of field shallow, for example, you direct attention to the eyes. By maximizing depth of field in a landscape shot, on the other hand, you emphasize the great distances involved by simulating how our eyes would view a scene. You can, of course, shoot a landscape with a very limited depth of field and, in fact, that's a great method for focusing viewer attention on just one part of the picture.

The Three Keys to Depth of Field

1 Focal length

Focal length has a great effect on depth of field, and the shorter the focal length (the wider the lens) the more inherent depth of field it provides. A wide-angle lens, equal to a 28mm lens in 35mm photography, has much more depth of field at a given aperture than a 100mm medium-telephoto lens. When maximizing depth of field is important to an image, zoom to a wider focal length (or switch lenses with an SLR) to provide more depth of field.

2 Aperture size

The smaller the aperture (the higher the number), the greater the depth of field regardless of the focal length of the lens. If you want to increase the range of sharp focus then, you can switch to an Aperture-Priority mode and choose the smallest aperture available for the existing light. Conversely if you want to limit the depth of field to isolate a single rose in a garden shot you can select a larger aperture. The ability to set a specific aperture can be critical. When buying a camera, try to choose one that offers one an Aperture-Priority mode.

3 Your distance from the subject

Assuming you're using the same focal length and aperture, the farther you are from your subject the greater the depth of field in the picture. As you move closer to a subject, depth of field decreases. Keep in mind that as you change your relative position to your subject the scene's perspective also changes — something that does not happen by merely changing focal lengths.

Because of the magnification involved, depth of field decreases very noticeably in close-up photography and, depending on focal length and aperture, you may be limited to having just fractions of an inch in sharp focus. Similarly, depth of field diminishes quickly as focal lengths get longer.

With most compact zoom cameras it's tough if not impossible to visualize just how great or how shallow the depth of field will be, so it's largely a matter of experience. Some digital SLR cameras have a depth-of-field preview button that lets you view the area of sharp focus in the viewfinder; but it's a feature typically found only on expensive professional cameras.

©BILL DURRENCE

By maximizing depth of field in a landscape shot, you emphasize the great distances involved by simulating how our eyes would view a scene.

A Shutter Speed Primer

Very few things that we photograph are absolutely still. People, pets, rivers, traffic and the stars in the night sky are all in constant motion. Some subjects, like landscapes, have very subtle movement in their fluttering leaves, waving grass or meandering streams. Others, like kids racing around a playground or ocean waves crashing to shore, have motion at their very cores. How you interpret motion in your photographs profoundly affects the creativity of your pictures. And the way in which you interpret motion is through the duration of the shutter speed.

Your camera's shutter opens and closes to let in just the right amount of light for a good exposure (in tandem with your aperture). Typically your camera will have a shutter speed range of several seconds to several thousandths of a second (1/2000 second is a common top speed—fast enough to stop a bullet). But, as we saw in the previous section on aperture, there is no one correct combination of shutter speed and aperture.

In Program mode your camera selects a shutter speed safe for handholding, with no consideration of subject motion and certainly no consideration for your creative intentions. Your camera has no way to know if you want to freeze the motion of your cat leaping after a moth or exaggerate it. Using your camera's Shutter-Priority mode, however, you can control precisely how long the shutter will be open—and just how sharply your cat will be recorded. Understanding how exposure times will affect different subjects will provide you with some terrific creative options.

The more extreme the shutter speed you choose, the more obvious the results of freezing or blurring motion will be. Using a shutter speed of 1/8000 second to record horses racing around a track, for instance, will freeze not only the horses' legs but every tiny clod of turf that kicks up around their hooves—perhaps even the droplets of sweat flying from the jockey's brow. An exposure of a half second, on the other hand, will turn the thundering herd into a motion-filled blur of colorful jockey silks and graceful equine shapes.

To see how time effects motion in a photograph, experiment with various shutter- and subject-speed combinations and study the results. Find a motion

subject you can control (like the bicycle wheel of an upturned bicycle) and photograph it using half a dozen different shutter speed settings. Take notes on the exposure times (or check the meta data for exact shutter speeds when you download the images) and you can compare their effects.

Other factors will influence just how motion is recorded, including subject direction (relative to the camera), your distance to the subject and the focal length of the lens you're using. The direction of motion is particularly important because you can enhance the movement of slowly moving subjects, or freeze the motion of quickly moving ones at slower shutter speeds, by altering your shooting position. Subjects moving toward or away from the camera are much easier to halt, for instance, than those moving side-to-side in front of you.

Because the size of the moving subject in the frame exaggerates the perception of motion, the closer you are (physically or optically) to your subjects, the more motion you'll capture. If you're trying to blur the movement of an ice skater spinning, for example, the more you fill the frame, the more apparent the motion will become. Similarly, if light is low and you're shooting at a slower shutter speed than you'd like, you can enhance the perception of sharpness by not working so closely.

Below
Remember that the subject doesn't have to be the only thing moving in your pictures—you can also put yourself in motion. In the photograph below, I was a passenger in a car driving down the Las Vegas Strip and shot a two-second exposure as we cruised past the neon signs. Viva ideas.

Sports and action subjects are the most obvious targets for playing with shutter-speed effects, but other action subjects can be equally enhanced: a spray of fireworks, colorful carnival rides, or the rush of a mountain stream. There's no way to predict the effect that different shutter speeds will have on motion, so it's entirely a matter of experimentation.

©DEREK DOEFFINGER

Shutter Lag

You're at the edge of the skating rink waiting for your daughter to leap into the air and execute her first-ever double axel jump. Just as she leaps from the ice and begins her thrilling rotation, you press the shutter button and…nothing happens. So you jam your finger harder into the shutter button and, a second too late, you hear the *kerflunk* of the shutter. There, in the LCD display, to your great dismay, is a lovely shot of an empty ice rink.

You've just experienced one of the few annoying qualities of digital cameras—a phenomena known as shutter lag.

Say what you will about film cameras (now that you're a digital convert), but one of the nice things about them is that when you press the shutter-release button an amazing thing happens: it takes the picture. Instantly. This is not always the case with digital cameras and it can be infuriating.

The delay in firing the shutter is caused by the series of procedures the camera has to follow in order to capture an image: turning on the internal processor, setting exposure, white balance, focusing and charging the flash. The problem is most noticeable when you're photographing action subjects, but in some cameras it can be annoying even with stationary subjects.

There are a few methods you can use to get an upper hand on shutter lag, including pre-focusing on the spot where you expect the action to occur by pressing the shutter release halfway down. It also helps to have a good sense of anticipation and some familiarity with the action itself.

A second type of lag that occurs with digital cameras is based on the time it takes your camera to store the image it has just recorded. Once the CCD has captured the image the camera needs time to process that image and move it to your memory card. This delay is often negligible if you're shooting in the JPEG format, but if you are shooting in a format—such as RAW or TIFF—that creates larger files, the delay can be considerable.

Shutter lag and processing lag is worse with some cameras than others and, as you might expect, both are much less pronounced (to the point of being almost nonexistent) in more expensive cameras and particularly with professional level SLRs. More sophisticated cameras, in fact, have a high-speed or multi-shot mode and are able to shoot several images in rapid succession with virtually no delay and then batch process them. Lag time is a problem that is being addressed by manufacturers and, no doubt, it will soon become a ghost of digital past.

Developing a Shooting Workflow

No one will ever accuse me of being an overly organized person (it looks as though it would take a team of Sherpas and a clairvoyant just to locate my car keys most of the time), but when it comes to taking pictures, I have learned that having a routine is of great value. I am somewhat like a robot when it comes to setting up and working with a camera—the routine rarely varies. Professional photographers use the term *workflow* to describe the progression of steps used in capturing and processing images—creating your own workflow (both before and after you shoot pictures) will make your life much easier.

A good shooting workflow should begin before you're actually taking pictures and shouldn't end until you've downloaded your images and printed a few favorites. Let's assume, for instance, that you're going to take a nice Sunday drive in the country looking for landscape pictures (or "cruisin' for snaps" as I like to call it). The more organized you are before you leave home, the more time you'll spend shooting pictures as opposed to fumbling with cameras and manuals.

Here is a typical workflow you might follow.

The night before your shoot...

1 Charge Batteries

Be sure to charge your batteries the night before you plan on shooting pictures. If you have several rechargeable batteries, it's a good idea to number them so that you can keep track of which ones are used up while you're shooting. I have a special section of my camera bag where I toss used batteries so I know without glancing that they're depleted.

2 Reformat Memory Cards

Once you've downloaded your pictures and have backed them up onto a CD or a secondary hard drive, reformat your memory cards. Reformatting erases the images you've already downloaded and readies the cards for your next shoot. If you fail to erase the previous shoot, you're not only wasting precious card space, but you'll also find yourself downloading images you've already downloaded. Trust your computer: download, backup and then reformat the cards.

3 Review Your Manual

Bringing your manual into the field is a great thing to do, but it's not always the best time to stop and review it. If you're planning on using a technique that's new or that you don't use often (like using the Close-up mode), take the time to review your manual and look over your camera controls. I often take notes for setting certain camera modes or menu routines on 3 x 5-inch cards so that I can refer to them quickly, particularly if it's a new camera or a feature I don't use often.

4 Clean Your Camera

Take a few moments to look over your camera the night before a shoot and, if necessary, use a microfibre cloth to clean filters, your LCD monitor, and optical viewfinders. Use a small can of compressed air to blow dust off of the front element of your lens; wipe the glass itself only when it absolutely needs it.

At your location...

1 Prepare Your Tripod

The minute I get into a shooting area I set my tripod to height and leave it extended the whole time I'm shooting. Outdoor lighting changes quickly and it's a shame to miss a picture while you're messing with a tripod.

2 Select a Quality Setting

Choose the resolution and file format settings based on what you plan to do with your images. For general shooting, choose the highest quality JPEG setting and the highest quality resolution setting if available on your camera. Periodically check the settings to be sure you haven't inadvertently changed them.

3 Select an Exposure Mode

Switching exposure modes is pretty simple, so you should always select a mode to match a specific subject. Be sure when you first start shooting that you know which mode you're in and how to get out of it.

4 Set the ISO

Choose the ISO to match shooting conditions. In bright daylight, use a lower ISO, such as 50 or 100. ISO greatly affects image quality, so a lower ISO gives better results, except in dim lighting when a slow shutter speed could lead to blurred pictures.

5 Set the White Balance

Set the white balance to the type of lighting you're in. If you will be shooting in mixed lighting (for example, an interior lit by both daylight and lamplight), use the auto white balance setting.

6 Recheck Battery Level

If you've been shooting with a rechargeable battery for more than an hour or two, check the battery power. Rechargeable batteries tend to die suddenly.

Back at home...

1 Download Your Images

I'm one of those photographers that tended to hang around the lab counter waiting for my prints in the old days, so I download immediately after a day of shooting. Then, using the iPhoto slide show feature on my Macintosh computer, I watch a slide show of my day's work. It's the most relaxing time of the day.

2 Organize Your Pictures

The minute you've looked them over, use your organizing software to give the pictures at least a blanket keyword name, such as "Vermont, Tractors" or "Volleyball, Beach." If photography is your hobby you'll have thousands of pictures in no time and adding keywords to them is vital if you ever hope to find them again.

3 Back Up Your Pictures

The minute you've looked at and organized your pictures, back them up. I back up my images in two ways:

on CD and on an external hard drive. Label the backups carefully. Backing up takes less than 10 minutes and it's a good feeling to know your images are safe.

4 Make a Few Prints

I can't resist making one or two prints at the end of the day. It's the reward you should give yourself for all of your hard work.

Later...

5 Display and share your pictures

The real joy of digital photography comes from letting others see your work, so pass your pictures around. Hang them up on the refrigerator, pop them into a desktop frame, email them to friends or post them to a website for the whole world to see.

"Photography is really a simple statement and the clearer it is the better."

—Eliot Elisofon

Design

1 Introduction

3

I grew up with a mother to whom the exact placement of a flower vase on a table was nearly a matter of national concern. There were times when she would leap up while reading a book to move a candlestick three-quarters of an inch and then go back to her reading knowing that *now* everything was right with the world. It's only natural then that I am sensitive to the arrangement of subjects within a picture.

As neuroses go, being a compulsive composer is probably a good thing because each small variation that you work into a photo's design can impact how your subjects are perceived. The graphic impact, the conceptual theme and the emotional content of your images all hang on your ability to cleverly arrange and display the various elements of your compositions. Each time you snap the shutter you are describing a unique moment in your life's journey, so it's important that you take the time to present your vision clearly.

Even the simplest of compositions—a flower vase on a table, for instance—can be composed in many different ways, and each offers its own distinct visual statement. By placing the vase far to the left of an

© DEREK DOEFFINGER

otherwise empty frame, you emphasize the sense of space to the right of it; by placing it dead center you emphasize symmetry. By cropping the vase tightly you remove it from its context, forcing the viewer to focus solely on the merits of the vase. And by cropping even further, you fragment the subject and offer the viewer a question about your intent.

There are many elements that go into the design of an image: organization, balance, depth, orientation (vertical, horizontal, or skewed), subject position, subject characterization—and even if you want your images designed at all.

These are the areas you must address each time you compose a photograph; the decisions you make help define you as both a photographer and a person.

Design > Artistic Arrangement:
RELEASING YOUR INNER ARTIST

The first step in designing an image is deciding where to put everything. A photograph is a lot like an overfilled closet—a lot of stuff seems to sneak in there when you're not looking. It's your job to decide which stuff gets to stay and which stuff to toss out—and to arrange what remains so that the design you choose seems intentional rather than happenstance. You don't want strangers glancing into your visual closet and wondering what in the world you had in mind when you filled it. You want them to pause and admire the contents.

Where do you stand? That's the common question faced (or danced around) by politicians on a daily basis. Or, keeping to the political metaphor, should you even stand? Rolling over may not work well for photography, but lying down (biting my tongue here on further political metaphors) or kneeling can reveal a new perspective. For photogra-phers, where you position the camera in a scene is the primary determinant of how the design of a picture turns out.

Where you place the camera establishes the general organization of your composition. The relationships of size, scale and perspective, and the dominance that you give to one subject element over another, shift rapidly as you alter your position. As scenes grow more complex, your choice of viewpoint becomes even more critical because subjects quickly begin to overlap and hide (or reveal) one another with each shift of your position.

> Where you position the camera in a scene is the primary determinant of how the design of a picture turns out.

Even in simple scenes, small changes of camera position can drastically alter composition. Picture a harbor-side scene with a stack of lobster traps in the foreground, a fisherman standing on a dock in the middle area and a boat-filled harbor in the background. By shifting your viewpoint just a few feet horizontally, you either hide or reveal the fisherman. Or by choosing a low vantage point and moving closer to the fisherman, you make him the dominant element. Or by backing away or shooting from a higher vantage point, you cast him into a supporting role rather than the featured player.

Remember, too, that the vantage point you choose helps reveal and define the theme of a photograph. And like a film or a painting (or a greeting card illustration, for that matter) all of the elements of a photograph should play to the same theme. Image-editing programs aside, as a photographer you don't have the total freedom that painters enjoy in picking and choosing which elements to include and which to

discard. But by carefully choosing your vantage point (and your lens) you emphasize those elements that help carry the theme.

I often walk around a scene with the viewfinder to my eye, looking at the scene as if I were making a movie, waiting for the best organization to click into place. If I look at a scene and think it would make a great establishing shot for a film, then I know I've linked the main elements of the theme.

Keep in mind that while only a change in your physical position can truly alter perspective, you can modify the apparent perspective by changing to a different focal length lens. Using a wide-angle lens, for instance, elongates the distance between foreground and background subjects, while a longer focal length lens compresses space.

Also, the number of elements you decide to include in a composition is another aspect of organization. As they say in political-activism circles (or at least they used to say it in the 1960s), you're either part of the solution or you're part of the problem. The same goes for those objects that you choose to include in your image: either they strengthen it or they dilute it.

Whether you choose to include many elements or just a select few, organizing them into a cohesive and powerful arrange-

ment is perhaps the toughest compositional challenge you'll face. And no doubt one night your kids will see you get up from a good book to walk across the room

and inch a knick-knack across the mantle to a better position. They'll know instantly, of course, that you've been thinking about photography again.

LET CHAOS REIGN

Without discounting all of those nice thoughts about careful organization and obsessive order, there are times when it's worth implementing "Plan B": let the chaos of the moment take over. Often tossing aside your preconceptions of what a scene should look like is a good approach to unveiling the true nature of complex subjects. Instead of trying to get all your visual ducks marching in neat rows to your beat, let the madness of the moment invent its own design.

While it's possible to carefully craft an angle and a point of view that organizes a busy city street scene, that effort may not convey the mood and emotion of the location. Sometimes foregoing formal design and shooting from the hip (literally) is the best creative choice.

In the early 1960s a brave band of "street" photographers (led by great talents such as Joel Meyerowitz and Garry Winogrand) waded into the busy city streets of Manhattan with wide-angle lenses and equally wide-open minds. They were less concerned with traditional concepts of composition and design than with things like uncovering unexpected physical juxtapositions and capturing passionate—and absolutely spontaneous—glimpses of the human parade. Artfully dodging from pillar to post in an almost ballet like approach, they used their cameras to absorb the visual commotion of urban life.

As the street photographers discovered, amazing things can happen when you seek out the soulfulness of the moment. While I was shooting in New York's Times Square on a Halloween night and intentionally using one-second handheld exposures to capture the motion of the city lights, a person in a devil costume jumped out in front of me. I quickly snapped a shot of him as he waited for traffic—never having time to look through the viewfinder **(above)**. No amount of planning

could produce a shot like this and no composed shot would capture the frenetic mood so well. And you have to admit, there's something poetic about a devil watching over Times Square. At times, reflexes serve better than judgment.

You can apply the same technique to almost any subject—from a kids' birthday party to a Saturday morning dog wash. By using the swiveling feature on your LCD panel (if it's available), for example, you can hold the camera at very high or low angles to get a general sense of the composition and then just let the natural flow of the moment rule. To some of my friends' great annoyance, I'll often sit at a restaurant table and, with the lens set to its widest focal length, hold the camera overhead and shoot pictures around the table without glancing at the viewfinder. The images are a bit offbeat looking and there are a lot of near misses (chopping friends' heads off is something they've come to expect from me), but the fun and informality of the compositions are really refreshing.

Of course, such a freeform approach to photographic composition does lead to a higher percentage of unusable images—but you may just make some great visual discoveries. Let your imagination go and let your camera go with it—after all, you're not wasting any film.

In the same way that a novel relies on a main character to pull your heartstrings and dampen your brow with trepidation, so, too your photographs need a leading player. Without one important element upon which viewers can hang their attention and invest their emotions, you're likely to create an uncertain—if not confusing—storyline. And the success of the "Seinfeld" ("it's a show about nothing") philosophy aside, your photographs should strive to be about something.

Creating a center of interest not only provides a visual focal point but if chosen carefully, it helps to punctuate the overall theme (there's that word again) of the image. If you're trying to show just how messy your kitchen table is on a Saturday afternoon, for instance, placing a half-eaten hotdog in the foreground provides a thematic center of interest, and the piles of dirty dishes and used napkins in the background reinforce the theme.

Even abstract subjects need a dominant visual element—an interesting intersection or combination of color, lighting, pattern, or just a break in the visual rhythm.

Interestingly, too, while the center of interest is often the destination where the eye lands, it also helps lure the eye into exploring the other aspects of the composition more carefully. In looking at a photograph of a lone cross-country skier tracking across a vast field of snow, for instance, the eye goes immediately to the skier, then returns to examine the overall context. Where did the skier come from? Is she heading toward the woods or coming out of them? Without the center of interest to grab your attention you might never give the setting more than a cursory glance.

In order to emphasize the center of interest, you first have to identify it. Sometimes that decision is easy: a butterfly lands on a nearby zinnia and becomes a great focal point for your garden photograph. In more complex scenes, like a landscape, you often have to hunt around to find one element dynamic enough to serve as the visual centerpiece. In a forest scene, for instance, you might find one tree that is lighter in color or tone than those around it, or one whose unusual shape breaks the pattern of the others.

Fortunately, finding a good center of interest is a bit like appreciating art: it's hard to describe what you're looking for but once you see it, you'll know it. One way to test a center of interest is to hold your hand up in front of you and block the center of interest from your view—if the scene seems diminished by its absence you've found a likely candidate.

Within a larger scene, small objects often become the most interesting subjects. When shooting detail shots, pay attention to the background and shift your position until it is right—this will often make the difference in whether or not the photo is successful.

©ROBERT GANZ

Finding ways to emphasize your main subject is an important consideration. On the following pages we'll look at some of the more common sales pitches:

©DEREK DOEFFINGER

1 Get closer

There is a reason that Hollywood invented the close-up (other than to suffer the vanity of leading actors). Filling the frame is a powerful and immediate device for directing someone's attention to the main subject. The minute the camera closes in on the gunslinger's belt, you know there's going to be some shooting—there's little doubt about what the director wants you to notice.

Moving closer—either physically or optically—isolates your subject and is like saying to the viewer, "This is what I want to show you."

2 Get farther away

Getting closer and making your center of interest larger is usually a good idea, but it's not always the solution. Sometimes giving your focal point a lot of space provides more dramatic and emotional emphasis. By including a lot of space around a lone beachcomber on a deserted beach, for instance, you heighten the feelings of solitude by showing the larger environment. The eye has no trouble finding the center of interest, rather it is drawn to it by the emptiness of the overall scene.

Design

Top—sunflower
A plain black background not only provides simplicity, it can also offer striking contrast. By exposing for the sunflower, the shadowed background area went completely black.

Above—barn
In addition, using a simple foreground such as the field of corn surrounding the barn can help to draw the viewer's attention to the subject.

3 Use a simple background

Placing your subject in front of a plain background eliminates any doubt about what your point of interest is, and it also makes for a cleaner-looking image. Finding a clutter-free background isn't always easy, but often a simple shift in your viewpoint will reveal one. By climbing up on a porch to photograph your kids running through the sprinkler, for example, you can eliminate things like the neighbor's clothesline or the pile of garden tools leaning against the fence (the ones you were supposed to put away yesterday) and isolate the kids against the lawn. Similarly, by kneeling to photograph kids you can isolate them against the sky or a row of tall shrubs.

4 Use selective focus

Another way to simplify and soften backgrounds is by restricting sharp focus to your main subject. Using a moderate telephoto lens or zoom setting with a wide-aperture enables you to restrict the range of sharp focus to just a few feet. Shallow depth of field is a particularly effective tool for shooting individual portraits. In the photo of the little girl blowing bubbles (above) I used an f/4 aperture setting and focused carefully on just her eyelashes. By tossing the back-ground totally out of focus your attention goes directly to the little girl and her bubble.

5 Use your computer skills

Of course, there are times when finding a simple background isn't possible or you just don't have time—which is where your post-production skills come in handy. By selectively adding a Gaussian blur to the background (above) you can isolate your subject even more than you can by restricting depth. For more on this technique see page 252.

6 Experiment with subject placement

For some odd reason we often take the term "center of interest" a bit too literally and feel obliged to put the main subject square in the center of the viewfinder, as if we were shooting it with a rifle instead of a lens. Dead center in the frame though is probably the worst of all choices because it surrounds your subject with equal amounts of space creating a stagnant composition. Instead, shift your main point of interest to the left or right of center, or slightly above or below the center of the frame to establish a more dynamic use of space and a more natural feeling of balance.

One of the reasons we tend to center the main point of interest is that the autofocus and light-metering indicators are in the center of the viewfinder and so we center the subject to get sharp focus and good exposure. You can do an end run around this, however, by pressing and holding your shutter-release button halfway down to lock both focus and exposure. You can then re-compose your image and still get a sharp, well-exposed picture.

7 Create a silhouette

Silhouettes command attention. They attract the eye. Why? Because of the stark contrast between your subject and its surroundings. They also reduce your subject to its purest shape.

In photographing the father and son shown here, I positioned them between the camera and the brilliant sun shimmering on the water so I could silhouette them. In reality I didn't have a long enough lens to isolate them entirely against the water and so wasn't able to completely crop out the horizon and the sun itself. I shot a dozen or so pictures anyway and then added a few inches of water and sun over the sky area by using the Clone tool in Photoshop. Creating the actual silhouette exposure was easy: I took a reading from the bright water area (without the sun reflection) and then exposed for that. I also enhanced the contrast and tweaked the color a bit in post-production.

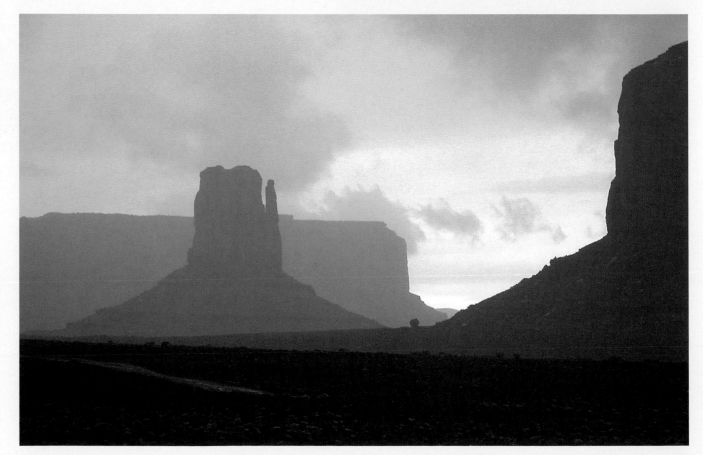

Design > Elements of Design:
CHOOSING A FORMAT

Because most digital cameras are designed to be comfortable when held horizontally, many photographers ignore the option of turning them on end to compose pictures vertically. And that is often a big mistake because frequently the best way to compose a photograph is to use the tall and narrow format of the vertical rather than the wide, low view of the horizontal.

If nothing else, tilting the camera vertically once in awhile gives your pictures some variety—particularly if you're placing them in albums. I'm always impressed when I look at someone's pictures and see a good mix of verticals and horizontals because I know they spent time examining their subjects and trying to give their pictures more visual and psychological impact. Having a mix of formats also livens up a website a great deal and gives you more design options.

Some subjects, of course, call out for a vertical framing—tall buildings, waterfalls and even tall basketball players. It's simply more natural to fit Shaquille O'Neal into a vertical frame than a horizontal one (unless you happen to catch him laying on a very long beach towel). By using the vertical format with very tall subjects you not only emphasize their height, but you also encourage the viewer to study and examine that height.

And by combining a vertical format with a wide-angle lens, you can use interesting foreground lines or patterns to lead the viewer deeper into the scene. If you're shooting a stream leading to a waterfall, for example, using a wide-angle lens and a vertical framing pulls the eye along the stream to its destination.

Certainly, too, many subjects are much more impressive when they are allowed the full and unrestrained width of the horizontal format. The wide blue sea, your wife's new Harley, and your teenage son

©DEREK DOEFFINGER

I'm always impressed when I look at someone's pictures and see a good mix of verticals and horizontals because I know they spent time examining their subjects and trying to give their pictures more visual and psychological impact.

asleep in a hammock are all great subjects for horizontal framing. Psychologists will no doubt tell you that the reason we instinctively frame things horizontally is because it creates the feeling of stability—as do floors, level horizons and (let's not forget) psychologists' couches.

Deciding which way to orient the camera is based on a variety of considerations. Since it doesn't cost any more to shoot it both ways with a digital camera, it's

worth experimenting with format—particularly with subjects that seem obviously destined for one format or the other.

Sometimes, too, you can catch viewers' attention by intentionally photographing a vertical subject horizontally and vice versa. By placing the subject in an unconventional framework you can startle and unsettle viewers. Challenging preconceptions is always a great thing for visual artists to attempt.

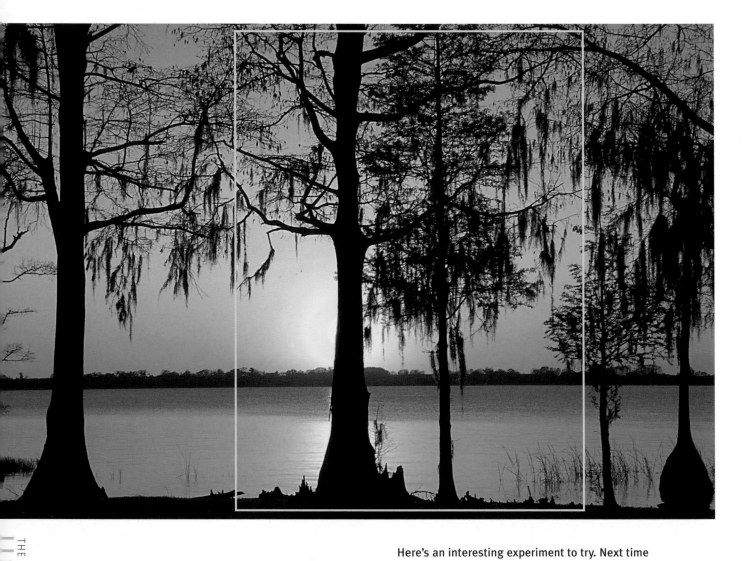

Here's an interesting experiment to try. Next time you're planning on going shooting, take a piece of cardboard (8 1/2 x 11-inches works well) and cut a 4 x 6-inch opening in the center. As you walk around looking for potential subjects, hold the card up at arms length and view your subject through the opening, held both vertically and horizontally. It's intriguing to see how differently the same subject looks when viewed in both formats—and it will help you to visualize how differently your prints will look later.

PLACING THE HORIZON

The horizon is kind of like the "heavy" in a Hollywood western: the minute it enters the frame it becomes a dominant character in any storyline. No matter how you dress up the rest of the frame with pretty dancehall ladies, there's that horizon, patiently laying low in the background—waiting for you to make your move: "Go ahead, design me—make my picture." Well, you get the point.

Whether you're photographing a Manhattan skyline, a wilderness landscape or a sunrise at the local beach, you'll use the horizon to define the spaces involved. The primary thing that the horizon tells us, of course, is where land ends and the sky begins. You can use that information not only to manipulate how the spaces in the photograph are perceived, but also to help emphasize your main subject in dramatic ways—which hopefully is what you want to do.

Imagine, for instance, that you're photographing a lone olive tree in a large open field in Tuscany (as long as we're fantasizing, we may as well make it inviting). What you have is a basic composition with just three main elements: foreground, tree and sky. Placing the horizon low in the frame heightens the isolation of the tree by diminishing its size in relationship to the sky. By placing the horizon high and aiming the lens down at the foreground, you exaggerate the distance between your vantage point and the tree, and emphasize its physical environment—the tree becomes punctuation for the landscape. With a simple tilt of the camera you've shifted the entire emphasis of the composition.

Sometimes an extremely low or high horizon can add just the drama a scene needs.

Design > Elements of Design:
PATTERNS AND REPETITION

Patterns are one of my favorite subjects to look for because it really doesn't matter what the subject itself is. If the pattern is strong, it will be visually interesting. Some patterns—like the lobster floats shown here—literally shout out to be photographed (above). I spotted them while driving through a tiny village in Maine and, worried something might disturb the pattern before I got there, I quite literally slammed on the brakes and went running off down a hill to make the picture. Later a little girl in the village told me that this sort of manic behavior was common among visiting photographers. Other patterns are subtle, or even somewhat hidden, and reveal themselves only to the very observant.

Patterns exist whenever any of the familiar elements of design—lines, shapes, colors, or textures—repeat themselves in an obvious way. Nature in partic-

ular is a boundless source of interesting patterns, but human-made creations are also rife with repetition. From the colorful diamonds and squares of patchwork quilts to the lines of a New Orleans wrought-iron balcony, we use patterns as a motif whenever we can.

Some patterns, like the stairs that you climb from your living room to your bedroom are obvious (not to mention useful) and others, like the pattern of spots on an insect, have to be sought out. Once you become aware of patterns though, they seem to pop up everywhere. And because they're so prevalent, it's great fun exploring for new ones.

You can use patterns to build compositions in many ways. By choosing the right vantage point, you can use them to direct attention to your main subject—letting newly tilled farm rows lead the eye to a distant farmhouse, for example. Or, if they're obvious and interesting enough, patterns can transcend a supporting role to swoop in and take over the leading role. In the shot of the chambered nautilus shown here **(at right)**, for instance, the pattern of spirals becomes the main subject.

The key to building a composition from a pattern is to isolate it from its surroundings—either by cropping tightly or by finding just the right angle to emphasize the repetition of elements. Anything that isn't a part of a pattern usually distracts from it, so be ruthless in excluding extraneous material.

By using a tunnel to frame the lamp in the scene above, photographer Doug Jensen has heightened the mysterious gothic mood of the scene.

Design > Elements of Design:

FOREGROUND FRAMES

Foreground frames help isolate and focus attention on your center of interest. Chosen carefully, they can also reinforce a visual theme.

Frames also have a functional use because they can hide extraneous background material. One decision you'll face in using foreground frames, however, is whether to keep the frame in or out of focus. By using a relatively wide lens and a small aperture, for instance, you can get enough depth of field to bring both into sharp focus. By using a longer lens or a wide aperture you can toss the frame out of focus to further emphasize your main subject.

In the classic example of a tree branch being used to frame a landscape or travel scene, an out-of-focus branch will enhance the feeling of distance between it and the rest of the scene—but it can also be a distraction. In general, having both parts of the scene sharp is less distracting than a totally unfocused framing device.

As a rule (and rules, as you know, were meant to be broken) you should also try to choose a frame that is darker than the main subject. If the frame and subject are too similar in brightness, the impact of the frame is diminished. It's important to take your light reading without the frame in place and then use your exposure lock feature to lock that exposure while you recompose the scene to include the frame.

THE DEPTH ILLUSION

From the time we're two or three months old the ability to perceive distance and depth becomes an increasing part of our visual reality. In fact, you can almost tell the moment some babies discover depth because they start reaching into space, testing distances and discovering that their toes are very handy for playing with and that their sister's nose is much closer than the clock on the wall.

Perceiving depth, of course, is a wonderful skill to possess (as both a baby and an adult) because it enables you to make judgments about all sorts of important things, like how far you can crawl before you tumble down the stairs and just how far you'll have to reach to swipe a cookie from the kitchen table. Humans are able to perceive distance because we view the world through a pair of front-facing eyes set about two-and-a-half inches apart. Each eye provides its own separate visual signal to the brain. Using a system called binocular vision, our brain sorts the differences in the slight offset of the two images, compares them and then formulates a sense of distance.

Since photographs are only a two-dimensional interpretation of a three-dimensional world, we have to rely on a little visual trickery to create the appearance of depth in our pictures. And while no one has ever bumped their nose trying to step into a photograph, the imagined sense of depth and distance can be quite believable. We know that objects get larger as they get closer, for instance, so if we see a car heading toward us and getting larger, we know it's time to hop out of the road.

In composing a photograph then, it's important to be aware of and use the various visual cues that help establish depth in a two-dimensional plane. By exploiting (or eliminating) these cues, you can greatly exaggerate (or remove) the sense of depth in any type of scene.

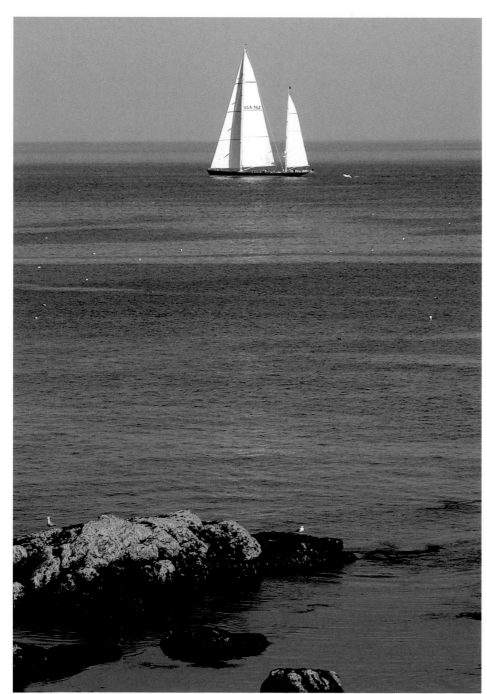

1 Linear perspective

If you've ever driven across the American West and found yourself on a road that seemed to stretch on forever and diminish to a tiny vanishing point in the distance, you've experienced the classic example of linear or "one point" perspective. Linear perspective occurs whenever parallel lines—railroad tracks, highways or even split-rail fences—converge as they recede. Our brain knows that the lines are, in reality, parallel—so it perceives the convergence as an indicator of distance.

You can exaggerate linear perspective and heighten the feeling of distance by carefully choosing your lens and your vantage point. By using a wide-angle lens from a vantage point that clearly reveals the convergence—as in this shot of a state highway in the Arizona desert—you can intensify the illusion of distance.

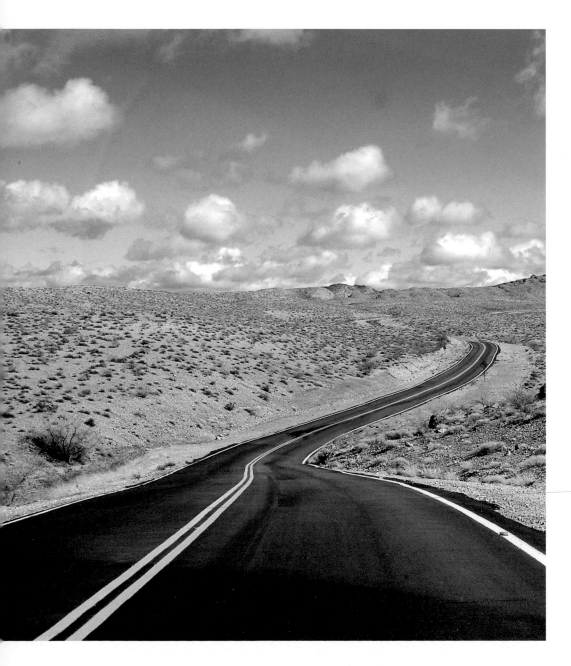

©DOUG JENSEN

2 Diminishing size

Exploiting our common knowledge of the size of known objects is another powerful way to depict distance. We know how big a person looks when they're standing eye-to-eye with us, so when we see a tiny human figure in a photograph we can assume that the person is quite a distance from the photographer. When you include a series of similar objects at different distances from the camera—a line of telephone poles along a country road, for instance, the illusion becomes even more obvious. On the contrary, eliminating any references to size helps to remove that sense of distance when you're trying to create more abstract pictures.

Design

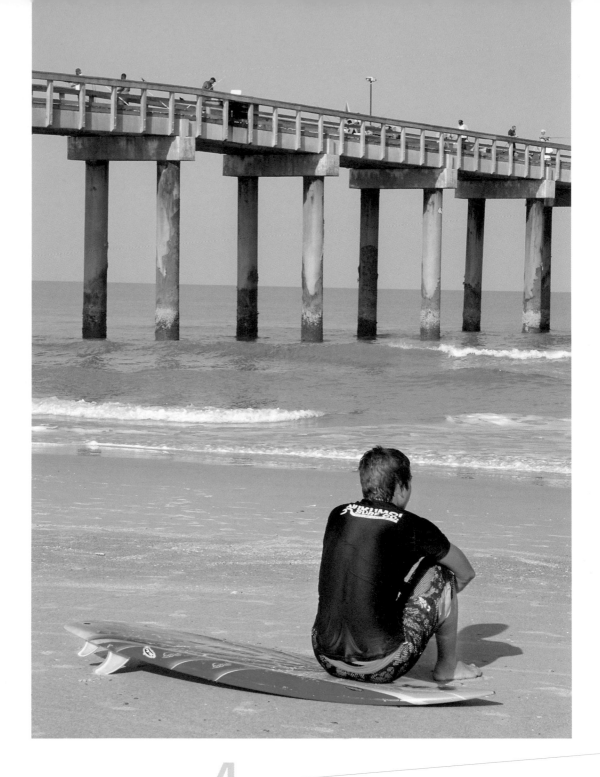

3

Loss of detail

The farther objects get from your eyes (or the camera's lens), the less apparent their details become. You are especially familiar with this concept if you happen to be near-sighted. You can exploit this fact further by finding ways to accentuate nearby details at the expense of more distant ones. By using a large aperture to reduce depth of field, for instance, you emphasize the texture of near-by sand and rocks in the foreground and de-emphasize detail in the background.

4

Upward dislocation

Subjects that are higher in the frame enhance the appearance of distance because they emphasize the expanse of the foreground in comparison to the smaller subject size. If you're photographing a runner on a track, for instance, by using a low shooting angle and placing the runner at the top of the frame, you make the runner seem more distant than if you were to shoot at eye level and place him in the center of the frame. Landscape photographers often use this technique—placing the horizon high in the frame, for example—to exaggerate distance in outdoor scenes.

5 Aerial perspective

Aerial perspective happens when atmospheric haze or fog lightens distant objects more than nearby ones. You can see the effect clearly when you're looking at a mountain range from an overlook and the nearby peaks seem dark and then get progressively lighter as they fade into the distance. You can help create the effect by using a long lens that, while compressing apparent perspective, exaggerates the tonal contrasts by bunching them closer together. Aerial perspective works best when you include both nearby and more distant objects and when there are several layers to the composition. Hazy or foggy days make the illusion that much more real.

Design > Design Elements:
A SENSE OF SCALE

Among the most famous postcards to ever come out of the American West were the shots of cars and trucks driving through the trunks of giant redwoods. While the habit of hewing tunnels through these magnificent trees (which thankfully is no longer practiced) certainly didn't do the trees much good, it was an eloquent way to prove one point to the folks back home: these are big trees.

Short of carving up a monumental work of nature to make a point, placing something of known size in your photos to reveal a scene's true scale is very important. Even with a subject as grand as the Grand Canyon—or perhaps especially with a subject so grand—it's important for your viewers to have something of known size for making visual comparisons.

The best measuring stick for expressing scale, of course, is another person—everyone is familiar enough with the size of the human figure to make a good judgment about the size of the surroundings. While shooting this photograph of red rock cliffs near Mexican Hat, Utah, for instance **(above)**, I had my traveling companion hike down into the composition (the dancing was her addition). Putting her into the shot also added an element of human interest to the scene.

At times, particularly if you're shooting natural pictures, you may not want to introduce something that isn't an inherent part of the composition. Instead, try getting close to one object—a rock or an outcropping of ferns, for instance, so that the viewer at least has one familiar object for comparison. Even if the exact size isn't known, having something familiar in the foreground does provide a sense of proportion.

Of course, there may be times when you want to pervert the sense of scale in a scene by providing wrong size cues. Hollywood film directors frequently do this by creating special room sets where the scale of common objects has been shrunk or enlarged by a small percentage to play tricks with perspective. Another way to do it is by using a wide-angle lens close to a small object and letting it tower over larger, more distant subjects—making a mushroom towering over distant trees, for instance. Or you may want to eliminate all hints of size and scale to create a more abstract view.

One of the most common complaints from photographers who return from trips to mountainous areas is that the feeling of space and grandness so overwhelming in person disappears in their photographs.

"It is light that reveals, light that obscures, light that communicates. So it is light I *listen* to. . ."
—John Sexton

Light

Ancient alchemists believed there was a magic substance called the philosopher's stone that could turn lead into gold and, as the legend goes, they believed it to be a common substance, found everywhere but neither recognized nor appreciated. For photographers that enchanted touchstone is light. Though we often take its beauty and power for granted, by its very presence the right light can turn a crowded city street into a temple of gold, a rusting tractor into a bucolic antiquity—or restore the glint of youth to the fading eyes of age. Call it the photographer's stone.

No matter how often we witness the beauty of light, because it is so fleeting and so infinitely variable, it almost always has the power to surprise. Scenes to which our visual and emotional receptors have grown numb suddenly demand our appreciation. Out of the blue a neighborhood pond you've driven past a hundred times mirrors the shimmering dawn and your inner-artist slams on the brakes to record it—a good argument for always having your camera handy (and for wearing your seatbelt). Without warning, light has beckoned and you must respond.

Training yourself to appreciate the many moods and whims of daylight is the starting point. Though the sun that lures us to the morning garden with its buttery caress later sends us dashing for cover in the brilliant blaze of noon, we rarely take notice of the thousand faces of that transformation. As mercurial and transitory as light is though, you can—and must—study not only its charms but the very qualities that make it special: its color, its direction, its quality and its intensity.

Photographic light is not limited to the light of the sun. As professional photographer Dan Heller's wonderful shots on pages 150-151 show, even the stars (of which our sun is one) can be fascinating sources of illumination—as can campfires, city lights or even an informal grouping of candles in a fireplace. And both indoors and out, artificial lights offer their own special beauty.

Whatever the light source, whatever the subject, once you become aware of the qualities of light, you'll discover your own philosopher's—or photographer's—stone and begin turning ordinary moments into golden ones.

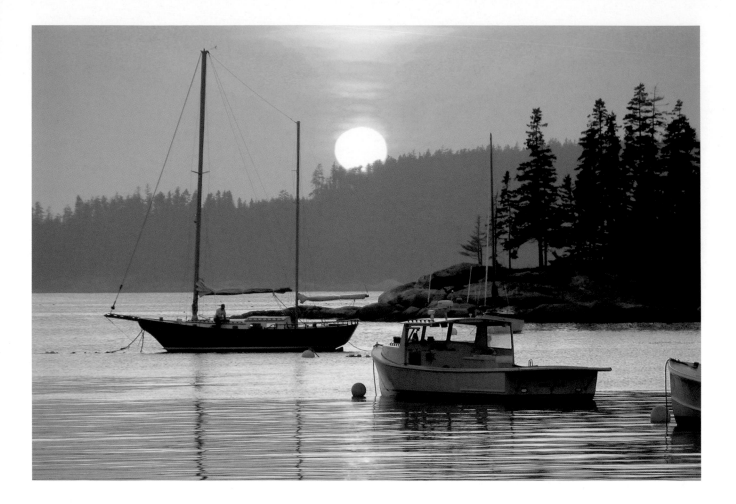

Time of Day

If you were really ambitious (or incredibly lazy, depending on your perspective) and sat in one place from dawn until dusk and every fifteen minutes shot one picture of the exact same scene, you would create an amazing visual study of how light changes throughout the day. You would also, no doubt, acquire a seriously sore backside, but the pictures you produced would show exactly how changes in daylight affect the look of a particular place. You would see those changes from only one perspective, of course, but you would still learn a tremendous amount about the nature of daylight.

The most important thing you would learn in studying your images is that as the earth spins merrily on its axis and revolves lazily around the sun, light perpetually changes the appearance of everything it strikes. Naturally, a high percentage of pictures from an experiment like that would be rejects—even if the

If you know what to look for, you can call upon even subtle changes of light to improve virtually any scene.

scene itself were interesting and attractive. Some would have the light coming from the wrong side of the subject, or hit it at the wrong angle; some would be lit too flatly and others too harshly. And in some shots the lighting might be adequate but boring.

But in that collection of pictures, you would find a few that were aglow with a beautiful illumination—graceful and gentle in quality, elegant in color and flattering in direction. And those would be the pictures that were created for you by the sheer beauty of the lighting. After all, if nothing but the light had changed and a few images rose above all of the others, you would have to give credit where credit was due.

The next time you're walking around your neighborhood or a local park and you suddenly become aware that light has muscled its way into your consciousness, try to analyze why that particular light is so special.

I photographed this gentleman in a community garden in the ancient walled town of Dinklesbühl, Germany, in the late afternoon light, just before the sun clipped the horizon and disappeared.

Because daylight changes gradually, we simply don't notice it (kind of like the way a few cookies a day end up changing our waistlines). Only when lighting changes suddenly—when storm clouds part and a ray of golden light ignites the landscape—do we really become aware of the presence of light. But if you know what to look for, you can call upon even subtle changes to improve virtually any scene.

Most of us, of course, don't have the time (or the patience) to sit beside one scene and watch it morphing from sunup to sundown. But next time you're walking around your neighborhood or a local park and you suddenly become aware that light has muscled its way into your consciousness, try to analyze why that particular light is so special. Is it the color of the light? The intensity? The direction?

In the following pages we'll take a look at some of the ways in which light changes—and how you can use it to capture ordinary places at extraordinary moments.

Light Direction

Light seduces when it surprises, and one way to surprise your viewers with light is to have it strike your subject from unexpected directions. Though most of us have been conditioned to keep the light over our shoulders and flush on the front of the subject, there's no reason not to put the light behind or above or to the side of your subject. Changes in lighting direction (as well as your position relative to the light) have a tremendous impact on your subject's appearance. In fact, virtually every aspect of a subject's shape, form, color and texture is affected by direction of the light striking it.

As the direction and angle of light changes, so does the personality of your subject. A tulip safely (and predictably) lit from the front is bright and colorful, but when lit from behind its translucent petals glow as they radiate light and color; lit from the side it becomes a brief and beguiling hesitation in light's meandering journey. Still-life photographers may spend hours positioning lights so that each tiny nuance of their composition is shown to its best advantage.

Of course, one of the nice things about using the direction of light as a creative tool is that you can change how your subject looks by simply walking to a different vantage point or, if you're using artificial light, moving the light source. Outdoors, even if you can't physically move around your subject (it's kind of tough to walk around a mountain peak sometimes), you can always take on the sun as a partner and wait for its position to change. And, of course, with some subjects (your dog when he's feeling cooperative, for example), you can change your subject's position relative to the light.

Keep in mind that the direction of light also affects the mood of a photograph. The bright, strong colors produced by front lighting remind us of cheerful and carefree summer afternoons, while the long low light from the side creates a more contemplative tone. Backlit scenes exude warmth and, particularly with landscapes, often kindle recollections of summer days gone by.

LIGHT FROM THE FRONT

Although not particularly interesting or dramatic, front lighting does have a few redeeming qualities, and excels at some visual tasks. Front light acts like a spotlight, stripping away all modesty and mystery and revealing great amounts of detail. By lighting all areas of the scene equally, it encourages the eye to explore every facet and fold of a scene. Front light buffs colors into brash brilliance, allowing you to emphasize color as a design element.

The biggest drawback of front lighting is that the near absence of shadows diminishes depth and dimensionality. Falling away from the camera, shadows are hidden by the objects casting them. Without shadows to help sculpt objects, scenes lack three-dimensionality. On the other hand, the absence of shadows criss-crossing your scenes prevents your designs from becoming too busy.

Above
Late afternoon front lighting is particularly good for architecture and city scenes because it brings warmth to otherwise cold subjects. In the detail on the urn at Vanderbilt Mansion in Hyde Park, New York, I waited until the sun was almost at the horizon and level with the building so that the normally gray limestone was bathed in a rich orange glow that revealed the fine detail of the filigree. It would have been just as easy to choose a position on the side of the building and use the low-angle sun as side lighting, but I liked the straight-on view. One small problem you may encounter when using a low sun for front lighting is keeping your own shadow out of the composition, particularly when using wide-angle lenses.

LIGHT FROM BEHIND

One of the marks of a very experienced photographer is the use of backlight: the main light coming from behind the subject. It takes some practice and experience to get the exposure right, but when it's handled well, backlighting can be very dramatic.

When you place the light source behind your subject, particularly if it's a strong directional light like a late-afternoon sun, several interesting things happen simultaneously. The most obvious visual effect is that opaque subjects suddenly turn into silhouettes and translucent subjects, tree leaves and people's hair, for instance, begin to glow. If you combine these two concepts, a gnarled old oak tree in its autumn foliage, for example, you get a lovely dark shape of a tree set afire by a crown of glowing leaves. And you just can't beat glowing leaves and black tree trunks for drama in an autumn landscape.

Shooting directly into the sun also creates a great sense of depth in landscape scenes because all of the shadows are coming directly at the camera, an effect you can exaggerate with a wide-angle lens. It's best if you hide the sun itself behind a solid object, a tree limb or a building, for instance, because otherwise the sun's rays will obliterate foreground detail and wreak havoc with your exposure system. If you're lucky enough to get a strong sun coming through a morning mist or fog, however, the effect can be positively magic, and that's exactly what photographer Doug Jensen did in the beautifully lit scene below.

Left
Exposing for backlit subjects can be tricky because even the sophisticated light meter found in your digital camera is easily fooled by the stark contrasts. Not only does backlighting place the front of your subject in relatively deep shadow, but it also permits the rays that make it past the subject to go directly into your camera's lens.

If your subject is relatively close—as in this head-and-shoulders portrait—use your camera's fill-flash mode to open up the shadow areas. Alternately, you can simply aim a small reflector at the subject and use the sun's rays to brighten dark areas.

Right
With broad scenes, you'll have to experiment with exposure compensation to control exposure. In most cases you're better off adding just enough exposure compensation (start with +1 on the exposure compensation control) to record some foreground detail while not burning out the highlights entirely.

You might want to experiment with exposures by manually bracketing in one-stop increments, or by using your camera's auto-bracketing feature.

Light > Light Direction:
LIGHT FROM THE SIDE

Of all the directions that light can strike your subject, light coming from the side gives subjects a very tactile appearance. As the light steals across surfaces, shapes and forms expand and contract while surface details ignite in the passing light or hide in newly created shadows. Whether you're photographing a broad scene like a landscape or a more intimate subject like a portrait or a still life, side lighting brings the third dimension to photographs.

In landscapes, sidelight lays out a patchwork of shadows that, like backlighting, adds depth and a three-dimensional feeling. The length of the shadows, of course, depends on the time of day (and in part the time of year), but the lower the sun is to the horizon, the longer the shadows are. A benefit

of photographing outdoors in side light is that on a clear day you get two chances at it: if you're working early in the day you'll see long shadows shrink as the sun rises, only to lengthen again traveling in the opposite direction at sunset. Sidelight works best if you have just a few dominant features: a row of trees at one side of a meadow casting shadows across the field, for example.

Above
Sidelight from an early or late sun can create a pleasing portrait because its yellow color and softer shadows flatter subjects—both human and animal. I photographed the dog shown here very late in the afternoon on the Navajo Reservation in southern Utah from a car window. As I lowered the window and composed the scene, I asked the subject to turn and face the sun and he obliged nicely.

Exposure Tip
For high contrast scenes, you may have to notch up the exposure compensation to +1/2 or even +1. If your camera has a histogram display function, study the histogram to see if the contrast appears too extreme. The histogram graphic is a more accurate measure of contrast than looking at an LCD display.

LIGHT FROM ABOVE

Light from the overhead midday sun creates top lighting. Our first response? Ugh. So let's get the negative things about midday sun out of the way: it's harsh, it creates deep shadows, it hides textures and it sunburns the peaks of some of my middle-aged male friends (not me, of course). There's no reason to make a blanket apology for top lighting, though, and simply put the camera away. While I wouldn't say high noon was my favorite time of day to shoot pictures, top lighting is light after all and, personally I'll take its dominating brightness over a gray day anytime. Like any bully, midday light has its charms, you just have to peer a little deeper into the shadows to uncover them. Mad dogs and Englishmen aside, going out in the midday sun can be a very interesting time photographically.

Above
One of the redeeming qualities of this brilliant blast of daylight is that it ignites colors.

Left
Be careful when shooting in midday sun. If you expose to capture highlights and bright colors, the shadows will go tar black. But if you choose your vantage points carefully, you may find that black shadows (beneath trees or in doorways, for instance) aren't much of a concern.

From the first
pinkish rays at
sunrise until the
sun disappears
in a brilliant
blaze of glory,
the color of day-
light endlessly
morphs itself.

The Colors of Daylight

Light > The Colors of Daylight:

Although there are many sources of light on earth—some manmade, some not—our main source of illumination for outdoor photography is the one that travels approximately 93,000,000 miles (at 186,000 miles per second) to get here. Day after day, eon after eon, the sun illuminates every corner of our waking world with enough energy left over to warm our faces on a winter's day. As one astronomical website put it: you've really got to admire a light that travels that far and is still bright enough to hurt your eyes.

Though we refer to sun's light as "white" light, daylight is, in fact, made up of virtually every color in the visible spectrum—violet, blue, green, yellow and red are all a part of the ultimate rainbow coalition. If you doubt that the sun's light bears all color just hold a prism in its path—or chance onto a rainbow glinting in the spray of a lawn sprinkler. There spilled out before you are the inner workings of color—visible proof of the symphony of electromagnetic wavelengths that engulf us.

During most daylight hours the blend of wavelengths in sunlight is equal enough so that we see daylight as a neutral color. But as anyone who has walked out into the first yellow rays of morning knows, there are times when daylight takes on some pronounced hues. As it passes through the atmosphere, pollution and the morning mist, portions of the light's energy are deflected or scattered causing the color of the light to change.

Indeed, from the first pinkish rays at sunrise until the sun disappears in a (hopefully) brilliant blaze of glory at sunset, the color of daylight endlessly morphs itself. It can scorch the landscape with the scarlet vengeance of an African sunset, or retreat sullenly in the purple glow of an urban dawn. And as its color changes, of course, so does the color of virtually anything that it illuminates—a white barn sits awash in yellow in the early morning light, a figure walking on the beach is bathed in orange from the setting sun.

Light > The Colors of Daylight:
GOING FOR THE GOLD

The color of daylight is perhaps most dramatic—and changes fastest—closest to dawn and dusk because the light is at such an extreme angle to the earth. In the first moments before sunrise, as the black night sky yields to the coming daylight, the landscape is cool and violet, inhabited only by the dark shapes of barely recognizable objects. Within moments, though, as the sun slips over the horizon, its pastel light washes the landscape.

Painters and photographers often refer to the first hour or so after sunrise and before sunset as the "golden hours," and you'll find a lot of travel and landscape shooters who work only during these hours. And who can blame them? Given the choice between a bright but coldly-lit midday shot of a lighthouse and one glowing in the bronze light of the day's last rays, editors will go with the "glow" every time. Because the light is changing so quickly at this time, however, picture opportunities don't last long. I've spent many mornings photographing swans on a river near my home and found that 30 minutes after the sun pops over the horizon the light loses its alluring blush.

Fog and mist tend to exaggerate the golden colors of the dawn and dusk.

Within an hour the light has become pale, top heavy and far too contrasty.

Weather, of course, has an impact on the color of light. Fog and mist tend to exaggerate the golden colors of the dawn and dusk, but they can also smolder with an almost platinum iridescence at the middle of the day. Cloudy days steal away all trace of warmth and paint the earth in a cool, bluish wash. The amount of pollution in the atmosphere will also have an effect on the color of light because, as the sun's light reaches the last miles of its epic journey, it encounters atmosphere particles that cause the light to refract and scatter, intensifying colors.

The color of daylight profoundly affects the mood and emotions of a scene. The transient light of the golden hours gives pictures a cozy and inviting radiance, while the cooler light of a cloudy day or of the

pre-dawn and twilight hours lends an air of mystery and perhaps even foreboding. A misty marsh might seem completely safe and inviting photographed as the morning rays warm the grasses with yellow light; but captured in the cool light of a stormy afternoon it would seem threatening and unwelcoming.

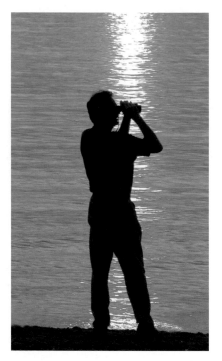

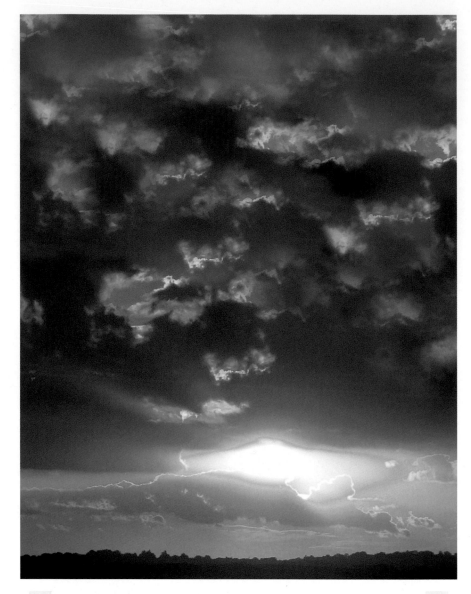

Finally, because film is designed to be exposed with light of a particular color temperature, film cameras are fairly honest in recording the color of daylight. If you use daylight-balanced film to capture a rose in morning light, it will record that color accurately. Ironically, the auto-white-balance feature of your digital camera will try and neutralize strong color biases—assuming that what you're after is "correct" color. In effect, this strips away much of the heightened color that you found so attractive.

To record the daylight accurately, set the camera's white balance to the Daylight setting or if your camera allows, set it to 5500K.

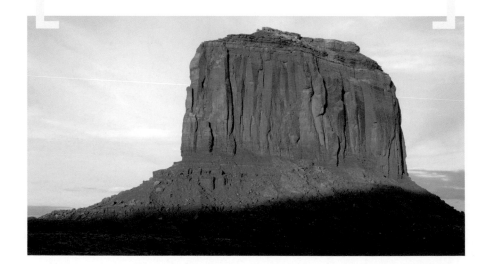

The Quality of Light

When photographers talk about the quality of light, they're referring to its softness or hardness. Light quality can be a wonderful tool in establishing the mood and look of a photograph, especially when you carefully match it to the right subject. There's nothing like the crisp light of a sunny day to fire up the colors of a meadow full of wildflowers, for example, but there's also nothing quite as flattering as the soft sensual illumination of a north-facing window to light an indoor portrait.

The quality of light depends on a single factor: the size of the light source. Smaller light sources—like the sun on a clear day or your camera's built-in flash—create a hard and directional light. It seems odd to think of the sun (which has a diameter of a mere 870,000 miles) as a small light source, but because it is so far away, it has the same effect as a tiny sharply focused point light source here on Earth. Larger sources—like the sun diffused by a large cloud or a flash bounced off of a ceiling—create quieter, gentler light. The larger the light source, the softer the light.

As clouds diffuse the light, the lighting softens, shadows lighten or disappear, colors become more muted and rough textures soften, revealing subtler more delicate surfaces.

As light quality changes, even the same subject can evoke radically different emotions. The mood of a landscape changes dramatically (and quickly), for instance, when a thin cloud veils the sun. In the hard bare light, shadows are deep and distinct, colors are vibrant and highlights are luminous. As the cloud diffuses the light (creating a larger light source) the lighting softens, shadows lighten or disappear, colors become more muted and rough textures soften, revealing subtler more delicate surfaces.

Hard lighting usually provides a very cheerful feeling. It reveals textures and accents the strong lines of geometric subjects like modern architecture. Hard lighting also emboldens colors, though you run the risk of blowing out delicate tonal gradations.

Softer lighting is ideal when you want to create a soothing and inviting atmosphere. It caresses curved forms and shapes and softens shadows, romanticizing portraits, figure studies and landscapes.

If you're photographing people or some other moveable subject in harsh sunlight, you can often find a pool of softer lighting by taking your subject into an area of open shade—the shadow side of a building or under a canopy of trees. With light from the blue sky illuminating shady areas, its color, not surprisingly is a bit bluish. You may want to reset your white balance to a "cloudy day" setting to warm up the colors or use a slight warming filter.

Controlling quality of artificial lighting—flash or lamps—is fairly simple because you can often diffuse the light source itself. You can soften the harsh light of a flash, for example, by putting a layer of white fabric (a handkerchief, for instance) in front of the flash. Or, if you're using an accessory flash with a tilting head, you can soften the light substantially by bouncing it off a white ceiling or bouncing it into (or shooting it through) an inexpensive accessory diffuser. Indoors, lampshades soften the tungsten light bulbs beneath them, but you may want to turn on more room lights to lighten deep shadows.

Light quality can be a wonderful tool in establishing the mood and look of a photograph, especially when you carefully match it to the right subject.

Above
The soft light of late afternoon has a gentle and unassuming quality that draws out delicate hues and tonal gradations, particularly when there is a hazy cloud cover. I photographed this Amish schoolhouse near Lancaster, Pennsylvania late in the day as clouds began to gather in front of the sun; the diffused light helped to soften the details of the scene.

DRAMATIC LIGHT

Few sights pump up the pulse of a photographer faster than lightshows erupting across the sky: the brilliant angelic rays of golden sunlight piercing through storm clouds, the gold and black wildness of churning storm clouds or the last rays of scarlet sun pouring across a cornfield. These are the moments photographers lust for. And though discovering such moments is largely a matter of luck, you can increase your odds of experiencing them if you know where and when to look. (Or, as Edward Steichen replied when asked by a writer if he thought there was luck involved in creating his images: "Yes, there is, but isn't it amazing how often the same photographers get lucky?").

Approaching and departing storms often unleash a torrent of platinum rays as the cloud formations begin to break up. Such rays typically begin to appear when the sun is at about a 45-degree angle to the horizon and gather intensity as the sun gets lower. Because the surrounding skies are usually a rich gray just before rays begin to burst forth, it's important that you use your exposure-compensation feature to underexpose the scene by a stop or more from your camera's meter. If you were to expose for the dark clouds at the recommended exposure, the clouds would lighten in tone and the glory of the rays would evaporate.

Windy days also present opportunities for capturing wild light because clouds swirl and whirl into crazy formations that when combined with the rising or setting sun can produce spectacular displays. One of the few (very few) times I set my alarm to go off before the sunrise is when a nighttime storm is expected to begin clearing by dawn. Seeing the colors and shapes of the parting clouds painted by the first rays is like witnessing the creation—beautiful indeed (you thought I'd get up early for something mediocre?).

Interestingly, you can also find dramatic sunbeam effects in large interior spaces—cathedral interiors or large train stations—where high windows funnel the light into the dark interior. The great thing about finding the effect indoors is that you can go there on almost any sunny day if you know what time to arrive and see the phenomena repeated.

Exposing in this situation is difficult because the rays are so bright and the interior is so dim. You'll almost always want to expose so that you get some detail in the interior and then let the rays burn out. It's best to shield the lens from the rays when you take your initial reading and then use your exposure-lock feature (typically just holding the shutter-release button halfway down locks the exposure) to hold that setting while you recompose the image. Also, because the interiors of these places are pretty dark it's sometimes hard to make a handheld exposure. In most places tripods are welcome, if you ask for permission.

Finally, be patient enough to wait for great light events. If you're out shooting landscapes or scenic travel shots, wait until you're sure the sun has finished its performance before you pack up and leave. Often there will be a spectacular afterglow just after the sun has slipped away and the landscape ignites with a rich warmth reflected from the sky. After shooting Maine's much-photographed Nubble Light one summer

evening I noticed that all of the other photographers packed up when the sun hit the horizon. Suspecting they were leaving a bit soon, I left my camera set up. A few moments later a beautiful orange light painted the lighthouse (above). By the time the other photographers scrambled out of their cars the show was over.

You can find dramatic sunbeam effects when windows funnel the light into a dark interior. The great thing about finding the effect indoors is that you can go there on almost any sunny day, if you know what time to arrive, and see the phenomena repeated.

EXISTING LIGHT INDOORS

When you move inside it's tempting to simply pop the electronic flash on and let it rip—but rarely is on-camera flash as pretty as the existing light. Whenever possible, suppress the urge to use flash and go with the existing light; whatever you lose in ease of shooting or action-stopping ability, you gain in atmosphere.

In some ways taking pictures indoors by existing artificial light is easier than working with daylight since, at the very least, the lights remain in a constant position (unless, of course, you move them). You also don't have to worry about dodging a passing squall or waiting for a cloud to pass over the light source. On the downside, most interiors are lit solely to keep people from tripping over the furniture (and other people) and rarely will you find any natural charm in the lighting.

Since indoor light levels are typically low, you'll either have to raise the ISO setting (which increases digital noise) or increase the light level—assuming you can adjust the existing lights. If you're shooting an entire interior space—friends gathered in your living room, for instance—the simplest way to increase the existing light level is to turn on all of the room lights. Not only will the additional lights boost the light level, but also the added light will help fill dark voids. If you're photographing a person or a pet, you can often gain a stop or two of light by moving them closer to the light source and (in the case of people or very cooperative pets) having them face the primary light.

When you lack control of the existing light—such as inside public buildings—all you can do is to mount your camera to a sturdy tripod or monopod (if it's allowed) and switch either to the Shutter-Priority or Nighttime exposure mode. In public spaces, there may be times when people's motion becomes a factor. The best thing to do is to set the exposure time for a proper exposure and ignore the motion. In photographing New York's Grand Central Terminal, **(above)**, I used a monopod leaned up against a hand railing to support the camera for a half-second exposure and used the movement of the travelers to create interesting motion patterns.

Unless you know the color temperature of the existing light, your best bet is to use manual or custom white balance and do some test shooting. If you're shooting familiar interiors—houses, hotel lobbies,

restaurants, etc.—you should probably accept a certain amount of warmth in the images in order to help capture the real feel of the location. Again, the auto white balance will make some limited corrections, but it won't compensate for mixed lighting or an unusual light source.

Speaking of which, these days many interiors are lit by strangely colored vapor lamps whose odd colors can be distracting in photographs. By shooting and examining a few test shots you'll be able to tell if the lighting is simply warm-toned or if it's turned a sickly green or yellow. In either case, by setting the white balance manually you can correct for most—though not all—light sources. If you happen to come across a particularly difficult source, you're better off setting the white balance as close as you can to neutral and making fine-tuned corrections in post production.

You can create interesting effects outdoors at night using the Slow-Sync with Rear-Sync flash mode. Also called, "Second Curtain" sync, this mode fires the flash at the end of an exposure, providing some sharp detail in contrast to the blur created by the longer Slow Sync exposure—which is how I photographed one of New York's finest on patrol in Times Square.

Light > The Quality of Light:

OUTDOORS AT NIGHT

One of the nice things about the sun going down is that once it's dark out you can flip on the television and forget all about this photography nonsense, right? Wrong! While the sun may have slipped below the horizon to get a good night's rest, for photographers the nighttime world provides a whole new set of subjects and opportunities.

In fact, taking pictures after dark can be a lot of fun because there is such a wide variety of subjects and interesting light sources. From the full moon hanging over a harbor to streaks of taillights zooming along city streets, the nighttime world provides a great number of visual challenges. Shooting night scenes while you're traveling—particularly if you're in a city—is a great way to add some variety to your travel album. And since so few photographers make an effort to shoot after dark, your photographs will be sure to catch people's attention.

Because there is an almost infinite variety of artificial light sources, it's impossible to know what the color of a particular light source will be without making test exposures. Many cities have switched over to sodium vapor lamps for streetlights, for example, and they provide a warm-toned coloring. But there are many other vapor-type lamps out there that create crazy color shifts in the green and purple regions and, again, you won't know which is which until you shoot a few frames. Spotlighting on buildings and monuments can also vary widely in both color temperature and attractiveness and again, it's best to experiment. One of the nice things about shooting these subjects digitally, of course, is that you can correct odd color shifts with your editing software.

Urban areas are particularly rife with interesting night subjects—neon signs, traffic streaks, theater marquis and floodlighted buildings all make great subjects. Exposure tends not to be critical for most subjects (floodlit buildings, statues, etc.) but it's worth experimenting because as you increase or decrease exposure times the look of the subject will change—shadows will open with longer exposures, for example and highlights may start to burn out. Try for an exposure that provides both good shadow and highlight detail.

You can vary exposure settings using either your exposure-compensation feature (adding +1 and

+2 stops, for example) or by using your auto-bracketing feature (or by putting the camera in its manual exposure mode if it has one). Keep in mind though that if stopping motion is important to you, it's best to use a wide aperture and the fastest available shutter speed. The LCD screen of your camera can be used as a rough exposure guide, but often it can be misleading—making highlights appear more washed out than the really are, for instance. Be aware though that long exposures use up more battery power and using the LCD only compounds that problem—so use it as little as possible or carry several extra batteries.

Because most nighttime subjects require a long exposure, you'll need a tripod to keep the camera steady. Long exposures though can work to your creative advantage because any lights that are moving during the exposure (taillights, fireworks, stars) will record as streaks of color and light. But even if you don't have a tripod handy it's worth experimenting with exposures that are long enough to capture those lights in motion and just let the camera shake become a part of the composition. Carnival rides, traffic patterns and fireworks are just some of the motion subjects you'll find and all create very colorful and light-filled images. Again, the length of exposure is really very experimental, but try to keep the shutter open long enough for the light to write an interesting pattern—letting a Ferris wheel make a complete revolution, for example, to get a circular light pattern.

You can also get some interesting night effects by using long exposures and moving the camera during the exposure. I love shooting photos of bright city lights from the windows of moving cabs. You can even just jiggle the camera during a long exposure because sometimes wild things happen. In the shot of the Christmas tree (above), I kept the camera steady for most of the several-second exposure and then arced it skyward at the end of the exposure. You never know what shots like this are going to look like, but they rarely disappoint.

Advanced Tip

Light > Star Trails:

One of the really exciting aspects of using long exposures to capture images of light in motion is that often these pictures reveal patterns of motion that we otherwise would never see. Among the most spectacular examples of this are photographs of star trails—the patterns of light that stars create during very long exposures as the earth spins on its axis.

Surprisingly the technique for making photographs of star trails is relatively simple. Photographer Dan Heller made all of the photographs on these pages using nothing more than a wide-angle lens, a long exposure, a tripod—and, of course, a very fertile imagination (not to mention some rather exotic locales). The only other element needed is a very dark sky on a clear night with as little light pollution as possible. "The first mistake people make," says Heller, "is underestimating the intensity of ambient light from nearby cities which will dilute the sky with an ugly, greenish hue. Also, passing aircraft can create undesired lines that cross paths with the stars' trails."

Exposure times vary for star trails—from about 15 minutes to several hours—and the longer the exposure, the more complete the circular pattern will be. Heller says that a large aperture is important for a good exposure: "Since the purpose is to capture as much light as possible, you want to use the widest aperture you can. Wide-angle lenses are best, not just for wide angles, but because of their larger apertures."

Whether you get partial arcs or full circles will depend to a large degree on where you aim your camera and how long you leave the shutter open. Shorter exposures will record only partial circular trails, or arcs, because the earth has had less time

Below
It is important to use an interesting foreground subject to frame the stars and to provide a sense of scale. Heller has used everything from palm trees in the South Pacific to tents on top of Africa's Mt. Kilimanjaro.

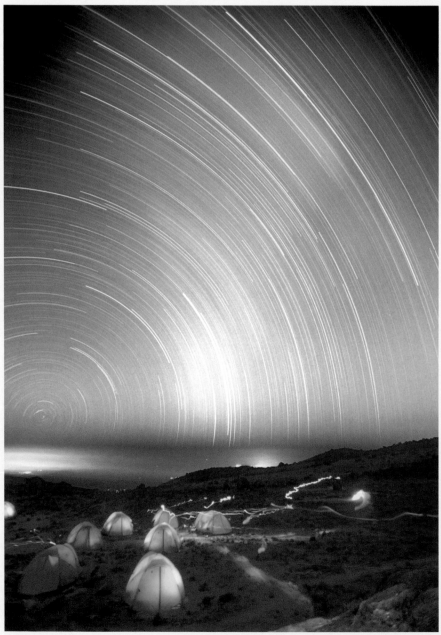

ALL PHOTOS THIS SPREAD ©DAN HELLER

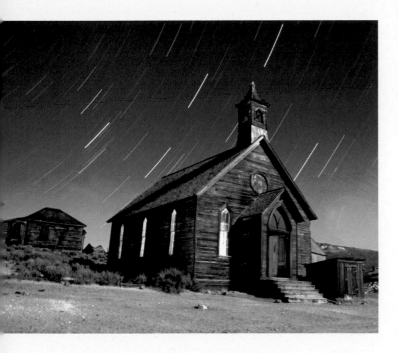

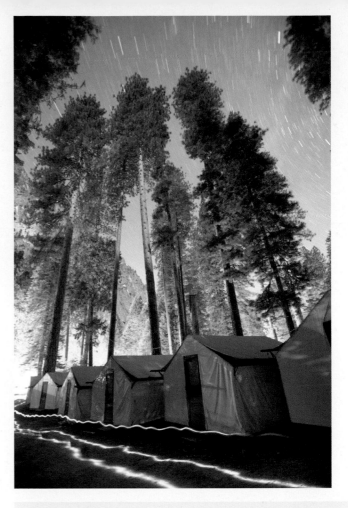

to rotate. Focal length will also play a role and Heller suggests using a wide-angle lens to take in as much of the sky as possible. Where you aim your lens is important too: if you aim your camera at the North Star (Polaris) for example, you will get concentric circles surrounding a single star.

Because the shutter needs to be left open for long periods of time and because this requires that the camera be in the "on" position, one of the problems with shooting star trails digitally is battery consumption. It's best to begin a star-trail session with a fresh set of batteries and, for very long exposures, to use an external battery pack that provides a longer charge. (And, of course, you should use rechargeable batteries, otherwise you'll be tossing a new set of batteries after just a few exposures.)

Another problem that Heller sometimes encounters (particularly in humid areas) is condensation forming on the lens—and he admits there's really not much that can be done except to be aware of it and accept it. You can try to wipe the lens (using a clean micro-fiber cloth) between exposures, but there is no way to prevent the condensation from returning.

You can see more of his star photos at www.danheller.com.

Here is Heller's step-by-step guide to photographing star trails with a digital camera:

1> Find a dark location as far from city lights, highways and other sources of light pollution as possible.

2> Set the widest aperture possible to get a bright image of the stars.

3> When possible work on a moonless night, but don't worry if a crescent moon is in the frame for 15 minutes or less.

4> Secure the camera to a heavy tripod and use a wide-angle lens to take in as much of the sky as possible.

5> Expose for anywhere from 15 minutes to several hours, using a cable release to keep the shutter open. (With some cameras you can set the shutter at the "B" or "bulb" setting and you can simply remove and replace the lens cap to begin and end the exposure.)

6> Bracket exposures by at least 15 minutes so that you're able to see a distinct difference in the star trails.

©ROBERT GANZ

"Ultimately success or failure in photographing people depends on the photographer's ability to understand his fellow man."

—EDWARD WESTON

© NANCY BROWN

The great photographer Edward Steichen once said that photography's job was "…to explain man to man and each man to himself." And each time we photograph another person, whether we are aware of it or not, we are fulfilling Steichen's credo. By the simple act of photographing another person we begin to examine not only the people with whom we share our homes, our town and our planet—but who we are as well.

It's not surprising then that the one subject we photograph more than any other is people. Whether it's at special events like birthdays and weddings, the family vacation or just the kids racing along on their bicycles, we record almost every aspect of our personal relationships. In fact, for most of us, our very first interaction with a newborn baby is to photograph it.

Photographing people challenges us more than any other subject because it requires trust between photographer and subject. The instant you raise a camera to your eye to photograph another person, you leave the safe distant world of the camera as mere observer and become part of a dialog between you and your subject. And if you've ever tried to photograph a

The success of your people pictures depends not so much on your mastery of f/stops and shutter speeds, as on the grace and wit with which you handle this intimate interaction with your subject.

shy child, you know how fragile the threads of that bond can be. The success of your people pictures depends not so much on your mastery of f/stops and shutter speeds, as on the grace and wit with which you handle this intimate interaction with your subject.

Not surprisingly, photographing other people intimidates us most. After all, people are the only subjects we photograph that can talk back to us—or like wildlife can run away from the camera. But confidence comes with practice and, at least with the people we know well, photography eventually becomes a seamless and invisible aspect of our relationships. And once you and your subjects reach that level of comfort, your portraits will move past superficial likenesses and begin, as Steichen believed, to reveal more about your world and yourself.

©JACK REZNICKI

KIDS AT PLAY

While getting kids to pose for the camera can be difficult, getting them to *play* is easy—after all, playing is what they do best. Taking photographs of kids at play is relatively relaxing (for you and them) because once involved in an activity they block out the rest of the world—even if that world includes an adult mercilessly aiming a camera at them. And, of course, the more often you take pictures of them playing, the more used to the camera's presence they become.

Give your subjects something fun that anchors them to a small area. Creative pursuits like blowing bubbles and finger-painting are particularly good because they keep your subjects at hand and elicit amusing expressions of deep concentration. A medium telephoto lens (35mm equivalent of 85 to 135mm) is a good focal length because it enables you to remain at a reasonable working distance (usually four or five feet) and still fill the frame with a small face. I shot the picture of the girl blowing bubbles (above, right) using an Olympus E20n at the maximum zoom setting of about 140mm.

Confining your kids to a specific area also works well for action pictures. Fortunately most kids love a physical challenge. Think of your daughter doing handsprings or reaching the high point on a rope swing. Kids playing will probably exhaust you (and your batteries) before they run out of energy.

To stop action in photos, like Jack Reznicki's exuberant shot of a boy rollerblading, set your exposure mode dial to Shutter Priority (sometimes indicated by "Tv" or "S") and choose a relatively fast shutter speed (1/250 second or faster) if the light allows. Personally I'll accept a certain amount of subject motion if it makes the photo more genuine—but that's an individual preference.

Before taking pictures, scout for a good location in terms of both lighting and background. For the photo of the girl blowing bubbles, I chose an area of cheerful dappled sunlight and positioned her so the sun didn't shine in her eyes and cause her to squint. Also, by using a relatively wide aperture I was able to cast the background into soft focus (see page 108 for full image).

One important thing to remember is that you can't keep a child's interest in any activity once boredom sets in. Some kids are brutally honest and will tell you when a photo session is over, others will just grow progressively less cooperative. (Then, of course, the clever ones simply disappear the moment you look away.) When a session begins to disintegrate, let it end and you'll have a willing partner the next time you bring out the camera.

People > Kids:
THE RELUCTANT SUBJECT

All kids react differently to being photographed. Some kids love it. Others (I was one of them) would rather go to the dentist than pose for a photograph. This can be a really frustrating (and expensive) thing if you've paid a professional to take a portrait of your kids, but it's just as frustrating when you're trying to get informal snapshots around the house. And it becomes a self-perpetuating problem because the greater your frustration, the more pressure you put on yourself (and them) the next time the camera comes out. In a contest of stubbornness, four-year-olds will win almost every time.

Kids resist pressure—whether it's the pressure to sit still, to look pretty, to smile or to hold a pose. These are responsibilities a teenager might be coerced into accepting, but to a five-year-old they border on the absurd: *You want me to sit still, look pretty, smile and act happy? What planet are you from?*

Surprisingly I've found that with particularly young kids (from say three to six) using a digital camera actually makes picture taking much more like a game because they can see instant results on the

If you're working indoors, try positioning your subject facing a brightly lit north-facing window so the subject is well illuminated with soft light. If none of your windows is north facing, try shooting early or late in the day when direct sunlight is softer so contrast isn't a problem. Natural light is pretty at these times of day, but it vanishes quickly, so you won't have as much time to shoot.

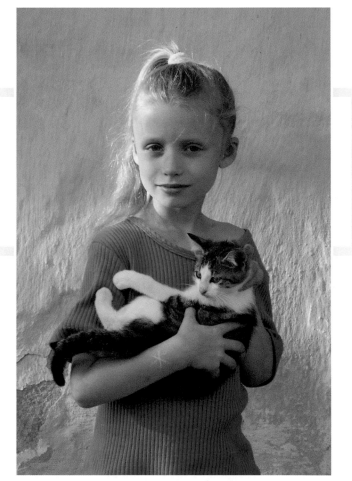

©VERA SYTCH

LCD screen. I first experienced this while sitting at the dinner table with a three-year-old niece who ducked for cover under the table every time I aimed a camera at her. Once I showed her how she looked on the LCD, however, posing for the camera and looking at the instant replay became her favorite game. So while having to stop and share the image after every shot can slow things down a bit, at least you gain a willing model.

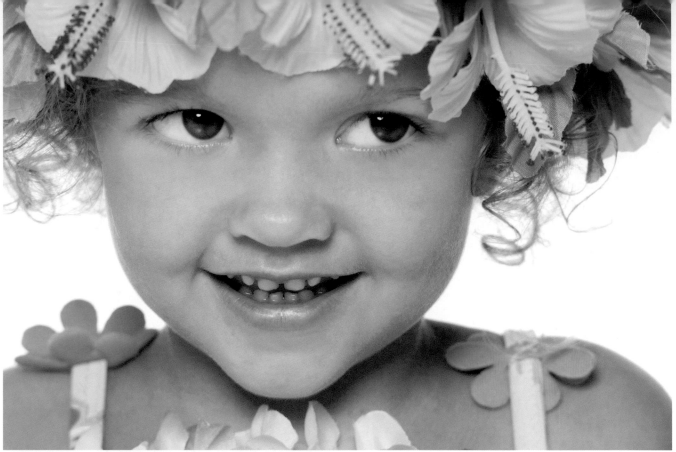

©NANCY BROWN

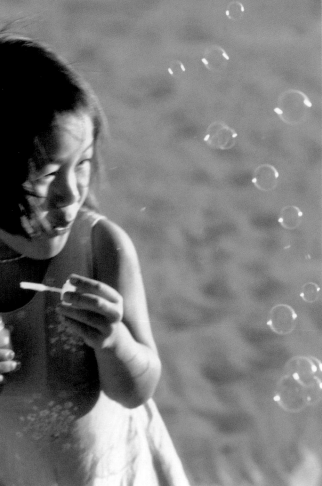

©NANCY BROWN

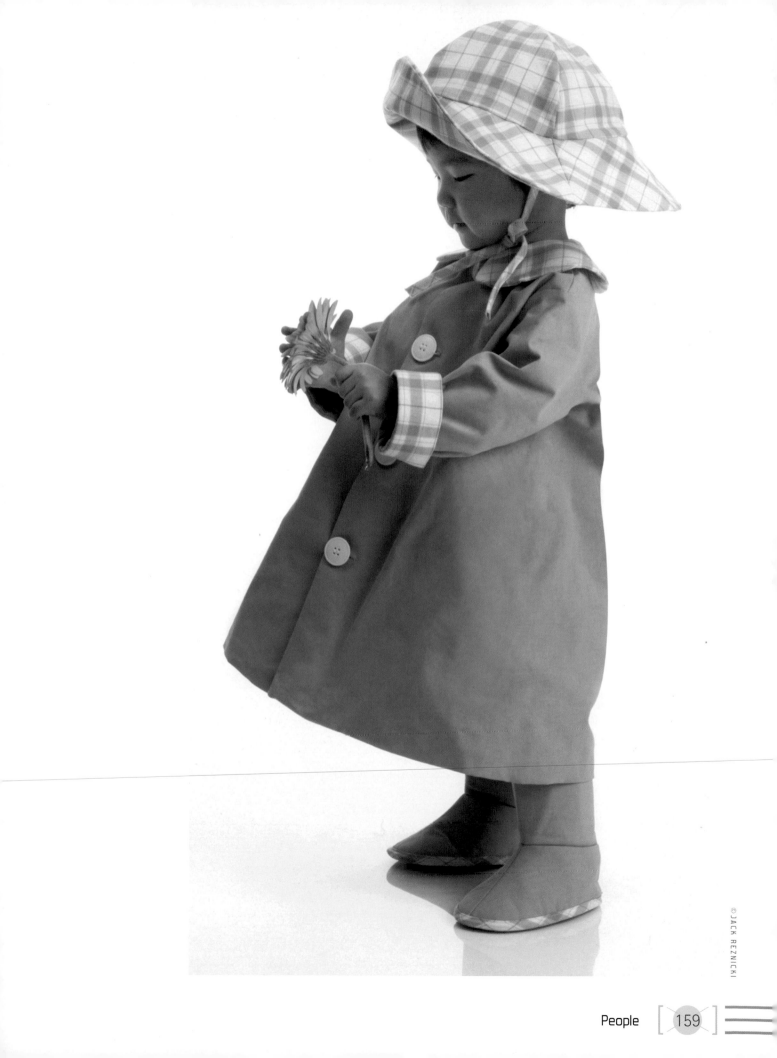

People > Parents and Kids Together:
CANDID PORTRAITS

Very often the best photographs of parents and children interacting are the ones where neither of them knows they are being photographed. With no thought of the camera to inhibit their activities (or stifle their affections in the case of older kids) pictures taken of kids and parents spending time together reveal sweet and poignant moments that often the subjects themselves are unaware of. Capturing these brief interludes requires a bit of journalistic finesse on your part, but the results are often spontaneous moments that add great emotional depth to the family album.

The activity that your subjects are involved in doesn't have to be profound or even obviously emotional. Often the most tender or touching moments arise out of everyday incidents: a dad tying his toddler's shoe, mom and daughter rocking on the front porch or a dad and his son

just casually enjoying the sunset together. When you find your subjects involved in some natural and meaningful activity, seek a position that puts a plain background behind them. The simpler the activity and the less movement the better generally (though certainly a mom pushing the kids on a swing works better as an action photo) because it lets you concentrate more on the relationship between the subjects.

A moderate telephoto lens or zoom setting (the 35mm equivalent of 105 to 135mm) is ideal for photographing parents and kids candidly because it lets you move to a discrete distance and still keep your subjects large in the frame. How close you can work really depends on how sensitive your subjects are, but generally it's worth sacrificing close-up facial expressions to remain at a friendly working distance. The longer you go unnoticed the more photo opportunities you'll get. There are no rights or wrongs, however, and once you get a few distant shots you might want to tighten up the circle and edge your way closer to your subjects.

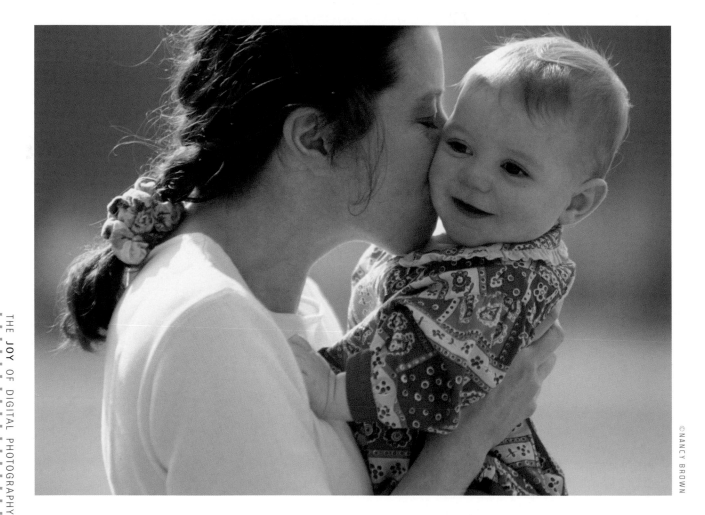

©NANCY BROWN

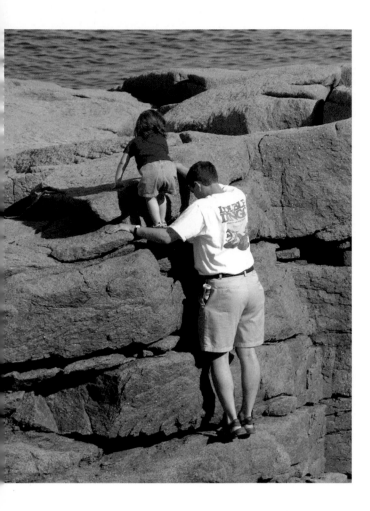

It's a wonderful thing when you watch an event unfolding through a viewfinder and an instantaneous moment of wonder happens: a butterfly briefly landing on your daughter's hand as she sits in the garden with her father.

One interesting point about shooting parents and kids together is that while it's nice from a personal standpoint if the subjects are members of your family, from a photographic point of view, the pictures work even if they are of strangers. If you happen to see a particularly interesting or cute moment in the park between a dad and his daughter, for instance, give your journalistic skills some practice and try to capture the moment even though you may never see your subjects again. Provided you don't invade anyone's privacy, most people don't mind being photographed and will probably ask for a peek at your LCD or even a print. Since almost everyone has email these days, you can easily share pictures.

Often the most tender or touching moments arise out of everyday incidents.

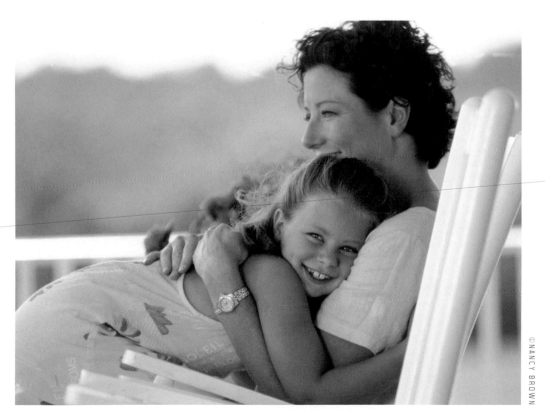

© NANCY BROWN

Capturing Moods

While it's probably rude to photograph a person when they're moody, photographing a person's many other moods can make for enticing and emotionally rich portraits. Pensive, proud, shy, aloof, exuberant, sad, joyful—for most of us changes in mood (or "changes in attitude" as Jimmy Buffet puts it) jostle through our days like a sailboat on a restless sea. Because moods are so fleeting and often evaporate in the presence of a camera you'll need to work quickly to capture them.

Reading people's moods, of course, is something we all do a hundred times a day. You judge your wife's mood before you ask her to bring you a tuna sandwich (while you lay on the couch), you judge your boss' mood before you ask for the day off (no doubt so you can lay on the couch ordering tuna sandwiches) and you judge strangers' moods before asking to jump ahead of them in line at the grocery store (to buy the tuna, of course). You certainly don't want to bring up the subject of days off when your boss is thumping his fist on the weekly efficiency reports (you probably don't want to photograph him at that moment either).

The most obvious indicator of mood, naturally, is a person's face. You can pretty much assume that a smiling person is happy or that a toddler biting her lower lip is pouting. The best way to heighten the emotions in a facial expression is by filling the frame with just the face. By using a medium telephoto lens (35mm equivalent of 85 to 135mm) to frame a face tightly from chin to hairline you can exaggerate expression. You can isolate and accent the face further by using a large aperture to get shallow depth of field. Using your camera's Portrait mode (if available) will automatically set a wide aperture. Since the eyes are the most essential and emotionally potent part of the face (or the "windows to the soul" as the poets will tell you), focus on them.

The best way to heighten the emotions in a facial expression is by filling the frame with just the face.

Lighting, in both color and quality, plays an important role in establishing mood. Bright warm early morning sun lends warmth and well-being while the cool tones of an overcast day instills melancholy.

©ROBERT GANZ

Faces aren't the only barometer of mood. Body language can be equally revealing. Your ten-year-old son sitting on the back steps with his chin in his hand is the very essence of boyhood ennui. But a moment later when his best friend shows up and they are splayed out on the front lawn using each other for pillows, the picture is one of self-confidence and sublime joy just waiting to be captured. Same kid, same day—worlds apart in mood.

Exploit a setting to reveal or emphasize a person's emotions. By including lots of space around your teenage daughter sitting alone on a rock jetty, you heighten her brooding. By moving in tightly on a granddaughter whispering a secret to her grandfather, but still showing the rocking chair they're nestled in, you use the chair to enhance the intimate and trusting mood of that moment. Would a chaise lounge or a bar stool evoke emotions as powerful as a rocking chair? Unlikely.

Lighting, in both color and quality, plays an important role in establishing mood in a portrait. Bright warm early morning sun lends warmth and well-being while the cool tones of an overcast day instills melancholy.

©ROBERT GANZ

Most of all, though, depicting moods in people pictures is about being ready—having the camera on, the mode set properly and the lens pre-focused on a spot near your subject. If the subject is camera shy, use your LCD to compose the picture because you'll be less intrusive. The more subtle you can be in your approach, the better your chances of capturing the moment.

People at Work

There's a funny running joke in Woody Allen's movie *Radio Days* where the young protagonist wants to know what his father does for a living, but the father—apparently embarrassed by his occupation—refuses to tell him. Eventually the boy finds out that his father drives a taxicab and he's thrilled at the discovery. People at work can be fascinating subjects. From butcher to baker to candlestick maker to stockbroker to deliveryman to teacher, people's jobs and work environments tell us a lot about that person—hide it as they might from their own kids.

Finding people to photograph at work isn't as difficult as it might seem—most people are genuinely flattered that you'd be interested enough in their work to photograph them. The mechanic who tunes up your car isn't asked to be photographed at work very often, but posed over the engine of a sports car with a rack of tools (and dare I say the Miss April calendar) behind him, he'd make a great picture. Friends and family at work on hobbies or crafts—your neighbor at her potting bench, for instance—are great subjects because most people are proud of their artistic talents and enjoy showing them off.

People at work tend to be relaxed and comfortable around the tools of their craft—whether it's a computer screen, a bench full of woodworking tools or even the steering wheel of a cab. Having props available gives subjects something natural and meaningful to do with their hands and prevents that awkward and stilted pose that most people get when being photographed. Certain types of work environments—particularly where an unusual trade or craft is involved—also have an inherent charm because most of us rarely see the "inner sanctum" of that world.

One trick for getting an interesting and comfortable pose is to ask people to demonstrate their work. The shots of the Ukranian beekeeper **(above)** seem completely natural because he is simply doing what he does everyday when a photographer isn't watching. The hives and honeycombs not only give the subject something to do, but provide a great deal of interest to the shots. Before you photograph somebody at work, first observe their activity and become familiar with their work routine and the photogenic aspects of it. Then use a gentle "hold that for a second" request to

Don't be afraid to let your subject look directly into the camera—that eye-to-eye contact between subject and viewer creates powerful portraits with a glimpse of the subject's personality. In Peter Burian's wonderful shot of three firemen (above), the men's friendly but intense expressions add emotional power to the image. Similarly the light-hearted smile of Connecticut radio personality Ken Brown hints at his slightly lunatic on-air persona (bottom right).

get them to hold a pose. Even if you happen to get some blur in their hands or face, it only adds to the genuineness of the shot.

Finally, because you'll often be working in cramped spaces, be sure to have a wide-angle lens available. Pay attention particularly to the foreground and background and, if possible, arrange a few props in the frame to enhance the theme of the shot.

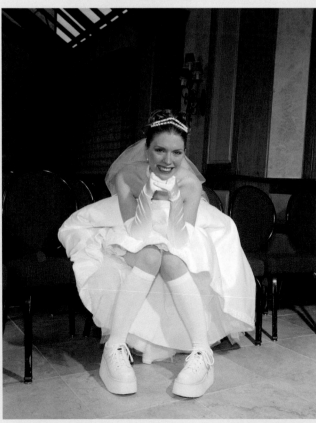

People > Photographing Weddings:

Sooner or later it's bound to happen. You get a call from some old friends who tell you they're finally getting married, and since you're such an expert with digital photography, they'd love to have you shoot some pictures of their big day. And who can blame the happy couple for inviting their photographically inclined friends to shoot extra pictures? Lucky for you, the pressure will be off. A professional wedding photographer will provide those critical and traditional wedding photos, but you can add the intimate and informal touch to the wedding album. Besides, your only option at this point is to either hang up and change your phone number or accept the offer.

Assuming that a professional crew will also be covering the wedding, it's important that you do not interfere with their need to get the pictures they are being paid to shoot. Most professionals approach the wedding day as a story with a beginning (at home before the wedding), a middle (the ceremony itself) and an ending (the party afterwards). You might limit your offer to wandering the reception capturing candid pictures of guests eating or dancing.

THE CEREMONY

The concept of the wedding ceremony has loosened up in recent years and some couples handle the event very creatively. Regardless of the setting or the script, once the ceremony begins it becomes a very solemn event. The vows themselves are a sacred moment. Photographing the bride and groom during the actual vows can be tricky business because you have to work with great stealth and not disturb the ceremony. You will also have to concentrate on your photo assignment and not get caught up in the emotions. You certainly can't be sniffling back tears while you're trying to shoot.

The best tactic is to shoot from one spot that you stake out before the ceremony begins and then stay there for the remainder of the ritual. In most churches the biggest technical obstacle you'll face is dim lighting, so you'll probably have to boost your ISO setting (if it's not done automatically by your camera) so that you can shoot by existing light. Even though the lighting may be dim, usually it's designed to be quite attractive. Flash isn't forbidden in most churches, but it's often discouraged—no one wants their ceremony looking like a paparazzi event.

There are a lot of accessible picture opportunities just before and after the ceremony—the couple arriving at the church, for instance, can be shot from the church steps. And, of course, the traditional shot of the bride and groom leaving the church after the ceremony is usually one of the most festive moments of the day.

THE RECEPTION

Going from the sanctity of a sacred ceremony to a wedding reception is like moving from a poetry recital to a reggae concert. That same sweet couple that stood eyeball-to-eyeball in solemn contemplation in front of the congregation is now giving a demonstration of the virtues of *My Big Fat Greek Wedding*-style partying—and photographing that party can be a tremendous amount of fun.

When you choose to shoot is a big part of getting good candid pictures at a wedding party (or any other party for that matter). It's usually best to shoot heavily at the beginning of a reception or dinner because as the end nears people look partied out. A few hours of eating, dancing and drinking takes a toll on

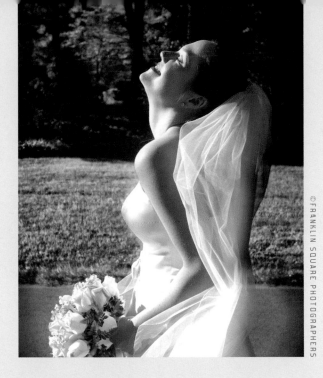

appearances. Also, by the end of the day the bride and groom and their families will be tired of having their pictures taken and often begin to withdraw and reflect on the day.

Receptions and parties are a nice time to organize informal group pictures, and often you can arrange groups of friends that a professional might not know about—members of the groom's high school baseball team or the bride's college roommates. Photographing people dancing is a real challenge. Because the light is often low and the motion constant, use your flash in its automatic mode to make sure you get some well-exposed pictures.

Finally, take time to look for meaningful "found" still lifes that can be used as transition or thematic shots in an album—shots of the flower arrangements on the guests' tables, the bride's high heels kicked off under her chair, or perhaps just an empty bottle of champagne sitting in the sunlight. In the rush and madness of a wedding day these are the vignettes that will bring the day alive again—and they're often the scenes only a true artist like you would discover.

> Beg or borrow enough memory cards to get you through a long day. Even if you're specifically shooting for a web gallery, it's a good idea to shoot at the highest resolution available because you're bound to get shots that the couple will want to see as prints or enlargements.

©PETER BURIAN

People > Group Photography:

THE ORGANIZED GROUP

Once you include more than three or four people in a photograph, you step over the threshold from simple portraiture into group photography and a whole new picture-taking dynamic opens up. Suddenly rather than just a few pairs of sweet and familiar eyes staring back at you, you have a crowd of people all waiting for you to impress them with your social charm and creative talent. Usually though, their patience is short lived.

Because gathering a group together for any kind of occasion—a wedding, a family reunion or even a company picnic—is a relatively infrequent thing, the photographs you take will be an important memento for years to come.

Keeping your group interested, happy looking and well organized is no easy chore. Like an orchestra waiting for the conductor to raise the baton, your group is waiting for you to take control of the situation—and that's exactly what you should do in the gentlest possible way. Without becoming dictatorial (remember, they outnumber you), it helps keep things moving if you are a benevolent but firm leader.

The goal of most group photos is to capture the moment in a way that not only relates the fun of the occasion but also presents a recognizable likeness of each individual person. It's important then that you strike a balance between a relaxed mood and organization.

Surprisingly, the more direction you offer to the group the more they'll like you and the more takes you'll get. And it's very important to shoot several pictures because it will vastly increase your odds of getting everyone looking at the camera at the same time.

Photographing a group can—and should—be a fun experience for everyone (even you), and it's better to keep the mood light and have a few people looking at their shoes than to turn them all to stone. One of the blessings of digital photography is that you can instantly proof your shots and if someone happens to yawn just when you snapped the shutter, you can shoot again. And, of course, if you are a part of the group, be sure you have your tripod handy and know how to use your self-timer mode so that you can run and join the group for a few frames.

Explain to the group what you'll be doing and warn them up front that you're taking more than one shot. When I first worked as a newspaper photographer, I learned the hard way that the moment you click the shutter most groups disperse instantly—and getting a group back together once they've strayed is like trying to corral an armload of kittens. Also, until the instant that you're going to snap the shutter, let your group converse and interact naturally. If it takes your digital camera a few seconds to get ready for the next shot, use the time to praise the group, have them squeeze together more or just try a slightly different pose.

Lighting is a particularly important issue with groups and, if you're outdoors, you definitely don't want everyone squinting into a bright sun. It's better to move your group into an area of open shade—at the edge of a wooded area. If you can't find a shaded area, pose the group so that their backs are toward the sun and then use fill flash to open up their faces.

Also, while a wide-angle lens will let you work a bit closer to the group (and may be a physical necessity if the group is very large or if you're shooting indoors in tight quarters), a normal lens will offer a better perspective and will keep people at the edges of the group from being distorted. If you're photographing a particularly large group, consider taking several overlapping shots and then stitching them together later in post production—not the simplest technique with a group, but certainly worth attempting.

your equipment are important. Unlike posed groups where the people will hang together until you've gotten your shot, ad-hoc groups dissipate as quickly as they come together. It's important to have your camera on and ready.

Even if you see a moment begin to fade, you can often make it last a few seconds longer just by asking everyone to do something together—smile, wave, point at you—anything that keeps them together without making them feel like they're being photographed. If your presence spoils the moment, shoot anyway—even after you've tipped your hand the poses will still look more relaxed than a traditional group picture. Also, some moments in life are worth having even if they're not perfect—better to get a somewhat sloppy shot of all your neighbors digging out a car stuck in a snowstorm than not to have any record of the moment.

Action animates an informal group shot. If the neighborhood bicycle brigade is tooling down the street, have them line up and ride slowly toward you—or just pose side by side. Stopping action that is headed toward you is pretty easy even with a moderate shutter speed (1/125 second or faster will work), and a shot of a group in action is especially fun because it's so unexpected. Since nothing (other than your artistic reputation) is riding on these kinds of pictures, it's much easier to experiment with pose, lighting and mood. Not all group shots have to be happy either—your son and his teammates looking forlorn after losing a football game is a great group subject.

People > Group Photography:
CASUAL GROUPS

Some of the most fun group pictures are the impromptu shots that just fall together naturally—a half dozen fishing buddies sitting on the dock, or your trail-riding companions heading over the next hill, totally unaware of your camera. Informal group shots have a wonderfully spontaneous feeling to them, and we almost don't recognize them as group photos.

Capturing spontaneous group shots requires that you be something of a journalist—awareness of your surroundings, quick reflexes and a good working knowledge of

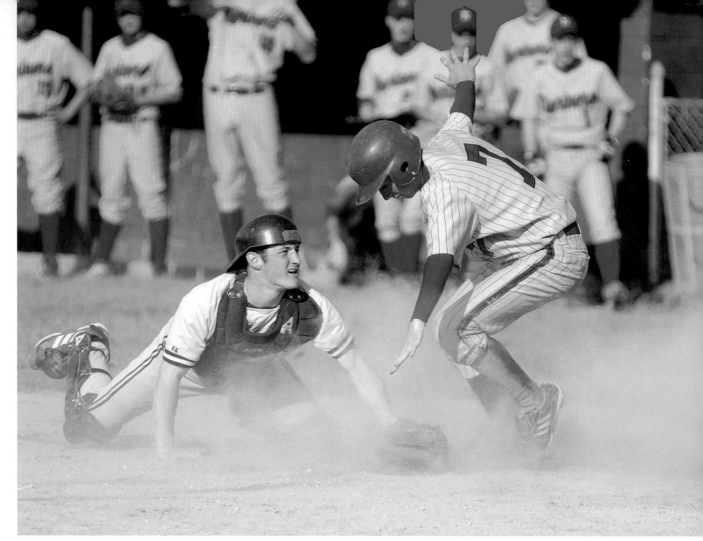

People > Sports Action:

Few subjects offer as much color, action and emotion as sports. Whether you're photographing your daughter's field hockey team in the state finals or taking casual snaps of Trot Nixon from the cheap seats at Fenway Park, taking good sports action pictures is a real challenge. Much of the difficulty comes from the fact that everything in sports happens so quickly that if you're not ready at precisely the right instant then the picture will pass you by. If you hesitate for even a half-second while your son is breaking the ribbon at a downhill snowboarding event, what you'll end up with is a shot of his rival finishing in second place (which his parents will probably be happy to have).

One of the biggest obstacles to getting good sports pictures is getting close enough to fill the frame with action. Professionals, of course, use lenses the size of baseball bats to cover sports from the sidelines—and there is no denying that long telephoto lenses make your work easier. An alternative to a digital SLR and long telephoto lenses is a compact camera with a built-in 8x or 10x zoom lens. The extreme telephoto setting of such a lens is over 300mm; I have a Kodak EasyShare 6490, for example that takes fabulous sports shots with a whopping 380mm (35mm equivalent) lens. That's plenty of lens power for school or league sports. For years I photographed high school football for a local newspaper with a 300mm lens and always found it to be more than enough lens—it's amazing that I now have a compact zoom camera with a longer focal length lens.

Perhaps more important than having a super telephoto lens is getting close to the action and finding creative shooting positions. At outdoor track meets and soccer games, roam the perimeters to find shooting positions close to the participants. If you're photographing an equestrian event, for instance, look for a spot near a jump that is in nice light and where the rider will be coming toward you as they clear the jump.

Shutter speed is crucial to create sharp action photos. Fast shutter speeds freeze action. Slow shutter speeds blur action. Inbetween shutter speeds can freeze

Left
Perhaps the most vital quality that all good sports photographers possess is an innate sense of timing—anticipation of the great moment. Doug Jensen, a well-known Rhode Island professional videographer, spends much of his free time shooting local high school and college sports. As this photo shows, he has an almost uncanny knack for being in the right place at the right instant—and having his camera ready.

Right
Stopping action isn't the only technique that works with sports. Sometimes intentionally blurring motion creates beautiful interpretive effects. In this photograph, for example, Doug Jensen used a technique called "panning" to keep the subject sharp but blur the background. By selecting a slower shutter speed (usually 1/30 second or slower) and positioning himself parallel to the subject, he moved his camera at the same speed as the subject which kept her in sharp focus but blurred her surroundings.

part of the subject and blur other parts. The actual shutter speed you choose will depend largely (but not entirely) on the speed of your subjects. While you might be able to get perfectly sharp pictures of a high jumper at a shutter speed of 1/250 second, for instance, it might take a shutter speed of 1/1000 second, or even faster, to completely stop a race horse charging around a track.

Equally as important as the shutter speed is the angle from which you shoot action—the same subject shot at the same shutter speed from several different directions will yield radically different degrees of sharpness. All other things being equal you can stop action at slower shutter speeds when it is moving toward or away from you. Action crossing your path, either parallel or diagonally, is much more difficult to stop. While a shutter speed of 1/250 second might be enough to stop a speed skater coming directly at you, it might take a shutter speed as fast as 1/2000 second or faster to freeze a skater passing in front of you.

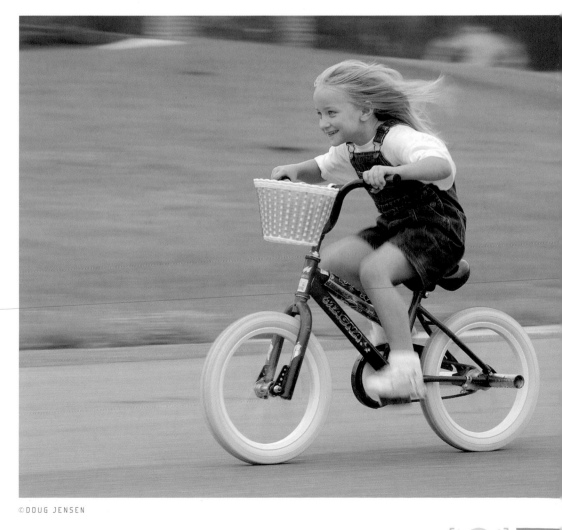

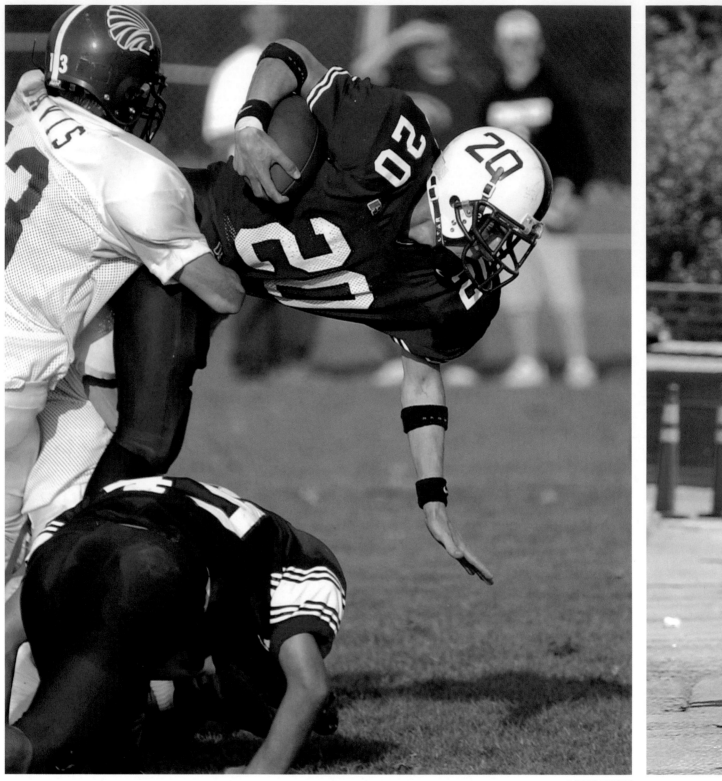

©DOUG JENSEN

People

People > Travel:

PICTURING YOUR TRAVEL COMPANIONS

With the possible exception of special events like birthdays and holidays, most of us shoot more pictures while traveling than at any other time. The travel pictures that mean the most are usually those that show our companions. After all, a picture of the Taj Mahal without your kids sitting beside the reflecting pool seems more like a postcard than a family photo. Their presence invokes memories of that entire day.

Some people (particularly kids who have far fewer inhibitions than their parents) are naturally good at being photographed and look entirely relaxed and cool, but others turn to stone the minute you aim a camera in their direction. The challenge is to get lively and fun images of your companions that look like they're actually enjoying the places they're visiting, not just tolerating your obsession with photography.

Setting up travel portraits can be a lot of fun if you're lucky enough to have cooperative or even enthusiastic subjects. Who cares how goofy you get in front of a bunch of strangers that you're never going to see again? So if your husband wants to pose like he's going to leap off of Fisherman's Wharf in San Francisco, let him. Better still, if you can create a running gag through all of your trip pictures—like posing your spouse as a tour guide explaining the sites—then you won't have to invent something new for each location.

If you don't happen to be traveling with the Marx Brothers but you still want dynamic shots, give your subjects a small task to perform that seems to fit with the locale. My girlfriend and I always travel with

binoculars, so if I run out of ideas for posing her I hand her the binocs and have her look off into the distance—which is exactly what I did in this shot from a trip to Monument Valley **(above)**. Map reading is another good pose because it lets you use the map to bounce light into your subject's face to fill facial shadows—it's a technique that works quite well.

Another secret of getting good travel candids is to leave some space—physically and emotionally—between yourself and your subjects. By stepping away from the campfire and shooting back toward his group and the splendid African sunset, travel and adventure shooter Dan Heller created a dramatic shot of both his companions and the location **(below)**.

© DAN HELLER

Finally there is nothing wrong with the occasional "we were really here" pose. If it captures both the location and your companions in a fair light, then go for it. In the end you'll be happier having obviously staged shots than no pictures at all. And who knows, after the hundredth photo in front of a landmark maybe you'll get lucky and they'll stick their tongue out at the camera.

THE FACES OF STRANGERS

The idea of aiming a camera at someone you don't know—and may not even share a language with—is just something that makes a lot of people uncomfortable. But if you can work past this inhibition, if you can commit to photographing strangers as a regular part of your travel photography, you will broaden the depth of your images a thousand fold. No photograph of a landmark, no matter how beautiful, will ever compare to a well-made photograph of someone who lives in the place you're traveling.

For most people, particularly in touristy areas, having cameras aimed at them is a pretty common occurrence and they are usually receptive as long as you are polite and aren't invading their privacy. You certainly don't want to photograph a couple romantically conversing at a sidewalk café, but a waiter resting at an empty table probably won't mind at all. Think about the situations that you yourself would or wouldn't mind being photographed in and then use that as a gauge for judging when it's appropriate to shoot strangers.

©PETER BURIAN

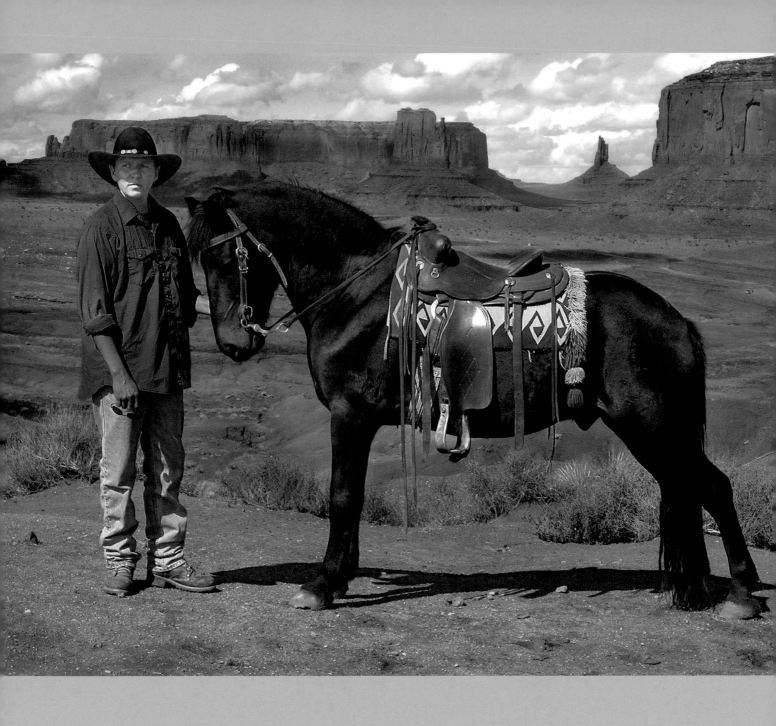

In a lot of tourist areas, locals expect—or even demand—to get paid a few dollars to pose—and personally I don't see any problem with that. It's not a secret that they are there, in part, to earn a living from the tourists, so paying them to perform a small service like posing seems acceptable to me. And in some situations, paying models is the only way to get a photograph. In Monument Valley, for example, the Navajo people who own the valley and generously open it to the public for a very nominal fee consider photographers who take pictures of them without permission to be rude. Often, of course, if you treat people with respect you get far more than you pay for. After giving this handsome Navajo a few dollars to pose at the much-photographed Ford's point, for instance, we got into a nice conversation. He was obviously very proud of the horse that he had spent years training and spent a lot of time making sure I got a great picture of them both. Though I shot hundreds of images during that week, this remains my favorite **(at left.)**

Language, of course, becomes a problem in some situations. Even if you don't speak the language, just making brief eye contact and then pointing to your camera will get the point across—either a person will smile and nod back or turn away from you. If they accept your polite advance, take a few quick pictures and then, if you're feeling really brave, just walk up and shake hands—and then gesture that you'd like a specific pose.

One of the best results of photographing strangers is that often you make a new friend—and that opens up a myriad of image opportunities that you could never have predicted. I tend to start conversation with strangers wherever I go (even if I don't speak more than a few words of the language) and I've developed some lasting friendships over the years.

©PETER BURIAN

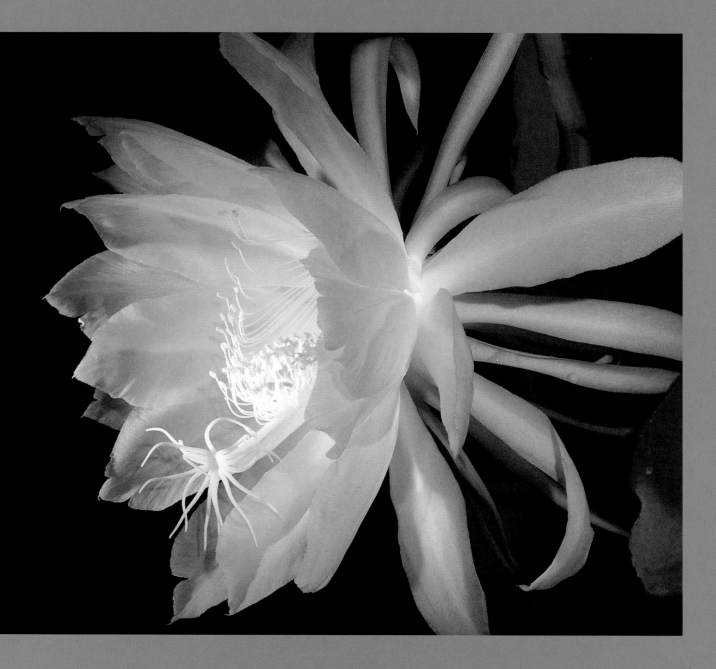

"Sometimes I think I do get to places just when God's ready to have somebody click the shutter."

—Ansel Adams

Nature

It takes only a quick glance at the calendar section of the local bookstore to see that nature is one of our favorite subjects—and with good reason. Five minutes spent in the company of a clump of wildflowers or aiming a lens at a mountain stream has a powerful ability to mend the frayed edges of modern living. And we experience a rekindled sense of that serenity every time we look back at our outdoor photographs. It's not surprising then that next to photographing family and friends, we probably spend more time photographing nature than any other subject—and you certainly couldn't ask for a more diverse creative challenge.

Whether you have a specific interest such as wildlife or close-up photography, or simply like to explore in wild areas with your camera at the ready, nature never ceases to delight and inspire. In fact, part of the fun of nature photography is that you never know what you'll find and—visions of the Crocodile Hunter wrestling giant pythons in the rainforest aside—you need never travel farther than your own back yard in search of interesting subjects. From the creepy crawly beasts hiding beneath garden stones to the stars swirling radiantly in the nighttime sky, even the most mundane of suburban locales provides a veritable jungle of opportunities. Even the urban world has its share of wild creatures and happenings. Just a short walk from downtown San Francisco, enormous sea lions have crowded boaters out of the local marina and provide an extraordinary—and very accessible—photo opportunity.

One of the enjoyable aspects of nature photography is the more you explore a particular subject, the more fascinating and diverse it becomes. Although Ansel Adams traveled widely during his career, he devoted more than half a century to exploring a single national park—his beloved Yosemite. Galen Rowell, who was one of the world's most highly regarded mountaineers in addition to one of its greatest nature photographers, devoted much of his life to photographing mountain landscapes that few of us had ever witnessed before. His book *Mountain Light* remains one of the finest wilderness books ever published.

Plentiful and diverse as nature's bounty is, however, nature does not yield her finest treasures lightly. To capture the beauty of a rainbow, you must endure a certain amount of rain. To witness the unexpected color of the desert in bloom, you have to travel to the desert not knowing whether your quest will be

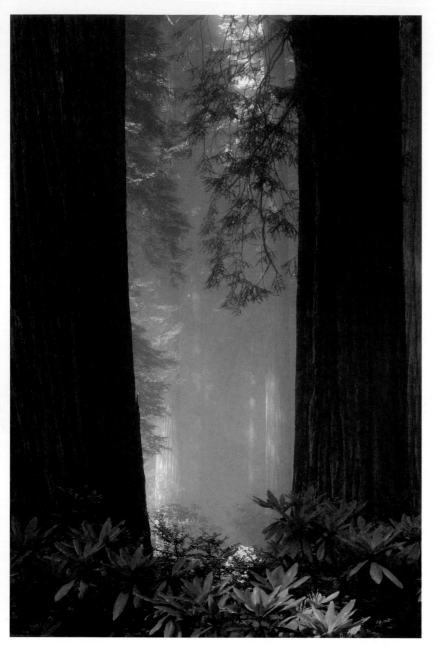

© B. MOOSE PETERSON

THE NATURAL LANDSCAPE

When early landscape photographers like William Henry Jackson and Timothy O'Sullivan started across the American West in the late 1800's to record extraordinary vistas that few non-native people had ever seen, they brought cameras equal to the task. Their "field" cameras, built to record images on light-sensitive glass plates as large as 20 X 24-inches (unfortunately, enlargers had yet to be invented), had to be hauled in horse-drawn wagons or carried up mountains on the backs of mules.

To further complicate things, the plates needed to be coated with a light-sensitive emulsion (the film) in totally dark tents just prior to exposure—a process that often took hours of tedious labor. Jackson once boasted that he was able to coat a single plate in a record time of just less than fifteen minutes. These same plates had to be exposed and processed almost immediately, before the wet emulsion dried and rendered them useless.

Needless to say, you had to really like a scene before you clicked the shutter. (On the other hand, if you didn't like the scene afterward, you could scrape the image off the glass, clean it and start again—kind of like an early version of digital photography.) Jackson's work profoundly influenced both photography and American history. His images of the Yellowstone area of the Wyoming Territory were largely responsible for convincing the United States Senate to create Yellowstone National Park—America's (and the world's) first national park.

Since most compact digital cameras fit in your jacket pocket, the physical process of shooting landscapes is decidedly less burdensome today. The goal, though, remains the same: to tell the story of an interesting setting clearly and dramatically.

A landscape photograph then is simply an image that tells a visual story about a particular place—any place. Though we're talking about natural landscapes here, landscape photography does not begin and end with nature—the local strip mall, forgotten rural railroad crossings and the parking lot at work are all worthy landscape subjects.

rewarded or ignored. And to record the hundreds of images of waterfalls that are his specialty, photographer Derek Doeffinger (see pages 196-198) has spent years exploring New York's Adirondack and Catskill Mountains—with little more than a topographic map and the anticipation of good photo opportunities to lead him on.

Whatever your photographic ambitions, nature has the challenges waiting for you. On the following pages we'll take a look at some of her themes and offer points on how to capture them with your digital camera.

INTERPRETING THE LAND

The kinds of settings you choose to photograph and the types of landscape stories that you choose to tell say as much about you as they do about what you place in front of the lens. Ansel Adams' magnificent landscapes of Yosemite Valley are not so much about waterfalls and mountains and gathering winter storms as they are about Adams' reaction to those elements. That Adams was awed by his surroundings clearly shows in his amazing photographs.

How you interpret a landscape then is your own personal statement about the world around you. Landscapes can be brash, refined, somber, gentle, or clever. They can whisper, scream, entice or even shock. While one photographer might look at a pristine shore line and see the cheerful beauty of sand and sun and turquoise waves, another might see only the loneliness of the deserted beach.

When it comes to natural scenery, many photographers (myself included) often think only in terms of the "grand vista" and the exotic locale. We spend so much time stumbling around looking for the magnificent panorama that we ignore the subtle scenes of mystery and magic that surround us everyday.

A landscape can be as large and profound as the Grand Canyon or it can be as common as the local fishing hole. Use that creative freedom to ferret out the landscapes that others overlook and you'll never run out of interesting subjects. Varying the scope of your landscapes not only challenges your imagination, it provides variety and depth to your photographs. As you explore for the big picture, also look for simple, quiet landscapes—they often reveal the true character of a place better than a grand view.

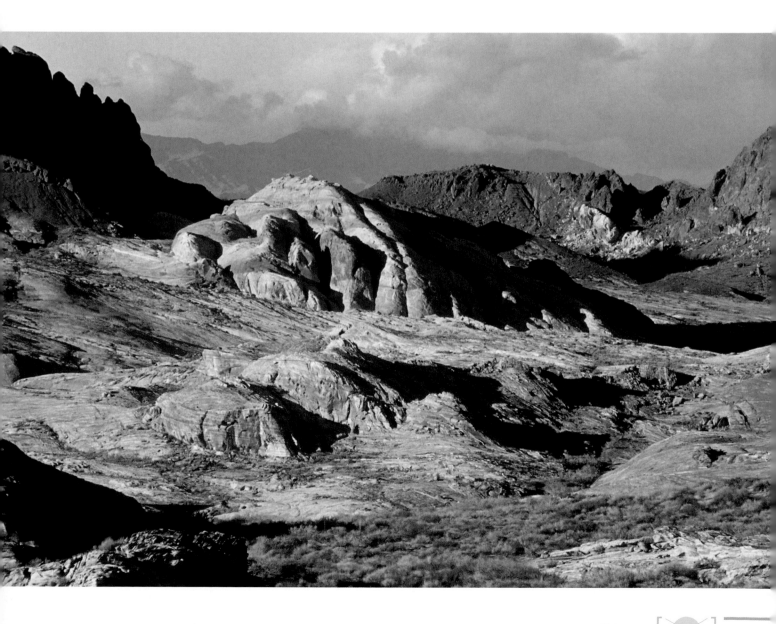

Choosing the best vantage point is one of the toughest aspects of photographing natural landscapes. The world isn't marked with helpful little signs telling you where to stand to get the best shots—that part is up to you. When you first happen upon a scene that excites you, examine why before you begin photographing. Is it the sun filtering through the trees in the background? Or is it the curve of the river winding through a canyon? Identifying the elements that caught your attention in the first place will help narrow down your ideas and isolate the visual ingredients needed to tell your story. In time this sort of introspection will become second nature.

Getting to know a place is another useful and crucial part of landscape photography. Sometimes you'll get lucky and stumble onto a great vantage point, but most good landscape photos arise from an intimate knowledge of the land. When I arrive at a new fishing cove in Maine or a wildlife refuge in Florida, my instinct is to start shooting immediately. Sometimes those first-impression shots are good because my reaction is instinctual. But in the days that follow, I'll almost always find I can better isolate and identify what is exciting me, and I get better pictures.

Pace is another important consideration in finding great landscapes. If time is short (as it usually is on vacations), don't spend too much time on one view or one aspect of a landscape—you might miss other opportunities around the corner. If a place is new to you, explore it before locking yourself into one viewpoint. I can't tell you how many times I've spent hours working a landscape scene that I thought was the just the coolest thing on wheels, only to hike a few hundred yards farther down the path and find a much better shot. It's a lesson I've had to relearn many times.

On the other hand, after you've spent some time exploring, if you have the time to linger, try to relax into the scene until the mood and the charm of the locale come to you. Lighting and time of day play such a profound role in most landscape photographs that sometimes the best decision is to simply stay put until the light and mood reach their peak. One of the best pieces of landscape advice I ever got came from my friend, travel shooter Catherine Karnow, who advised me to "slow down" and spend more time in one

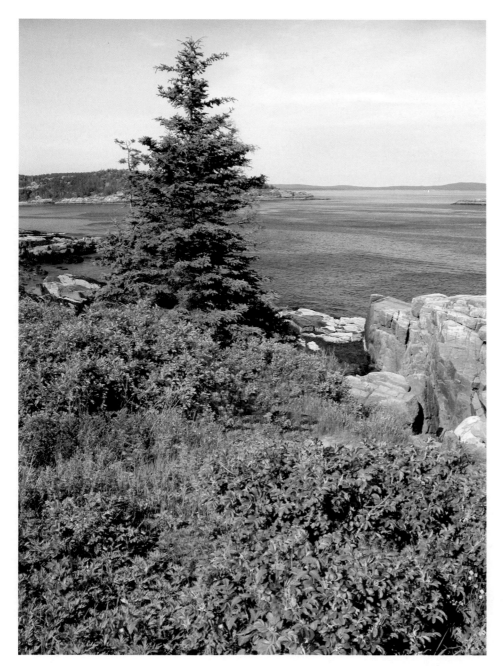

small area. She told me that one of the secrets to her photography is that she often covers "less than a mile—often far less" of territory over an entire day.

Finally, you might think that landscape photography is all location, location, location—but sometimes it comes down to experience, experience, experience. The more you shoot, regardless of how common the scene might be, the better your pictures will be. So practice wherever you are, whenever you have spare time.

Getting a great landscape shot is tough, but on the following pages we'll look at some popular landscape subjects and how to handle them.

If you have the time to linger, try to relax into the scene until the mood and the charm of the locale come to you.

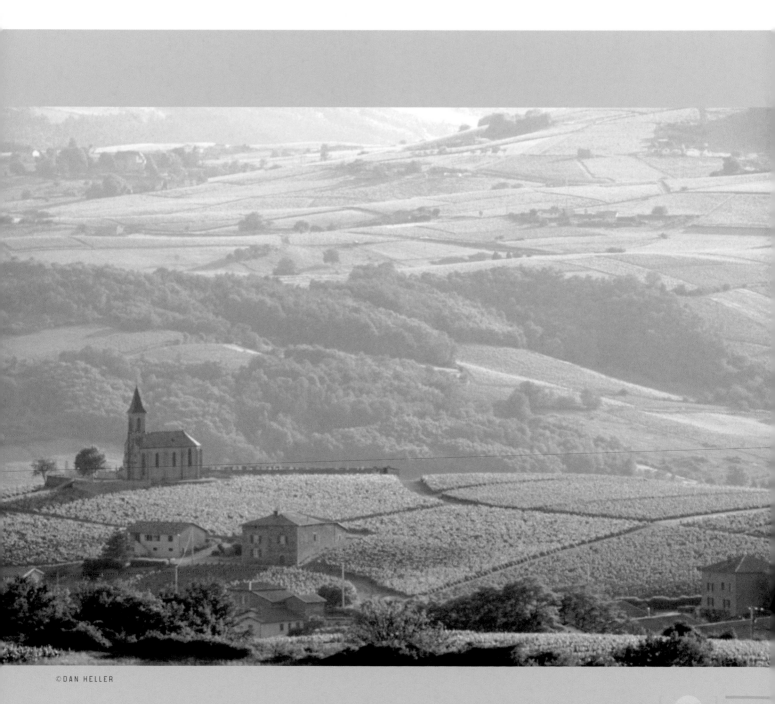

©DAN HELLER

Beaches and Shorelines

There's no place I'd rather be than beside the sea, and nothing I'd rather be doing than taking photographs, so you can imagine that I'm quite a happy person when I'm taking pictures of beaches or shorelines. I'm happier still when I download my pictures and find that I've captured a place's drama or beauty (and I'm equally miserable when I haven't).

Shore areas vary greatly in character, ranging from the sugary sand beaches of Florida and the Caribbean, to the rocky coastlines of Maine and Oregon. Some beaches are so pretty that it would seem difficult not to get good pictures of them; but even in the prettiest of settings, it usually takes work—both mental and physical—to coax their beauty into your camera.

The one thing that all beaches and shorelines share is the perpetual interaction of water and land. Wind, water, and shore exist in a relentless battle of erosion and replenishment and, though they seem idyllic, the battle is never ending—it's a fascinating process to watch and photograph.

I've lived all of my life just a few miles from an area of gentle suburban beaches and tidal marshes. Although they are rarely dramatic, they never look boring because they never stop changing. The same hard-looking shore that beams with brilliant sparkling water and blue skies at midday slips into a softer romantic landscape at sunrise or sunset. During hurricanes and winter storms, I have seen these passive beaches turn treacherous.

The drama of your images is largely determined by when you arrive at the shore area. The time of day, tidal fluctuations, winds, phase of the moon, weather and season all affect shorelines in exciting and sometimes very beautiful ways. If you keep an online journal or gallery, consider posting images of your favorite beach shot at various times to show how different it can look.

As you explore, keep in mind that part of the reason that beaches and shorelines seem so attractive is that all of your senses are responding to the environment. The sound of the surf, the smell of the sea and the warmth of the sand on your feet, all conspire to charm you. But your camera is limited to capturing just light and color and only in two dimensions, so before

you begin to shoot, step back a bit and examine the scene's visual elements. What are its strengths? What is the core of its drama? Is it the waves crashing into the rocks? The spray misting the air? The rippled sandbars and turquoise waters? Or are you being wooed by the morning fog shrouding the rock formations? This may seem like a rather analytical approach to finding a good landscape photograph, but in reality good photography is equal parts emotion and analysis.

Some beaches are so pretty that it would seem difficult not to get good pictures of them; but even in the prettiest of settings, it usually takes work both mental and physical to coax their beauty into your camera.

Faced with broad swatches of sea, sky, and shore that can easily overwhelm a composition, you must balance them in a pleasing arrangement. A large sky area exaggerates the spaciousness of a scene, while placing a rock formation or a long sandbar in the foreground accentuates the drama between land and sea. Often the best vantage point for finding appealing compositions isn't on the beach but rather on a bluff overlooking the sea. High vantage points provide a bird's-eye-view that reveals the graceful, natural curve of a beach or the expanse of a rocky shoreline.

Although an empty beach may be pretty, you can almost always improve a picture of a seaside scene by including a foreground frame or a center of interest—a pair of palm trees framing a sunset, for instance. Try placing a small center of interest—a lone beachcomber or an overturned dory—in the frame to provide both a focal point and a sense of scale. Look at the chapter on Design for more ideas on creating interesting compositions.

Also, take advantage of your built-in zoom lens. Even small changes of focal length can have a big effect on how your beach and shore shots look. For example, wide-angle settings exaggerate distance and heighten the isolation of an empty beach, while a medium telephoto setting (85 to 135mm) slightly compresses the scene and helps you isolate a pretty section from cluttered surroundings. Unfortunately most compact zoom digital cameras don't have extreme wide-angle capability, which can get frustrating at times.

Bright skies make it difficult to see your pictures on the camera's LCD screen. Commercially made hoods will help somewhat, but I've found another option: As silly as I probably look, I've taken to carrying a large black cloth (the kind professional portrait photographers use) that I throw over the camera and my head to see the LCD better.

Finally, remember that salt water—and the air around it—will damage electronic gear, so keep your camera in a small case or a zippered bag when you're not using it.

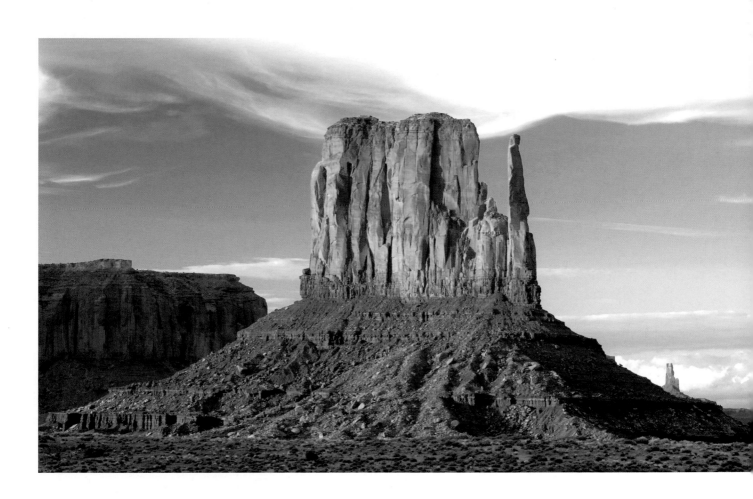

Deserts

When I was a kid my father worked for a publisher and one day he brought home a huge picture book about the desert that I found fascinating. Since I lived in New England where everything was green and lush and you could barely swing a fishing pole without hitting a pond or a brook, those haunting images of the stark desert landscape captivated me. While other kids my age were memorizing the names of dinosaurs or baseball players, I was dreaming of rattlesnakes coiled on rocky ledges in the Sonoran moonlight (waiting, no doubt, for the hapless pocket rat to saunter by).

It wasn't until many years later that I actually came face-to-face with a real desert (and a real rattlesnake), but it did not disappoint. I knew I had found one of the great visual loves of my life.

Though it's easy to think of the desert as a lifeless, severe and unchanging environment, in reality the desert landscape is teeming with life, and it is a place rife with both perpetual change and interesting photo-graphic opportunities. I think the desert reveals a greater palette of color and texture than any other natural environment. There is a price to pay for access to all of this glory—the desert is not a place to explore casually—but it is worth the effort required.

The three most dominant visual elements in the desert land-scape are texture, color and shape—and often you can find subjects that integrate the three to create interesting compositions. Twisted, pitted and ground by millions of years of relentless erosion, rock formations stand like modern sculptures **(right)**. And painted by their ancient geologic chemistry, the colorful sandstone and limestone "hoodoos" of Utah's Bryce Canyon create a visual fantasy carved in stone. In places like Death Valley (California) or White Sands (New Mexico), the ever-shifting dunes provide a continually transforming tableau of sands, shadows and textures that looks more like a location for Lawrence of Arabia than an American landscape.

The scale in many desert landscapes is deceiving because there are few visual cues to size and distance. Other than including another person, it's difficult to translate the spaces involved. One trick is to place a small cactus or other plant in the foreground to at least create some semblance of scale.

Because the desert is such a dramatic place, it's easy to get fooled into thinking that the more features you include, the more interesting the picture will be. But as with any landscape, when composing desert scenes, try to isolate a particular concept or visual theme by simplifying the number of elements. To make the picture of Nevada's Valley of Fire State Park **(right)**, I used a zoom lens at a medium-telephoto (85mm) setting to emphasize the immensity of the rock wall. This medium-telephoto setting also helped contrast the warm colors against the cool blue sky. By shooting late in the day, the textures of all the surfaces were exaggerated as well.

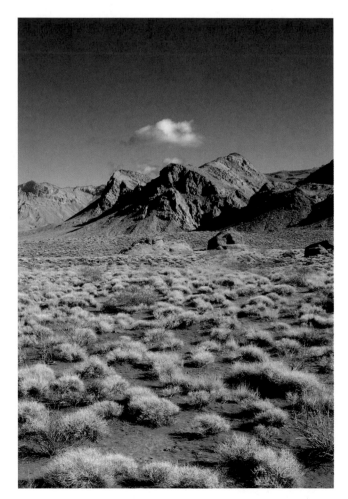

Nature > Deserts:
DESERT LIGHT

The image of desert light is an icon and a misleading stereotype: Umpteen B movies have shown us some poor half-dead cowboy stumbling through the relentless desert heat as the merciless sun threatens to microwave him on the spot (of course, he survives and fills the villain full of lead by the movie's end). Although midday in the desert is extremely harsh and

photographically unfriendly, desert light has a unique quality all its own.

Go at the right time and in the space of just a few minutes you can watch as the desert panorama re-paints and re-invents itself, rapidly revealing a new palette of colors and shapes and textures. That "right time" is early and late in the day—the golden hours for photography—when rapidly changing light gives you a full menu of color and textures to select from.

During the "golden hours" (also a time you can enjoy the cooler temperatures), the warm colors of the lighting exaggerate the already flamboyant desert colors. In places like Nevada's Red Rock Canyon **(above)**, for instance, the setting sun brushes the landscape with crimson red just seconds before it slips behind the rocky crags. As the sun disappears, be sure to turn away from it so you don't miss this sudden flood of wine-red light spilling across the landscape. Because

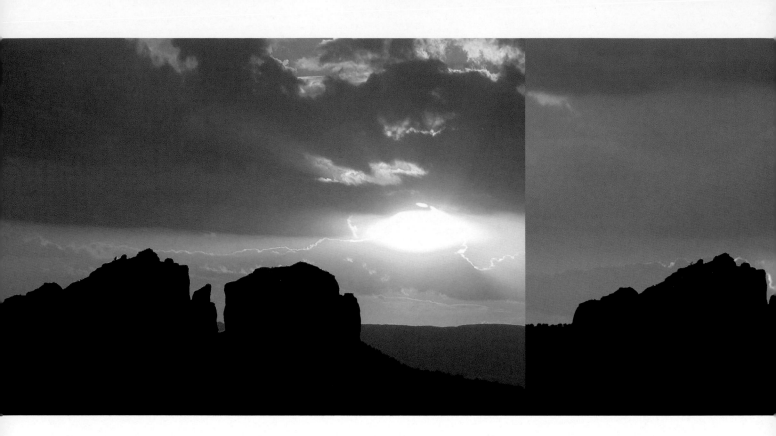

the light changes so rapidly, you should have a scene picked out and a composition ready to photograph.

Don't be too quick to leave after the last rays of light have passed. Many times I've seen other photographers pack up the moment the sun slips below the horizon only to see the sun ignite the sky with one last great crescendo of spectacularly colored afterglow. Under the vast desert sky, daylight lingers and twilight skies shimmer.

Of course, once twilight fades, the desert is as dark as a cave, so bring a flashlight along for safe passage through the witching hour of snakes and other creepy crawlers.

Nature > Deserts:
PLANT LIFE

Plant life is a surprisingly abundant subject in the desert and, unless you happen to live in the Southwest United States, the plants you'll see there are unusual compared to what you see every day. I've spent days at a time photographing cacti in southern Arizona, and I'm always surprised by how interesting and pretty desert plants are. I always leave wishing I had more time or more daylight. If you plan on photographing cacti or wildflowers, bring gloves and

a pair of kneepads—the best vantage points are down low, and your hands and knees will thank you later.

What makes desert plants visually fascinating are the unusual forms they have adopted to exploit and defend against their unforgiving surroundings. All of these plants have evolved in odd and beautiful ways just to survive. From the myriad flowering groundcovers of the Mohave Desert in Nevada and California to the forests of giant saguaro of the Sonoran Desert of southern Arizona and Mexico (which tragically seem continually victimized by human development), the sheer variety of desert plants boggles the mind.

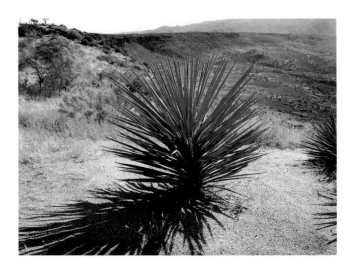

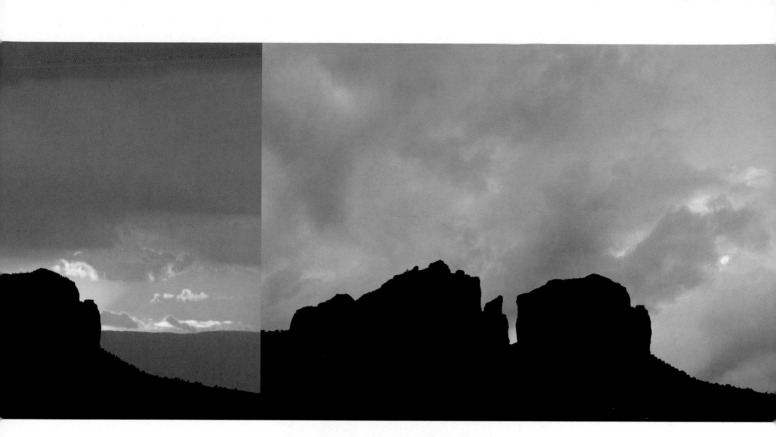

Photographing cacti and other plants is really just a matter of wandering and experimenting with interesting confluences of texture and shape. In shooting the giant saguaros, for example, I wanted to capture the bold eccentric shapes of these desert trees **(at right)**. Some saguaros live to be 200 years old and their size and the peculiar shapes of their "arms" seem to me to have been conjured by (or perhaps inhabited by) mercurial desert spirits.

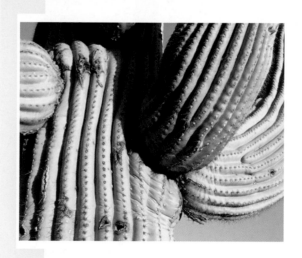

As you wander and explore, experiment using low angles and wide-angle zoom settings to exaggerate the height of taller plants and contrast or silhouette their shapes against the sky. Alternately, try longer zoom settings from higher vantage points to compress spaces and make the plantings seem denser.

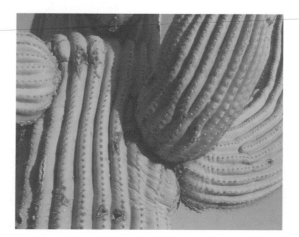

One of the things I love about the graphic nature of desert plants is that they lend themselves very nicely to creative enhancements. Here, I modified the color to rekindle that 1950's monotone postcard look.

Nothing that comes out of your camera is a finished product—play with your images until you find the vision that inspires you.

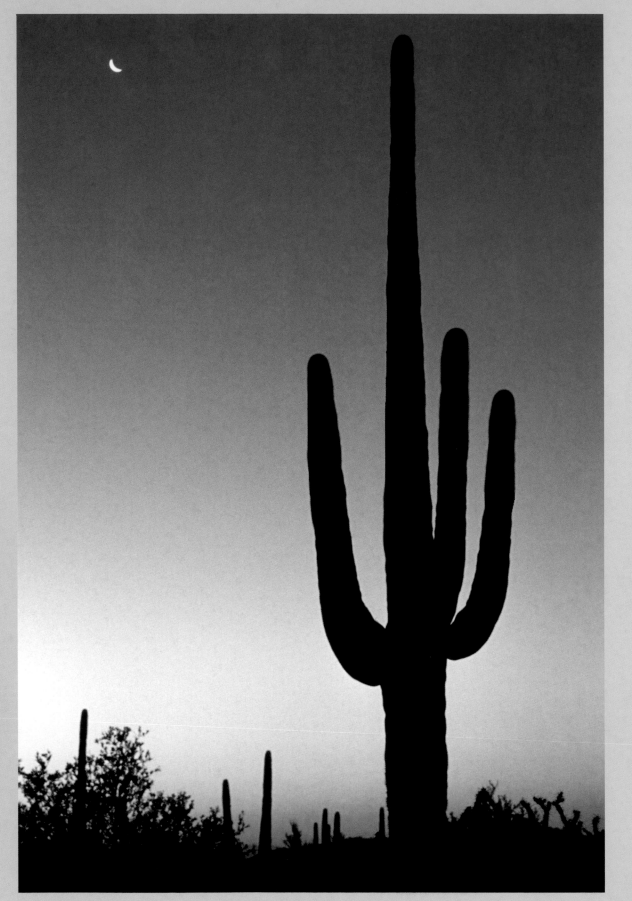

Early spring is a wonderful time to photograph desert plants, especially after wet winters.

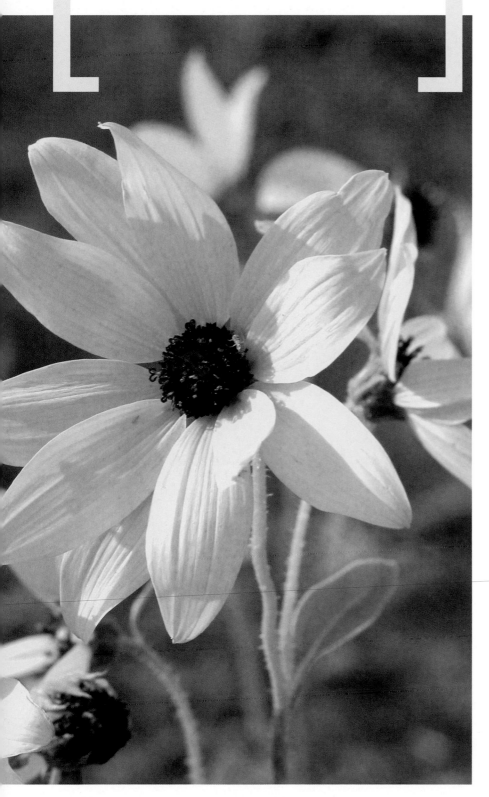

One of the first things I do when I arrive in any new or unusual natural environment, particularly a state or national park, is to stop by the visitor's center and pick up detailed trail maps, as well as some post cards of the area to see how other photographers have handled the same situations.

Early spring is a wonderful time to photograph desert plants—especially after wet winters—because the entire desert floor magically erupts into floral displays that jangle the imagination of even the most jaded gardener. Although I've seen seemingly dormant plants burst into bloom just a few days after a rainstorm, the best shows usually happen a few weeks after a good rain. Unfortunately, it's impossible to know just when the desert is going to burst into bloom, but if you contact the state or national parks in a particular region they will supply up-to-the-minute information (hopefully they won't say, "Oh, you should have been here last week!").

Most compact digital cameras have surprisingly good close-up or macro capability, so if the desert is in flower, capture individual blooms in addition to more sweeping scenes. Using a smaller aperture will help you increase depth of field (near-to-far sharpness) in the Close-up mode (if your camera has it), but you will have to switch to an Aperture-Priority mode to select your own aperture.

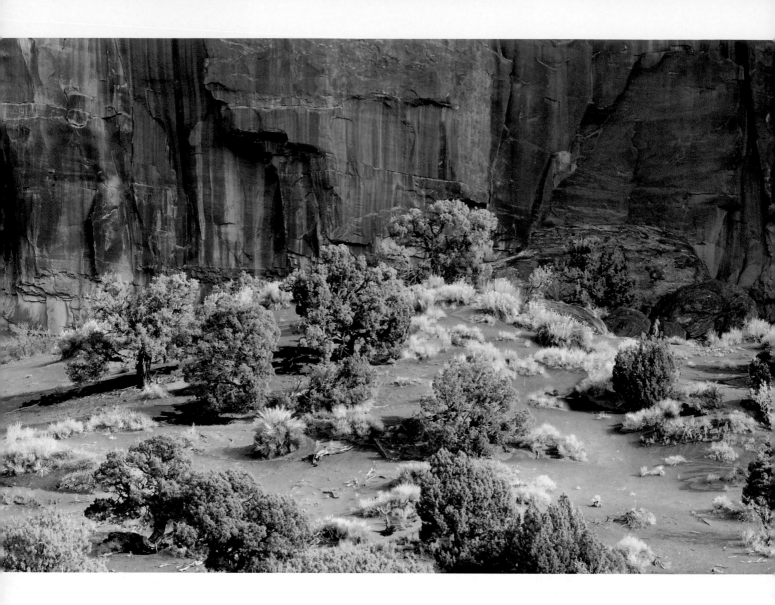

Bring plenty of water, a wide-brimmed hat, and an umbrella to keep yourself and your cameras cool.

Don't get too close to any cactus when shooting or you'll find out just how they defend their space. (They don't call the cholla cactus the "jumping cactus" for nothing—if you look at it wrong it will send a spray of needles your way.)

Needless to say, whenever you shoot in the desert you'll need to protect yourself and your cameras from heat, sand and rocks. Bring plenty of water (for drinking and washing hands), a wide-brimmed hat, and an umbrella to keep yourself and your cameras cool. It's also not a bad idea to announce your presence (to snakes, in particular) by stomping around a bit as you amble down a trail; it's great to see them,

but it's usually best if it's not a total surprise (for either party).

Keeping digital cameras clean is no less important than keeping film cameras clean. Be especially careful not to let fine windblown dust into the memory card slot when you're changing cards—and always put your extra cards into their plastic holders to keep them clean. If you're using a digital SLR, take particular care when changing lenses because the dust can get onto the image sensor and it's a nightmare to get it out. I always carry a lot of small zipper bags and microfibre cleaning cloths (that I store in plastic bags) and keep a constant eye on the cleanliness of the body and lens.

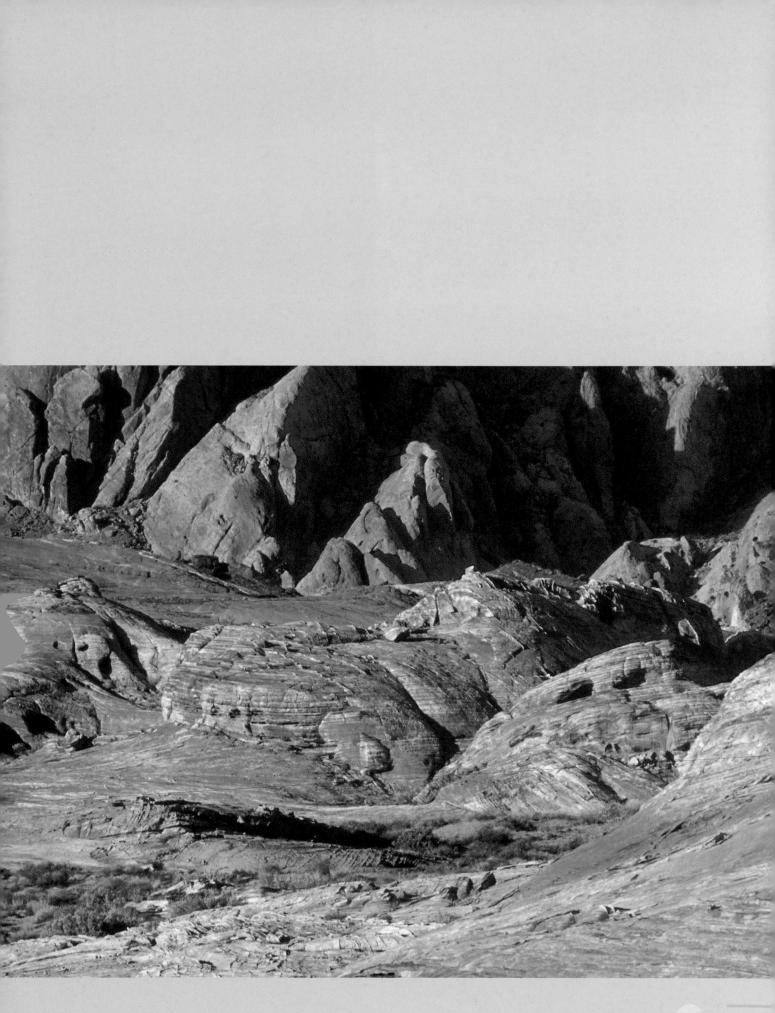

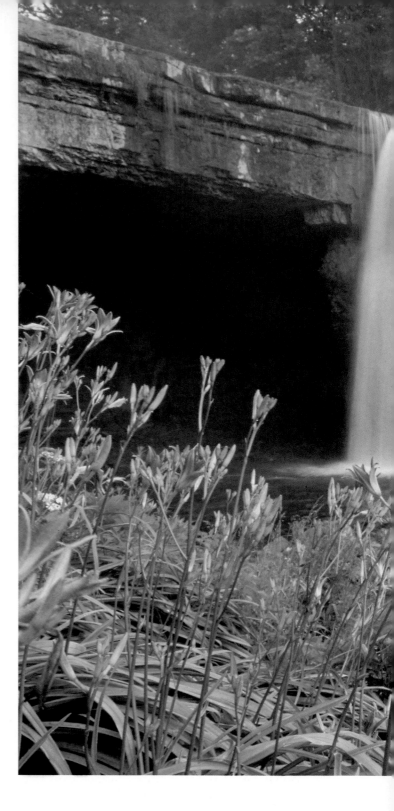

Waterfalls

Few things mesmerize us more than water responding to gravity's siren call. Perhaps it's the inner kid in us (no doubt anxious to launch a stick boat into its plunging waters) or just the fun of watching nature in action, but no matter how many waterfalls we've seen, it's hard to turn away from them. Whether it's the local brook tumbling over a few fallen logs, a mountain stream carving its downhill journey home, or one of the world's grand cascades, waterfalls inspire creativity. Indeed, when commissioned to create what was to become his most famous building (a home for Pittsburgh department store owner Edgar J. Kaufmann), architect Frank Lloyd Wright incorporated the waterfall on his client's property into the structure—and, of course, named it Fallingwater.

In most parts of the world waterfalls are a plentiful phenomena—I've even seen impromptu waterfalls sprout up in desert canyons after a heavy rain. Most falls are relatively remote and finding them can be part of the challenge—and the fun—of photographing them. If you're traveling in a mountainous region or in an area noted for its waterfalls, find them by studying local tourist maps and brochures or, for more prominent or historic falls, look for pictures of them on the post card rack. Studying cards and brochures is a great way to see how other photographers have approached particular falls.

In large wilderness areas, waterfalls are so numerous and well hidden that it can take years to find and get familiar with them. For the past 20 years Derek Doeffinger, a marketing communications manager during the week, has spent weekends and vacations exploring the hundreds of waterfalls in New York's Adirondack, Catskill and Finger Lakes regions. The results of his ambitious explorations have been published in two books: *Waterfalls of the Adirondacks and Catskills* (McBooks Press, 1999) and *Waterfalls and Gorges of the Finger Lakes* (McBooks Press, 2002). As his photos show (at right and on the following page), he has pursued his passion in every season, returning to the same waterfall time and again to capture it in the right light.

If you're exploring on foot, it's best to limit yourself to one or two lenses, or even one zoom. A wide-angle lens (35mm equivalent of 28mm or wider) is a good choice because it will enable you to work in tight confines while providing the inherent depth of field necessary to keep both near and far in sharp focus. One of the main creative decisions you'll need to make is choosing a shutter speed: a fast speed (1/125 second or faster) will freeze most water motion and a slow shutter speed (1/15 second or slower) will reveal the motion. An even slower shutter speed of 1/4 second or slower will turn the flowing waters of a mountain stream or falls into a silvery ribbon of liquid motion.

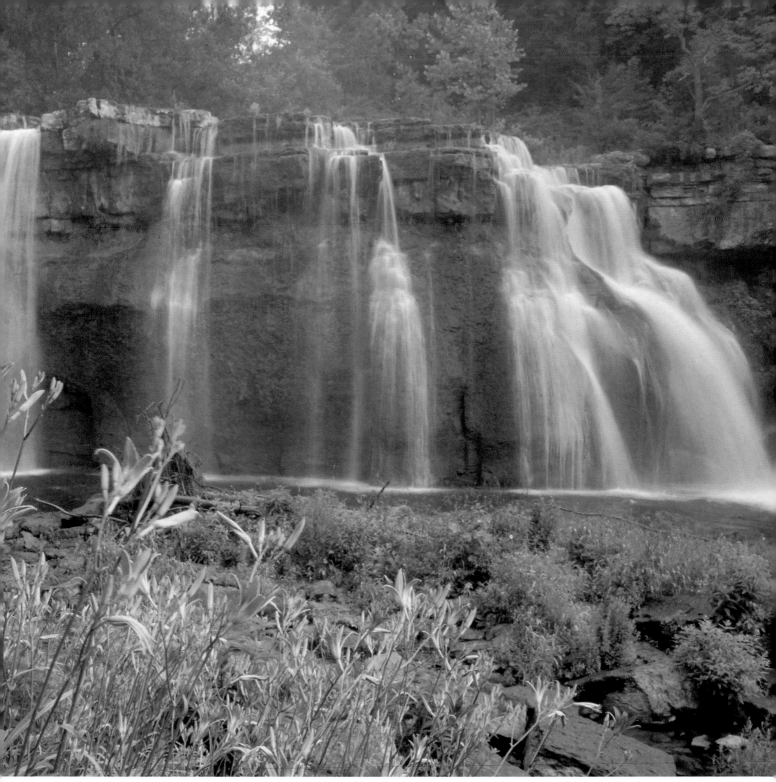

The vantage point has a large impact on how the falls will be perceived: photographed from their base or from the stream below accentuates their height and puts the viewer "into" the scene. Photographing them from the rim of the ravine or from a more distant vantage point offers a better perspective of the waterfall in its environment. Often, too, you can find a vantage point partway between top and bottom that provides an "eye-level" view of the falls.

One difficulty of photographing many waterfalls—particularly in wooded areas—is the contrast between sunlit water and shaded forest. The best solution is to shoot when the light is relatively even, or on cloudy and misty days when the lighting has a muted quality.

Whatever your vantage point, take special care—streams and waterfalls are slippery by their very nature and in the distraction of trying to set exposure and compose a photo, it's easy to lose your footing.

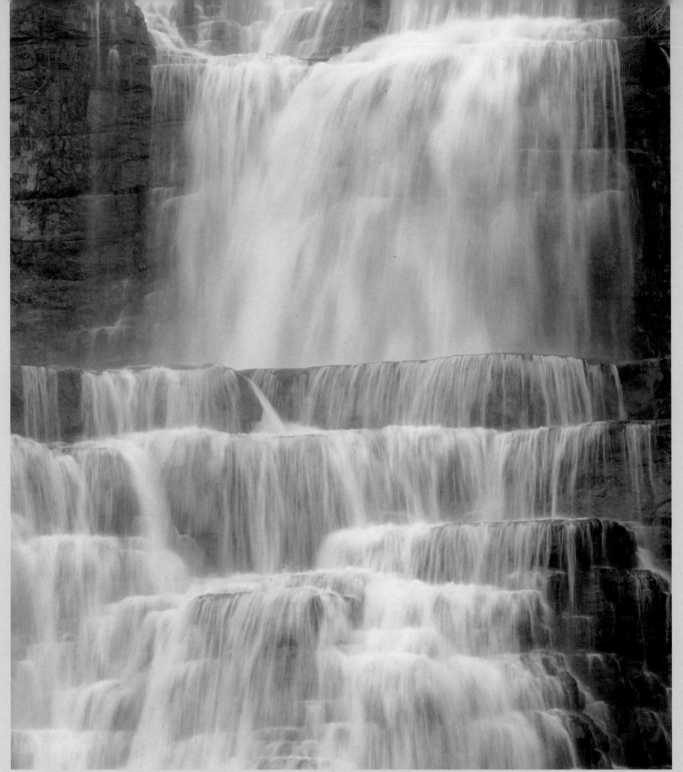

Often even very spectacular falls are known only to locals and back woods hikers. One way to uncover hidden falls is to study the topographic maps created the U.S. Geological Survey that are available in most wilderness supply stores (or you can purchase them directly from the government store at: http://store.usgs.gov/).

Another way is to spend a few hours reviewing maps at www.topozone.com. But the easiest way to find falls is to do an Internet search. Just go to your favorite search engine and type in "waterfalls" and the appropriate region. Waterfall aficionados are everywhere and often publish websites with pictures and directions to their favorite falls.

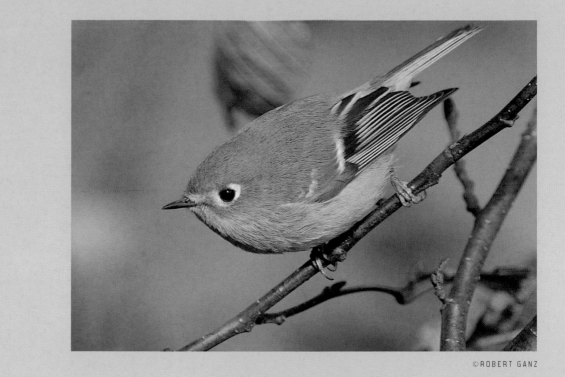

©ROBERT GANZ

Birds and Animals

Getting a great picture—or any picture for that matter—of a wild bird or animal makes shooting pictures of an uncooperative toddler seem like, well, child's play. At least you can catch and return a toddler to the vicinity of the camera—which is probably not something you'd want to try with a wild animal.

The difficulty of getting an interesting close-up photograph of a wild creature is precisely what makes wildlife photography such a challenging—and rewarding—hobby. Other than the birds and squirrels that frequent our backyard feeders, most animals recognize us and avoid us for the predators we are. So the first thing you have to master, before you can hope to get a good photograph of an animal, is getting closer to your quarry.

Telephoto Lenses

Most amateur photographers would argue that professional photographers get good wildlife pictures because they have access to powerful (not to mention very expensive) telephoto lenses. Most pros, on the other hand, will tell you that, while owning big long lenses is helpful, there's a lot more to getting close to animals than a telephoto lens.

There's no question; telephoto lenses make the job of getting good wildlife shots easier because they enable you to fill the picture area with your subjects from a substantial distance. The longer the focal length of the lens, the larger your subject will be in the picture. Shooting from a distance also means that animals will take less notice of you, which not only allows for more natural behavior and more interesting photos, but also makes it a lot safer (usually for the photographer).

The problem with getting close-up shots of birds and wild animals with a compact digital camera is that, with a few notable exceptions, most compacts have a limited zoom range. At the moment, the longest built-in zooms have a maximum optical zoom of 14x which is the 35mm equivalent of roughly a 380mm lens—which is a very substantial focal length, but still at the short end of the super-telephoto range. Still, if wildlife photography is something you'd like to pursue then a camera with a zoom lens in that range is something to consider.

©ROBERT GANZ

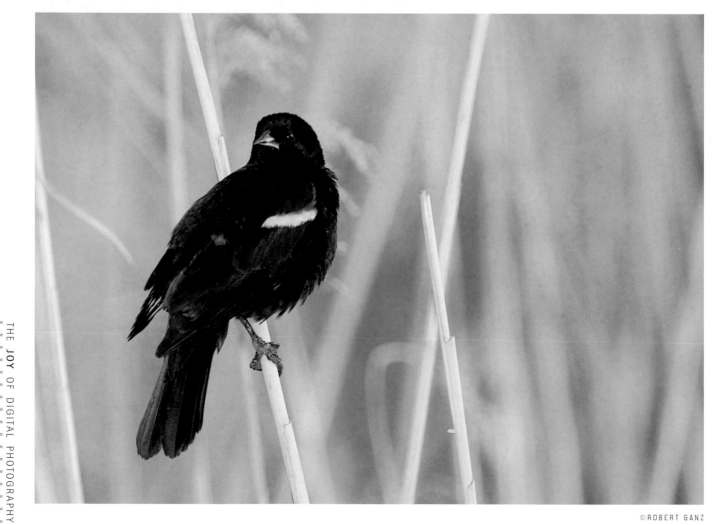

©ROBERT GANZ

Nature

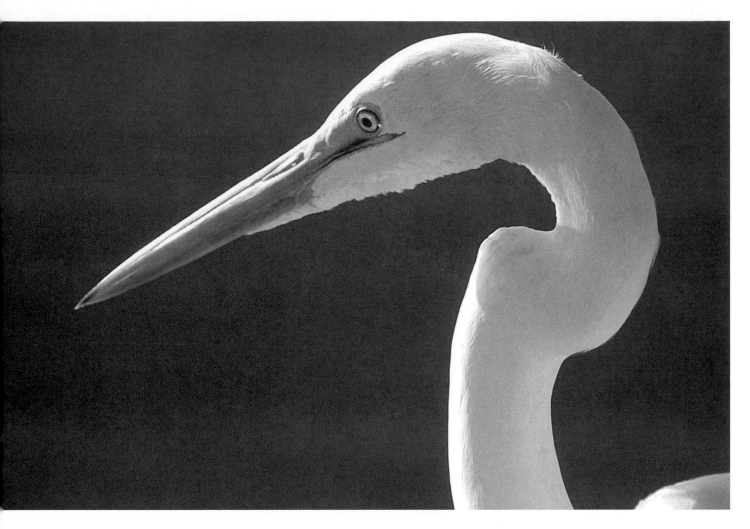

One of the benefits of the focal-length-magnification factor inherent in many digital SLRs is that your longer telephotos instantly become super teles. Here, the 1.5x magnification factor provided by my Nikon digital SLR turned a 400mm telephoto into a whopping 600mm lens that let me fill the frame with this great egret's profile (shot at the Merritt Island National Wildlife Refuge, Florida).

A digital SLR with interchangeable lenses offers the best solution because the availability of lenses in focal lengths ranging from 200 to 800mm and beyond substantially solves the distance problem. And as the price of digital SLRs continues to fall we'll no doubt see more and more affordable telephoto zoom lenses entering the market. The recent introduction of the 6.2-megapixel Canon EOS Digital Rebel was a quantum leap for amateur wildlife shooters because, priced at well under $1,000, it provided affordable access to the entire line of Canon telephoto and zoom lenses.

Just to give you some perspective on focal length and distance, I shot this photo of a Great Egret **(above)** using a 400mm f/5.6 lens with a 1.4x tele-extender, which provided a total focal length of 560mm from a distance of roughly 12 feet—with a 35mm film camera. To be honest, the lens was almost too powerful for the situation, and I had to move back a few feet to maintain the minimum focusing distance of the lens.

It's important to note that most digital SLRs (including the Canon EOS Digital Rebel) actually increase the focal length of traditional lenses used on them because the imaging sensor is smaller than the 35mm film frame for which SLR lenses were designed. In practice what this means is that the focal lengths (of lenses designed for film cameras) are effectively increased—typically by a factor of about 1.4 or 1.5x.

A 400mm lens effectively becomes a 560mm or 600mm lens—with no loss in lens speed when mounted on a digital SLR. Check your camera manual to find the magnification factor of your digital SLR camera.

Avoid the temptation to use the digital zoom found in many cameras. This feature crops your image digitally to make it appear large, but there is an absolute loss in quality. You can do the same thing (with better results) in your computer using the crop tool.

Long lenses do come with inherent drawbacks, including substantial size, weight, and (except for the most expensive—and we're talking new car expensive here) much slower lens speed. Also, lenses in the 600mm range often come with their own (very) over-

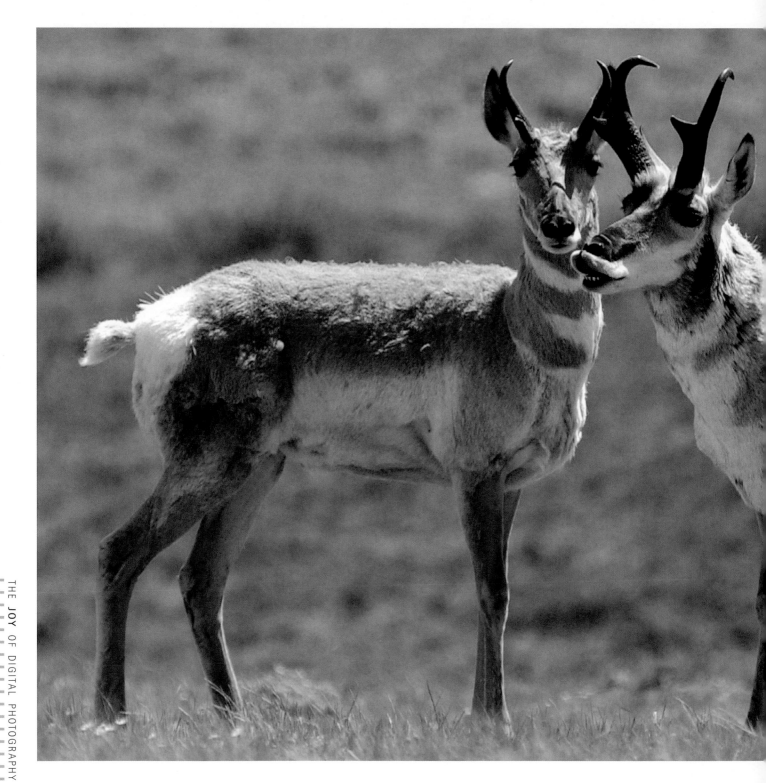

sized hard-shell aluminum cases that can make a day spent shooting pictures seem more like helping a friend move into a new apartment. Remember too, the more you magnify an image, the more you magnify camera shake—a tripod is essential.

WILLDLIFE FACE TO FACE

All the long lenses in the world aren't a substitute for two far more important elements required in wildlife photography: patience and knowledge of your subject. If you're photographing shore birds or wading birds in a marsh, for example, knowing a simple thing like whether they prefer to feed at high or low tide will help you predict when birds will be plentiful. It might also help to know that birds busily feeding are far less skittish than birds just shooting the breeze with other birds on the shore.

Not to be overly dramatic, but a bit of knowledge could also save your life. Knowing that when a moose lowers its head and folds down its ears it's about to charge (as opposed to asking for a good scratching) could come in handy should you stumble onto one in the woods of Maine or Minnesota.

Sometimes having a little luck and making a small effort can result in a winning picture. Photographer Doug Jensen happened upon this pair of antelope **(at left)** while driving in Yellowstone National Park. "I saw the tops of their heads while we were driving, so I got out and kept shooting as I got closer and closer," he recalls. "They kept walking away at about the same pace so I never got closer than 100-150 feet." Jensen made the shot with a 200mm lens on a Nikon DSLR and then cropped it tighter in post production.

Guided wildlife viewing trips offered in many parts of the world are a wonderful way to get close to animals.

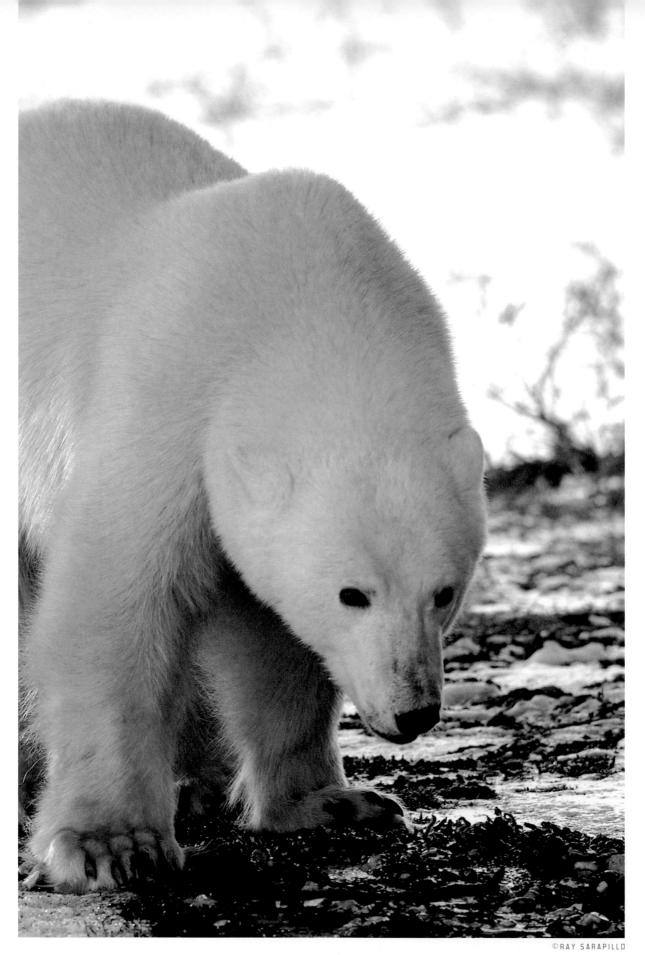

©RAY SARAPILLO

Nature

Guided wildlife viewing trips offered in many parts of the world are a wonderful way to get close to animals. In places like Alaska, where brown bears are plentiful, professional guides will take photographers incredibly close (talk about camera shake) to feeding bears. Photographer Ray Sarapillo shot this amazing photo of the polar bear **(left)** near Churchill, Manitoba from the safety of a Tundra Bus that brings photographers to within a few hundred feet of the polar bears.

Guided wildlife shooting trips are expensive, but the access they provide to dangerous and exotic animals is unparalleled. Magazines like *Outdoor Photographer* are a good source of information on reliable tour operators and wildlife guides. Also, some resorts and tour operators have particular well-known photographers that they work with on a regular basis.

©DOUG JENSEN

Left
Photographer Ray Sarapillo shot this amazing photo of the polar bear near Churchill, Manitoba from the safety of a Tundra Bus that brings photographers to within a few hundred feet of the bears.

Right
Doug Jensen took this photograph of a lion in a private game reserve in Massachusetts.

That can be an advantage because the photographers have an intimate knowledge of local conditions. Photographer Boyd Norton, world renowned for his African animal photos, has been leading photo safaris with Tanzania's Unique Safaris for nearly 20 years.

Some professionals occasionally use private captive animal preserves to get close to species—like cougars—that are nearly impossible to find or approach in the wild. If this idea appeals to you, you can find many preserves advertised in magazines like *Outdoor Photographer.* Although the preserves may charge a hefty fee, they offer once-in-a-lifetime opportunities to photograph animals that you're never likely to see, let alone photograph, in the wild. As a matter of ethics, though, if you do shoot in a captive environment, it's important to label any of your photos as a "captive subject" (particularly if you're trying to sell your photos or entering photo contests).

You can get very close to many birds and animals right in your own backyard. Setting up a birdfeeder next to a window and shooting from behind dark drapes provides an excellent method for getting close ups of small song birds even with compact-zoom digital

Right
Photographer Boyd Norton has made more than 35 photographic trips to Africa, including several trips to Rwanda to photograph endangered mountain gorillas. He shot this poignant portrait of a silverback gorilla named Mrithi while working on his book, *The Mountain Gorilla.* Mrithi was the leader of a group of gorillas called Group 13. Tragically, Mrithi was shot and killed by rebel terrorists in 1992.

cameras. You can manipulate birds into camera position by setting up a bare branch between your window and a feeder; the birds will land there to rest between feedings, giving you a predictable place to shoot them. As the birds get used to landing on the branch, simply snip it a few inches shorter and you can control exactly where they'll land.

At home or in the field, regardless of how far away you think you are, animals will almost certainly be aware of your presence. The more time you spend in the company of your subjects, the more they will regard you as an acceptable part of their immediate environment.

©BOYD NORTON

Underwater

Nature > Underwater:

While picking up shells on the shore may be the most intimate connection many of us have with sea life, there is a world of color, life and wondrous photo possibilities just a few feet beneath the waves. From exotic fish to beautiful corals and plants, the undersea world is brimming with colorful subjects— and bringing a digital camera down to record them is much simpler than it might seem.

There are basically two ways to get a camera below the waves: one is to use a digital camera made specifically for underwater shooting, and the other is to use a waterproof housing to protect your existing digital camera. If snorkeling at a seaside resort or going on the occasional dive trip is the extent of your underwater shooting you can often rent the gear you'll need from dive outfitters, dive resorts, or local dive shops. If diving is a more serious part of your life, however, you might want to consider either buying a camera made just for underwater use or, if you've already invested in a digital camera, buying a housing and an accessory flash for your camera.

And, as with all forms of photography, remember that it's not how expensive your gear is but how devoted and imaginative you are as a photographer. The spectacular photos on these pages were all shot by Jim Langone (a Springfield, Massachusetts-based commercial photographer) using a relatively inexpensive Ricoh (3.2 MP) digital camera in a Sea & Sea underwater housing with a Sea & Sea flash unit. He shot these images off of the island of Curacao in the Caribbean.

A few good sources for underwater equipment are: Underwater Photo-Tech (www.uwphoto.com), Sea & Sea (www.seaandsea.com), and Sealife (www.sealife-cameras.com). You'll also find lots of good equipment news and general information at these two sites: www.wetpixel.com and www.digideep.com.

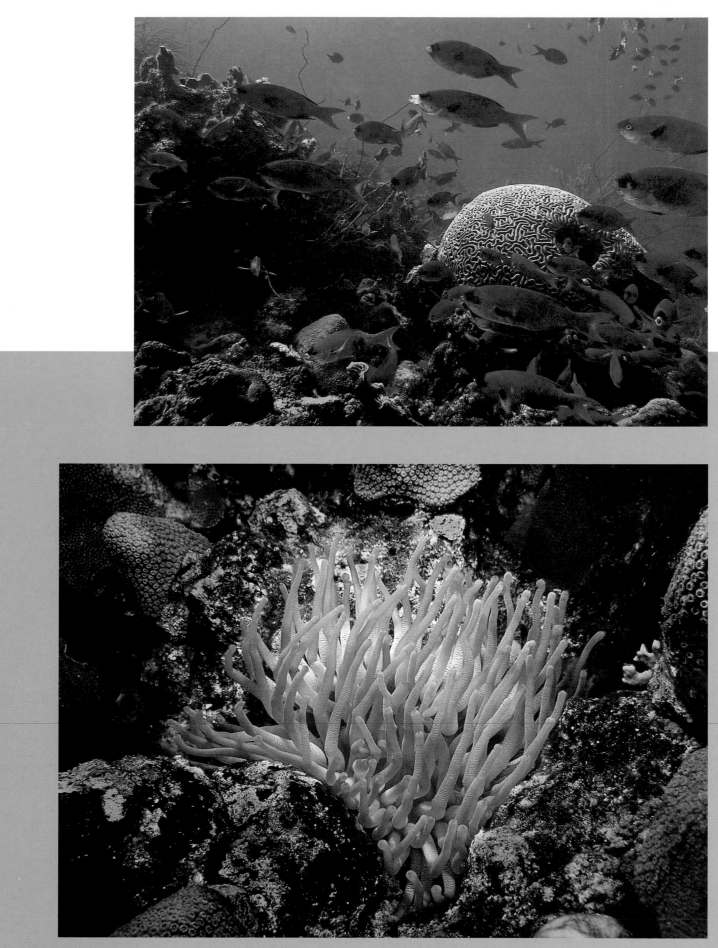

Close-Ups

Nature> Close-Ups:

TAKING CLOSE-UPS WITH A DIGITAL CAMERA

As kids we all explored the world around us with a magnifying glass in hand, fascinated by the alien appearance of everyday objects magnified. Somehow as we get older we become jaded to such experiences, but taking close-up photographs is a terrific way to journey back into this miniature world that surrounds us everyday but that we rarely explore as adults.

Until you get down on your hands and knees and start poking around the blossoms in your garden or the Lilliputian world of the forest floor, you never know what you'll rediscover. Interesting close-up subjects are easy to find. Flowers, bugs, a butterfly's wing, dew drops glistening on a spider's web, the intricate veins of a maple leaf and the colorful patterns on seashells are fascinating when viewed up close. As they say, the closer you look, the more you're bound to see.

Taking close-up photographs with a digital camera is surprisingly easy and, unless you really get involved in this part of the hobby, you won't need much—if any—special equipment. Most compact-zoom digital cameras have a Close-up (macro) mode capable of getting to within an inch or two of your subject. With some cameras, you can focus at these close distances without using the Close-Up function. With my camera, I can fill the frame with a single violet blossom—pretty amazing for a compact digital.

If you're shooting with a digital SLR that accepts interchangeable lenses, you can get even closer to your subjects using special accessories.

Nature

Digital SLRs (whether or not they have interchangeable lenses) have one main advantage in macro photography and that is that you're seeing in the viewfinder exactly what the lens (and the camera's sensor) sees.

Most compact cameras are also capable of showing you what the lens is seeing—but only if you use the LCD monitor. If you use the optical viewfinder you'll run into a technical problem known as "parallax." Parallax simply means that there is a difference between what the viewfinder is seeing and what the lens is seeing—and when your subjects are only a few inches in size or smaller, that can be a major problem. You might frame the center of a zinnia blossom, for example, and find out later that you've only recorded the outer petals.

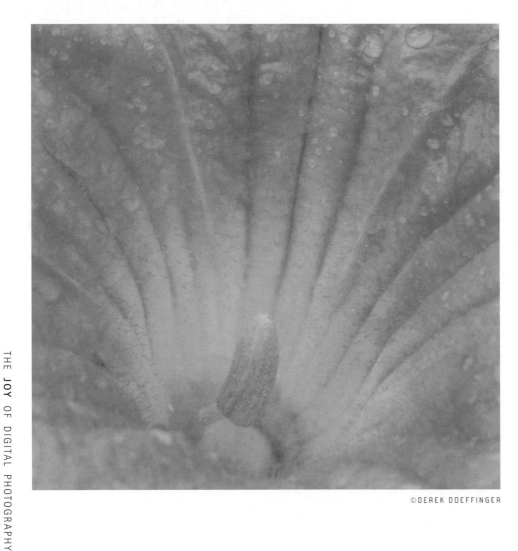

Nature>Close-ups:
LIGHTING FOR CLOSE-UPS

Lighting can be tricky with close-up subjects for several reasons, not the least of which is that because your subjects are so small even minor changes in intensity, quality or direction of lighting are exaggerated. If a shadow moves one yard in a landscape, you'll probably never see the difference, but if it moves a few millimeters across a flower blossom, your entire composition changes. Light changes also happen much more rapidly with

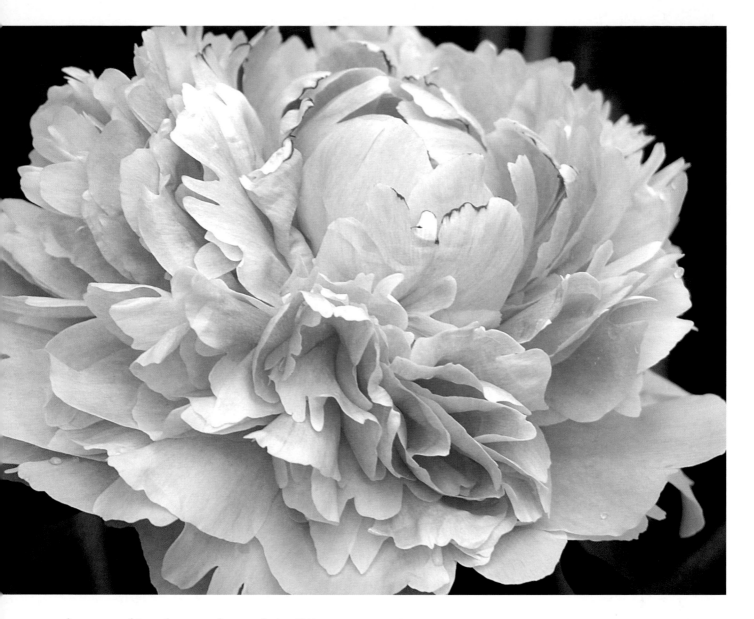

close-ups subjects because the area being lit is so miniscule. If you dawdle or don't anticipate changes in lighting, you may find you've missed your shot.

Quality of light is very important in close ups and each type of lighting can have both benefits and drawbacks. Soft lighting from an overcast sky (or open shade) is nice because it reduces shadows and works well for intricate subjects, but it tends to mute colors and hide textures. Harder and more direct lighting saturates colors and accentuates textures, but makes contrast and exposure much trickier.

Lighting direction also profoundly affects close-up subjects and often dictates your vantage point. Backlighting, for example, will create pretty fringe lighting on small flower blossoms or petals, but often casts other parts of the subject into deep shadow. If you change your shooting position to avoid the shadows, you lose the beauty of the rim lighting. And again, even

> Soft lighting from an overcast sky (or open shade) is nice because it reduces shadows and works well for intricate subjects.

small changes in camera placement will impact the appearance of your subjects.

Getting enough light on your subject is yet another important issue and often you'll have to rely on adding lighting—either from reflectors or electronic flash. Because you're using small apertures to get more depth of field (the near-to-far area in sharp focus) and smaller apertures let in less light, you'll have to use longer shutter speeds to get a enough light for a good exposure. But here comes the catch-22: longer shutter speeds in turn increase the likelihood of a blurry picture from both camera and subject motion. Also, because both you and your camera (and probably your tripod) are so close to your subject, you have to be careful not to block the light falling on your subject— which is almost impossible to do in certain situations.

If you're working with a digital SLR, your lighting options open up because you can use accessory flash units. Accessory flash units are generally much more powerful, but more importantly, you can remove them from the camera body and place them in more creative positions—to the side or behind the subject, for instance. Also, by using a light-activated triggering device called a "slave" you can use several flash units simultaneously to provide more even and balanced lighting to your close-up subjects.

You can increase the amount of light hitting your subjects and hopefully gain a few stops in shutter speed in several ways:

1> Use small white or silver cards to bounce light back into your subject; by placing the cards facing the light source (the sun), you'll be able to aim light at your subject.

2> Try turning on your flash (some cameras will turn the flash on automatically in the Close-up mode), but flash at close range tends to obliterate subject detail and replaces, rather than enhances, the delicate natural lighting that might have attracted you in the first place. If you've got the patience, you can soften flash by folding a few layers of white lens tissue over the flash head.

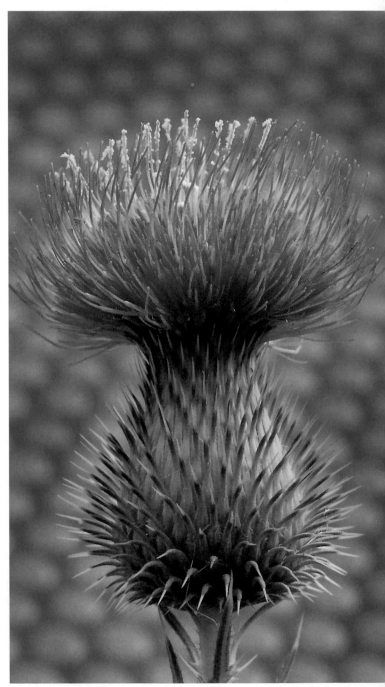

©DEREK DOEFFINGER

Nature

Advanced Tip:
FOCUSING

Regardless of the type of camera you're using, accurate focusing is crucial because the depth of field is very shallow—often a fraction of an inch. If you're using an SLR, switch to manual focusing and focus on the exact part of the subject that you want sharp. Some compact digital cameras also have a manual-focusing feature but these typically work by fixing the focal length at a specific setting and then requiring you to position the camera at a specific distance from the subject. If you don't have a ruler handy, manually focusing a snapshot camera will be difficult, even when you use the LCD monitor. This method can take some getting used to (not to mention good eyes) and requires you to have some flexibility in your shooting distance, but it works.

You can maximize depth of field by switching to an Aperture-Priority mode and using as small an aperture as possible. Of course, using a small aperture requires the use of slower shutter speeds that increase the possibility that a puff of wind or a slight camera vibration will blur your subject. (You will never speak kindly of breezes again once you starting shooting a lot of macro pictures.)

A small tripod capable of very low positioning is essential for most macro work because camera shake from handholding the camera can easily blur the picture. The problem with tripods, even small ones, when working close to the ground is that it is difficult to keep the front leg of the tripod or the shadow of the tripod from appearing in your picture. I often overcome this problem by resting the camera on a small soup-can sized beanbag that reduces camera shake and doesn't interfere with my subjects.

Macro photography is a world unto itself and there are a lot of devotees out there. If this subject interests you, post your images to a group online gallery where the world can enjoy your discoveries.

Above
While shooting grape hyacinths in my backyard, I rested the camera directly on the ground, and using the articulating LCD screen to frame the scene, I was able to turn these diminutive flowers (about three or four inches tall) into towering spires. Explore different angles and remember our motto: The closer you look, the more you'll see.

Using an LCD screen to compose a close-up shot has both advantages and disadvantages. Cameras with an articulating LCD screen (one that lets you adjust its position) make it easier to compose shots of flowers and other low-lying subjects because you can aim the screen up and view it from a kneeling or bending position. On the negative side, it's hard to see LCD screens in bright sunlight, making both composition and critical focusing difficult.

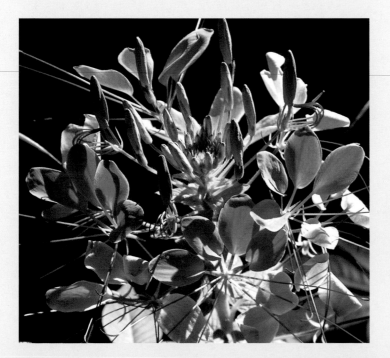

Left
Backgrounds are very important in close-up work, so keep a dark or plain background behind the main subject; an errant blade of grass or a curled leaf that may seem innocuous enough in person will often create a distractingly out-of-focus blob in the picture. When I'm working in my yard, I feel free to pluck any offending flotsam out of my camera's way, but in the forest I leave living subjects unharmed. Instead I use a stick or a piece of photo gear to temporarily restrain an errant piece of greenery.

Weather

I̲t's natural to think about taking outdoor pictures when the sun is high, the clouds are puffy and innocent, and the scent of summer fun floats on the breeze. But nice weather can lead to terribly dull pictures—particularly if those are the only days you pick up the camera. Limiting your outdoor shooting only to nice days will give your images an inescapable sameness. Making an effort—even just occasionally—to include stormy skies, fog and mist, ice and snow and the occasional lightning streak will paint your pictures with drama and freshness.

On a more practical note, unless you happen to live in Hawaii, the odds of your having nice weather all the time are small. Finding beauty in all kinds of weather then will expand your outdoor opportunities considerably. More importantly, as weather patterns change, a single landscape or outdoor scene may quickly offer up a variety of distinctive moods. And after all, capturing nature's moodiness is what makes nature such a fascinating subject.

Remember that often it's not the weather itself that supplies the drama, but rather the agents of change themselves: gathering storm clouds, swelling waves, or wind-driven treetops. The after-effects of weather are equally appealing: the intensified colors of a desert landscape or a fresh blanket of snow in the forest. Although you may have to sit out the nasty weather, you can dine on a buffet of one-of-a-kind photo opportunities before and after a storm.

Remember that often it's not the weather itself that supplies the drama, but rather the agents of change themselves: gathering storm clouds, swelling waves, or wind-driven treetops.

FOG AND MIST

Fog and mist make intriguing additions to any landscape photograph—they soften edges, simplify complex scenes and add mystery and romance to familiar locations. So if romance and mystery are things you like, fog and mist can be wonderful visual additives. Draped in fog, once ordinary scenes can beckon like a wallflower come unexpectedly to life at the prom.

The best time to discover such scenes is early morning, before the sun has burned away the excess moisture in the air. Morning mists burn off quickly, so arrive before dawn for adequate shooting time (which may explain why I don't have a lot of fog and mist shots in my files). Early in the morning you may also encounter dramatic compositions of golden rays cutting through the silvery veil and raking across the landscape.

You're more likely to find both morning and evening mist near bodies of water, such as ponds, rivers and marshes. Open ponds in winter are a good place to look for misty landscape scenes because as the warm air of the day passes over the cold water, a mist forms over the surface. In hilly or mountainous areas, fog often begins to tumble over the treetops in the late afternoon and again, the long rays of afternoon light can create very dramatic scenes.

Because mist steals away details, colors, and textures, build your compositions around bold shapes and bright colors—a silhouette of a lone pine tree on a hillside or a red tugboat tied to a dock. Also, because fog and mist do simplify the landscape so drastically, very often scenes with bold shapes and colors will jump out at you even if you're not looking for them.

Underexposure is a common problem with foggy and misty scenes because both are very reflective and will trick your meter into thinking there's more light available than actually exists. The solution is to add an extra stop of exposure by using a +1 setting on your exposure compensation feature.

In very thick mist or fog your autofocus may have difficulty finding a sharp point of focus because most systems use areas of contrast to help them focus. If your camera is spending an inordinate amount of time racking back and forth searching for a point of focus, try instead to focus on a particular object that has more defined edges—or switch to manual-focusing if your camera has that feature.

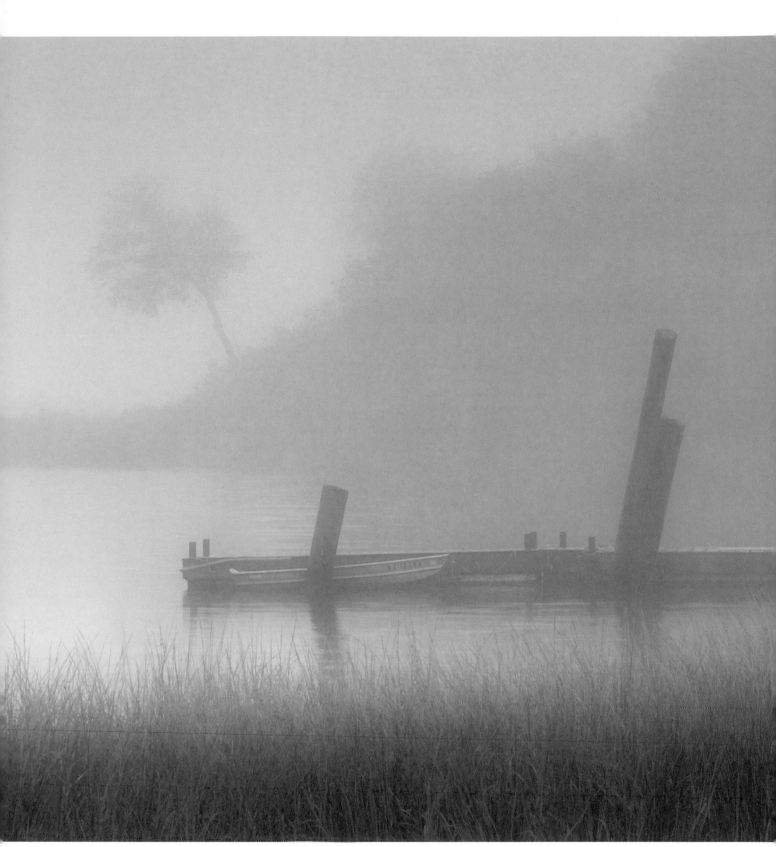

©DOUG JENSEN

If romance and mystery are things you like,
fog and mist can be wonderful visual additives.

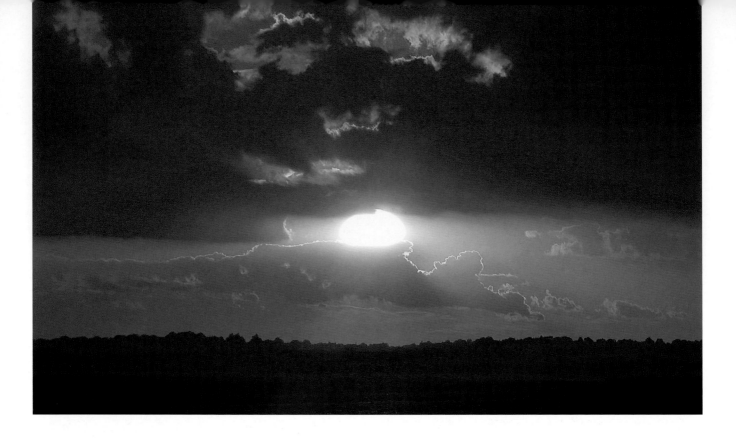

SUNRISE AND SUNSET

In 1883 the Krakatoa volcano near Java blew its top and shook the entire planet. It sent tidal waves racing around the globe, reaching even Manhattan, although greatly diminished by distance. One hundred times more powerful than Mt. St. Helens, Krakatoa spewed monstrous quantities of dust high into the jet stream and sent spectacular sunset skies more than halfway around the world. Skies glowed so wildly and brilliantly in places as far away as Poughkeepsie, New York that local fire departments sent crews to extinguish what they thought was a fire in the sky. Now that is a sunset worthy of a postcard! According to written journal accounts, those skies continued to "burn" radiantly for more than three years after the eruption.

While we probably won't witness anything like Krakatoa-induced skies in our lifetime, sunrises and sunsets still seduce photographers everywhere. Indeed, it's hard to resist the beauty of a sunrise or a sunset because, like snowflakes, fingerprints, and Miles Davis solos, no two are ever the same.

However pretty a sunrise or sunset might be, you can't expect their beauty alone to carry your photographs any more than you can expect one pretty pot of geraniums to rescue a poorly designed garden. The key to creating an interesting sunrise/sunset photo is to provide an attractive landscape in which to hang your colorful sky. Look for subjects with simple and appealing shapes that can hold their own against the colorful fat lady singing in the background. Still, because you want the sky to dominate your scene, the best foregrounds are simple scenes with just a few bold graphic elements—a few sailboats in a harbor, a lighthouse on the beach or a trio of hikers on a rocky cliff.

Exposure is not critical with sunsets, and a variety of different exposures will give you interesting results. Because the sun is so bright, it will no doubt fool your autoexposure system. It will make the sun look good, but everything else will likely appear too dark.

Before taking the picture, set exposure by pointing the camera at the sky adjacent to, but excluding, the sun. Lock in the exposure (usually by holding the shutter button halfway down), recompose the scene to include the sun, and press the shutter button to take the picture. If your camera has a Manual exposure mode use it and, again, take your reading away from the sun itself, then re-compose to include it.

Bracket exposures to give yourself several pictures of different brightnesses to choose from—particularly if the intensity of the sun's light is changing rapidly. Of course, if all else fails, a little adjusting in post-production will fix most exposure flaws (but you wouldn't fool with the colors, would you?).

Lens choice profoundly affects "sunscapes" because focal length determines how big the sun appears in your pictures. The longer the focal length of the lens you use, the larger the sun will appear. Larger sun images are usually more dramatic.

Needless to say, whenever you include the sun in a shot, you're looking at a very bright star, so be sure not to look directly at it.

Nature > Weather:
RAINBOWS

If you're lucky, and have ventured bravely into the rain, the clouds may part and the photo gods may reward you with their ultimate blessing: a rainbow. No matter how long you wait for it, one great shot of a rainbow erases the frustration of many hours of rain.

You can often enhance the intensity of a rainbow in-camera by using a polarizing filter. If you're using a digital SLR you'll be able to see the effects of the filter in the viewfinder; as you rotate the filter the colors will begin to intensify and then fade if you rotate it further. Most compact digital cameras don't accept filters but try experimenting with a polarizing filter (one that's large enough to easily cover the diameter of the lens) being careful to maintain that orientation while holding it in front of the lens. It's not terribly convenient, but any port in a storm is better than none.

You'll have to remember a bit of grammar-school earth science to find rainbows: always remember to turn your back to the sun as it emerges and face the darkest part of the sky. Also, if you're out shooting in the rain, always take the time to scout a good foreground location while it's raining—don't wait until the rainbow appears to find a location for your shot.

Finally, I'd be a bit remiss not to tell you that there are software filters out there that let you add rainbows to any scene. Your friends will be very impressed. You could even add two rainbows, or three, or four. There, I've told you, but you didn't hear it from me.

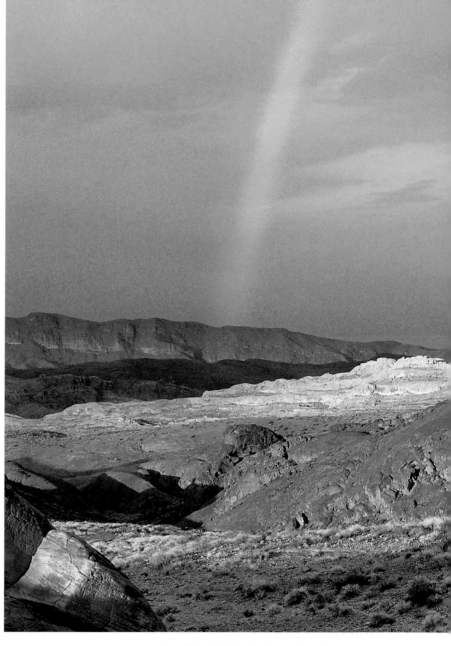

I shot this rainbow in the Valley of Fire State Park in Nevada after (barely) tolerating two continuous days of downpours sitting in a Las Vegas hotel room.

In utter frustration I drove to the "desert" park because I had a feeling that the sun was about to make an appearance (and let's face it, you can only watch so many "Leave it to Beaver" reruns). Just moments after getting to the most remote section of the park, the skies began to clear and the rainbow appeared. It never gathered the intensity I hoped for, but it was pretty and I've learned not to complain about rainbows.

Time Passages

Marking the passage of time is essentially what we do every time we pick up a camera, and it is the reason that most of us own cameras. We record the growth of our children, changes in the backyard garden and the highlights of our lives. After all, what fun would your twenty-first birthday be without Mom passing around the baby pictures of you naked in the bathtub?

The ability to freeze time allows us to look back, compare and study various moments and see how our lives and our environments have evolved. The family album is basically a visual journey through the times of our lives. Time sweeps past us constantly like an invisible wind, and photographs can help us at least slow it down enough to notice it, even if we are helpless to stop it.

Once you become aware of time as a conceptual element, you can apply it to different nature subjects and even make it the central theme of a series of images. One of the interesting twists that digital photography adds to this mix is that with many still cameras you can also record sound bites at the instant you record an image. So you can not only take a long exposure of waves crashing into the shore, but you can record their sound as well.

The passage of time you record can be anything from a few seconds, to fractions of a second, to a few days, to many years. Think of the difference between a city street shot at rush hour and the same street photographed at dawn. Imagine how different a meadow looks in summer, then in the dead of winter, shrouded in snow.

The most basic method for capturing small slices of time is simply to vary the shutter speed using very brief ones to record fractions of a second (still a passage of time, yes?) to long exposures of several seconds. In the photograph of the waterfall **(right)** for example, the photographer used an exposure of several seconds to record water rushing over a mountain stream in the Adirondacks. The ribbons of water visually trace time as their image moves across the camera's sensor.

By carefully photographing the same scene over a period of days or weeks or even years, you can record longer passages of time the progress of a wild morning glory vine moving up an abandoned billboard, a time-lapse sequence of a single rosebud opening or the growth of a special tree planted to celebrate a baby's birth. For years I've tended a

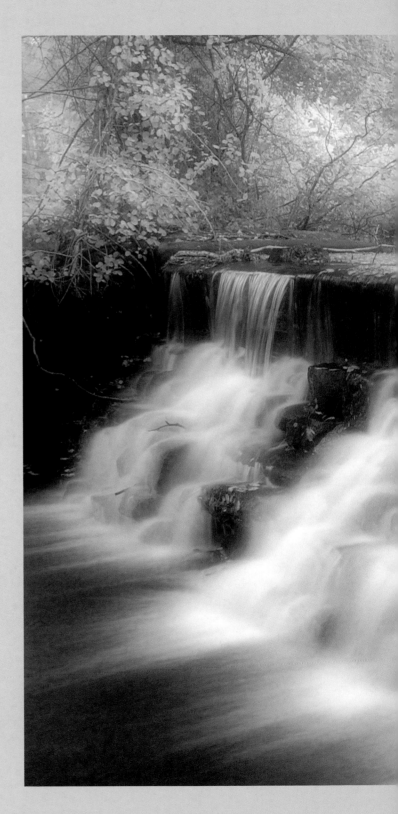

perennial garden along the side of my house and now that the garden has matured, I'm astonished to compare "then and now" photos and see how much the plants have grown.

One of the nice things about photographing time passages digitally is that the meta data recorded with your images includes the date they were shot, removing the burden of you having to remember or write down when you shot a picture. And amen to that!

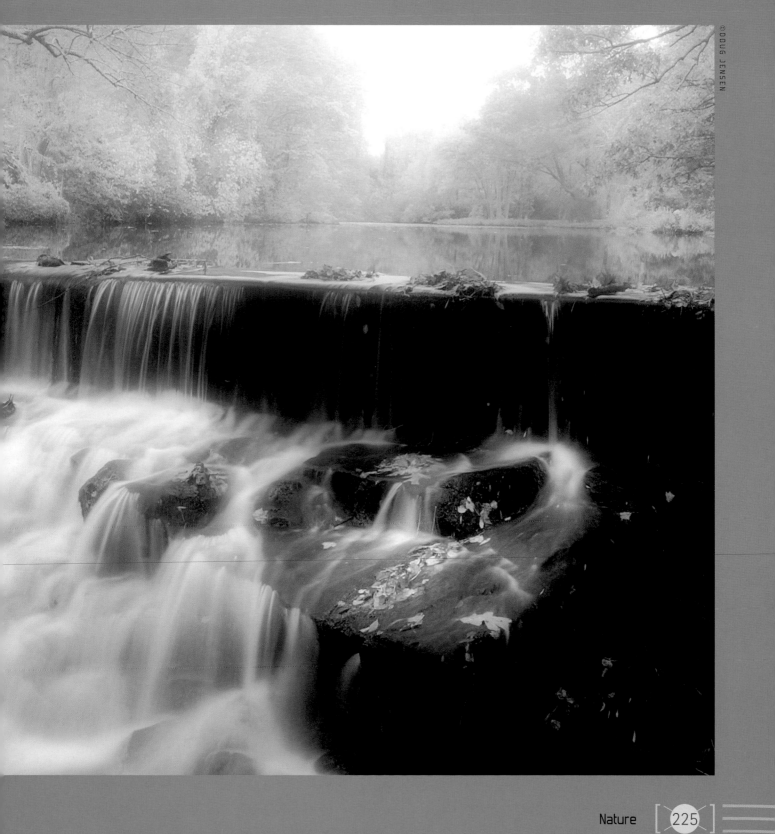

© DOUG JENSEN

"Retouching had become controversial ever since Franz Hanfstaengl of Munich showed at the 1855 Exposition Universelle in Paris a re-touched negative with a print made from it before and after re-touching. It was . . . the beginning of a new era in photography."
—Beaumont Newhall

The Image Enhanced

Introduction

In one of the more unexpected twists in cinema history, the classic movie *The Wizard of Oz* begins in drab tones of black and white befitting its depressed Kansas dustbowl setting. But when Dorothy, Toto and their farmhouse crash into the unsuspecting Wicked Witch of the West, they emerge into a magically transformed Technicolor landscape. The sudden change was the director's way of showing that the new surroundings had enchanting powers—and that Dorothy wasn't in Kansas any more.

In many ways, switching from film to digital photography is like emerging into a new photographic wonderland, as filled with magic and surprises as Oz. And you, as the photographer, are the new Wizard—or at least the new person behind the curtain. With the aid of a computer and basic digital imaging software, you have the power to turn normal buildings into Emerald Palaces, the ordinary into the extraordinary and the mundane into the magnificent.

On a purely practical level, image-editing software enables you to endlessly and dramatically improve your pictures. From correcting bad exposures to eliminating color shifts, from removing facial blemishes to restoring colors in treasured family photos, there is nothing you can't alter or improve. With just a few clicks of your mouse, you can banish red-eye in portraits or replace a gray sky with a bright blue one—you could even add a rainbow to your backyard garden. And the wonderful thing is, if you make mistakes along the way, you can revert backwards as easily as shaking a drawing out of an Etch-a-Sketch (or perhaps as easily as clicking your ruby shoes together). And then you can begin again.

It is in the creative realm where the challenges and fun of digital imaging are revealed. Regardless of whether or not you have any drawing skills, the digital domain is a place where boundless creativity and personal vision rule above manual dexterity, and where imagination trumps reality. In this brave new landscape you'll be reinventing your photographs with the unabashed glee of a five-year-old with a new box of crayons—a very big box of crayons at that. Whether you want to replace real color with false color, combine several images into one, or turn the cornfields of Kansas into the poppy fields of Oz, you have the tools.

As you master these many useful and creative skills you will surely come to discover the true joy of digital photography—the joy of setting your imagination free. And you'll discover that neither you, nor your photography, are in Kansas anymore.

Cropping

It's funny what great photographers we become after the fact. Like backseat drivers and Monday morning quarterbacks, it's easy to spot the mistakes after they've been made. Fortunately, in photography we at least have the quiet dignity of being able to spot our own errors. And, of course, being able to rethink pictures and revisit your vision is the beauty of digital imaging.

The quickest way to improve any composition is to crop away unimportant or distracting information. Perhaps you included one too many boats in your harbor scene, skewing the composition. Or maybe in the excitement of the moment you put too much

sidewalk foreground into your shot of a street musician and he now seems lost in the clutter of the crowd. By digitally cutting away the excess visual fat, you get a second chance to re-focus attention on your main subject.

You'll find the cropping tool in your tools palette indicated by a pair of intersecting "L" brackets that form a disjointed rectangle. Click on the cropping tool, and either an adjustable box automatically appears on your image or, as with Photoshop, will appear after you click in the image. You then click and drag the border of box to surround the area you want to keep. Or, depending on

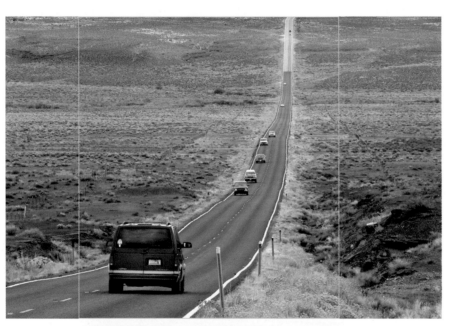

your program, you may also be able to drag the crop box into position. In some programs the area you're deleting will appear shaded but visible until you commit to the crop, so you will be able to see exactly what you're cutting away. If you're going to print your picture on a standard-size paper (4 x 6, 5 x 7, or 8 x 10 inches), then maintain that aspect ratio when you crop the picture. In most programs you can enter the final dimensions of the crop and the software will let you crop only that size. You can move the crop box around in the image, but the ratio remains fixed. Unless you have a demanding need to keep the image a certain size (to fit in a family newsletter, for instance), you'll have far more flexibility by not restricting the aspect ratio.

Some photographers are reluctant to snip away parts of their precious images. Don't be one of them. The advantage of post-production work is being able to improve your images after you've shot them. Besides, you're the only one who will have seen the un-cropped image; everyone else will see only your masterpiece— beautifully composed and without a millimeter of excess visual baggage.

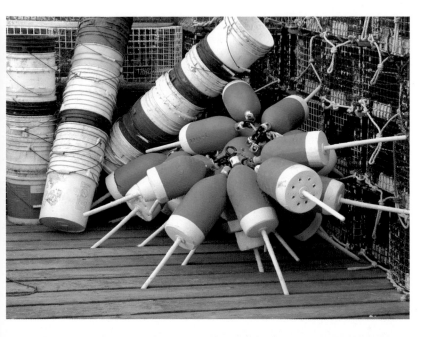

After you crop an image, its file size is smaller because you've eliminated data from the file. It's as if you took a traditional color print and cut away a few inches of paper; you haven't hurt the remaining information, you've only deleted what you didn't need. If you crop a substantial amount of the image away, your final print will, of course, be substantially smaller. If your original file was adequate to print an 8 x 10-inch print at 300 dots per inch (dpi) and you cropped 20% of the image away, you would have to settle for a smaller print.

However, within certain limits, you may be able to regain the approximate original image dimensions, by simply resizing the image and lowering the dpi (in **Photoshop Elements: Image>Resize>Image Size**). As you lower dpi, though, you will lose some image quality; exactly how far you can reduce the print resolution and still get an acceptable print is largely a subjective matter—if you like the results, ignore the rules about print resolution. I've made numerous prints in the 200-220 dpi range that look just fine.

Don't be afraid to use an unusual cropping shape, such as a square or an oblong if it happens to suit your subject. Of course, nothing in digital imaging is permanent, and if you change your mind after you've cropped the image, you can always Undo the crop using the Edit menu. In Adobe Photoshop Elements, for example, the Step Backward command lets you make infinite reverses or simply call up the original image and try again. (You did make a duplicate and safely save the original, didn't you?)

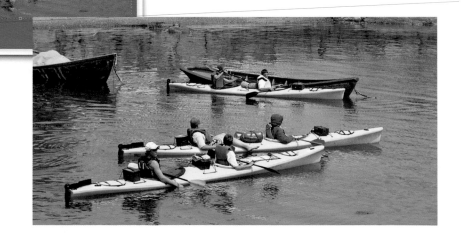

We've all done it: shot a beautiful sunset only to discover later that the horizon is so tilted that the sun seems to be rolling right out of the picture. No matter how pretty the scene, a skewed horizon will give viewers an instant case of vertigo. And though landscapes are particularly susceptible to looking off-kilter because the horizon line is so obvious, almost anything with a noticeably tilted horizontal or vertical line will upset our visual equilibrium— buildings, mantelpieces or even your normally straight and tall teenage son.

Crooked pictures are also common when scanning prints and it's much easier to straighten a flawed scan than to begin all over again. Some scanner software lets you make rotation corrections in the prescan, which is very handy.

In the pre-digital days the only cure for a crooked picture was to send the negative to a custom lab and have the composition hand-leveled in the darkroom— not a cheap or speedy option. Ah, but you live in the computer age. Fixing crooked pictures is a piece of digital cake using the Rotate or Transform tools (the exact tool will depend on which program you're using). Many programs provide you with several options to rotate your pictures: the most common being freehand, by one-degree steps, or in ninety-degree increments.

A NOTE ABOUT IMAGE-EDITING PROGRAMS

As I discuss editing techniques throughout this chapter, I describe the process when using Adobe Photoshop software, which comes in two flavors: one for pros (Adobe Photoshop CS2) and one for advanced amateur photographers (Photoshop Elements 4.0). Other programs may offer almost identical functions, but you enact them slightly differently.

The transformation of your pictures starts with an image-editing program. Image-editing programs come in a variety of levels: from basic to intermediate to advanced to professional level. Most digital cameras and scanners come with at least a basic image-editing program. What's the difference between the different levels of programs? Mainly complexity and ease of use.

Basic Image-Editing Programs
Basic programs like Kodak EasyShare software and Roxio . PhotoSuite 7 Platinum try to make it as simple as possible for you to adjust your pictures. They favor automatic adjustments, and often give you step-by-step wizards that lead you through the process. And they have a limited set of features — which means you don't have to learn a lot, but also, you can't do as much. For instance, you may be able to adjust overall brightness or color but not select a face or other small area to adjust only it.

Intermediate
Intermediate programs, such as ArcSoft PhotoImpression 5 and Microsoft PictureIt give you more features, and more ability to adjust your pictures. They often include a variety of picture accessory enhancements, such as templates for printing projects like greeting cards and newsletters.

Advanced
Advanced programs like Adobe Photoshop Elements, Jasc Paintshop Pro, and Ulead Photo-Impact, empha-size control over automation and provide rich feature sets. Sure you can adjust color or brightness by clicking on a button, but you can also manually tweak them. Plus, they pro-vide creative features like layers (discussed later) and masks.

Professional
The primary professional program is Adobe Photoshop CS2. It provides the ultimate in creative control, plus a variety of features that a professional photographer or graphic designer needs to control color management and preparation of images for professional offset printing, web production, or pro-fessional photo labs. The complexi-ty of this software makes flying a fighter plane seem simple. Of course, the advantage is that if you screw up with software, you don't have to eject.

In Adobe Photoshop Elements, for example, in addition to the various default settings (90° Left or Right, 180°, Flip Horizontal or Flip Vertical, etc.) that are found in the Rotate tool, there is also a Free Rotation Layer option **(Image>Rotate>Free Rotate Layer)** that lets you nudge the offending lines (like the horizon) into submission a few degrees at a time. Alternately, in this program you can choose the Custom Rotate option (also under the Image>Rotate menu) and enter a rotation angle numerically in degrees.

Using the tool is very simple: just open your image and select the correct Transform/Rotate option and you'll notice several sets of tiny handles at the corners and in the middle of the vertical and horizontal edges of the image. Click on and tug a pair of handles and twist your image around a small rotation point in the middle of the picture until it looks level. You're done.

Anytime you rotate an image, it's best to do it in one step because if you attempt to do it in stages you'll deteriorate the image; if you need a few practice runs, it's best to trash the test images and then start over with a fresh duplicate image. Also, because you're skewing the image from its original frame lines, you will notice some blank (white) areas are now showing around the edges of the image; you can get rid of them by simply cropping them away using the Crop tool.

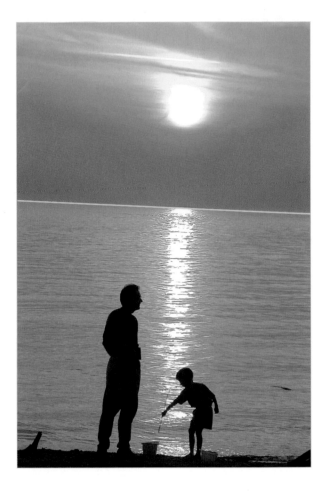

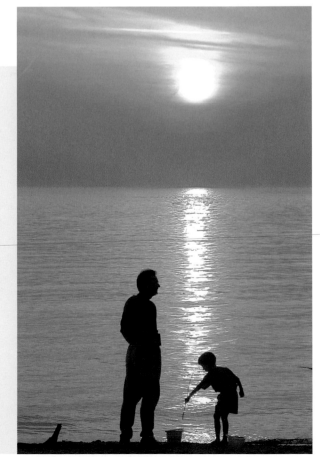

Here are the steps for leveling an image:

1 > Open the image in your imaging software and, as always, make a duplicate to work with. Some programs (like the full version of Adobe Photoshop) require that you select the entire image before beginning the rotation process.

2 > Select the correct Rotate or Transform tool (in most programs it's found in the Image or Edit menus).

3 > Put your cursor on one set of the grab handles and rotate the image until it is level.

4 > Select your crop tool and crop the image to eliminate the white border edges created by the rotation.

5 > Save the new image under a new name.

The best way to achieve proper brightness is to create a good exposure in the camera by admitting the correct amount of light. Rarely, though, is a camera's ability to set exposure so perfect that a little tweaking with your image-editing software won't improve things. Of the thousands and thousands of digital images I've shot, I don't think a single one was perfectly exposed out of the camera. Most of them were acceptable, but there is always room for improvement (you can imagine what a pain I was as a customer back in the days when I used a processing lab).

Exposure isn't always just a matter of being correct either. Often you can change an image's mood by making it brighter or darker or, as often happens, your interpretation of a scene will change from the time it was shot. Even if you like the exposure of a particular shot, it's worth experimenting with darker and lighter versions to see if it improves the image.

Exposure problems can fall into two categories: incorrect brightness (too dark or too light) or poor contrast (too little or too much contrast). Virtually all image-editing programs have one-step Auto Exposure or Auto Contrast options that you can click to get instant results (though usually not instant satisfaction). Like most instant solutions in life, these options often fall short of their promise—though it certainly doesn't hurt to give them a click when you're in a hurry or if you're just curious to see how they work with a given image.

Even if you like the exposure of a particular shot, it's worth experimenting with darker and lighter versions to see if it improves the image.

BRIGHTNESS/CONTRAST

A somewhat more useful tool is the Brightness/Contrast adjustment. When you select this option, a small dialog box with two sliders opens up: one slider is for brightness and the other is for contrast. As you adjust the position of each of the sliders you can see the effects on the image (be sure you have Preview clicked or selected).

The problem with both automatic exposure fixes and simple brightness/contrast controls is that they adjust all the parts of an image—shadows, middle tones and highlights—in a particular direction. If the shadow areas of an image were just fine, but you wanted to darken the highlights slightly, moving the darken slider (to bring down the highlights) would also darken the shadows and mid-tone areas. Similarly, if you wanted to brighten the highlight areas, you would inadvertently lighten the shadow areas too much.

Fortunately, the software writers sensed your impending dissatisfaction with simple fixes and have created other options.

When it comes to contrast and brightness corrections, tread gently—a little goes a long way. In this example, by pushing both sliders to extreme positions you can see the image gets completely obliterated, at right. Somewhere between ordinary and outrageous is the prize you're after.

Improving Exposure

USING LEVELS

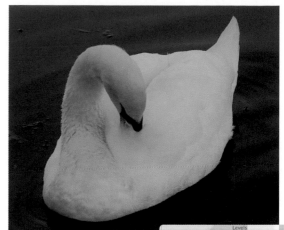

A better choice for fixing both exposure and contrast is a tool typically referred to as either Levels or Gamma. This control enables you to individually correct the shadow (dark), middle tones and highlight (bright) regions of your images, offering you precise control over both contrast and brightness.

In many programs when you select the Levels or Gamma tool, a dialog box displays a scary-looking graph called a histogram (which always sounds vaguely medical to me). Almost everyone is intimidated the first time they encounter this odd graph, but the histogram is merely a graphic representation of all the tones in your image ranging from shadows (on the left side) to mid tones (middle) to the highlights (right side).

You'll notice that below the graph are three small sliding triangles—one each for the shadows, midtones and highlights. The beauty of the Levels or Gamma controls is that they let you adjust each one of these areas independently by repositioning the triangles. As you slide the shadow triangle toward the center, for example, you'll notice that more areas of the image get darker—that's because any part of the image to the left of that triangle now becomes a shadow area. Similarly, if you move the highlight slider toward the center of the image more of the image will get brighter—because everything to the right of the triangle is now in the highlight region.

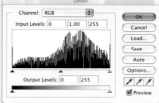

The histogram looks like a silhouette of hills. In fact, the height and width of those hills tell you a lot about the contrast, exposure and tonal range of your images. If the hill to the left is high and wide, for example, it indicates there is a substantial amount of shadow area. Or, conversely, if there is a large hilly area in the center or right side of the graph, there are large mid-tone or highlight areas, respectively. If all the areas of the histogram appear relatively equal in height and width, the contrast of your image is very even. In the uncorrected shot of the mute swan (at top), the spike is in the shadow area because the exposure meter was fooled by the brightness of the white swan, therefore underexposing the entire scene. By using the Levels tool to redistribute brightness, I was able to bring up the pure white of the swan without sacrificing the dark areas (bottom photo and histogram).

Using the Gamma/Levels control is much simpler than it might sound and once you begin to experiment, the concept will become more apparent. (You can always click Cancel to close the box and flee back to the safety of the auto corrections if your courage suddenly evaporates.)

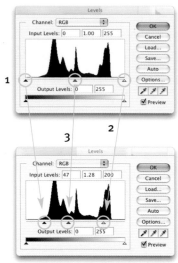

1 Begin by sliding the shadow (left) triangle slider until it is under a solid area of black hill on the left edge of the scale.

2 Repeat this by moving the highlight (right) triangle until it is under a highlight region in the graph. You'll notice that as you bring the two closer together the contrast of the image increases.

3 Next, adjust the position of the center triangle until the image looks good to you.

This is a very basic approach to using Levels or Gamma and it's worth reading your software manual for a more in-depth discussion.

When it comes to improving the brightness and contrast of your images, there is no substitute for patiently experimenting and printing out a comparison of your results (if a print is your final objective). To speed up the process, I will often duplicate an image, reduce its size so that three or four copies can fit on the screen together and then adjust the contrast of each

one separately and see which one looks best. You can also create a "test strip" by placing several versions of the image on a singe page and printing them on one sheet.

Remember, too, that there is no right or wrong with exposure or contrast, so experiment with these controls until you get an image that pleases you.

Enhancing Color

If you've ever wondered what it would be like to live in a house painted in subtle stripes of, say, purple and green, or if you've been curious what your daughter might look like with (heaven forbid) pink hair, image-editing software was made for you. In fact, the ability to alter, adjust, duplicate or even replace the colors in your photographs is one of the most intriguing aspects of digital imaging and one that will no doubt keep you glued to your monitor into the wee hours. Whether you're trying to overcome a distracting color cast, churn up the intensity of a sunrise, or just add some creative spice to your pictures, there is something positively addictive about repainting your images from a seemingly infinite digital palette.

There are a lot of reasons why the colors in your images may not be what you want or expect. Fluorescent lights or bad weather, for example, can create unwanted color casts; so can an incorrectly set white balance control. Also, cameras and scanners frequently have an inherent color bias that needs to be corrected. And if you're restoring the family album, you may want to rejuvenate the color of old, faded photos. Or you might just be bored with reality and decide to toss the-world-as-we-know-it into a color mix-master just to see what happens (remember, you were the one that wanted to color your daughter's hair pink). In any case, making the right color adjustments—whether for technical or creative reasons—will vastly improve your pictures.

Even the simplest of image-editing programs offers a fistful of color-adjustment options, and when you combine these tools with the ability to selectively re-color areas as small as a few pixels, you have a mighty powerful tool indeed. No one tool, however, is likely to be the best or for every situation, so dig around in your color toolbox and experiment with various methods—combining various tools and techniques, if necessary—until you get results you're happy with.

COMMON COLOR CORRECTION TOOLS:

[Automatic Correction]

Virtually all programs contain an automatic color correction function and using it is simply a matter of opening an image and choosing that option **(in Photoshop Elements: Enhance>Auto Color Correction).** This is a fast and simple solution, and while it generally will improve rather than degrade an image, it provides absolutely no user interaction.

Variations

Many programs have a color correction option called Variations. When you open an image and then select this tool, it displays a gallery of thumbnails of the same image, each with a slightly different color shift, along with your original image. What you're shown is a selection of variations that includes slightly heavier color casts: more red, more blue, more yellow, more green, etc. You can then incrementally increase/decrease a given color shift by clicking on a particular thumbnail; increase the reddish cast of an image, for example, by continuing to click on the More Red thumbnail or decrease it by clicking on the Less Red image. In Photoshop Elements, your Current Choice (the most recent image enhancement you've clicked on) is shown side by side with your original image in a slightly enlarged (compared to the thumbnails) version.

With some programs you may also be able to select specific tonal ranges of the image shadows, midtones or highlights from which you can sample variations. If you want to see how adding more blue to the shadow regions would look, for instance, you simply select the shadows option and then click on the Increase Blue thumbnail.

You probably won't see the exact color correction that you're looking for, but the benefit of using Variations is that seeing side-by-side comparisons of several color adjustments simultaneously will help point you in the right direction. If your early morning landscape looks better with more yellow, for example, you can turn to a more sophisticated color adjustment tool and manually enhance the yellow until you see what you like.

Hue/Saturation

Although the Hue/Saturation tool is another simple adjustment, it is quite useful in turning up the volume of individual color ranges or creating or enhancing color casts. When you open the hue/saturation tool, you'll get a dialog box that shows sliders: the hue slider affects the overall color tint of your image, the saturation slider affects how saturated the colors will appear. The great advantage of this tool over the Automatic Color or Variations tools is that it puts you in control to decide how much to adjust.

Playing around with hue and saturation is a good way to find the color limits of a given scene and it's often the first tool I'll turn to if I want to see how extreme I can go with an existing hue range. You'll see instantly when you've gone too far because the colors will begin to look unrealistic or cartoonish (which is fine if that's the effect you like). I use this tool on almost every image I print, but I typically use it in conjunction with a selection tool to adjust only selected areas rather than the overall image (tweaking the red of a rose, for example).

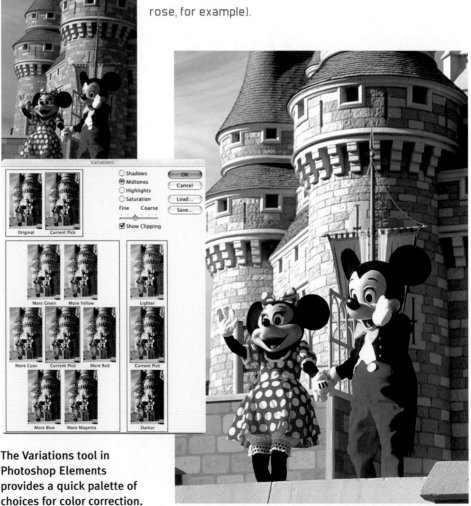

The Variations tool in Photoshop Elements provides a quick palette of choices for color correction.

[Color Balance]

One of the most flexible and precise color-manipulation tools found in most programs is the Color Balance tool. If you're new to color theory, it may seem a bit complicated, but in actual use the Color Balance is very simple because you can see the changes as you make them. For example, as you move a particular color's slider to the right, that color increases in intensity; as you move it to the left, it decreases. Let's assume you have photographed a farm scene with a rich green pasture, but on your screen (or in your prints) the green has become faded looking. By sliding the green color selector to the right, the grass will pick up a richer green color. It's a magic that will make you gasp the first time you see it happening.

Won't altering one color affect the coloring of other objects? Yes, in fact, it will, which is yet another reason for correcting selected areas rather than the entire image.

Within reason, you can increase one particular color without devastating impact on the remaining colors. Keep an eye on neutral highlight areas, such as white clouds or a white dress. If they start to show color casts you will know you have over-corrected the color balance. When that happens, simply back off of that color until the whites are neutral looking. If the object(s) you're trying to re-color still aren't picking up the color strength you're after and the neutrals are starting to pick up a tint, you'll have to switch to making selective corrections (see Making Selective Corrections, page 248).

Also (depending on the program you're using) you'll notice that at the bottom of your Color Balance box there may be three tonal-range choices: one each for shadow, midtones and highlights. By selecting one of these you can limit your color corrections to that particular range of the image. Adjusting colors that are tied to brightness ranges is a bit trickier and less aggressive than overall changes, but again, a little experimenting is a great learning tool.

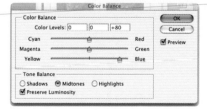

When you select the Color Balance option, a dialog box opens with three sliders, one for each of the color pairs: red-cyan, yellow-blue, and green-magenta. On the right end of each slider is one of the primary or additive colors: red, green or blue. On the left end is the color's subtractive counterpart: cyan (for red), magenta (for green) and yellow (for blue). These paired colors counteract each other. To reduce red, for example, add more cyan, its subtractive opposite. To reduce the cyan cast, you add more red.

Sharpening Filters

It seems ironic that after you buy the best digital camera featuring the latest in razor-sharp optics, and then take the time to hold the camera very steady, that you would have to sharpen your digital images. But take heart, sharpening digital images is a part of the normal flow of preparing your pictures for output and has nothing at all to do with either the quality of your gear or your skill in using it.

Digital images are soft partly because, while they are made up of millions of pixels, they lack the contrast created by film's grain edges that helps to create a sharp appearance with film-based pictures (score one point for film). Also, in order for very fine subject details (an eyelash, for example) not to get "lost" between pixels, many digital cameras use a gentle blur filter in front of the camera's sensor that prevents this, but has the side effect of gently softening your images.

Does this mean that you can take an out-of-focus picture and make it sharp? Not necessarily, but you might be able to sharpen a slightly soft image and enhance it enough to make it acceptable.

Software sharpening tools (usually called sharpening filters) enhance the appearance of sharpness by increasing the contrast along tonal edges in your images. Most image-editing programs have a number of sharpening options and, depending on the program you're using, you may find basic sharpening tools like Sharpen, Sharpen Edges, and Sharpen More. All of these methods work. There are differences in the quality of these various tools though, so it's important to select the right tool for the job.

Basic sharpening tools are very simple to use: you open an image, highlight the particular sharpening filter in the pull down menu and the image is sharpened. If you want the image sharper still, you can repeat the step or simply choose Sharpen More. The flaw in these filters is that they apply a blanket amount of sharpening to the entire image without providing you with any control over the degree that the image edges will be sharpened—or more importantly, which edges will be affected or how wide the sharpened edge will be.

A good option found in many programs is a sharpening tool called Unsharp Masking (also called USM), which, despite the name, is actually the best and most flexible sharpening tool available. Unsharp Masking provides a set of sliding scales that allows precise control of image sharpening through these three important image-sharpening elements:

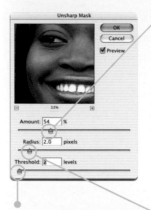

Amount (or strength) lets you set the percentage of sharpening. Most experts agree that it's best not too oversharpen—you might want to start with about a 50% setting and experiment from there. Read your software manual for the manufacturer's suggested settings.

The minimum **threshold** of contrast edges that will trigger sharpening—this basically defines which contrast edges will receive sharpening.

The **radius** of edges being sharpened—or how many pixels away from the exact edge will receive enhanced contrast. Typically a setting of 2 to 3 pixels is plenty.

Regardless of which tool you use, sharpening should always be done with a bit of conservatism. Oddly enough you have to be careful not to oversharpen a picture because images that have received too much sharpening tend to develop odd-looking patterns along contrast edges and begin to look less sharp. Experimenting with different levels of sharpness by changing the various settings is really the only way to see how they work. As with most things visual, it's a very subjective process and, in time, you'll know the sharpness you like when you see it.

Finally, it's important to do all of your sharpening with the image size set to 100% so that you can see the sharpness at its actual size. Remember, too, that if prints are your ultimate goal, even the best of sharpening jobs is still at the mercy of printer and paper interactions. What you see on the monitor may not match the appearance of your prints. Still, the better you get at sharpening images on your monitor, the better your prints will look.

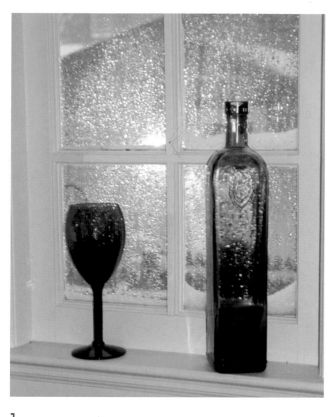

1 The image with no sharpening applied.

2 When you select Photoshop's Unsharp Mask (USM) filter, a dialog box pops up that enables you to choose three settings; this photo shows the Amount is set to 55%, the Radius to 2.8 pixels, and the Theshold set to 2. Your software manual will explain more about these choices— but you can see the results change as you alter each of the settings.

3 Here, the sharpening amount is set to 126% which might be too high. Print your image to be certain.

DUST AND BLEMISHES

When you scan prints and film, you also scan all the flaws on their surfaces. Dust, crinkles, scratches, fingerprints—they all come through faithful to the original. While it could be argued that keeping some of the flaws of the original helps to maintain the charm of older images (particularly if you're copying very old pictures), the truth is that surface flaws are more distracting than charming, even when it comes to family photos that are several generations old. Besides, your grandmother would be appalled to find out that you wanted to preserve that big blob of dust on her wedding dress.

Most programs offer a choice of techniques for removing surface flaws and imperfections. The simplest method for eliminating minor dust and other blemishes is the automatic dust and scratches removal feature found in most image-editing programs (and in most scanner software). The problem is that this filter works by softening the image and in the end you're left with a clean but soft-focus image lacking in fine detail. You can experiment with applying this filter to selected areas, but you may find the final image is uneven in its overall sharpness.

There are better solutions, and they're all fairly straightforward. In the old days a retouching professional would hunch over a brightly lit print and dip a single-hair brush into dye. She (back then women most often held this job) would dab dye onto each dust spot until it blended in with its surroundings—a painfully slow process that required enormous patience. Using the cloning tool you can do essentially the same thing

THE CLONE STAMP

If I were cast away on a desert island with only a laptop computer (and hopefully a solar battery charger) and just a few image-editing tools, the Clone tool, or Cloning stamp (as it's often called), would certainly be among the tools I would bring along. In fact, the Clone tool is such a valuable part of digital imaging that I can't imagine editing images without it. It's one of the first tools you should learn to use.

The job of the Clone tool is to replicate pixels exactly and then paste them wherever you choose. You can copy as little or as much of an image as you like, and deposit that information to any other area of your image, or into another picture entirely. The magic you can pull off with this tool is mind-boggling. If creating image montages is a part of your artistic ambition, you'll come to love the Clone tool's ability to import pieces of other images into your creative meanderings. Think of the

Clone tool as a Star Trek-like pixel transporter able to "beam" pixels wherever you need them in the blink of an eye. (Maybe they should have called it the Transporter tool.)

There are many advantages to being able to replicate a particular part of a scene exactly. From a purely corrective point of view, the Clone tool enables you to hide unwanted details of an image so perfectly that no one will ever detect the changes. With just a few clicks you can banish an ugly No Trespassing sign from a wooded scene by cloning a tree limb over the sign, or erase that horrific zit (her term) from your daughter's otherwise alabaster forehead with a quick digital skin graft.

The Clone tool is also a wonderful clean-up tool for landscape photography. I can't count the number of times I've photographed what I thought was a pristine

beach only to return home to find a fast-food wrapper hiding in plain sight. With a film image you'd have to crop the intruder away, likely upsetting the balance of your composition. By using the Clone tool, though, you can simply paste a clean area of sand over the wrapper and hide the unsightly intrusion.

Again, you're not limited to cloning within one particular image; you can just as easily open two or more pictures and clone objects from one to another. You could, for example, clone an elephant photographed at the zoo into a photo of the parking lot at your local strip mall. Because the Clone reproduces pixels exactly, it's impossible to tell them apart.

And if ugly power lines have ever ruined one of your landscape shots, you'll love the ability of the Clone tool to erase those lines. I really loved the architecture of this

but in a fraction of the time. If you make a mistake, stepping backwards is just a click (or a keystroke) away. And if you're lucky enough to be using the new, full version of Photoshop, you can use the more sophisticated cloning tool called the Healing Brush.

The Image Enhanced >
Cleaning Scanned Images:

TEARS AND CREASES

Fixing the blemishes of scanned prints that have been torn or folded is a bit more tedious to fix than small blemishes or dust spots, but basically the repair techniques are the same. Because the flaws are typically larger, though, you'll need to be more cautious about not damaging nearby areas, as well as being more clever and vigilant when it comes to disguising your retouching. Several books have been written on the art

of digital retouching and if you plan to do a lot of this kind of work, Katrin Eismann's *Photoshop Restoration and Retouching, Second Edition* (New Riders, 2003) is the bible; it was written specifically for Photoshop, but its techniques can be adapted to other programs.

small bridge in Maine (**below**), but the power lines were just destroying its graceful look. I made the shot anyway and spent about an hour carefully "erasing" the power lines.

Above
This scanned photo was saved using the Clone tool: In Adobe Photoshop or Photoshop Elements, for example, first identify the area that you want to reproduce by placing a target cursor over that area and then click the mouse (Option-Click with a Macintosh, Alt-Click with a PC) to specify the area you want to copy. Now place the cursor at the point where you want to re-deposit that image information.

1

Open your image. Eliminate edge flaws by cropping the picture; there's no sense fixing things you can eliminate. If you're working with a black-and-white (or sepia-toned) image, make an overall Levels adjustment before you begin more detailed work. Adjusting Levels after you clone areas may make your cloning work stand out like a poor plaster patch.

2

Use the magnifying tool to enlarge the picture to a size where you can clearly see the areas you're retouching.

3

Select the Clone tool and choose a brush size and style that matches the areas you want to retouch. Generally a softer edge brush will hide your retouching better in areas of low detail and a harder brush works better in very detailed areas. Select a brush that's just slightly larger than the flawed area you are retouching. You will probably find that as you move through an image you will change brush sizes and styles a few times.

(copy good pixels onto flawed pixels)

4

Now, sample an area near each flaw (Alt/Click in Windows, Option/Click on the Mac) and then click or stamp to fill it in. Basically what you're doing is covering the dust with a pixel swatch from a nearby area, so it's important that your sample area matches the area you're covering. For larger repairs, I tend to resample every two or three clicks, keeping the sample area close to the repair area and keeping the brush size only slightly larger than the flaw.

5

The real trick to fixing major flaws is to be patient and work with small areas and small brushes whenever possible. Also, keep the image magnified and occasionally decrease magnification to see your progress. As you find small fine points, increase the magnification further and retouch those areas.

6

Continue working on the entire image to make sure you've fixed all the blemishes and then return the image to its normal magnification.

7

Save the image, giving it a new name. Restoring old images is an art, and the more you get to know your editing software, the more useful tools and techniques you'll discover.

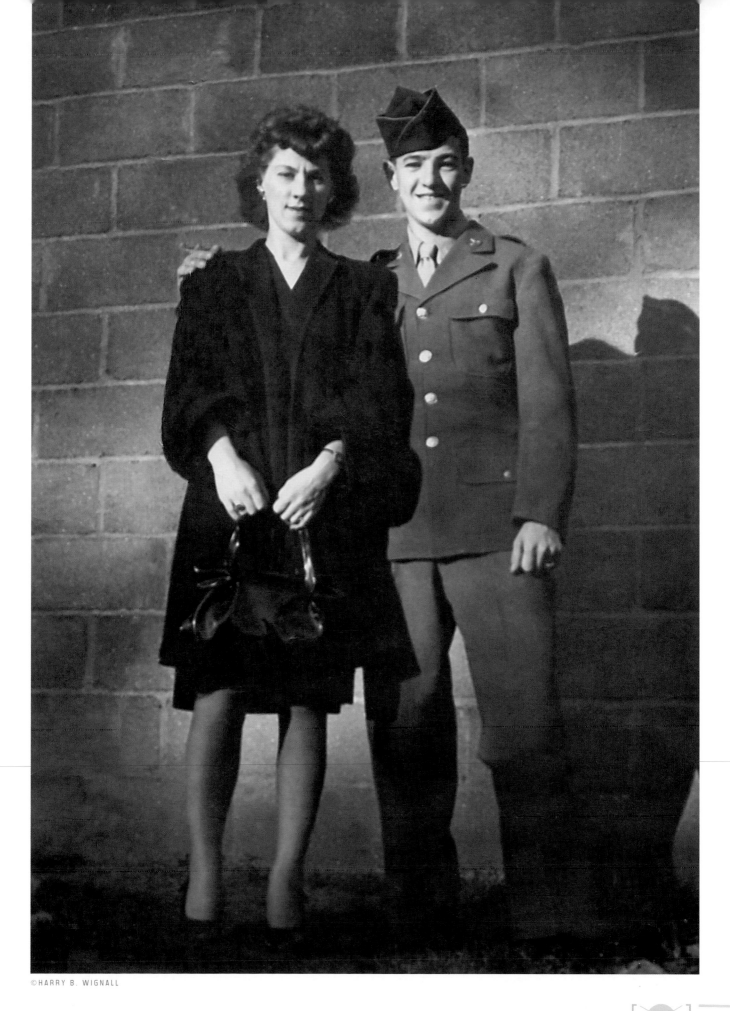

©HARRY B. WIGNALL

The Image Enhanced >
Eliminating Red-Eye:

In addition to being the drink of choice for cowboys in old western movies, red-eye is that eerie red glow (it's often green in animals) in the eyes of people photographed with built-in flash. The effect happens when light from your flash reflects back from the eye's retina (which is rich with red blood vessels). Most digital cameras have a red-eye reduction mode and if you remember to use that mode, red-eye won't often be a problem.

In any event, unless you want your friends looking like extras from the film *Children of the Damned,* you should get rid of red-eye when it appears. Many software programs bundled with digital cameras have an automatic red-eye removal tool. Nikon's Nikon View software that ships with their digital cameras, for example, has a very precise and reliable one-click red-eye removal system—ridding your subjects of red-eye is just a matter of calling up an image and zapping it with a single click. It's my favorite one-click feature to date.

Most image-editing programs also have a special red-eye tool and using it is fairly straightforward. In the simplest of programs, you click on each eye, and then click OK and the program eliminates the red in the eyes. Other programs give you more control, which means more work. Basically you use a brush tool to paint over the red portion of the eye with a replacement color.

In Adobe Photoshop Elements, the procedure for correcting red-eye has five basic steps:

1 > Select the Red Eye brush tool from the tools palette.

2 > Choose a brush size that approximates the size of the center of the eye (the red area).

3 > Next, specify the color you want to replace from a color picker (or you can use an eye-dropper tool to specify the color from the red area itself).

4 > Specify a replacement color using the color picker.

5 > Finally, brush the new color over the red. It's usually best to choose dark brown or perhaps a deep blue as a replacement color but you can use any color (including violet if you wanted to make your daughter resemble Elizabeth Taylor).

Experiment with different brush styles and sizes so that you get all of the red without bleeding into other parts of the eye. Usually a slightly soft-edged brush just bigger than the retina will enable you to replace the color with a single well-placed click.

There is another simple method for eliminating red-eye that I often use with great success. To begin, I simply select the center area of the eye using a basic selection tool and then I desaturate the color (using the saturation slider in the Hue/Saturation dialog box) until the red color of the eye is gone. It works surprisingly well and takes only a few seconds.

Whatever method you use to remove the red, remember to first duplicate the original and then enlarge the image so you can see the eyes clearly. By the time you reduce the image to its normal viewing size any minor flaws in your painting technique will be impossible to see.

Replacing Skies

There you are in the Vermont countryside: a beautiful red covered bridge, pretty maple trees with autumn leaves, a sparkling river—and, curses, a boring featureless sky the color of aging whipped cream. Nothing is more frustrating than coming across a first-rate landscape scene with a second-rate sky. And unless you've got lots of time and can wait for a change in the weather, you're stuck with the sky you're dealt.

Happily, image-editing software has solved this pesky problem forever. By keeping a library of interesting sky pictures in your files, you can borrow a sky from another photograph and replace dull skies with just a few keystrokes. With a little practice, you can create new-and-improved skies that are completely undetectable.

Replacing a sky is pretty simple, you'll need just two things: an image that needs a new sky transfusion and a better sky to replace it with. Begin by choosing an original scene that has a simple and clear separation between sky and foreground. Unless your selection skills are very good, using scenes with complex sky-foreground borders (a tree with a lot of naked branches, for instance) can be tricky so practice first with simple foregrounds. You can borrow the replacement sky from another scene, or you can build a library of interesting sky-only images to choose from.

If reality is your aim, it's important that you choose a new sky that visually matches your subject. If you choose a sunset sky full of fire and brimstone and place it into a midday scene of a wildflower meadow, your sky will look false. Instead, look for skies that have a tonal and lighting similarity to your main subject or foreground, such as puffy white clouds for a sunlit beach scene. If you *want* a false-looking sky, that's fine too—this is, after all, about exercising imagination.

Here are the typical steps for replacing a sky. These steps are specific to Adobe Photoshop Elements, but they're similar to those found in other programs:

1 > Open the scene that contains the sky you want to replace. Using your selection tools, select the sky area, being careful to find precise edges between foreground and sky.

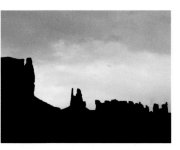

Feathering the selection tool by a few pixels will keep the foreground/sky edge gradation more gentle looking. Also, it's a good idea to save this selection **(Selection>Save Selection)** so that you can reload it later if needed.

2 > Open the image containing your replacement sky and select the sky area, using whichever selection tool works best.

3 > Use the Copy command to copy the new sky.

4 > Return to the original image and click anywhere in the selected sky area then use the Paste Into **(Edit>Paste Into)** command to place your new sky into that image. If the opacity is set to 100% for the new sky, the sky in the original scene will be completely replaced.

5 > If your new sky doesn't fit exactly, use the Transform tool to stretch (or shrink) your sky to its new home **(Image> Transform>Free Transform)**. Alternately you could use the Move tool to move the pasted sky around until you find a pleasing combination.

6 > Finally, save the image in its layered form so you can modify it later if you choose to make additional changes.

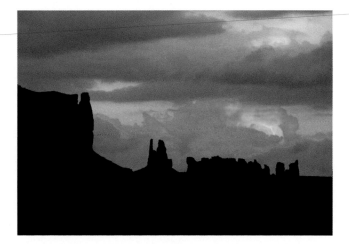

With so much emphasis on color digital photography, it might seem that black-and-white photography has been forgotten. But as the great photographer Minor White once wrote, "Black and white are the colors of photography." And in reality, digital cameras and inkjet printers are capable of making quality black-and-white prints; many fine-art photographers have readily adopted the technology—not only as an end in itself, but also as an aid in the traditional process.

Why would you want to convert pretty color pictures to plain old black and white (commonly referred to as grayscale in the digital parlance)? As Mr. White implied, there is a special bond between the photographic process and working in shades of gray that is dear to the hearts of photographers. Indeed, for many photographers, color is more of a distraction than an enhancement. In their vision, by reducing the world to a series of gray tones, they peel away the falseness of superficial color and enhance reality. Black and white has a way of revealing subtle tones, surface textures and design features that color often obliterates.

There are, of course, practical reasons for making black-and-white images: contributing photos to school newsletters or sending bridal portraits to the local paper, for instance. Also, it's often easier to restore old family black-and-white photos that have been tinted (either intentionally or by age) if you first convert them to their original black-and-white state before you begin restoration.

You can convert color pictures to black and white with a variety of techniques—some simple, others more involved. Experiment with a few of them before you decide which method you prefer. The simplest method, found in most image editing programs, is to open your image and then select Grayscale. Your image will be converted to a black-and-white photograph.

An alternate method is to use the Hue and Saturation dialog box and simply desaturate the image by sliding the saturation control all the way to the left—effectively draining them image of all of its colors.

You can then use the Brightness/Contrast (or Levels) control to tweak the contrast of your gray values. It's a simple method, but it does produce good results.

In the end, many variables are at work (your conversion decisions, paper, ink, your printer, etc.) and the method you choose may not be crucial. Just in case you stumble onto the perfect combination of steps though, it's a great idea to keep a notebook handy to track the individual steps in your experiments.

Black-and-White Conversion Tips

As you may know, with black-and-white film you can use colored filters over the camera lens to adjust the grays in your images by controlling different wavelengths of light. Each filter allows light of its own color to reach the film, while blocking opposite colors. Photographers use this knowledge to manipulate the tones of the image making some objects lighter and others darker. If you were to photograph a farm scene with a red barn, a blue sky and green fields with a red filter over the lens, for example, the result would be a lightening of red objects (the red barn) and darkening of green and blue ones (the grass and skies). By carefully selecting the right filter, you can control the tonalities of the final image.

In advanced image-editing programs (such as Adobe Photoshop) you can create the same visual effects using the Channels palette. When the Channels palette is open, you will see an icon for each of the three primary colors: red, green and blue. You can see how your image would look on black-and-white film shot through various filters by simply keeping one color channel turned on and deselecting the other two channels. For instance, by deselecting the blue and green channels, you can see how your image would look if shot through a red filter; similarly, by deselecting blue and red, you can see how the image would look if shot through a green filter.

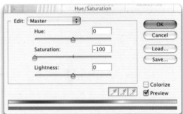

I loved the bright colors of this old gas pump that sits outside of a fun little tourist restaurant in Bar Harbor, Maine, but I thought it would look more nostalgic in black and white.

Left
One of the simplest methods for creating a monotone image is to just convert the RGB image to a grayscale image.

Above, right
Another way is to desaturate the image (remove the color saturation) using the Hue/Saturation tool. Don't judge the results purely from the screen because tonalities often change quite a bit during printing.

Making Selective Corrections

While most of what we've talked about involves making changes to the entire image, often you'll only need to enhance tiny portions of an image. In fact, the more experienced you get with image editing, the more you'll come to love the ability to make small, precise changes to your pictures.

The trouble with making any type of blanket correction—color, contrast, brightness, sharpening, etc.—is that you often correct things that don't need to be improved. In fact, when you make a wholesale fix to correct a small problem, you're actually doing unnecessary harm to the rest of the image. As the old saying goes, "If it ain't broke, don't fix it" or, more accurately, "If only part of it is broken, don't mess with the rest of it."

If you're bumping up the blue of the sky in an outdoor scene, for example, and you add blue to the entire image, you may be sending a row of pretty yellow daffodils in the foreground to their greenish doom (blue + yellow = green). Similarly, if you're trying to brighten a person's face shot in strong backlighting, you probably don't want to increase the lightness of the entire image and wash out the already bright background.

The solution is to limit your corrections to the areas that need correcting—while protecting the remainder of the image. Do this by making selective corrections (see Making Great Selections, on the following pages). Select only the area you want to correct, and then apply the correction just to that area. In this way you can make an unlimited number of small corrections to your scene and none of them will interfere with the surrounding image. It's a method pros use everyday and it's easy to learn.

Finally, as you gain experience at selective corrections, you'll save time if you develop a workflow rather than applying a random smattering of adjustments. Typically I begin by making an overall Levels adjustment to roughly set the contrast range, use Hue/Saturation to explore the hue range (and sometimes make a small adjustment), make some minor adjustments to Color Balance or Curves (a more advanced color adjustment tool), and then I'll begin the work of selective corrections. Eventually, of course, you'll get addicted to image editing and spend hours (if not days) working on a particular image and you'll have to include meal breaks in your workflow. Don't say you weren't warned.

Selective Corrections Tip

Whenever you select and change a small area, it's usually a good idea to feather the selection with a few pixels (you'll have to experiment to find the number of pixels, but from 2-4 is a good starting point) so that the corrected area blends into its surroundings more naturally. But don't be overly critical of your selections and corrections at first; it's unlikely anyone but you will ever spot them. I'm sure in the hands of a Photoshop master (which I'm certainly not) my Amish scene would be greatly improved, but I like the way it looks and that's all that matters.

Let's look at a particular image: I shot this Amish farm scene near Lancaster, Pennsylvania late on a hazy day. Although the backlighting was bright, the contrast of the foreground area was flat, and the colors seemed washed out. At right are the steps I took to enhance the scene.

1

My first correction was to make a general Levels adjustment to improve the overall contrast. Whenever I plan to make multiple corrections, by the way, I create a new layer for each manipulation (see Using Layers); in that way I can simply trash a layer if the correction turns out badly. Also, by using separate Image Layers for each correction, you can turn them on and off individually and see how the image looks with and without them.

2

After doing the basic levels adjustment, the farmhouses still seemed dull, and the corn and grass lacked the rich green color I remembered. To begin the fine-tuning, I used the Rectangular Marquee tool in Photoshop Elements to select the corn and grass area (basically drawing a rough rectangle around them) and then applied a color adjust-ment (+ green) to just that area. While I still had that area selected, I also slightly increased its brightness.

3

Next, using the Magic Wand selection tool, I selected the farm buildings and applied a levels adjustment to brighten them up.

Finally, I again used the Magic Wand tool to select the sky area, and then applied a cool-toned gradient burn to the washed-out sky area to add some color. I could have used any color in the sky, and perhaps the warm color is a tad too dramatic, but it seemed to fit the other scene tones nicely.

While it might seem like a complicated formula, it took only a few minutes and no overall fixes would have given nearly the same results. The ability to select and make adjustments to specific areas literally saved this image.

MAKING GREAT SELECTIONS

Making an overall correction—such as Levels or Color Balance—on an entire image is kind of like painting your whole house because you don't like the color of the front door. Enhancements are much more effective and usually far simpler (and less detectable) when you apply them to a specific area of an image—darkening just the sky, for example, or slightly saturating the color of someone's dress.

Correcting or changing individual elements of a scene gives you a level of precision in retouching (or altering) images that can literally be taken down to the level of individual pixels. Although you might not find too many occasions to alter individual pixels, you will often find yourself editing tiny areas of an image, like perking up the sharpness on someone's eyes to make them stand out.

Image-editing programs offer a variety of selection tools to help you select even the most intricate object—though some objects are much harder to select than others (separating a tree from the sky, for instance). Learning to use these tools requires varying levels of skill and/or patience but mastering them is one of the most important editing skills you can acquire since you will use these tools on virtually every image that you enhance. And the greater your skill and finesse with them, the more professional and satisfying your results will be.

Anything you can do to an overall image (sharpening, blurring, painting, adding noise, etc.) you can also do to even a tiny selection. Very often, for instance, I will use a selection tool to lighten just the shadow in a landscape and then use another selection to sharpen a nearby rock.

Here are some of the more common selection tools and suggestions for how and when to use them. In most programs, these tools and the selections they create can be modified in some very sophisticated ways (such as feathering edges or making selections within selections), and your software manual will be a big help in learning to use them. Also, you can usually modify a selection after it is made: expanding or contracting it by a specified number of pixels, for instance. The tools that follow are specific to Adobe Photoshop or Photoshop Elements, but similar tools exist in most editing programs:

Marquee Tools:

Marquee tools are the most basic and simplest of the selection tools and come in a variety of shapes, including rectangular, elliptical (oval), single-pixel wide row (horizontal), and single-pixel wide column (vertical). The Marquee tools offer a very quick and simple method to surround a regularly shaped area—a barn door, for example. By simply placing the cursor at one corner of the shape you want to select and then dragging it until you've captured the shape, that area is selected. Once you've made a marquee selection you can move it freely around the image to fine-tune its position.

Lasso Tools:

Marquee tools are fine for regular shapes, but they are of little use with objects of irregular shapes. Lasso tools let you outline very intricate shapes. The basic lasso lets you freehand trace virtually any shape—a person, a flower, a winding road. The Polygonal Lasso is useful for selecting irregularly shaped geometric objects—a rowboat, a barn, a fence. The Polygonal Lasso uses "anchor points" so you can make precise angles when turning corners or selecting very specific outlines in tight spaces. Think of the anchor points as creating your own version of connect-the-dots. The Magnetic Lasso further refines your ability to select areas. You can loosely trace an object and with its "magnetic" properties it attaches itself to the contours of the area you're tracing. Like the Polygonal Lasso, you can create anchor points. It works by identifying the contours of an object and is best for objects whose borders are clearly distinguishable from their surroundings (a gray cat in a coal bin). It works less well on objects with borders of similar tonality to their surroundings (a black cat in a coal bin or a white dog on a white sheet).

Magic Wand:

I call this the "holy cow" tool because the first time I teach people how to use it, that is usually their immediate response. The Magic Wand is the tool that most beginners use for capturing very complex shapes (largely because it does its job so well and is easy to use), and it is a very important tool to learn. Regardless of the complexity of an object's shape, this tool, based on a range you set, selects colors of a similar brightness to those in the spot you click on. For grayscale images (fancy talk for black-and-white pictures), areas selected are based only on brightness. If the explanation seems a bit foggy, using the tool is fairly straightforward. For instance, if from your picture of a harbor scene with boats

and docks and buoys, you wanted to select just the blue water, you simply click anywhere in the water and the Magic Wand selects most, and maybe all, of the water the first time you click. This can be a fast way to select large intricate areas of similar color.

There are several settings that help you refine exactly what the wand will and won't select, including a tolerance setting and whether you want the areas you're selecting to be contiguous (connected) or not. Very often when I'm using this tool I will refine the tolerance setting, as I get closer to other objects. For example, if I'm selecting the sky around a tree and the selection begins to creep into the tree, I will reduce the tolerance to the point where it stops at the edge of the leaves—selecting the sky right into the tiniest folds of the leaves, but not picking up the leaves.

Color Range:

This tool (found under the Select menu in Photoshop) is perhaps the most sophisticated tool for making complex selections across an entire image. As the name implies, the tool works by selecting areas of similar color. You tell the program which color to select by sampling specific areas in the image with the eyedropper tool. You can continue to add to (or subtract from) that selection and view the areas being selected in a preview window, and by using a tolerance setting, you can control the range of colors being selected. This is a precise tool for making amazing selections. If, for instance, you want to select all the greens in a landscape (leaves, grass, flower stems), you can modify their color or brightness without touching any other part of the scene. It takes patience, but there is simply no other tool that can do the same thing. Color Range is well worth the time invested in learning to use it correctly.

Making moderately complex selections with the Lasso and Magnetic Lasso tools gets easier with patience and practice. I spent about an hour doodling with the Magnetic Lasso on these lobster floats and eventually got just the selection I was after (above right). Enlarging the image helps a great deal.

Once you have made your selection, you can experiment with creative uses, such as in the example at right.

Normally your goal is to make your photographs—or at least the main subjects in them—as sharp as possible. There are times, though, when softening an image (or part of an image) is the better creative option. In portraits, for example, gently blurring wrinkles away or hiding minor blemishes creates a more flattering appearance. You can also gently blur landscapes and travel scenes to evoke a mood or just to create visual variety in a photo album or online gallery.

Most image-editing programs offer a choice of several blurring filters such as Blur, Blur More, Smart Blur, and Gaussian Blur. The best choice is Gaussian Blur because it gives you the most control over the amount of blur that is applied. The Smart Blur does offer some degree of control, but it's generally used as a special effects filter for overall use rather than as a fine-tuning filter.

Like other blur filters, Gaussian Blur reduces the contrast between adjacent pixels to create the illusion of softness. But Gaussian Blur allows you to determine how much blur to add. Typically you'll see a preview of the effect in the preview window of the filter's dialog box. As you adjust the radius setting (how many pixels away from each contrast edge will be softened), you'll see the degree of blur changing. There is no right or wrong pixel radius; you just have to experiment until you see an effect you like.

Incidentally, although they're not often thought of as diffusion filters, two other filters—the Median filter and the Dust and Scratches filter (if your software has them) also create diffusion. The Median filter is really a noise-reduction filter (often used with scanned images to reduce unwanted patterns) and the Dust and Scratches filter is used to reduce small blemishes. Some programs also have special effects blur filters such as Radial Blur (it applies blur in concentric circle patterns) and Motion Blur (it simulates a subject in motion). Any of these filters might create the effect you're after, so don't discard them out of hand—experiment and see how they compare with one another.

Blur is kind of like flattery. If you use too much of it, people suspect your motives—so be stingy when it comes to applying it, especially if you're painting it over the entire image. You wouldn't want to become known as the Eddie Haskell of image editing.

SELECTIVE BLUR

As with many image enhancements, the most effective way to apply blur is to add it only to specific portions of an image. In close-up photography, for instance, you can blur the background to separate your subject from its surroundings; or you can use it to gently blur the foreground in a landscape to focus attention on an important element in the center of the field.

Many programs have a Blur (or Soften) tool that works like a paintbrush tool—you select the brush size and then sweep it across the areas you want to blur. Because you can control the brush size and apply the blur to precise areas, this can be a very accurate method of creating selective diffusion. The Blur tool is particularly adept at softening tiny details like wrinkles around the eyes, but you have to apply it carefully so that different areas (both lower eye lids, for instance) have the same degree of blur.

Alternately, to quickly blur the background, select the subject then invert (Select>Invert) the selection, which selects the background. Now apply the Blur filter to the background. This is the technique I used in the photograph of the red tractor. To blur the grass area, I first selected the tractor, then inverted the selection, then applied a Gaussian Blur filter to the background area.

Layers

Layers are probably the single most useful and creative tool in image editing. They provide a wealth of flexibility and control both in enhancing images and in creating complex composite pictures. In fact much of what is done in digital imaging, both creatively and technically, could not be done without using layers. If you are entirely new to digital imaging, the concept of using layers will seem foreign at first, but you will soon find yourself reveling in their possibilities and usefulness— particularly if making composite images is something that sparks your imagination.

So what exactly are layers? The most frequent analogy used to describe layers is that each one is like a transparent sheet of acetate that contains one element (or one adjustment) of an image. You can think of them as the transparent (and/or partially transparent) layers of a thick visual layer cake. All images start off with one layer (the "background") that is not transparent because it contains the main image and is at the bottom of the other layers.

The various layers in any image are easy to visualize because they are displayed in the Layers palette stacked one on top of the other. If you were to stand above that stack and look down, you would see the entire image with all of its elements in place **(at right).** Some elements in the stack would be opaque and block portions of other layers that are underneath them, and some would be partially transparent showing you varying degrees of what was underneath them. One of the very fun aspects of using layers is that you can rearrange the stacking order of the layers so that you can play with which elements are blocked and which are revealed. This is a particularly important aspect of creating complex composite pictures.

It would be possible to write an entire book just on the subject of layers, but here we'll simply present a few basic concepts to get you started. Speaking of books, though, the absolute best in-depth explanation of layers (and image-enhancement in general) that I've seen is in Ben Willmore's fine book *Adobe Photoshop Studio Techniques* (Adobe Press). While the information is aimed specifically at Photoshop, the concept and potential of layers can be applied to any layers-oriented program. It's a book well worth owning.

There are many intricate uses for layers, but they are used primarily in one of two ways: either to create an adjustment layer for modifying the image (creating a new layer specifically to adjust the contrast or color balance, for example) or to add new objects to a composite image (perhaps superimposing a quaint cottage over a background of blue sky and fluffy clouds).

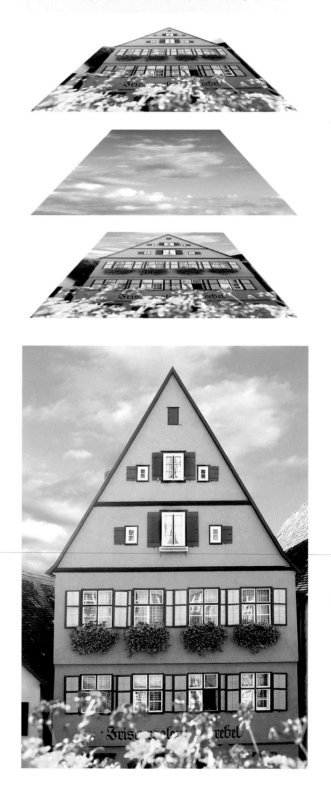

ADJUSTMENT LAYERS

Making image corrections on a layer rather than on the background image itself is extremely useful because it lets you correct certain aspects of an image without putting the background image at risk. Let's assume, for example, that you are working on a landscape image and decide to adjust the Hue and Saturation settings to get richer colors. You could just go to the Image menu and select Adjustments and choose the sub-menu item to adjust the Hue and Saturation without creating a new layer. Once you make that adjustment, however, it affects the entire image and you're stuck with it. If you decide you don't like the adjustment later on, you have to start the image all over again. You'll get old before your time working this way.

By creating a new adjustment layer, however, you can make a Hue and Saturation adjustment in its own layer. If you decide you don't like the effect it creates, you can either temporarily shut the layer off (using the eyeball icon which acts as an on/off switch) or drag that layer to the trash to get rid of it permanently. Or you can double click the tiny Hue and Saturation icon in the layer and re-adjust the settings. Also important, an adjustment layer will only affect the layers that are below it in the stack and it will have no effect on the layers above it—which in itself offers a tremendous degree of image control because it lets you apply certain enhancements only to selected layers.

In Photoshop and Photoshop Elements there are actually two ways to create an adjustment layer: you can either go to the **Layers menu** and select **New Adjustment Layer** and then select a specific adjustment—or you can click on the Create New Adjustment Layer icon at the bottom of the Layers palette (a shaded round circle in Photoshop and Elements).

In either case a new layer will pop up in the Layers palette and it will automatically be labeled Hue and Saturation. Now any adjustments you make to the hue and saturation of the image will live in their own layer.

If you decide that you don't like that adjustment, nothing is lost. You can simply turn off that layer or drag it to the trash.

The beauty of this method for making adjustments is obvious: you can make an infinite number of corrections to an image without actually committing to them until you're certain that you like them. Often my images contain as many as two or three dozen individual adjustment layers and I can play endlessly, turning layers on and off to see how the various adjustments combine. Be forewarned: whenever you add layers to an image you dramatically increase its file size.

Once you are satisfied with the look of the image and have made all the adjustments you are going to make, you can "flatten" the image **(Layers>Flatten Image)** to compress all the layers into the background and make the changes permanent. Often too, even if I do flatten and save a finished version of the image, I will save a layered version so that I can tweak it later on.

LAYERS FOR COMPOSITE IMAGES

Layers are also the primary tool for creating composite images. Each time you add a new element to an image, a new layer will be created automatically and placed in the Layers palette. Try it. Open two images and then use a selection tool to select an object from the second. Then copy and paste that object into the other image and you will see a new layer containing the pasted object pop up in the Layers palette. Some

If you are entirely new to digital imaging, the concept of using layers will seem foreign at first, but you will soon find yourself reveling in their possibilities and usefulness particularly if making composite images is something that sparks your imagination.

software programs let you paste an image directly into an existing layer.

To make things even more flexible (notice I didn't say complicated), you can also adjust the opacity of each of the individual layers by adjusting the Opacity slider. In most editing programs there are also an assortment of blending modes that further alter the way individual layers appear (and again, I refer you to Mr. Willmore's book for an in-depth explanation of layer blending modes).

One important thing to know is that you can only have one layer active at a time, so only the layer that is highlighted in the palette is active. Remembering this fact will often get you out of the woods when you try to use a tool on an image and nothing happens (or

when it's happening to the wrong part of the image): check to be sure the layer you think you're working on is the active layer.

The key thing to remember whenever you are adding elements to an image is this: Each new picture element lives on its own little layer island; you can do anything you want to it and change it without affecting the rest of the image. And if you want to see how the overall image looks with and without that layer in the stack, you can simply turn it on or off by clicking the "eyeball" icon next to the layer.

The only true way to learn about layers is to experiment with them—so don't be afraid to open an image and start playing. Just be sure to make a duplicate of the image first.

"My favorite thing is to go where I've never been."

—DIANE ARBUS

Improvising on an Idea

Introduction

I have a good friend named Phil Bowler who is an extremely talented and respected jazz bassist, and I've seen him perform in concert many times. When he takes off into one of his intense and intricate solos at some seemingly invisible sign from his band mates, it's as if he is making the music up at the very instant that his fingers dance along the strings of his big double bass. And, in fact, he is making the music up. He's improvising on a theme, inventing ideas and experimenting with new directions at the very speed of sound. It's quite an experience to witness.

But what we don't see or hear when we see a jazz musician perform are the thousands of hours spent mastering the rudiments, playing the scales, or "getting their chops down" as they would describe it. Before they can take an eight-note bar and bend and twist and stretch it inside out, they learn to play it note for note, beat for beat, until it becomes a part of their being. Learning how to create great photographs—both in the camera and in the digital darkroom—is very much like learning to play a musical instrument: you have to master the basic techniques before you can soar to places unknown.

In the previous chapters we've looked at the basic skills that it takes to turn an average photograph into a very good one. In this chapter, you'll learn to solo, to go beyond the techniques themselves and create ideas that are yours and yours alone. You'll get a brief glimpse at the almost infinite variety of ways that you can take a traditional tool and re-invent its purpose and make it your own. Some of these ideas and techniques have been done to death, they may even border on corny, but it's through experimenting and taking chances that new ideas are born. Or, as my friend Phil puts it: "When one improvises, one enters the world of creating."

As a visual artist, it's important that you learn to improvise on an idea—to take your vision to the next level, to watch it grow at the speed of light. Not everyone will get what you're going after or see the beauty that you see. But there is one thing you can count on: in the same way that jazz musicians chart a path that is truly their own, you too will be exploring directions that are entirely yours. And it wouldn't hurt to have a little Sonny Rollins playing in the background while you work.

HUE AND SATURATION

As we saw in The Image Enhanced chapter, the Hue and Saturation controls can be a simple and effective tool for adjusting the tint and saturation of a picture. When the sliders in the control are "pushed" to extremes, however, even the most average subject begins to resemble an Andy Warhol experiment (and who knows, perhaps your extreme pictures will get you that 15 minutes of fame he promised). If you're a lover of intense color, Hue and Saturation extremes will keep you busy for days.

In truth, there probably aren't a lot of practical uses for such extreme color variations, but at times I'll find a photograph that I like in terms of composition, but that is lifeless in terms of lighting or light quality. By zapping the colors with the Hue and Saturation tool I make the image more about the colors than the subject—and that can be a very effective for graphic designs. If you're designing a website, for example, you might use a series of vibrantly churned variations of the same shot to act as icons or links—or even just to add some eye-catching graphics to a homepage.

What I find really interesting about using extreme colors is that they work best with very simple subjects.

The shots on this page are variations of a quick snapshot of a plastic cigar-store Indian I saw at a flea market in Maine. I find something very mystical in the face, and churning up the colors seems to enhance that bit of mystery. In each example, all I did was experiment by pushing the sliders one way or the other and then save the results when I found an image I liked. In some cases I created one variation, saved it, and then made another variation from that starting point.

This is the original image. Opposite, variations using the **Image>Adjustments>Hue/ Saturation** sliders in Photoshop.

CURVES

The Curves tool is a graphic way of showing and adjusting the tonal range of an image (**Image> Adjustments>Curves**). For experienced photo editors, the Curves tool provides an extremely precise method of adjusting color. As a creative tool it can be like taking a blowtorch to a box of wax crayons—you just can't predict how wild the combinations of tonalities and color will become.

When you first look at the graphic display of tones with the Curves tool, instead of a curve, you'll see a straight 45-degree angle from the lower left (shadows) of the curves box to the upper right (highlights). But when you start to curve the straight line, the colors and tones of the image begin to change.

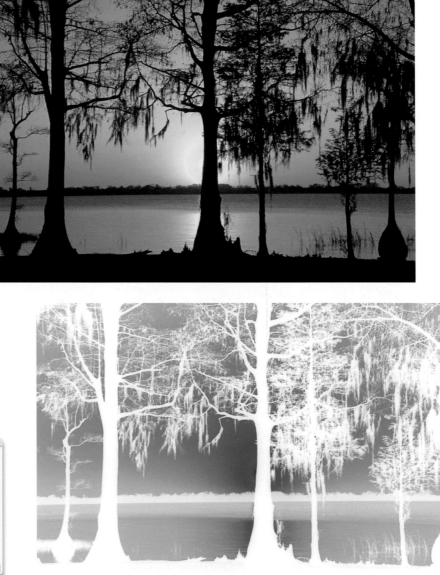

This example shows the Curves line completely reversed.

Above
If you pull down the center of the image into a "U" shape, you reverse all the tones that are normally darker than middle gray.

By creating an upward curve, you reverse the highlight values.

And, of course, as you begin to create random shapes or multiple hills and valleys, you hop down the rabbit hole leaving reality behind, reversing some values but not others. Playing with curves is fun and, if you do it methodically, you will get to know how changing the curve will affect various aspects of the image.

GRADIENT MAPPING

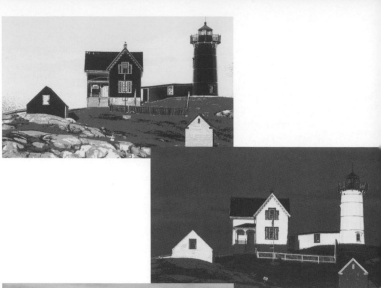

Gradient Mapping is a tool found in recent versions of Photoshop and Photoshop Elements, and has equivalents in other programs as well. This is a quirky little tool that I seem to experiment with when I'm bored. It's pure eye candy. Even if you end up not liking the look it gives a particular image, it's fun to play with. Basically, a gradient is a blending of two or more colors in a particular pattern and there are a variety of samples in the software, but you can also create your own custom color blends.

You'll find the Gradient Map in two places: under the Image menu in the Adjustments area **(Image>Adjustments>Gradient Map)** or you can create a Gradient Map adjustment layer in the Layers palette (which is the method I recommend). If you use the Adjustment Layer method (see page 253), you can adjust the opacity of the layer as well as play with various layer-blending modes. Because the gradient colors tend to overwhelm the image tones (though that can be interesting too) you will probably use the opacity or blend modes with every image.

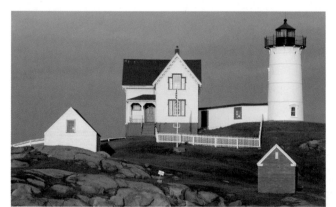

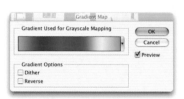

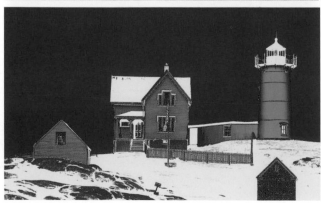

What Gradient Mapping does is to map a particular gradient blend to the grayscale values of the image. Suppose that the gradient has a yellow-to-blue coloring and you're applying it to a landscape scene that has a full range of tones from highlight to shadows. The gradient map will apply one color to the shadow areas (let's say yellow) and the other color (blue) to the highlights—and the middle part of the gradient will fall into the midtones. The fun really comes when you're using a gradient map of multiple colors. It's impossible to predict where the colors will fall and where the blends will be.

POSTERIZATION

Posterization is a technique that I spent years learning to master in my darkroom. It was time consuming, expensive and tedious—though the effects were often worth the effort. The technique involved making multiple enlarged copies of a film negative and then printing them in succession and in perfect registration in almost total darkness. Today you can posterize an image with the click of a mouse while you chat on the phone. Somehow that just doesn't seem fair, but it sure is convenient.

In Photoshop and Photoshop Elements you'll find the Posterize tool in either the Adjustments tools (**Image>Adjustments> Posterize**) or by navigating to it from the Layers palette. When you select the tool, you will be asked to choose a specific number of tonalities, and typically four or five will provide the best result. Two or three tones isn't dramatic enough and more than five starts to hide the effect too much.

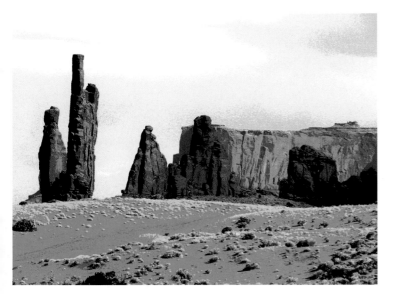

Above
The Posterize tool groups certain tones together and then divides the tonal range of an image into distinct bands. Instead of an image having a smooth transition of tonalities, it ends up with three of four or five (or more) distinct bands of colors and tonalities. The technique is a nice way to turn a fairly ordinary image into a nice graphic representation—posterized images work very well for greeting cards, newsletters and any time when a bold graphic look is more important than detail.

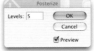

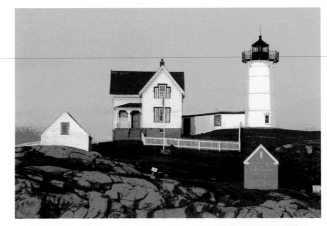

COLOR INFRARED

For years photographers seeking a psychedelic look in their color images experimented with a "false color" film called Kodak Ektachrome color infrared film. It was impossible to predict what the colors would look like with the film since one of its layers responded to invisible infrared light, but the results were often interesting. The images shown here, while shot digitally, look remarkably like those I formerly shot on color infrared film. The infrared look in these images, however, was created by selecting **Image>Adjustments> Hue/Saturation**, and then shifting the Hue slider all the way to the left and the Saturation slider all the way to the right.

Filters

If you're the kind of person that likes to bake a cake by tossing in a little bit of this and a little bit of that just to see what new flavors you can invent, you're going to love filters.

Like a rack of visual spices and flavorings just waiting to be sprinkled onto your images, filters can change and enhance images in ways you may never have imagined.

Filters, in fact, are probably the first thing most people try after they install their image-editing software. By simply pulling down a menu and selecting a particular filter you can add any of dozens of visual effects, ranging from gimmicky to beautiful to just plain strange. Many filters, of course, have practical technical applications (such as sharpening or blurring) that can solve numerous artistic problems, but there is nothing wrong with using them just for fun.

Also, in addition to the filters that came with your editing software there are many filter packages that you can buy as plug-ins.

Filter Basics

Filters are generally divided into several categories depending on the manufacturer. Adobe Photoshop and Photoshop Elements, for instance, include these basic categories, all of which have many sub categories: Artistic, Blur, Brush Strokes, Distort, Noise, Pixelate, Render, Sharpen, Sketch, Stylize, and Texture.

On the following pages I've run a few simple images through various filters. Your software manual will provide a list of all the filters available to you.

Some Software Filter Manufacturers

Alien Skin Software
Auto FX Software
Eastman Kodak Company
FM Software
ImageAlign
Jasc Software
nik Multimedia
PictoColor Corporation
Pixel Genius, Llc.
SilverOxide

The best way to learn about a filter is to try it. Open an image and apply a series of different filters to see how the basic image changes. Many filters also have dialog boxes—some of them rather complex—that let you control or exaggerate the effects of the filter to a very precise degree. And like the mad chef you may be, you can also mix and match different filters for entirely new flavors of eye candy.

Palette knife filter

Pointilize filter
applied to image.
Hue/Saturation
altered for the
final effect.

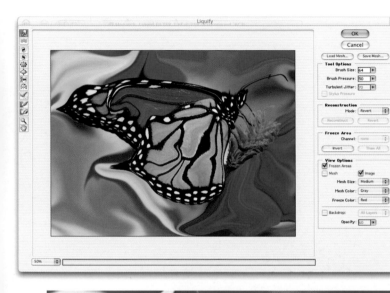

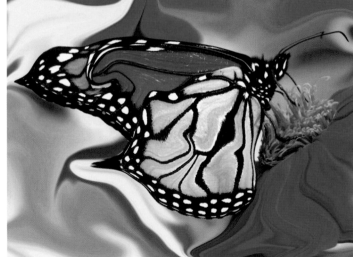

Photoshop Elements Liquify filter

As shown
above, the Trace
Contour filter
can be applied
once, multiple
times, or even
inverted for
varying results.

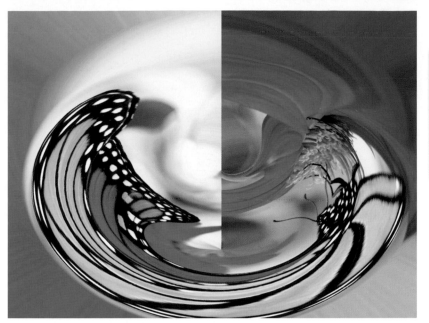

Polar Coordinates filter

Cut Out filter

1

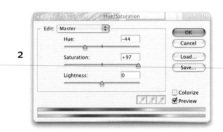

2

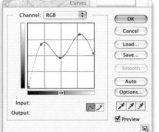

3

The image above was created in three stages:
1. Apply Sumi Filter
2. Adjust the Hue/Saturation sliders
3. Manipulate the Curves

Advanced Tip:

CREATIVE SKY REPLACEMENT:

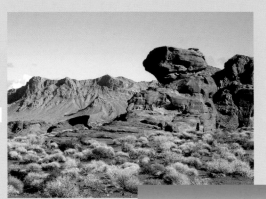

In The Image Enhanced chapter we looked at replacing dull skies with interesting ones using skies from other photographs. It's also possible, of course, to get more extreme and unusual replacement skies by using gradients, patterns and objects instead.

For example, I selected the sky in this desert scene and then used the Gradient option in the Layers menu to replace the sky area with the yellow and orange gradient.

To insert the chambered nautilus shell into the background of this desert scene, I simply selected the shell from one image and then, after selecting the sky in the desert scene, used the Paste Into command to insert the shell.

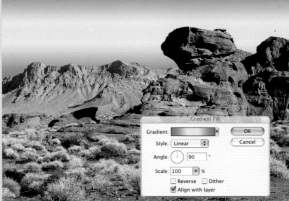

Improvising on an Idea

THE JOY OF DIGITAL PHOTOGRAPHY

Advanced Tip:
CREATIVE BACKGROUND REPLACEMENTS:

In the same way that you can replace a sky by selecting it and inserting a new one, you can do the same thing with any relatively simple object. Just use your favorite selection tool to select the background area and then paste in a new background.

In Photoshop you can use the Gradient and Pattern tools to insert a new background, as I have done on several of the shots here. These experiments show how various gradients and patterns work as a replacement background, but as you experiment you'll find that some new backgrounds complement your subjects nicely. I find exercise like this a great way to get to know image-editing tools and prepare for making more complex composites and corrections later.

Shape Distortions

Most image-editing programs provide a variety of ways to distort shapes. The tools can be a real help in correcting leaning or tilting buildings or even just nudging the dimensions of a scene to fit a particular size layout (in a newsletter for example). Of course, if you are playing in the land of extreme enhancements you can exploit these tools to alter the shape of an object beyond mere correction, and the results can be very eye catching. This image began as a simple snapshot of a cottage and then I used several tools and Photoshop filters to distort the building's shape.

This is the straight image with no shape corrections.

This variation was created using the Distortion tool in Photoshop (Edit>Transform>Distort).

Edit> Free Transform

Edit>Transform>Skew

Edit>Transform>Scale

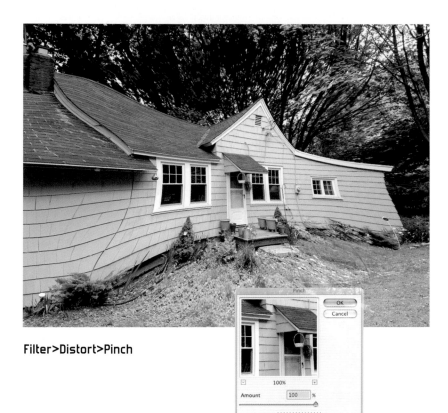

Filter>Distort>Pinch

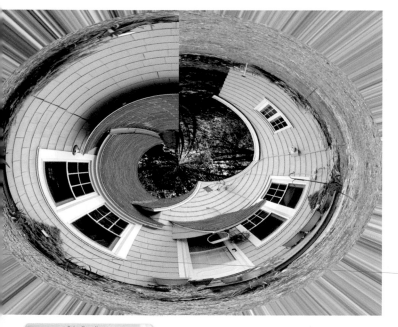

Filter>Distort>Polar Coordinates

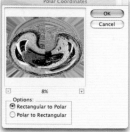

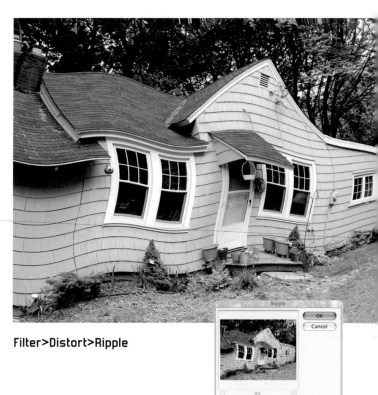

Filter>Distort>Ripple

The ability to combine many different images in an infinite number of ways is one of the most addictive allures of editing images. In pre-digital days the only way to combine images was either by printing multiple images onto a single sheet of paper in the darkroom or by using a slide duplicator to combine various images. While some artists—like the great darkroom master Jerry Uelsmann—are able to create richly sophisticated and clever montages this way, there are limits to what can be done with traditional means.

In the digital darkroom, the only limit is your imagination. Using tools that range from very simple (copy and paste) to very complex (layer blending modes and masking), it's possible to create new image combinations from dozens—or, if you have the patience, thousands—of individual image elements. Once combined, the various elements can be resized, reshaped, made more or less transparent, moved, re-colored, curved, bent, twisted, stretched—in short, anything that your mind's eye can envision your computer (given enough RAM and enough hard drive space) can create.

Your ability to combine things in sophisticated ways requires a good grasp of individual skills and tools. Any visual riddles that you aren't able to solve while compositing can probably be unlocked by examining each of the specific tools you're using—or exploring the capabilities of tools with which you aren't yet familiar. Be sure to use the software instructions as a resource when you come across a stumbling block in your image editing. This will help you to pair your creativity more effectively with the tools at hand.

The Yale Montage: Step-by-Step

I created the accompanying montage of Yale University's "Old Campus" section from five individual photos. The montage was relatively simple to create. Here are the basic steps:

Goal: The Old Campus is the sentimental heart of Yale University and I wanted to combine a series of images in a way that would capture the romance, charm and history of the area.

Plan: When I started creating the image, I knew that I wanted to include these five elements: Harkness Tower, the statue of Nathan Hale (a graduate of Yale), Connecticut Hall, a current Yale student, and Phelps Gate (the formal entrance to the campus).

1 I began by opening the shot of Harkness Tower and fiddled with the Levels and the Hue/Saturation until the building had a golden color and enough brightness to remain the dominant visual element.

Color Balance

Color Balance
Color Levels: +3 0 -33

Cyan ———————□————— Red
Magenta ————□———— Green
Yellow ———□—|———— Blue

Tone Balance
○ Shadows ● Midtones ○ Highlights
☑ Preserve Luminosity

OK
Cancel
☑ Preview

2

I then opened the photo of Nathan Hale's statue, cropped it slightly, adjusted the Levels to brighten the image, and then selected and copied the entire image.

3

Working from the image of the tower as the background (from step 1), I carefully selected the tower using the Polygonal Lasso tool. I used the **Paste Into** command to place the statue behind the tower. I then chose the **Color Burn** mode, which created the purplish-blue color of that layer. The opacity for that layer was set to 88-percent. I used the Move tool to position the image accurately in the upper left-hand corner.

4

I opened the image of Connecticut Hall, adjusted Color and Levels, and used the Polygonal Lasso tool to select the front of the building. I copied this area and pasted it over the main image of the tower.

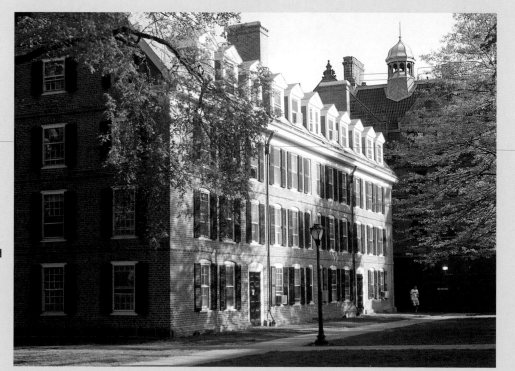

5

Because I wanted the building to face the center of the montage from the right, I flipped the pasted image horizontally (Edit> Transform>Flip Horizontal). I rotated the selection slightly (Edit>Transform> Rotate) until I liked the angle, and used the Move tool to position it. I also added a very slight amount of Gaussian Blur (Filters>Blur> Gaussian Blur) to this layer to soften the details.

6

Next I opened the image of the young woman playing a Celtic harp. I used the Lasso Tool with a pressure-sensitive pen on Wacom Intuos tablet to "select" her from the background. I feathered that selec-tion by two pixels.

7

I copied that selection and pasted it into the montage and then flipped it horizontally so she would be facing into the composition. I then used the Move tool to carefully place her at the bottom left.

8

Finally, I opened the image of Phelps Gate, did a Levels correction and a Hue/Saturation correction, then copied and pasted the entire image onto the collage. I used the Scale tool (**Edit> Transform>Scale**) to size the image to fit into the upper right hand corner, and I repositioned that layer so that it was "under" (and therefore behind) the image of Connecticut Hall.

9

With the entire montage in place I tweaked the colors and brightness values of various individual layers and then saved a "working" version of the collage with the layers open in case I wanted to make corrections later. I then flattened the image (**Layers>Flatten Image**) so that all of the layers merged to the background and saved the image under a different name. Total time for the collage was probably about three hours.

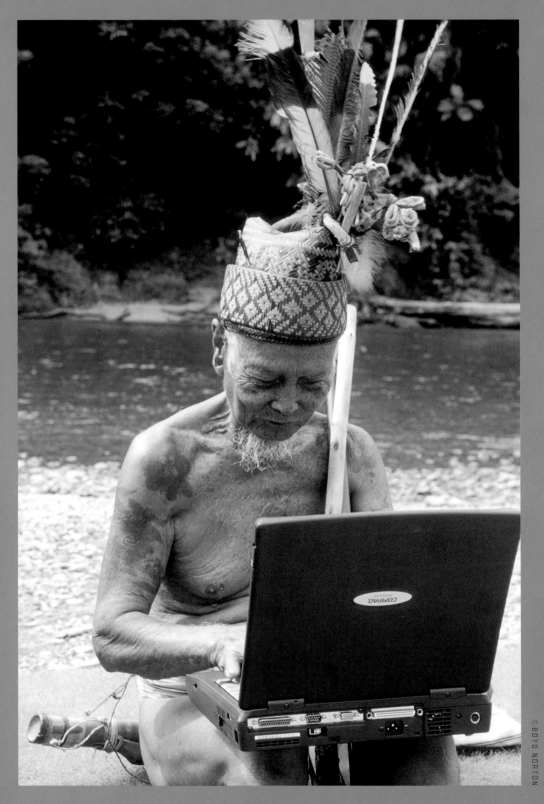

©BOYD NORTON

"Derive happiness in oneself from a good day's work, from illuminating the fog that surrounds us." —HENRI MATISSE

The Digital Darkroom

9

Introduction

From the time I was a kid there has always been a darkroom in the basement of my house. I still have one, though it's a bit covered in cobwebs and dust at the moment. For me there is a certain coziness in escaping to the cool darkness of the darkroom, of being lulled by the continuous gurgle of a print washer and listening to music from around the world on a shortwave radio (another hobby). Above all, there is the amazing mystery of seeing a print materialize in the dim glow of a red safelight.

Today I have a new darkroom—a digital one. My digital darkroom is a cheery white room lined with bookcases and the gurgle of water has been replaced by the whir of the fan in my computer. But thanks to iTunes, I still listen to music from all over the world. Instead of seeing prints emerge in near darkness from a watery bath, they are delivered to my desktop fully formed in brilliant color and almost completely dry to the touch. All in all, the digital darkroom is amazing.

Indeed, you can view, organize, enhance and print your photographs without ever leaving the comfort of your office chair. Because you can create a digital workstation any place that you can fit a computer and a printer, you don't have to dedicate a large area of your home, reroute plumbing or tape dark plastic over your basement windows. About all you need is a hammer and nail so you can hang out your own shingle, "Digital Photographer: Pictures Made to Order."

In the end, perhaps the greatest gift that digital technology has given to photographers is that it is easier than ever to take creative ambitions beyond the camera. With a small investment in computer equipment, a few evenings of practice and a strong desire to fulfill your creative ambitions, you will come to realize that in the realm of the digital darkroom is a magic every bit as potent as seeing prints emerge in the developer tray. And you may also come to see the ultimate truth that Ansel Adams put so eloquently: "You don't take a photograph, you make it."

> Instead of seeing prints emerge in near darkness from a watery bath, they are delivered to my desktop fully formed in brilliant color and almost completely dry to the touch.

The Digital Darkroom >
Choosing Your Computer:

How elaborate you make your digital workspace depends on how much work you expect to do there. If you only occasionally download images and make prints for the family, a computer and printer on a table in a corner of the den will work just fine. But if you plan to add a scanner, some matting and framing supplies, a resource center of how-to books, software manuals, photo magazines, and storage for your backup CDs, ink jet supplies and camera, then you might need some shelves or cupboards in addition to a table.

If photography is your passion, setting up a digital darkroom should be a well-thought-out project because you're going to spend a lot of time there. And you should probably spend as much energy thinking about your computer equipment as your camera gear—perhaps more.

The Digital Darkroom > Choosing Your Computer:
CHOOSING A PLATFORM

There are essentially two types of people in the world (computer-wise, at least): Windows people and Macintosh people. If you start a computer conversation in a roomful of strangers you will soon know which people are which. While the two platforms have merged closer together in recent years, you won't convince advocates of either platform of that. And if you already own one platform or the other, this is a moot discussion. But if you are about to buy your first computer system, there are some differences worth noting.

Despite the overwhelming popularity of Windows computers, Macs have long been favored by professional photographers and graphic artists. Macs are simple to use and have an incredibly intuitive interface—a Mac lends itself naturally to people who think visually.

The criticism of the Mac platform has long been that, because it occupies such a small market niche, there simply isn't enough software written for it. Also,

to some degree, Windows machines are perceived as less expensive than their Apple counterparts—though by the time you beef up a Windows machine to have the same graphic capability of a Mac, you'll end up paying a very similar price. Is there more Windows software available? Absolutely. Will it matter in digital image editing? I don't think so—but that is a question you have to answer.

In the end it comes down to which platform you feel more comfortable using. And now that I've re-ignited that debate…

Processor Speed versus RAM
Computer makers push processor speed (described in Mhz or Megahertz or, more recently, as Ghz or gigahertz) as the primary measure of a computer's speed, but there's more to the story.

The amount of RAM (random access memory) in your computer is probably the single most important speed factor. It is far better to buy a slightly slower computer with more RAM than to own the fastest computer with minimal RAM. Most image-editing programs require a minimum of 256MB of RAM to even operate and having twice that, or 512MB, will greatly decrease the time it takes your computer to perform editing tasks. Certain tasks, like use of creative filters or sharpening tools, take a lot of computer power. Few things are more frustrating than asking your software to apply an artistic filter and then having to watch a timer icon spin around while you wait…and wait.

RAM has become very affordable (at least up to the one gigabyte level), and I suggest getting at least 512MB of memory—and more if you can afford it. It's important to remember that each time you do something to an image file, the file gets larger and what began as a three-megabyte image can be come a 25- or even a 50-megabyte file by the time you finish fiddling with it. The larger the files get, the more RAM you need to maintain a sane working speed.

Other factors to consider are the speed and size of the hard drive (100 gigabytes or bigger), the speed of the graphics card, and the size of the monitor (17-inch minimum). Whatever computer platform or hardware you buy, remember that most computer salespeople are not image-editing experts. Take time to seek out friends that do a lot of digital photography or read magazines like *PC Computing* or *Macworld* to learn the latest on computers for digital imaging.

If there is one practical piece of advice in this book that will save you the greatest amount of time and energy, it is this: create a good method for organizing your digital images and stick with it. If you're like most photographers (including this one), you've got a shelf full of half-stuffed photo albums, overstuffed shoe boxes and ragged processing envelopes full of hidden photo treasures—and almost no hope of ever gaining control over them. The best of intentions often get lost in the worst of messes—particularly when it comes to organizing our photos.

You can choose a variety of software and hardware tools to organize your digital pictures. But use them you must. Heed my dire warning and make organization an integral part of your digital workflow from day one. Digital pictures seem to breed during the night. What starts out as a few casual shots turns into hundreds, if not thousands, of images in short order. Twenty images a week may not seem like a lot of pictures to keep track of, but by the end of the year you've added over a thousand picture files to your computer's hard drive.

There are numerous cataloging programs available that are designed specifically for organizing your images. The software that comes with many digital cameras may have some facility for organizing and labeling images, but dedicated archiving programs are better at handling large libraries. Programs such as Apple's iPhoto (that comes with all Apple computers) or Adobe's Photo Album (for Windows) are capable of creating a very sophisticated and searchable library for tens of thousands of files.

STEPS FOR STAYING ORGANIZED

The moment that you shoot a digital photograph your camera assigns it a sequential number (DSCN2711.JPG, DSCN2712.JPG, etc.) and when you download the image, that number stays with it. Those numbers are useful for precise identification of specific shots, but they are virtually no help in organizing and retrieving your images. Also, because many cameras begin the numbering sequence over again each time you re-insert a memory card, you can end up with countless photos having the exact same file number—and that is the road to digital perdition. If possible, turn that feature off so that the image numbers continue to advance, rather than repeating themselves.

Of course, a more sane way to identify each image would be to simply give it a name, such as "Lynne in Utah, #27" which gets rid of the image numbering altogether. In the newest version of iPhoto you can also give your images a star rating—so that you can locate your five-star images at a glance. And, of course, you can arrange images by category in virtually all image-management programs. Many software programs also provide alternate methods for tracking your photographs, including key wording, date searching and "roll" numbering (the word "roll" simply refers to a particular group of images downloaded at the same time).

In choosing a program, try to find one that provides the ability to search by any (or all) of these criteria. It's also important that the system is easy to use and that it enables you to alter photo labeling at a later date. Some programs (including Adobe's Photo Album) also have the ability to search image databases—such as images stored on a DVD or CD disc—that are no longer in the computer. And though you can't view the images, the program will locate the disc and tell you where the images are stored—a very handy feature.

Heed my dire warning and make organization an integral part of your digital workflow from day one.

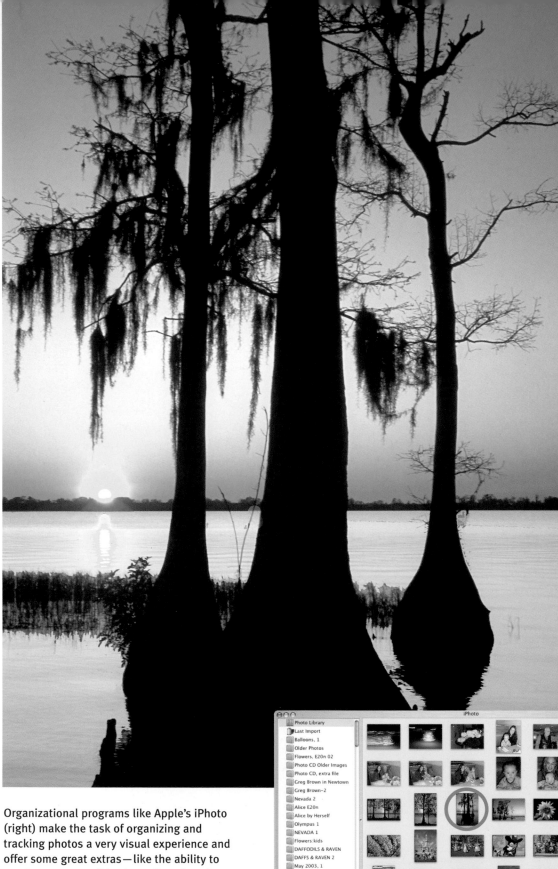

Organizational programs like Apple's iPhoto (right) make the task of organizing and tracking photos a very visual experience and offer some great extras—like the ability to create on-screen slide shows from favorite pictures. But don't be lulled too easily into relying on thumbnails: once you have a few thousand images in your database, keywords and titles are a far more efficient means of locating stray images.

The Digital Darkroom

Organizing and Managing Your Photo Library:

NAMING SAVED FILES

Once you open your images in an image-editing program and begin manipulating or enhancing them, you will be able to title and save those files as well. At this point you have a choice whether you want to organize them separately from your organization software and rely on your operating system to navigate to those files, or to export them back into your organizing program—or both. My personal preference is to use both—since that way you can view enhanced or altered versions of images using the same keywording codes, and you can also look at thumbnails of enhanced images side-by-side with the originals.

[
You need to be equally methodical organizing your pictures saved to CDs and DVDs. Trust me, if you don't label the discs as you burn them, you will spend much of your time flipping through a tower of discs looking for the lost photographic chord.
]

The Digital Darkroom >
Organizing and Managing Your Photo Library:

TRACKING AN IMAGE

Here's a quick example of how I track images from the moment they enter my computer until they're output as prints, CDs, etc.:

1

Immediately after a file is downloaded, I use my Apple iPhoto software to **assign keywords** to each image. Since most of the images from a particular take are of the same subject, I keyword the images as a group. The Florida sunset shown here, for instance, might be given the keywords: "Sunset, Florida, Cypress, 2003" (left).

2

I burn a backup of those images to CD and then label it with the subject matter, the dates shot and downloaded, and the camera file numbers.

3

Once I open the image in Adobe Photoshop to edit, I **duplicate it and save it as a tiff file with a new file name,** such as: "Cypress Sunset,8027,1." "8027" are the last four digits of the number that the camera assigned, which I keep to identify the image since I often shoot many similar exposures of the same subject.

4

Each time I create a new version of a particular image, **I increase the last number,** "Cypress Sunset, 8027,2" or "Cypress Sunset, 8027,3." That way I always know the most recent version of that image because it has the highest number at the end of the file name.

5

After the image is printed, **I write the exact file name on the print** so that I know which file created it. This is a very important step if you plan to make future prints (as you almost certainly will).

6

When I back up edited images in groups, **I put them in folders by subject** and I assign a matching number to both the folder and the CD. This lets me know which folder an image is in by looking at the CD or which CD an image is on by looking at the folder. For instance, if I label a folder "Florida Cypress Sunsets, #112" I then label the CD the exact same way. I can have multiple folders on any given CD, but they will all have the same CD number.

7

Last, **I label both the CD and its jewel box** just so that the two stay together and so that I can find the CD without opening all the jewel boxes.

A Scanning Primer

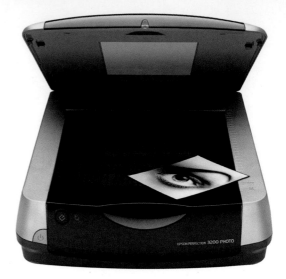

One fear that many people have when a new technology like digital photography is introduced is that it will make their old photographs obsolete. If anything, however, the opposite is true: digital imaging gives new life to older images because it enables you to copy, enhance and share those images much more easily. The simplest way to bring analog images into the digital domain is with a scanner.

Scanners work similarly to digital cameras. They measure the brightness and color of light reflecting from a photograph (or, in the case of film, passing through). A sensor captures the data. Software converts the data into a digital picture. The digital picture is transferred to your computer and editing software displays it as a recognizable image.

Scanners have become so good in quality and so affordable that they should be a part of every digital darkroom. Scanning is a very simple, automated procedure and once you set the scanner up you will be able to scan your old photos in a matter of seconds. And the quality of scanned images usually rivals or exceeds the originals.

SCANNER RESOLUTION

A scanner's resolution is important. It determines how much detail a scanner captures and how big you can print the file created by the scanner. The key number that you're looking for in choosing a scanner is its optical resolution—stated in dpi or dots per inch. Typical resolutions for flatbed scanners range from 1200 to 4800 dpi. The higher the dpi, the bigger you can print a scanned picture—and the higher the cost of the scanner. For general use, such as scanning snap-

TYPES OF SCANNERS: FLATBED AND FILM SCANNERS

Flatbed scanners

Flatbed scanners are used for scanning two-dimensional art like old photos or your daughter's first finger painting.

Flatbed scanners come in a variety of sizes, and with varying levels of sophistication, but even the most inexpensive are capable of making good quality files in a matter of seconds. Some flatbed scanners can scan negatives or slides, although the quality may be good, a true film scanner will give much better quality. The very artistically inclined can use a flatbed scanner to scan three-dimensional objects. Anything that will fit on the scanner's glass plate can be scanned: fabrics, people's hands, your seashell collection, or even your favorite piece of china. These scanners have an inherently high depth of field and that means that even three-dimensional objects will remain sharp, though of course the scanner can only view those portions of the objects that are facing the glass.

Film scanners

Film scanners are used to scan both slides and negatives. Film scanners use considerably more sophisticated technology, and they typically cost anywhere from several hundred to several thousand dollars.

Because film scanners are creating files from camera originals (negatives and slides) they provide a much higher level of definition and capture much more information (they also create much larger files). If you own a large slide or negative collection and would like to import it to your computer, a film scanner can be a good investment. Most film scanners will accept 35mm slides or strips of 35mm negatives but check to be sure of other formats (such as APS) before buying one.

shots and then making an 8 x 10-inch or even bigger print from the scan, a 1200 dpi scanner will be fine. But if you can afford to spend a few more dollars, a 2400 dpi scanner will let you crop images more or print them as large as poster size.

How dpi affects print size

Let's assume that you want to scan a 4 x 6-inch print. If you were to scan it 100% size at 300 dpi, you would have a scan capable of making a very good quality same-sized print. But what if you want to make an enlargement? By selecting a higher resolution of say, 600 dpi, you can make a print enlarged to twice the size of the original—or approximately 8 x 10-inches. Similarly, if you were to scan the print at 900 dpi you could make a print three times larger than the original, or approximately 11 x 14-inches.

Most flatbed scanners in the $100 to $150 range produce excellent scans at 1200 dpi. As you go higher in price, you will find that scanners typically have greater dpi (2400 or 4800), larger glass surface areas (for larger originals) and better negative/transparency scanning capability.

Don't let resolution be an issue that scares you away from scanning—as long as you know the size of the output you want and remember that 300 dpi is the maximum print output resolution you'll need, setting scanner resolution is simple. It will be second nature to you after just a few scans.

The Digital Darkroom > A Scanning Primer:
MAKING GOOD QUALITY SCANS

Using a scanner requires a software program called a "driver" that you install when you set up the scanner (in many cases the driver is referred to in menus as "TWAIN" software). While some scanner software operates as a stand-alone program, in most cases the scanner driver is installed as a "plug in" or a program-within-a-program that you access through your image-editing software.

You access the scanner's operating controls through the software, and most software also has its own image-correction functions for adjusting the scanned image. Using my Epson 2400 scanner with Photoshop, for instance, I can turn the scanner on by navigating in the file menu: **File>Import>Epson Twain.** The driver automatically turns on the scanner, warms it up and then creates a prescan.

STEPS IN MAKING A GOOD FLATBED SCAN:

1 > Clean the glass and the print you're scanning, because scanners capture every detail, including dust and stray hairs.

2 > Line up the print. Line the print up carefully with the indicator marks along the edges of the glass so that the image scans squarely.

3 > Choose a format for the piece you are scanning. Most scanner software provides a pull-down menu that lets you tell it what your original is: a color print, a black-and-white print, a black-and-white document, etc. Be sure to match that setting to your original so that you're not scanning a black-and-white photo in the color print mode, for example.

4 > Choose a resolution. The resolution you set depends on what you'll be using the image for (the web, email, printing, etc.) and how big your final output will be. If you're going to scan a photo to send in email, for example, you can set the scanner to scan the image at 72 dpi, which is the standard resolution for email (and website) usage. However, if you're making prints, use the dpi that you typically use for printing to determine the resolution necessary to make whatever size enlargement you have in mind.

5 > Examine the pre-scan. Before the scanner makes a final pass it will make a pre-scan. Check it for dust and squareness. Clean or align the print as your examination indicates.

6 > Correct the pre-scan. At this point you can use your scanner's software to make a host of corrections, including cropping, color corrections and brightness/contrast corrections. You can make these corrections with your image-editing software, of course, but you can often see obvious flaws in the pre-scan it will save you time if you correct them before making the scan.

There is, thankfully, an Auto mode in most scanners that takes most of the decision making out of your hands. For general scanning it delivers very good quality.

7 > Click on the Scan button. At this point the scanner will make its final scan and then open the image on your screen.

Printing

As extraordinary as the capabilities of digital cameras may be, the revolution in digital printing is perhaps even more amazing. Today you can make an exceptional color print in minutes, and soon it will no doubt be seconds. And you can do it in the daylight of your kitchen, living room or even your patio while you sip a cup of Jasmine tea and watch the kids swim. Now that's a revolution—out of the darkroom and onto the patio.

The technology of ink jet printing is truly extraordinary: in less time than it takes to warm up a corn muffin in the microwave, you can make a 5 x 7-inch print. Seconds after you click on Print and send a photo the printer, tiny nozzles track across the paper emitting millions of two- picoliter (a billionth of a liter)

droplets of ink in an extremely precise pattern. When these millions of droplets combine they almost magically become the lighthouse you photographed just hours before.

Interestingly, this amazing process has its roots in a technological fluke. In the 1970's a researcher at a Canon facility accidentally bumped a soldering iron into a syringe of ink and observed a drop of ink emerge from the needle. Cause-effect. Synapses fired like fireworks streaking across his brain, light bulbs exploded in ceilings throughout the facility, and a double rainbow arced across the sky beneath the forked lightning (an event soon to be made into a television movie). Fortunately for the world of digital imaging, the gentleman understood the potential of what he had witnessed.

PIXELS AND DOTS (OR CAN I HAVE AN INTERPRETER, PLEASE?)

Perhaps nowhere does digital photography become more confusing than at the intersection of picture resolution and printing resolution. Before we get into the explanation, you should try this with your printer:

Choose a typical picture to make some test prints. I suggest making them 5 x 7 inches on a glossy photo paper or whatever paper you most commonly use. You are going to make prints at image resolution settings of 200, 225, 250 and 300 to see if there is a noticeable quality difference. In your image-editing software, set the resolution, or dpi, or ppi, whatever it's called, to each of these numbers and make a print.

For example, in Photoshop Elements 4.0, go to **Image> Resize>Image Size>Resolution,** and in the Resolution box (set to pixels/inch) type in 300. Click okay and then make your print. On the back of each print you make, mark the setting used. Repeat this procedure for each of the different resolutions. When all prints are done, examine them from about 2/3 arm's length (normal viewing distance for a print this size) and see which print gives you the quality you desire.

Yes, the 300 setting will probably give the best results, but the point here is that you may not be able to see a significant difference between it and the print made with the 225 setting. The main advantage of lower settings is faster printing , and potentially bigger prints. For most printers, a setting of 225 to 250 will provide quality prints while not taking forever to get through the printer.

The Explanation...
Both camera and printer specs like to tout resolution as a key factor in image quality. However, they are speaking different languages, which can lead to confusion.

Cameras make images based on pixels. Printers make images based on dots. They're not the same. A printer depicts each pixel using several ink dots. And each ink dot consists of many small ink drops. To add to the confusion, both camera and printer specs tout resolution as a key factor in image quality.

A typical printer states its resolution in dots per inch (dpi): 1200 x 4800 dpi would be fairly common. The lower value is always the maximum true number of dots a printer can apply in the space of one horizontal inch. The higher number (4800 in this case) refers to how small an increment the printer motor pulls the paper through before the printer again moves across the page and lays down more dots. So only the smaller number indicates resolution.

And just as many cameras have variable resolutions, so do most printers. The settings, made using the print driver may be expressed as "Best Photo" or "Photo Quality." Or they may be expressed in dpi numbers, the higher number giving the better quality: 2880 dpi or 1440 dpi. Again, a test may be worth making here. You could well find that the second highest quality setting acceptable for most of your photos while saving you print time.

Here are some critical ways to evaluate a sample print:

1. Look at large solid-color areas such as a sky, because they often reveal flaws. The tones should be smooth, without subtle streaks, bands or blotches.

2. Look for details and flaws in highlights—lightly colored areas—because they are difficult to print. Tonality should be smooth and continuous.

3. Flesh tones should also be even and a pleasant color.

4. Look for fine detail rendering, such as strands of hair and threads in fabrics.

Below are the basic features an ink jet printer should have to make superb prints from your digital pictures. Keep in mind, a photo printer can still print reports and other text heavy documents, but it excels in printing digital photos. Specs and features aside, the most important step in choosing an ink jet printer is looking at sample prints. Nearly all stores display sample prints, and some may even let you make one or two. If the sample prints don't look great, don't expect yours to look any better.

1 > Number of ink colors. Basic entry-level ink jet printers use four ink colors (CYMK, or cyan, yellow, magenta, and black). More high-end photo-quality printers often feature more colors, for example light cyan and light magenta inks, which can smooth the tones in delicate areas of color such as skin and skies. And some printers add a second or even a third black (often a dark gray) so you can make good black-and-white photos.

2 > Paper size. Most printers handle 8-1/2 x 11" paper (approximately A4), but you may want to print bigger pictures. Other models are designed to print just snapshots, 4 x 6-inch photos. Some models handle larger paper, and, if you'd like to trade in your European vacation, you could get a wide-format printer and print posters or murals.

3 > Dots per inch. When ink jet printers were first introduced about a decade ago, the dots of ink that were sprayed onto the paper were not so small. In fact, you could easily see them with the naked eye. Today printers produce dots so small you can't see them. Generally, a dpi of 1200 or higher is fine. Equally as important is dot pattern, or dithering, which is how the printer arranges the dots. Printer manufacturers often claim a proprietary technology for how they lay down the ink and give it some hoopla to make it sound good (and often it is). But with printing, the proof is in the print. So examine samples and make up your own mind.

4 > Speed. The time required to print an 8 x 10 photo can vary from about two minutes to ten minutes. If you make a lot of prints, you may want to check out the speed of the printer. Sites like PCworld.com and cnet.com often compare printing speed for photos and might also discuss printing costs.

5 > Cost. Aside from the cost of the printer, the biggest costs come from the ink and paper. A typical 8 x 10 photo costs from $1 to $2 to print. (Many experts recommend buying printers that provide each color of ink in a separate container, so you can replace each color when it runs out.) Do some research if you haven't yet bought your printer. Again, the best strategy is to review magazine and online articles about costs of printing photos. Check out sites like www.steves-digicams.com or www.dpreview.com for reviews of the latest printers.

Desktop printers such as the **Epson Stylus Photo R2400** (left) are perfect for your home digital darkroom. However, for your next family gathering, you may want to tote along an **Epson PictureMate** (opposite top) or **HP Photosmart 475** (opposite bottom). These nifty little models print directly from the camera's memory card so that you can quickly and easily make borderless prints to share with family and friends.

Printers have many more features and any one of these may greatly appeal to you and be critical in choosing a printer. They don't affect image quality, but can be of great convenience.

1 > Built-in memory card reader. Printers that have a built-in memory card reader enable you to print without using a computer. You simply slip the memory card into its slot on the printer, make a few settings and away you go. These printers may include an LCD and a few basic controls to adjust the image before you print it. Others connect directly to a camera, bypassing the computer.

2 > Paper/media handling. Print a lot of snapshots? Like to make banners for parties? Want to print images directly onto CDs? You can do all this and more with the right printer. Especially important may be how easily the printer handles snapshot (4 x 6) paper. Check if you have to attach a special holder or tray each time or fumble with reluctant levers and knobs.

3 > Wireless printing. Growing in popularity, wireless printing enables you to print without being connected to the computer. In effect, you are free to roam the house well up to 33 feet if your printer is Bluetooth enabled. That's kinda fun. Do you need it? Probably not.

4 > Print longevity. Great strides have been made in print longevity in recent years. The majority of printers use dye-based inks, which are the main culprits behind fading. Epson has developed a series of printers that use pigment inks. Prints formerly made from pigmented inks lasted longer but had a lower color range. Now pigmented inks can nearly match the color range of dye-based inks, and dye-based prints can nearly match the life of prints made with pigmented inks. In other words, it's all even Steven.

Products that have great longevity are typically referred to as having archival quality. Another term bandied about is print permanence. So far there are no clear definitions or industry standards for these terms. Also, there are a variety of archival products albums and album pages, storage sleeves, storage boxes, and matte boards built to prolong the life of photos so they last longer.

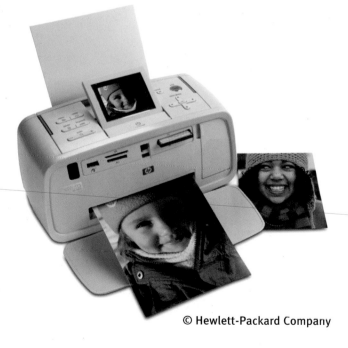

© Hewlett-Packard Company

THE CHECKLIST

Printing has become so incredibly simple, that it is easy to fall into the bad habit of simply pressing the print button and expecting to get good results. After all, if you don't like the results you can quickly make changes to the file and reprint the pictures. But that old do-it-yourself maxim of "measure twice, cut once" applies to printing digital pictures—particularly if you don't happen to own an ink or paper store.

Before you print, you should run through a checklist to make sure your picture is ready to be printed. Remaking prints may seem like an insignificant expense but with the price of paper running anywhere from $.50 to $2.00 a sheet, the cost of mistakes can quickly offset the convenience of one-button printing.

If you're like me, on more than one occasion you've dashed out to the grocery store to get a specific item only to be distracted by the lady holding out a delicious sample tray of stuffed mushrooms. You return home and realize you forgot the shampoo (or more likely the M&Ms)—the reason you went to the store in the first place.

Thus, the value of a checklist: checklists save time and money. Here's a pre-flight checklist worthy of a pilot. Copy it, modify it for your needs, and then put it by your computer.

1 Brightness/Contrast

White shirts should be bright white but show some detail in the fabric or buttons. Detail should also be apparent in fair-weather clouds, swans, and churches. Black shoes should be a rich black but the laces should be visible. Midtone areas, particularly faces, should look right. Much of this is a judgment call. But if you are using Adobe Photoshop or another editing program that displays pixel values, you can measure the extremes using the Info tool. Bright whites generally should measure out at 245-250, and deep blacks at 5-10.

2 Color casts

Again, you can use the Info tool to measure whether white shirts and gray house trim are fairly neutral as they should be. The info tool should show approximately the same values for red, green, and blue. For example a medium gray might read out at R-135, G-137, B-134. Of course, if it were perfectly neutral, the values would be identical, but few things are truly perfect. If it's too far off, adjust it. Keep in mind that with Photoshop, the Levels tool has eyedroppers for shadows, midtones, and highlights that can eliminate color casts so neutrals combine equal amounts of red, green, and blue.

You can also eyeball colors on your monitor if you're confident its display is neutral. Again, look at "memory" colors, such as faces, the sky, grass to make sure they appear appropriate.

Your printer driver: At first the name "printer driver" seems odd. But the name makes sense once you realize its function: located in the printer control panel, it drives many of the functions of your printer. Basically, it is software that comes with your printer and lets you make a variety of choices to influence your printing: resolution/dpi quality settings, media settings and controls, color management settings, utilities for maintenance and troubleshooting, print and ink status indicators. The driver handles all this and more. First read your printer manual for tips on its use. Then explore the printer on your own.

Retouching

3

Use your enhancement tools to eliminate dust, dirt, scanned-in scratches, unsightly blemishes, and red-eye. Double check the cropping. If you've done a lot of retouching, you're going to see flaws in the print that you didn't see on the monitor. Use the first print of an image as a guide for improvements.

Proper sharpening

4

When making prints, you can generally sharpen an image a bit past what looks good on the monitor. Examine sharpening effects with the image displayed at 100%. Faces (except the eyes) generally do better with normal or less-than-normal sharpening. Sharpening is such a critical element to print quality that you may want to consider a special sharpening program, such as Nik Sharpener Pro!, a plug-in for Photoshop users.

File size/resolution

5

Can you paint an entire house with a pint of paint? Of course not. And if you crop a picture, then that's like throwing away some of the paint, or in this case, part of the file. Your picture's file size corresponds to a maximum print size to obtain good quality. As you go beyond that maximum print size, image quality lessens.

Here are approximate file sizes you need to make common print sizes:

5 x 7-inch print: 5MB (a 2-megapixel camera)
8 x 10-inch print: 11.5MB (a 4-megapixel camera)
11 x 14-inch print: 22MB (a slight stretch for
 6-megapixel camera).

High-Quality Photo Paper

6

Using a high-quality photo paper is essential. Since photo papers are coated on only one side, make sure it's oriented correctly for your printer.

Paper selection

7

In your picture-editing software or your printer driver, choose the paper type to match what is in your printer. Based on this, the printer adjusts how much ink it lays down, the pattern it uses to lay down ink, and other choices such as the print speed.

Dots-per-inch (dpi) or quality setting

8

This setting appears in most printer drivers. You may have a choice of setting dpi or print quality, the result is the same. If asked to choose dpi, select a dpi above 1200 but below 4800. If asked to select quality, choose "photo" or the highest quality setting.

Aspect ratio

9

Thanks to many movie DVDs offering the option of retaining their movie aspect ratios on television, most of us now understand aspect ratio. Common print (and picture frame) aspects ratios are 4 x 6, 5 x 7 and 8 x 10. Did you crop your picture to fit well within the aspect ratio you desire? Are you using a specific paper size to fit a specific picture frame, such as 5 x 7? If not, then print away, but keep aspect ratio in mind.

Print preview

10

Set your printer driver or picture-editing software so it shows you the print preview window after you click the Print button. Check for orientation and fit.

Print Drying

11

As prints are completed, place them (without overlapping each other) on a flat surface to dry for a few hours. Try not to let the cat walk on them.

Use the Right Paper

Working with a high-quality photo paper is critical to making your pictures look their best. I've had a number of people complain to me about poor print quality only to whip out a print made on horrific quality paper. When it comes to paper, you get what you pay for and if you want to make prints you can brag about, you have to pay a little extra for good paper.

Photo papers are often available in three surface options: glossy, semi-glossy or luster, and matte. Glossy papers give brilliant, bright, and saturated colors capable of showing minute detail. These features lessen slightly with semi-gloss/luster papers and even more so for matte papers. Which paper you use is largely a matter of taste. If brilliant colors and fine details are critical, then use a glossy paper. If smooth, soft flesh tones are paramount, use a luster or even a matte paper.

Also, your photos will look somewhat different on various brands of paper, so it's worth trying a variety of ink and paper combinations for different types of shots until you find the combination that speaks to you.

To work efficiently, you should settle on one primary paper that you use for everyday printing. And then use only two or three other papers. For each paper type you should record the adjustments (brighter, more contrast, less red, less sharpening, etc) required to make pictures printed on it look their best.

The manufacturer of your printer goes to great lengths to optimize their printers to give exceptional results with their own papers and inks. And these combinations offer you excellent print longevity.

Of great interest are the specialty papers. They can give your photos a unique look. Imagine a sepia-toned photo of your grandfather standing beside his Model T Ford printed on a cotton art paper to reinforce the sense of antiquity.

Matching the right subject to the right paper is really an entirely subjective and experimental process. The mood of the image itself often suggests the use of one type of paper or surface over another, and it's surprising how different the same photo can look on two different surfaces. I often find that quieter scenes—like the shot at right—do well on matte surfaced papers, while more lively or colorful scenes (above) take well to luster or semi-gloss surfaces. Printing the same scene on several different papers and comparing results is a great way to sample different ideas—just don't expect your friends to agree with your choices.

Getting Your Prints to Match your Monitor

You've just spent an hour retouching a photo of your daughter playing at the seashore. You plan to give it to your spouse as a gift. You made the sand sparkling white, the sky a deep blue with puffy white clouds, and the water shimmering with aquamarine. And the flesh tones of your daughter's face are perfect. Now out comes a disappointing print: the sand and clouds are reddish, your daughter's face looks sunburned (but you know it isn't). The print is a far cry from what you see on the monitor and if you give it to your other half, he or she is going to take your digital camera away.

Nothing can be more frustrating than spending a lot of time adjusting your picture on the monitor only to make a print that strays far from its monitor appearance. And nothing can be more satisfying than to make a dead-on print the first time you try. The good news is that most digital cameras and printers incorporate effective color science that enables them to work together so you can make good prints with minimal effort.

If you're getting good results from your printer on the first or second try, then you may not even want to read this page to avoid being tempted to try techniques that could undo your current successful process. In other words, if it isn't messed up, don't mess it up. But if you do have problems consistently getting good prints, read on. We'll take a look at some tips that'll help you make better prints consistently.

PART I—ADJUST YOUR MONITOR

Setting your monitor to display neutral tones without color bias may be the most important step to better prints. The neutral tones include the full range of whites to grays to blacks.

The best way to achieve this is by calibrating your monitor. If you are using Photoshop or Photoshop Elements, use the included Adobe Gamma calibration software.

PC: On a PC, go to the Control Panel and click on Adobe Gamma. The program will lead you through a series of visual calibration steps to adjust brightness, contrast, and neutral tones.

Mac: On a Mac, go to the applications folder and then to the utilities folder (you can also use the Mac's Display Calibrator software in the utilities folder).

If you're using a picture-editing program that doesn't offer a monitor calibration tool, you have a couple of choices. On a Mac, refer to online help and use the Display Calibrator software. On a PC, refer to the monitor manual to see if it instructs you on calibrating or adjusting the monitor.

A number of products are available to help you manage accurate color reproduction among the different components of your digital system (monitor, scanner, printer, etc.). The 'mouse' on the screen, from Monaco Systems, is actually a colorimeter, a device that helps calibrate color values from your computer's display.

PART II—COMPARE A SAMPLE PRINT TO THE MONITOR DISPLAY

1 > Select and Correct the Sample Image. Once you've calibrated the monitor, select a digital image to use as a sample. Choose a favorite subject, but make sure it includes neutral white, gray, and black areas. If you take a lot of people pictures, then make sure a face is fairly large in the picture. You may want to create a special composite picture including a white-gray-black card arrangement. Looking at the monitor, adjust the image so the neutral tones lack color casts and the flesh tone is pleasing. The white areas should be bright and the black areas should be black, not dark gray. The picture should also show a pleasing brightness and contrast. In other words, you should like how it looks on the monitor.

2 > Make a Test Print. Now, make a 5 x 7-inch print to evaluate. For this test, use a photo paper made by the manufacturer of your printer, since your printer is set up to give good results with its own brand of paper. I use three different Epson printers and always make my first prints on Epson paper even if I plan on experimenting later with different art papers.

Make sure the print driver is set to the type of photo paper you are using and to the high (photo) quality (minimum 1200 dpi) setting you normally use. Everything you do to make this print should match the process you will use for most prints.

3 > Compare. Compare the finished print to its image on the monitor. Are you satisfied with the print? Does it approximate what you see on the monitor? Print and monitor won't match perfectly because each uses a different technology to create color: the monitor creates an image by emitting red, green and blue light; the print by reflecting light off cyan, magenta, yellow and black inks. However, the print should approximate what you see on the monitor.

4 > Re-adjust the Monitor. If you calibrated your monitor using the Adobe gamma method, you shouldn't have to recalibrate the monitor again during this test. If the print is simply too dark or too light, you can adjust the monitor's brightness and contrast controls until you get a better match. If the print's colors are off, adjust the color of the image using the picture-editing software until the print and monitor image are as close as you can get them. Keep a record of the color shifts you make in the image-editing program. The adjustments you make to obtain a pleasing print are the approximate picture-editing adjustments you should make on future prints. If the print's colors look good, but the monitor's are off, adjust the color controls on the monitor to approximate the print. For example, if you notice that all of your prints have a magenta cast or bias, you can add green using the color controls in your editing software to compensate.

> This trial-and-error method of matching printer to monitor can be time consuming, and sometimes ineffective. Eventually you may want to take advantage of one of the callibration tools on the market.

The Digital Darkroom > Your Computer Room:

Keep your computer room fairly dim, with no glare from lamps or windows on the monitor. The walls (and your clothing) should be a neutral color, such as gray or white so they don't reflect colored light onto your monitor or prints and throw off your judgment of color.

The Digital Darkroom > Your Computer Room:
PRINT-VIEWING LIGHT

The light you view your prints in can be critical. Professionals often spend thousands of dollars creating an entirely neutral room with neutral lighting just to examine prints. You don't need to do that, but you should try to view your prints using the same fairly neutral light source each time. The best solution might be a full-spectrum fluorescent or tungsten halogen light. It has to be full spectrum so it simulates white light. Normal fluorescent and tungsten bulbs are not suitable for viewing prints as they have distinct color casts. One company that specializes in making very high quality full spectrum daylight-balanced lights is Ott-Lite ™ and you can read more about their lighting at www.ott-lite.com. Alternatively, you can use indirect light (not full sunshine) from a window, although it tends to be a bit bluish and is hardly consistent from day to day.

Your perception of colors, brightness, and contrast, is affected by your surroundings. When adjusting and printing pictures, you need to minimize the influence of the surrounding light so it doesn't skew your evaluation of the prints you make.

"What we do during our working hours determines what we have; what we do in our leisure hours determines what we are." —GEORGE EASTMAN

Useful Photographic Websites

"Photo of the Day" Websites

Most of the following sites provide an opportunity to showcase your best digital images, on-line. Some require a membership, often free, before images can be submitted. Several of these sites display interesting photographs but do not accept submissions from the general public.

Best Photo (www.bestfoto.com): Accepts images, in various categories, for the daily contest. The prize is a gift certificate from a retailer of numerous types of digital camera batteries.

Colorado 0-Day, Colorado Scenic Picture of the Day (www.o-day.com/colorado.html): Images of Colorado landscapes. This site does not accept submissions.

Digital Photo Chat (www.digitalphotochat.com/picofday.html): Accepts images in most categories and offers a photo critique of submitted photos. A winner is announced each week, but prizes are not provided.

Digital Photo Contest (www.digitalphotocontest.com): One photo from each of many categories is selected as Photo of the Day. Daily winners are kept on file for the month, and monthly winners receive prizes, such as camera bags and other accessories.

Kodak Picture of the Day (http://pictureoftheday.kodak.com): Accepts images for daily consideration. The best images are occasionally selected for display in the Times Square Gallery in New York City.

NASA Astronomy Picture of the Day (www.issp.ac.ru/iao/ap/): Each day a different image of our universe is featured, along with a brief explanation written by a professional astronomer. This site does not accept submissions.

NASA Image of the Day (www.nasa.gov/multimedia/imagegallery): Daily photo made by astronauts or unmanned craft, with full information. This site does not accept submissions.

National Geographic (www.lava.nationalgeographic.com/pod): An exceptional image is featured each day, generally a photo made on assignment but not published in the magazine. This site does not accept submissions.

Outback Photo (www.outbackphoto.com): Features a different nature, landscape or travel image daily, often made by the publishers. The site invites submission of digital images from readers from time to time. Prizes are not offered.

Picture of the Day, Vermont Foliage (www.foliage-vermont.com/pictures.htm): Images of fall foliage, updated each day during the season. This site does not accept submissions.

Powershot User (www.benel.com/powershot/pic-of-the-day.php): Accepts images made with Canon PowerShot cameras for the Picture of the Day. Prizes are not offered.

SmartEagle (www.smarteagle.biz): A site specializing in the sale of members' images, SmartEagle operates a photo of the day feature with many categories. No prizes are offered, but the winners' images may be offered for sale (if desired), with the photographer receiving 30% of any revenue.

Shutterbugs Biz (www.shutterbugs.biz): Similar to other photo sites described, with categories including Animals, Macro, Black & White, People, Scenic & Still Life. A cash prize is provided.

Shutterline (www.shutterline.com/potd): Accepts readers' images for the daily contest; also offers brief critiques of images by a judge. Prizes are not offered.

Steve's Digicams (www.steves-digicams.com): Anyone may enter; monthly prizes (digital equipment and accessories) are awarded for the best images. This site is also a wealth of information about newly released digital cameras, generally published in the form of full News Releases.

Weather Picture of the Day (www.weatherpictureoftheday.com): Features a new image daily of some fascinating weather phenomenon. This site does not accept submissions.

Yellowstone Picture of the Day, The Wyoming Companion (www.wyomingcompanion.com/yellowstone/wcynppod.html): Images of the National Park and its flora and fauna. This site does not accept submissions.

Photography and Imaging E-Magazines

The following websites qualify as e-magazines, with many articles on various aspects of photography and digital imaging.

About Photography (photography.about.com/cs/digital/a/): Features brief articles about choosing and using digital cameras and links to numerous photographic websites. Covers many aspects of film-based photography as well as some digital aspects; naturally, some of the shooting techniques are applicable to both types of photography.

Apogee Photo Magazine (www.apogeephoto.com): A "full spectrum" on-line magazine, Apogee includes a comprehensive range of topics on both film and digital photography. The site offers interactive discussion forums, an add-your-own website link page, and a database of photo schools, tours, and workshops. Targets photographers of all levels.

Better Photo (www.betterphoto.com): An on-line magazine with informative articles about digital photography and image-editing. Includes a monthly photo contest with prizes, a Question & Answers forum and a members' photo gallery.

Digital Outback Photo (www.outbackphoto.com): Published by professional landscape and travel photographer Uwe Steinmueller, this is for advanced shooters who enjoy outdoor digital photography. The articles emphasize creativity in addition to technical aspects, with recommendations on image composition, message, color, story-telling and technique.

MSN Photos (photos.msn.com): This on-line magazine publishes new articles each week, and its archive of articles includes a myriad of topics including many on digital cameras and shooting techniques. While current articles often target the novice to intermediate-level shooter, the archive includes articles on more advanced topics. Includes a Photo of the Week section.

Nature Photographers.net (www.naturephotographers.net): An extensive on-line magazine, covering all aspects of nature photography, with conventional and digital cameras. Includes very active discussion forums, articles by professional nature photographers, and critiques of members' images.

Outdoor Eyes (www.cardsbymel.com): On-line magazine dedicated to wildlife photography with digital cameras. Features shooting tips, news and equipment information as well as stories behind photographs and a discussion forum. Invites members to submit articles on shooting and digital darkroom techniques; does not pay a fee for published articles.

PCPhoto (www.pcphotomag.com): This is the website for the leading U.S. digital photography magazine. It includes articles and reviews and a feature to sign-up for email updates.

Take Great Pictures.com (www.takegreatpictures.com/digital): This photo magazine, sponsored by equipment manufacturers, features articles about equipment and techniques. Other features include photo contests, book reviews, a calendar of photogenic events across the U.S., a forum for Q&A and discussions, as well as suggestions for fun photographic projects.

Wet Pixel (www.wetpixel.com): This site features underwater photography and equipment, and includes reviews, an extensive library of feature articles, and discussion forums. Other areas include News about underwater photo equipment and contests, links to related websites, and a Classifieds section for buying and selling underwater photo equipment.

Other Websites of Photographic Interest

The following websites are worth visiting, offering a broad mix of content as well as links to other sites that you may wish to explore.

Blue Pixel (www.bluepixel.net): Offering educational programs and services, including photo expeditions, this site provides choices for those who want to learn more about digital photography.

Computer Darkroom (www.computer-darkroom.com): A website dedicated to articles, tutorials, reviews and technical discussions relating to digital image processing. The site targets the intermediate to advanced photographer and covers a broad range of topics. Includes Photoshop tutorials and User Reviews of hardware and software related to digital darkroom.

Digital Photography Review

(www.dpreview.com): Published in England, this website provides extensive coverage of new digital cameras and extraordinarily comprehensive test reports with extensive technical documentation. Other features include a very active discussion forum (primarily about cameras), a Gallery of sample images made with various digital cameras, and a comprehensive glossary.

Imaging Resource

(www.imaging-resource.com): Includes daily news items about new equipment, often with an analysis by the publisher as well as thorough test reports, particularly of digital cameras. Other features include articles on selecting the right camera, scanner and printer as well as tips on using your new equipment.

PhotoBlink

(www.photoblink.com): A photographic forum and competition site for serious photographers, it features a portfolio competition. On PhotoBlink, you can view, critique and rate images, as well as submit your own for assessment.

Photo.net

(www.photo.net): One of the most popular and comprehensive discussion forums on the Web, photo.net includes many digital topics. Other services include a Gallery for uploading your images for critique and ratings, articles (written by members) with technical tips on various topics, travel stories, a stolen equipment registry, classified ads, and a comparison shopping section.

PhotoPoints Photography Community

(www.photopoints.com/main): This international site features critiques of images submitted by members. Various levels of critique can be chosen, with or without ratings, from basic to in-depth, depending on your preferences and whether you can accept a high volume of criticism and praise.

Equipment and Software Manufacturers

ACD Systems (Software) (www.acdsystems.com)

Adobe Systems (Software) (www.adobe.com/digitalimag)

Alien Skin Software (www.alienskin.com)

Apple Computer Inc. (Computer manufacturer) (www.apple.com)

ArcSoft Inc. (Software) (www.arcsoft.com)

Auto FX Software (www.autofx.com)

Bogen Imaging (Photo equipment, tripods) (www.bogenimaging.us)

Breeze Systems (Browser and RAW converter software) (www.breezesys.com)

Canon USA Inc. (Camera and lens manufacturer and accessories) (www.usa.canon.com and www.powershot.com)

Casio Inc. (Camera manufacturer) (www.casio.com)

Cerious Software Inc. (Browser software) (www.cerious.com)

Chromix (Custom Color Profiles) (www.chromix.com/profilecity/kits.cxsa)

ColorVision Inc. (Color management tools) (www.colorvision.com)

Corel Inc. (Graphics software) (www.corel.com)

Delkin Devices (Memory cards) (www.delkin.com)

Dell Inc. (Computer manufacturer and accessories) (www.dell.com)

Digital Mastery (Photoshop seminars and training) (www.digitalmastery.com)

DisplayMate Technologies Inc. (Monitor calibration software) (www.displaymate.com)

Dycam Inc. (Camera manufacturer) (www.dycam.com)

Eastman Kodak Company (Camera manufacturer, accessories, and services) (www.kodak.com)

Epson America (Printers, inks, and papers) (www.epson.com)

Extensis Inc. (Software) (www.extensis.com)

FM Software (www.fredmiranda.com)

Fuji Photo Film USA (Camera and printer manufacturer) (www.fujifilm.com)

Hewlett-Packard Development Co. LP (Printers, inks, and papers) (www.hp.com)

H&M Systems Software (www.hm-software.com/products)

Iomega Corp. (Computer peripherals) (www.iomega.com)

Jasc Software Inc. (Software) (www.jasc.com)

Konica Minolta Corp. (Camera manufacturer) (www.konicaminolta.us)

Kyocera Corp. (Camera and lens manufacturer) (www.contaxcameras.com)

L.L. Rue (Outdoor photo gear) (www.rue.com)

Lasersoft Imaging Inc. (Scanner software) (www.silverfast.com)

Leica Camera AG (Cameras and optics) (www.leica-camera.com)

Lexar Media Inc. (Digital storage media) (www.digitalfilm.com or www.lexarmedia.com)

Lexmark International Inc. (Printers) (www.lexmark.com)

Lizardtech Inc. (Software) (www.lizardtech.com)

Lowepro USA Inc. (Camera bags) (www.lowepro.com)

Maha Energy Corp. (Batteries) (www.mahaenergy.com)

LumiQuest (Flash accessories) (www.lumiquest.com)

Mamiya America Corp. (Cameras and equipment) (www.mamiya.com)

Matrox Electronics Corp. (Video cards) (www.matrox.com)

Maxtor Corp. (External Hard drives) (www.maxtor.com)

Microsoft Corp. (Digital Image software) (www.microsoft.com/products/imaging)

Monaco Systems Inc. (Color management tools) (www.monacosys.com)

Neat Image (Noise reduction software) (www.neatimage.com)

Nik Multimedia Inc. (Software) (www.nikmultimedia.com)

Nikon USA (Camera and lens manufacturer) (www.nikonusa.com)

Ofoto Inc. (Photo sharing and prints) (www.ofoto.com)

Olympus America Inc. (Camera manufacturer and accessories) (www.olympusamerica.com)

Ott-Lite (Lighting equipment) (www.ott-lite.com)

Panasonic (Cameras) (www.panasonic.com)

Pantone Inc. (Color management tools) (www.pantone.com)

Pentax Imaging Co. (Camera and lens manufacturer) (www.pentax.com)

Phase One (RAW converter software) (www.c1dslr.com)

Photodex Corp. (Browser software) (www.photodex.com)

PhotoRescue (Software to recover lost image files) (www.datarescue.com/photorescue)

Realviz (Software) (www.realviz.com/products)

Road Wired (Cases and bags for camera and electronic equipment) (www.roadwired.com)

Roxio Inc. (Software to burn CDs) (www.roxio.com)

Samsung (Camera manufacturer) (www.samsungcamerausa.com/Camera)

SanDisk Corp. (Memory cards) (www.sandisk.com)

Shutterfly (Photo sharing and prints) (www.shutterfly.com)

Sigma Corporation (Camera and lens manufacturer, accessories) (www.sigma-photo.com)

SmartDisk Corporation (Disk drives, scanners, cables) (www.smartdisk.com)

Sony Electronics (Camera manufacturer and digital recording media) (www.sonystyle.com/digitalimaging/)

Tamron USA Inc. (Lenses) (www.tamron.com)

Tiffen Co. (filters) (www.tiffen.com)

Toshiba America Inc. (Camera manufacturer and accessories) (www.dsc.toshiba.com)

TTL Software (Browser software) (www.ttlsoftware.com)

Ulead Systems Inc. (Software) (www.ulead.com)

Verbatim (CD and DVD discs) (www.verbatim.com)

Virtual Training Company, Inc. (On-line training and software) (www.vtc.com)

Vivitar Corp. (Camera and lens manufacturer and accessories) (www.vivitar.com/products.html)

Wacom Technology Co. (Graphics tablet and stylus) (www.wacom.com/productinfo)

Contributing Photographers

Nancy Brown (www.nancybrown.com)

Bill Durrence (www.billdurrence.com)

Franklin Square Photographers (www.fsphoto.com)

Robert Ganz (www.betterphoto.com/gallery/dynoGallByMember.asp?mem=50576)

Dan Heller (www.danheller.com)

Doug Jensen (www.dougjensen.com)

Boyd Norton (www.nscspro.com)

Brian Oglesbee (www.oglesbee.com)

Moose Peterson (www.moose395.net)

Jan Press Photomedia (www.janpressphotomedia.com)

Jack Reznicki (www.reznicki.com)

Jeff Wignall (www.jeffwignall.com)

Glossary

a **A**
See aperture priority.

aberration
An optical flaw in a lens that causes the image to be distorted or unclear.

AE
See automatic exposure.

AF
See automatic focus.

AI
Automatic Indexing.

angle of view
The area seen by a lens, usually measured in degrees across the diagonal of the film frame.

aperture
The opening in the lens that allows light to enter the camera. Aperture is usually described as an f/number. The higher the f/number, the smaller the aperture; and the lower the f/number, the larger the aperture.

aperture priority
A type of automatic exposure in which you manually select the aperture and the camera automatically selects the shutter speed.

artifact
Information that is not part of the scene but appears in the image due to technology. Artifacts can occur in film or digital images and include increased grain, flare, static marks, color flaws, noise, etc.

artificial light
Usually refers to any light source that doesn't exist in nature, such as incandescent, fluorescent, and other manufactured lighting.

astigmatism
An optical defect that occurs when an off-axis point is brought to focus as sagittal and tangential lines rather than a point.

automatic exposure
When the camera measures light and makes the adjustments necessary to create proper image density on sensitized media.

automatic flash
An electronic flash unit that reads light reflected off a subject (from either a preflash or the actual flash exposure), then shuts itself off as soon as ample light has reached the sensitized medium.

automatic focus
When the camera automatically adjusts the lens elements to sharply render the subject.

ambient light
See available light.

Av
Aperture Value. See aperture priority.

available light
The amount of illumination at a given location that applies to natural and artificial light sources but not those supplied specifically for photography. It is also called existing light or ambient light.

b **backlight**
Light that projects toward the camera from behind the subject.

backup
A copy of a file or program made to ensure that, if the original is lost or damaged, the necessary information is still intact.

barrel distortion
A defect in the lens that makes straight lines curve outward away from the middle of the image.

bit
Binary digit. This is the basic unit of binary computation. See also, byte.

bit depth
The number of bits per pixel that determines the number of colors the image can display. Eight bits per pixel is the minimum requirement for a photo-quality color image.

bounce light
Light that reflects off of another surface before illuminating the subject.

brightness
A subjective measure of illumination. See also, luminance.

buffer
Temporarily stores data so that other programs, on the camera or the computer, can continue to run while data is in transition.

built-in flash
A flash that is permanently attached to the camera body. The built-in flash will pop up and fire in low-light situations when using the camera's automated exposure settings.

built-in meter
A light measuring device that is incorporated into the camera body.

Bulb
A camera setting that allows the shutter to stay open as long as the shutter release is depressed.

byte
Eight bits. See also, bit.

c **card reader**
Device that connects to your computer and enables quick and easy download of images from memory card to computer.

CCD
Charge Coupled Device, a common sensor type for digital cameras from which pixels are interpreted sequentially by the circuitry that surrounds the sensor.

chromatic aberration
Occurs when light rays of different colors are focused on different planes, causing colored halos around objects in the image.

chrominance
Hue and saturation information.

chrominance noise
A form of artifact that appears as a random scattering of densely packed colored "grain." See also, luminance and noise.

close-up
A general term used to describe an image created by closely focusing on a subject. Often involves the use of special lenses or extension tubes. Also, an automated exposure setting that automatically selects a large aperture (not available with all cameras).

CMOS
Complementary Metal Oxide Semiconductor, a sensor type used in digital cameras as a recording medium that converts light into digital images. CMOS sensors are similar to CCDs but allow individual processing of pixels, are less expensive to produce, and use less power.

color balance
The average overall color in a reproduced image. How a digital camera interprets the color of light in a scene so that white or neutral gray appear neutral.

color cast
A colored hue over the image often caused by improper lighting or incorrect white balance settings. Can be produced intentionally for creative effect.

color space
A mapped relationship between colors and computer data about the colors.

CompactFlash (CF) card
One of the most widely used removable memory cards.

complementary colors
In theory: any two colors of light that, when combined, emit all known light wavelengths, resulting in white light. Also, it can be any pair of dye colors that absorb all known light wavelengths, resulting in black.

compression
Method of reducing file size through removal of redundant data, as with the JPEG file format.

contrast
The difference between two or more tones in terms of luminance, density, or darkness.

contrast filter
A colored filter that lightens or darkens the monotone representation of a colored area or object in a black-and-white photograph.

CPU
Central Processing Unit. This is the "brains" of a computer or a lens.

critical focus
The most sharply focused point of an image.

cropping
The process of extracting a portion of the image area. If this portion of the image is enlarged, resolution is subsequently lowered.

d daylight
A white balance setting that renders accurate color when shooting in mid-day sunlight.

dedicated flash
An electronic flash unit that talks with the camera, communicating things such as flash illumination, lens focal length, subject distance, and some-times flash status.

default
Refers to various factory-set attributes or features, in this case of a camera, that can be changed by the user but can, as desired, be reset to the original factory settings.

depth of field
The image space in front of and behind the plane of focus that appears acceptably sharp in the photograph.

diaphragm
A mechanism that determines the size of the lens opening that allows light to pass into the camera when taking a photo.

digital zoom
The cropping of the image at the sensor to create the effect of a telephoto zoom lens. The camera interpolates the image to the original resolution. However, the result is not as sharp as an image created with an optical zoom lens because the cropping of the image reduced the available sensor resolution.

diopter
A measurement of the refractive power of a lens. Also, it may be a supplementary lens that is defined by its focal length and power of magnification.

download
The transfer of data from one device to another, such as from camera to computer or computer to printer.

dpi
Dots per inch, referring to printing resolution.

dye sublimation printer
Creates color on the printed page by vaporizing inks that then solidify on the page.

e electronic flash
A device with a glass or plastic tube filled with gas that, when electrified, creates an intense flash of light. Also called a strobe. Unlike a flash bulb, it is reusable.

EV
Exposure value.

EXIF
Exchangeable Image File Format. This format is used for storing an image file's interchange information.

exposure
When light enters the camera and reacts with the sensitized medium. The term can also refer to the amount of light that strikes the light sensitive medium.

exposure meter
See light meter.

extension tube
A hollow metal ring that can be fitted between the camera and lens. It increases the distance between the optical center of the lens and the sensor and decreases the minimum focus distance of the lens.

f f/
See f/stop

file format
The form in which digital images are stored and recorded, e.g., JPEG, RAW, TIFF, etc.

filter
Usually a piece of plastic or glass used to control how certain wavelengths of light are recorded. A filter absorbs selected wavelengths, preventing them from reaching the light sensitive medium. Also, software available in image processing computer programs can produce special filter effects.

FireWire
A high speed data transfer standard that allows outlying accessories to be plugged and unplugged from the computer while it is turned on. Some digital cameras and card readers use FireWire to connect to the computer. FireWire transfers data faster than USB.

flare
Unwanted light streaks or rings that appear in the viewfinder, on the recorded image, or both. It is caused by extraneous light entering the camera during shooting. Diffuse flare is uniformly reflected light that can lower the contrast of the image. Zoom lenses are susceptible to flare because they are comprised of many elements. Filters can also increase flare. Use of a lens hood can often reduce this undesirable effect.

f/number
See f/stop.

focal length
When the lens is focused on infinity, it is the distance from the optical center of the lens to the focal plane.

focal plane
The plane on which a lens forms a sharp image. Also, it may be the film plane or sensor plane.

focus
An optimum sharpness or image clarity that occurs when a lens creates a sharp image by converging light rays to specific points at the focal plane. The word also refers to the act of adjusting the lens to achieve optimal image sharpness.

FP high-speed sync
Focal Plane high-speed sync. This is offered by some flash units that emit rapid flash pulses so that the unit will synchronize at camera shutter speeds higher than the standard sync speed.

frame
The complete image-exposure area.

f/stop
The size of the aperture or diaphragm opening of a lens, also referred to as f/number or stop. The term stands for the ratio of the focal length (f) of the lens to the width of its aperture opening. (f/1.4 = wide opening and f/22 = narrow opening.) Each stop up (lower f/number) doubles the amount of light reaching the sensitized medium. Each stop down (higher f/number) halves the amount of light reaching the sensitized medium.

full-sized sensor
A sensor with the same dimensions as a 35mm film frame.

g GB
See gigabyte.

gigabyte
Just over one billion bytes.

GN
See guide number.

gray card
A card used to take accurate exposure readings. It typically has a white side that reflects 90% of the light and a gray side that reflects 18%.

Gray scale
A successive series of tones ranging between black and white, which have no color.

guide number
A number used to quantify the output of a flash unit. It is derived by using this formula: GN = aperture x distance. Guide numbers are expressed for a given ISO film speed in either feet or meters.

h hard drive
A contained storage unit made up of magnetically sensitive disks.

histogram
A graphic representation of image tones.

hot shoe
An electronically connected flash mount on the camera body. It enables direct connection between the camera and an external flash, and synchronizes the shutter release with the firing of the flash.

i icon
A symbol used to represent a file, function, or program.

image-editing program
Software that allows for image alteration and enhancement.

image-processing program
See image-editing program.

infinity
A term used to denote the theoretically most distant point of focus.

interpolation
Process used to increase image resolution by creating new pixels based on existing pixels. The software intelligently looks at existing pixels and creates new pixels to fill the gaps and achieve a higher resolution.

IS
Image Stabilization, a technology that reduces camera shake and vibration. It is used in lenses, binoculars, camcorders, etc.

ISO
From ISOS (Greek for equal), a term for industry standards from the International Organization for Standardization. When an ISO number is applied to film, it indicates the relative light sensitivity of the recording medium. Digital sensors use film ISO equivalents, which are based on enhancing the data stream or boosting the signal.

j JPEG
Joint Photographic Experts Group. This is a lossy compression file format that works with any computer and photo software. JPEG examines an image for redundant information and then removes it. It is a variable compression format because the amount of leftover data depends on the detail in the photo and the amount of compression. At low compression/high quality, the loss of data has a negligible effect on the photo. However, JPEG should not be used as a working format; the file should be reopened and saved in a format such as TIFF, which does not compress the image.

k KB
See kilobyte.

kilobyte
Just over one thousand bytes.

l latitude
The acceptable range of exposure (from under to over) determined by observed loss of image quality.

LCD
Liquid Crystal Display, which is a flat screen with two clear polarizing sheets on either side of a liquid crystal solution. When activated by an electric current, the LCD causes the crystals to either pass through or block light in order to create a colored image display.

LED
Light Emitting Diode. It is a signal often employed as an indicator on cameras as well as on other electronic equipment.

lens
A piece of optical glass on the front of a camera that has been precisely calibrated to allow focus.

lens hood
Also called a lens shade. This is a short tube that can be attached to the front of a lens to reduce flare. It keeps undesirable light from reaching the front of the lens and also protects the front of the lens.

lens shade
See lens hood.

light meter
Also called an exposure meter, it is a device that measures light levels and calculates the correct aperture and shutter speed.

long lens
See telephoto lens.

lossless
Image compression in which no data is lost.

lossy
Image compression in which data is lost and, thereby, image quality is lessened. This means that the greater the compression, the lesser the image quality.

luminance
A term used to describe directional brightness. It can also be used as luminance noise, which is a form of noise that appears as a sprinkling of black "grain." See also, brightness, chrominance, and noise.

m macro lens
A lens designed to be at top sharpness over a flat field when focused at close distances and reproduction ratios up to 1:1.

main light
The primary or dominant light source. It influences texture, volume, and shadows.

manual exposure
A camera operating mode that requires the user to determine and set both the aperture and shutter speed. This is the opposite of automatic exposure.

MB
See megabyte.

megabyte
Just over one million bytes.

megapixel
A million pixels.

memory
The storage capacity of a hard drive or other recording media.

memory card
Typical recording medium of digital cameras. Memory cards can be used to store still images, moving images, or sound, as well as related file data. There are several different types, e.g., CompactFlash, SmartMedia, xD, Memory Stick, etc. Individual card capacity is limited by available storage capacity as well as by the size of the recorded data, such as image resolution.

menu
An on-screen listing of user options.

middle gray
Halfway between black and white, it is an average gray tone with 18% reflectance. See also, gray card.

midtone
The tone that appears as medium brightness, or medium gray tone, in a photographic print.

mode
Specified operating conditions of the camera or software program.

n noise
The digital equivalent of grain. It is often caused by a number of different factors, such as a high ISO setting, heat, sensor design, etc. Though usually undesirable, it may be added for creative effect using an image-processing program. See also, chrominance noise and luminance.

normal lens
See standard lens.

o overexposed
When too much light is recorded with the image, causing the photo to be too light in tone.

p pan
Moving the camera to follow a moving subject. When a slow shutter speed is used, this creates an image in which the subject appears sharp and the background is blurred.

perspective
The effect of the distance between the camera and image elements upon the perceived size of objects in an image. It is also an expression of this three-dimensional relationship in two dimensions.

pincushion distortion
A flaw in a lens that causes straight lines to bend inward toward the middle of an image.

pixel
Derived from picture element. A pixel is the base component of a digital image. Every individual pixel can have a distinct color and tone.

plug-in
Third-party software created to augment an existing software program.

polarization
An effect achieved by using a polarizing filter. It minimizes reflections from non-metallic surfaces like water and glass and saturates colors by removing glare. Polarization often makes skies appear bluer at 90 degrees to the sun. The term also applies to the above effects simulated by a polarizing software filter.

r RAM
Stands for Random Access Memory, which is a computer's memory capacity, directly accessible from the central processing unit.

RAW
An image file format that has little or no internal processing applied by the camera. It contains 12-bit color information, a wider range of data than 8-bit formats such as JPEG.

resolution
The amount of data available for an image as applied to image size. It is expressed in pixels or megapixels, or sometimes as lines per inch on a monitor or dots per inch on a printed image.

s S
See shutter priority.

saturation
The intensity or richness of a hue or color.

sharp
A term used to describe the quality of an image as clear, crisp, and perfectly focused, as opposed to fuzzy, obscure, or unfocused.

short lens
A lens with a short focal length a wide-angle lens. It produces a greater angle of view than you would see with your eyes.

shutter
The apparatus that controls the amount of time during which light is allowed to reach the sensitized medium.

shutter priority
An automatic exposure mode in which you manually select the shutter speed and the camera automatically selects the aperture.

single-lens reflex (SLR)
A camera with a mirror that reflects the image entering the lens through a pentaprism or pentamirror onto the viewfinder screen. When you take the picture, the mirror reflexes out of the way, the focal plane shutter opens, and the image is recorded.

small-format sensor
In a digital camera, this sensor is physically smaller than a 35mm frame of film. The result is that standard 35mm focal lengths act like longer lenses because the sensor sees an angle of view smaller than that of the lens.

standard lens
Also known as a normal lens, this is a fixed-focal-length lens usually in the range of 45 to 55mm for 35mm format (or the equivalent range for small-format sensors). In contrast to wide-angle or telephoto lenses, a standard lens views a realistically proportionate perspective of a scene.

stop
See f/stop.

stop down
To reduce the size of the diaphragm opening by using a higher f/number.

stop up
To increase the size of the diaphragm opening by using a lower f/number.

strobe
Abbreviation for stroboscopic. An electronic light source that produces a series of evenly spaced bursts of light.

synchronize
Causing a flash unit to fire simultaneously with the complete opening of the camera's shutter.

t telephoto effect
When objects in an image appear closer than they really are through the use of a telephoto lens.

telephoto lens
A lens with a long focal length that enlarges the subject and produces a narrower angle of view than you would see with your eyes.

thumbnail
A miniaturized representation of an image file.

TIFF
Tagged Image File Format. This popular digital format uses lossless compression.

tripod
A three-legged stand that stabilizes the camera and eliminates camera shake caused by body movement or vibration. Tripods are usually adjustable for height and angle.

TTL
Through-the-Lens, i.e. TTL metering.

Tv
Time Value. See shutter priority.

u USB
Universal Serial Bus. This interface standard allows outlying accessories to be plugged and unplugged from the computer while it is turned on. USB 2.0 enables high-speed data transfer.

v vignetting
A reduction in light at the edge of an image due to use of a filter or an inappropriate lens hood for the particular lens.

viewfinder screen
The ground glass surface on which you view your image.

VR
Vibration Reduction, a technology used in such photographic accessories as a VR lens.

w wide-angle lens
A lens that produces a greater angle of view than you would see with your eyes, often causing the image to appear stretched. See also, short lens.

z zoom lens
A lens that can be adjusted to cover a wide range of focal lengths.

Index

pre-focusing 95, 155, 163

printing 45, 23, 234, 247, 263, 283, 284-290

Program Mode (P) 67, 88

protecting images 41, 42, 43, 47, 97, 229, 278, 281

q quality (see resolution)

r RAM (random access memory) 272, 278

RAW 31, 36-38, 42, 71, 77, 95

red-eye (reduction) 34, 45, 49, 51, 227, 244, 289

Red-eye Reduction Mode 51

resolution 30, 31, 33, 40, 62, 70, 97, 229, 282-284, 289

restoration 23, 227, 235, 241, 242-243, 246

s scanner 58, 59, 230, 235, 240, 282-283, 292

sensor 29, 31, 33, 34, 37, 38, 59, 63, 194, 201, 219, 238

 CCD 29, 58, 59, 61, 95, 219

 CMOS 29, 63

shutter lag 36, 37, 95

Shutter-Priority Mode (Tv or S) 35, 88, 94, 147, 156, 218

shutter speed 94

slave unit 52, 214

Slow Sync Mode 51, 148

Sports Mode 35

sports photography 37, 38, 40, 48, 57, 95, 170, 171

spot metering (see metering, spot)

stitching 169

storing images 42, 47, 278, 287

t telephoto lens (see lens, telephoto)

TIFF 37, 42, 71, 95

tripod 46, 51, 56, 75, 77, 78, 97, 147, 149, 150, 151, 168, 203, 214, 215, 218

TTL 52

v viewfinder 36, 48, 50, 80, 83, 84, 92, 96, 212, 222

w white balance 34-37, 71, 76, 77, 95, 97, 142, 144, 147, 235

wide-angle lens (see lens, wide-angle)

Windows 45, 62, 278, 279

workflow 96, 248, 279

write speed 38, 40, 41, 69

z zoom lens (see lens, zoom)